Postfeminism and Contemporary Hollywood Cinema

Postfeminism and Contemporary Hollywood Cinema

Edited by

Joel Gwynne
National Institute of Education, NTU, Singapore

Nadine Muller
Liverpool John Moores University, UK

First published 2013 by
PALGRAVE MACMILLAN

Palgrave Macmillan in the UK is an imprint of Macmillan Publishers Limited,
registered in England, company number 785998, of Houndmills, Basingstoke,
Hampshire RG21 6XS.

Palgrave Macmillan in the US is a division of St Martin's Press LLC,
175 Fifth Avenue, New York, NY 10010.

Palgrave Macmillan is the global academic imprint of the above companies
and has companies and representatives throughout the world.

Palgrave® and Macmillan® are registered trademarks in the United States,
the United Kingdom, Europe and other countries.

ISBN 978–1–137–30683–8

This book is printed on paper suitable for recycling and made from fully
managed and sustained forest sources. Logging, pulping and manufacturing
processes are expected to conform to the environmental regulations of the
country of origin.

A catalogue record for this book is available from the British Library.

A catalog record for this book is available from the Library of Congress.

Contents

Part III Postfeminism and Genre

Foreword

In the twenty-first century, the university has witnessed a renaissance of feminist scholarship in the areas of film and popular culture. *Postfeminism and Contemporary Hollywood* steps into this conversation at a timely moment, looking back at the literature that is the product of this renaissance while foreshadowing its future. Significantly, the volume takes as its point of departure not the question of feminism, but the fact of its legacy, implied in the term 'postfeminism'. Feminism itself is posited as a given; the issues discussed in this volume, then, revolve around its relevance today and the degree to which its mandate has been relegated to the past by popular culture. Notwithstanding this discussion, the fact of a new tradition of feminist scholarship arising out of postfeminism testifies to the continued vitality of the problematic initially defined in the context of second-wave feminism: what does it mean to be a woman, a man, a father or a mother, and what are the political, economic and cultural implications thereof? How does gender intersect with other forms of identity, such as age, class, ethnicity and sexuality, in producing a particular subjectivity? Although the notion of a hegemonic discourse continues to function as a significant category of analysis, it is no longer synonymous with patriarchy. Rather, the feminine subject is, as often as not, posited as caught within a veritable network of competing discourses, a spectrum of femininities. In contrast, masculine subjectivity tends to be analysed as fragmented and fissured, lacking unity, coherence and drive, furthering a general sense of a proliferating and unstable social ground.

The Enlightenment spawned what we now commonly refer to as grand narratives of social reform and revolution; the last 50 years have seen a gradual erosion in the dominance of these belief systems, to which second-wave feminism, as it was expressed by its earliest proponents, owed many of its tenets. Thus, while this volume suggests a general unease, and the existence of unanswered questions, about the status of gender and sexual identities and the way that these continue to function as determining forces in the social, economic and cultural field, it also speaks to a general focus within popular culture on the individual as the site of introspection and action, and a movement away from notions of social reform – what I have referred to elsewhere as neo-feminism.

Currently, according to the analyses offered by the scholars in this volume, the field and scope of a particular set of circumstances are almost inevitably articulated with regard to the fate of an individual, extending perhaps to her or his immediate biological family, whose agency is the determining force in negotiating a more acceptable destiny for herself, himself and her or his intimates. As such, this volume, taken as a whole, sets the terms for a continuing conversation about the future of feminism within a society defined by the cult of the individual, thus making an invaluable contribution to the field.

Hilary Radner
Foundation Professor of Film and Media Studies
University of Otago, New Zealand

Contributors

Benjamin A. Brabon is Senior Lecturer in English Literature and SOLSTICE Learning and Teaching Fellow at Edge Hill University. His research focuses on Gothic fiction, cultural theory and gender studies. His book publications include *Postfeminist Gothic: Critical Interventions in Contemporary Culture* (2007), *The Influence of Benedict Anderson* (2007), *Postfeminism: Cultural Texts and Theories* (2009) and *The Influence of D. F. McKenzie* (2010). Forthcoming work includes a monograph, *Gothic Cartography: A Literary Geography of Haunting* (2013), and a co-edited collection of essays on the postfeminist eighteenth century.

Clara Bradbury-Rance is a doctoral research student at the University of Manchester, where she teaches an undergraduate critical theory course in the Department of English and American Studies. Her research, funded by the Arts and Humanities Research Council, explores contemporary lesbian cinema. As well as her contribution to this book, she is writing on queer adolescence for a collection on girlhood in the cinema edited by Fiona Handyside and Kate Taylor (forthcoming).

Alexia L. Bowler teaches literature and film across the College of Arts and Humanities at Swansea University. Her research focuses on the politics of cultural representation in twentieth- and twenty-first-century literature and film, with particular emphasis on feminism and popular culture, technology, the 'real' and the spectacle, as well as adaptation. She has published articles and reviews in *New Cinemas*, *Science Fiction Film and Television* and *thirdspace: a journal of feminist theory and culture*, and has edited a special edition of the *Journal of Neo-Victorian Studies* on adaptation.

Amy Burns is currently completing a doctorate in English literature at Northumbria University. Her thesis examines the literary value of contemporary chick lit within postfeminist popular fictions and 'chick' culture. She has published in the postgraduate journal *Networking Knowledge* and has co-edited a special issue of the *Graduate Journal of Social Sciences*.

Katherine Farrimond is a part-time tutor and Research Assistant at Newcastle University, where she teaches courses on film, media and theory. She was recently awarded her PhD, and her thesis, 'Beyond Backlash: The Femme Fatale in Contemporary American Cinema', maps various articulations of the figure in a range of popular film texts. Her broader research interests include the intersections of the body, sexuality, gender and genre, as well as (post)feminism and contemporary film and television. She has published work on femininity and Hollywood cinema in the collections *Women on Screen: Feminism and Femininity in Visual Culture* (2010) and *The Worlds of Back to the Future: Critical Essays on the Films* (2010), while her work on the femme fatale has also been published in the *Journal of Bisexuality* (2012).

Martin Fradley is a former lecturer at the University of Aberdeen and the University of Manchester. He is co-editor of *Shane Meadows: Critical Essays* (2013). His recent published work has appeared in the *Journal of British Cinema and Television* and the anthologies *Falling in Love Again: Romantic Comedy in Contemporary Cinema* (2009), *American Horror Film: The Genre at the Turn of the Millennium* (2010), *Fifty Contemporary Film Directors* (2010), *Handbook of Gender, Sex and Media* (2012), *Directory of World Cinema: Britain* (2012) and *Tainted Love: Screening Sexual Perversities* (2013). He is a regular contributor to *Film Quarterly*.

Vincent M. Gaine is an independent researcher and his research focuses on philosophy and film, especially in relation to contemporary Hollywood auteurs such as Michael Mann, James Cameron and Christopher Nolan. He is the author of *Existentialism and Social Engagement in the Films of Michael Mann* (2011). He has published articles in *Cinema Journal*, the *Journal of Theology, Technology and Religion* and *Networking Knowledge*, and has contributed chapters to *The 21st Century Superhero: Essays in Gender, Genre and Globalisation* (2011) and the *Journal of World Cinema: American Hollywood* and *American Independent Cinema* (2011, 2012). Research for his second book, on the subjectivity of truth in the films of Christopher Nolan, is underway, as is research into production cycles and the ethics of critical reception. He also publishes reviews and analyses on his blog: vincentmgaine.wordpress.com.

Joel Gwynne is Assistant Professor of English at the National Institute of Education. His research focuses on contemporary literature, film and media studies in the context of feminism and globalization. He has published articles in the *Journal of Postcolonial Writing, Women's Studies*

International Forum, the *Journal of Gender Studies* and the *Journal of Contemporary Asia*. His books include *The Secular Visionaries: Aestheticism and New Zealand Short Fiction in the Twentieth Century* (2010), *Sexuality and Contemporary Literature* (2012) and *Erotic Memoirs and Postfeminism: The Politics of Pleasure* (2013).

Hannah Hamad is Lecturer in Film Studies at King's College, London. Her principal research interests are postfeminist cultures of popular film and television, Hollywood stardom and celebrity culture, and the cultural politics of contemporary Hollywood. She has taught in the areas of gender and race in film and media, popular culture, and stardom and celebrity. She is the author of several articles on contemporary popular film and media culture, Hollywood stardom, and of the forthcoming monograph *Postfeminism and Paternity in Contemporary US Film: Framing Fatherhood* (2013).

Katharina Lindner is Lecturer in Film and Media Studies at the University of Stirling. Her research interests include gender and queer theory, media and sport, as well as film phenomenology. She has published articles in *Feminist Media Studies, NECSUS European Journal of Media Studies, Scope: An Online Journal of Film and TV Studies, New Review of Film and Television Studies, Journal of International Women's Studies* and *Sex Roles: A Journal of Research*. Forthcoming work includes a monograph on queer film phenomenology.

Ana Moya is Senior Lecturer in English Literature and Head of Studies at the Facultat de Filologia, University of Barcelona. Her research focuses on film studies, women's studies, adaptation and British fiction, particularly nineteenth-century fiction. Her publications include ' "I'm a Wild Success": Postmodern Dickens/Victorian Cuaron' (with G. López) in *Dickens Quarterly* (UK, 2008) and J. Glavin (ed.), *Dickens Adapted* (2012); 'The Politics of Re-presenting Vanity Fair: Mira Nair's Becky Sharp' in *Atlantis* 32 (Spain, 2010); 'Eagleton's Wilde Readings in *St Oscar*' in *The Wildean* (2011); and 'Historia(s) de la diferencia: la novela inglesa de mujeres en el siglo XIX' in *Espacio, tiempo y forma* (Spain, 2011).

Nadine Muller is Lecturer in English Literature and Cultural History at Liverpool John Moores University. Her research covers Victorian and neo-Victorian literature and culture, feminist theory and practice, women's fiction, and cultural histories of women and gender from the nineteenth century to the present day. She is working on two book

projects: *The Feminist Politics of Neo-Victorian Fiction, 2000–2010* and *The Widow in British Literature and Culture, 1850–2010*. She is a member of the *Journal of Gender Studies* editorial board, co-editor of *Women and Belief, 1852–1928* (2012), and a member of the Contemporary Women's Writing executive committee. She blogs at www.nadinemuller.org.uk and tweets via @Nadine_Muller.

Lauren Jade Thompson recently completed her PhD in the Department of Film and Television Studies at the University of Warwick. Her research focuses on postfeminist formations of masculinity in contemporary popular television and film. Other research interests include film and television comedy, film and young people, and television talk on social media. Forthcoming publications include a chapter on male makeover and the suit in *Fashion Cultures: Second Edition* (2013) and a study of television and Twitter for *Television and New Media*.

Helen Warner is Lecturer in Media and Culture at the University of East Anglia. Her research focuses on the intersection between gender, fashion and celebrity culture. She has published articles on contemporary American television, fashion and celebrity culture in several journals including the *Journal of Popular Narrative Media*, *Film Fashion and Consumption* and *SCAN: Journal of Media Arts Culture*. Forthcoming work includes a monograph, *Fashion on TV: Identity and Celebrity Culture* (2013), an article in *Media, Culture and Society* and a guest-edited special issue of *Film Fashion and Consumption*. In addition, she is developing an edited collection on gender and twenty-first century visual culture with Dr Heather Savigny.

Imelda Whelehan is Professor of English and Gender Studies at the University of Tasmania, Australia. Her research focuses on feminist thought, popular fiction and film, and adaptation studies. Recent books include *Screen Adaptation* (with D. Cartmell, 2010), *The Cambridge Companion to Literature on Screen* (ed. with D. Cartmell, 2007) and *The Feminist Bestseller* (2005). She is also co-editor of the journal *Adaptation* and Associate Editor for *Contemporary Women's Writing*. She is currently writing on bras, ageing and postfeminism.

Introduction: Postfeminism and Contemporary Hollywood Cinema

Joel Gwynne and Nadine Muller

Recent years have witnessed what can only be described as an explosion of scholarly interest in the representation of feminism and femininity at the turn of the millennium and beyond. Critical attention to this subject has been spread discursively across a number of genres, with critics such as Angela McRobbie, Rosalind Gill, Ann Brooks, Hilary Radner, Imelda Whelehan, Yvonne Tasker, Diana Negra, Sarah Projansky, Melanie Waters, Stéphanie Genz and Benjamin Brabon, to name only a few, producing monographs and edited collections devoted to the configuration of gender across multiple mediums (literature, film, television and media studies) and within what has come to be termed as postfeminist cultural praxis. In the field of film studies specifically, Hilary Radner and Rebecca Stringer's *Feminism at the Movies: Understanding Gender in Contemporary Popular Culture* (2011) and Melanie Waters' *Women on Screen: Feminism and Femininity in Visual Culture* (2011) are noteworthy recent interventions, and both collections share with this one a sustained focus on gender for both are works of feminist film criticism committed primarily to analysing cinema across the first decade of the twenty-first century. *Postfeminism and Contemporary Hollywood Cinema* aims to extend current scholarship on postfeminist media culture and postfeminism as a cultural condition by exploring popular culture's engagement with feminism through a range of cinematic genres. This collection interrogates not only mainstream staples of Hollywood cinema such as the romantic comedy or 'rom-com', the action and the horror film, but also explores the independent and avant-garde boundaries of commercial production. In doing so, this book presents 14 new essays charting the ubiquity of neoliberal and postfeminist sensibilities within one of popular culture's most influential mediums. The collection chronicles the changes in representations of feminism, femininities

1

and masculinities, and examines how contemporary Hollywood cinema engages with the aftermath of second-wave feminism and the emergence of 'new feminisms'.

Postfeminism, cinema and new gender paradigms

Given that postfeminism is central to the conceptual structure of this collection, it is important to begin by locating and defining the term, shrouded as it is in contradiction. While 'post-feminism' and 'postfeminism' could be understood as distinctly different terms – with the former representing a historical period and the latter a cultural sensibility – it should be noted that in both instances the prefix 'post' is ambiguous and can be understood as suggesting either a period 'after' feminism or, more optimistically, as denoting 'a genealogy that entails revision or strong family resemblance'.[1] The term can therefore represent both a repudiation and an affirmation of feminist politics, depending on how it is deployed within a certain cultural context. Even though many critics have drawn attention to the apparently empowering aspects of postfeminist discourse – comprising philosophies that espouse equality, inclusion and free choice – they have also highlighted how this celebration of the power of the individual is part of a more insidious process whereby the social constraints placed upon contemporary girls and women are deemed inconsequential. From this critical perspective, feminism is 'absorbed and supplanted by "postfeminism" in such a way that the complexity of contemporary feminist theories and activisms is lost'.[2] McRobbie extends this line of argument in her now canonical thesis statement that 'postfeminism positively draws on and invokes feminism as that which can be taken into account, to suggest that equality is achieved, in order to install a whole repertoire of new meanings, which emphasize that it is no longer needed, that it is a spent force'.[3]

Such critical appraisals appear to conclude that postfeminist ideology is ultimately disempowering. However, McRobbie's reference to the manner in which postfeminism 'positively draws on and invokes feminism' suggests that postfeminist sensibilities do not entirely, nor even deliberately, reject feminism. Indeed, postfeminism has been read as offering liberating possibilities to women as a discourse indicative of a post-traditional era characterized by dramatic changes in social relationships and conceptions of agency. Sarah Gamble astutely notes that postfeminism is a 'flexible ideology which can be adapted to suit individual needs and desires',[4] one which refuses 'any definition of women

as victims who are unable to control their own lives'.[5] While Gamble proceeds to highlight the problems of this position, positive conceptualizations of postfeminism have been discernible in representations of youthful femininity in popular culture. Even though female adolescents have always embodied powerful feminist potential – with their ability to negotiate gender roles an 'unconstrained freedom representing the most fearsome threat to male control'[6] – the figure of the girl has been resurrected in contemporary popular culture and utilized to demonstrate the empowering possibilities of reconfigured femininity. This resurrection has followed a historical trajectory in which postfeminist sensibilities have also emerged, and Projanksy observes that 'the current proliferation of discourse about girlhood literally coincides chronologically with the proliferation of discourse about postfeminism'.[7] Discourses affirming girlhood as an empowering period of social development were most conspicuously mobilized through the rhetoric of 'Girl Power' that began to dominate consumer culture in the mid-1990s, raising 'a series of striking questions about the relationship between feminism, femininity and commercialization'.[8]

Given the clear relationship between postfeminism and girlhood, it is hardly surprising that cinema within postfeminist culture remains preoccupied with the reconstruction of femininity, and this book begins with a focus on the various locations – including foreign 'borderlands', educational institutions, and public spaces – where traditional femininity is contested and negotiated. In its focus on various configurations of femininity in contemporary Hollywood cinema, the first section of this collection constitutes familiar territory for scholars of gender, film and popular culture. Yet, rather than reiterating existing debates on femininity and representation, the authors of the essays included here provide new critical and theoretical perspectives of well-known films as well as addressing important but underexplored conceptual ground.

The collection opens with Ana Moya's exploration of the relationship between the female cosmopolitan subject and transnationalism in *Vicky Cristina Barcelona* (2008) and *Eat Pray Love* (2010). Discussing in particular the significance of borderlands in these films' representations of their female protagonists, Moya utlilizes Radner's concept of neo-feminism to argue that these women – through their travels – eventually become 'in-betweeners' who transgress previously established formations of postfeminist femininity. Clara Bradbury-Rance, too, engages with blurred categories as her essay provides a long-overdue examination of the work of Lisa Cholodenko. This female director,

Bradbury-Rance argues, 'straddles feminism and postfeminism, independent and mainstream, high art and popular culture' as her films queer these categories as well as the notions of the definable feminine identity which postfeminism and consumer culture propagate. In her discussion of the rom-com *Easy A* (2010), Katherine Farrimond contends that this ostensibly traditional genre also has the potential to critically interrogate its own, usually heteronormative, politics. Concentrating in particular on *Easy A*'s representations of virginity and contextualizing them within a framework of (post-)feminist theorizations of sexual empowerment, girlhood and performance, Farrimond argues that *Easy A* and its sexual politics can be categorized neither as apolitical nor as straightforwardly conservative.

Through an analysis of *The House Bunny* (2008), Joel Gwynne not only draws our attention to the postfeminist rhetoric of this particular film but also addresses the complex feminist ethics of the popular makeover paradigm. The makeover process, Gwynne suggests, facilitates and charts the development of a new, ideal feminine and feminist subjectivity. *The House Bunny*, then, engages with second-wave feminism and postfeminist politics and their perceived disparities in relation to constructions of femininity, sexual empowerment and consumer culture. Turning away from young femininities, the final essay in this section addresses a largely neglected aspect of contemporary Hollywood cinema: its representation of the ageing woman. Focusing on *I Don't Know How She Does It* (2011), *Sex and the City 2* (2010), *It's Complicated* (2009) and *Mirror Mirror* (2012), Imelda Whelehan explores the interplay between sexism and ageism, arguing that these films' depictions of ageing women effect some positive changes within the postfeminist paradigm of power and choice. Challenging the manner in which postfeminist scholarship overwhelmingly concentrates on the experiences of girls and young women, Whelehan points out that neoliberalism and the cultural obsession with the makeover paradigm position 'viable ageing as deliberate neglect'. And yet, while postfeminist discourse has little to say to the Hollywood consumer who is not a young, white, heterosexual, middle-class woman, ageing is of course not the only experience overlooked by postfeminism.

Indeed, much more attention needs to be paid to the subject of masculinity, for despite important contributions such as David Hansen-Miller and Rosalind Gill's work on 'lad flicks' (in *Feminism at the Movies*, 2011), masculinity remains of secondary critical interest within scholarship on postfeminism. In her chapter on masculinity and

domestic space, Lauren Jade Thompson makes the observation that despite the important interventions of Gill and Whelehan, it is essential to continue our consideration of how masculinity is subject to its discourses, and to resist the tendency to marginalize the discussion of men and masculinity, or 'to treat their representation as more simplistic or less serious'. While it would be reckless to make assumptions regarding the reasons behind this critical neglect of men and masculinities within postfeminism, one reason could simply be men's comparative lack of engagement with feminist studies and women's understandable prioritization of films with a female address. Fortunately, this is likely to change, for while Stephen Whitehead and Frank Barrett note that 'feminism puts men and masculinities in a critical spotlight, in the process centring on the practices of men in ways many men would prefer it not to',[9] Hollywood cinema documents men embracing, with humour and self-reflexivity, critiques of the fallacies of heroic and hegemonic masculinity. The chapters in the second section of this collection respond to the increasingly and often highly ironic visibility of masculinity within cinema by analysing the role of male subject positions in 'chick flicks', rom-com and thrillers. They present the twenty-first century man as an object of consumption for the female audience, and also suggest that the rise of postfeminist 'chick culture' has engendered changes in masculinity in both the private and public sphere, positioning men as struggling in the public sphere and yet becoming increasingly successful in the private sphere, most particularly in terms of paternity and domestic labour.

The essays collected in this section not only make interventions into current discussions of men and masculinities in postfeminist culture but also serve to further contextualize and illuminate constructions of femininity and the relationship between gender and genre within. Hannah Hamad's chapter considers the recent cycle of films concerned with father figures and paternal masculinities. Analysing the films themselves as well as the processes of production and distribution, Hamad suggests that 'fatherhood acts as the anchoring trope of contemporary Hollywood masculinities', and that these postfeminist paternal figures create and reinforce new hegemonic masculinities. Moving away from fatherhood and towards singledom, Benjamin A. Brabon introduces us to what he terms the 'postfeminist male singleton' and the 'chuck flick'. Using *Failure to Launch* (2006) as the basis for his discussion of these phenomena, Brabon provides an analysis which suggests that the postfeminist male singleton is a figure that embodies a seemingly contradictory combination of gender scripts, depicting non-hegemonic

forms of masculinity that lack the potential (or intention) for any wider social or cultural transformation.

Amy Burns' chapter surveys a range of films in the chuck flick's sister genre, the chick flick, focusing especially on their 'new heroes', as she terms them, and provides an insightful analysis of the types of men and masculinities they represent. Despite the variety of roles in which these new heroes appear, Burns argues that they nevertheless continue to promote essentially conservative politics whose undermining of feminism aligns itself with postfeminist culture. Lauren Jade Thompson returns us to some well-known twenty-first century romcoms including *You, Me and Dupree* (2006) and *Knocked Up* (2007), providing a comparative discussion of the gendered domestic spaces they portray and their relationship with the postfeminist ideologies that these films advocate. While Thompson identifies the establishment of a masculine domestic space – the mancave – and a repeated disruption of feminine domestic space, she suggests that 'masculinity is still struggling to find its true home in the changed gender paradigm that the[se] films represent'. The final essay in this part of the collection turns to the crime genre, a traditionally masculine realm. Considering Michael Mann's *Heat* (1995), Vincent Gaine sees in this film not a celebration of the usual type of masculinity – or hypermasculinity – so often depicted in Hollywood crime cinema but, instead, proposes that *Heat* functions as a warning about the dangers of masculinity and acts as a predecessor to Mann's later films, which further problematize the gendered stereotypes surrounding men, masculinity and crime.

The first two sections of this book on femininities and masculinities pay specific attention to how these gendered subject positions constitute the central focus of the films under discussion. However, gender is of course a construction that permeates all cultural productions, for just as human beings are never beyond gender, nor is any work of art. This is especially true when we turn our attention to genre and film cycles, for genre and the gendered audience are invariably inseparable. As Pamela Craig and Martin Fradley point out, for example, contemporary teen horror 'deliberately engages with and celebrates the genre's long-term investment in subjectively expressing and empathizing with marginalized female experience'.[10] The same statement could be employed to describe the rom-com, and films with a specifically female address now dominate Hollywood cinema, concomitant with the manner in which young women have been identified and extolled as the driving force behind neoliberal economies.[11]

Across the broad spectrum of Hollywood genres, youthful femininity is packaged as empowering, yet as Radner notes this 'prolonging of adolescence has significant implications for consumer culture',[12] wedding self-fulfilment and autonomy for the contemporary woman as predicated on 'purchasing, adorning or surrounding herself with the goods that this culture can offer'.[13] The pervasiveness of this pernicious cultural shift, whereby women are erroneously positioned as empowered subjects in ways that are almost always connected to consumption and feminine physical appearance, is apparent even within historically masculine genres such as action cinema and sports films. These genres have now witnessed the growing presence of females who do not merely appear as supporting figures but who are actually the visual spectacle of the narrative proper. On occasion, these genres imbue their central female characters with the physical strength to compete with men on equal terms, while offering no answers as to how this translates into political and wider empowerment, most evident in the genre of action cinema where, as Hilary Neroni suggests, 'it is rarer to see a woman who can't fight for herself, or help out in a fight, than one who can'.[14] The 'violent woman',[15] 'feisty heroine',[16] 'tough girl'[17] and 'action babe'[18] have thoroughly colonized the formerly masculine genre, and have become archetypes in a wider cultural landscape, spurring important academic interventions such as Yvonne Tasker's *Working Girls: Gender and Sexuality in Popular Cinema* (1998) and, more recently, Lisa Purse's *Contemporary Action Cinema* (2011).

Extending the critical interrogation of cultural transformations within Hollywood genre, the final section of this book moves away from the critically saturated action genre and attempts to level the critical playing field by examining how changing perceptions of women's agency have resulted in multiple modifications of genre conventions in horror, rom-com and sports films. While all of the texts studied in this collection are, of course, genre films, this section is more specifically concerned with analysing how postfeminist subject positions complicate traditional understandings of genre as a fixed and reactionary formulation shaped by market and consumer expectations. The final chapters of this book interrogate the relationship between postfeminist politics and the narrative conventions of contemporary Hollywood cinema. Beginning with the postfeminist rom-com, Alexia Bowler's chapter discusses four very recent examples of the genre: *Crazy Stupid Love* (2011), *Friends with Benefits* (2011), *What's Your Number?* (2011) and *No Strings Attached* (2011). These films, she suggests, render visible the genre's conflict with feminism, and in particular 'with female

sexual agency that is not directed towards heterosexual union'. Consequently, the postfeminist rom-com advocates a sexual conservatism that serves rather than challenges patriarchal hegemonic social and cultural norms. A more optimistic verdict arises from Martin Fradley's subsequent discussion of contemporary teen horror films. This genre, he suggests, continues to return to key feminist issues and thus betrays an unresolved social anxiety. Fradley analyses a number of films, including, for example, *Prom Night* (2007) and *Scream 4* (2011), within the context of postfeminist commodification, consumption and self-actualization. Like other authors in this collection, Fradley seeks to counteract the often outright rejection of certain genres as apolitical or conservative, suggesting eventually that, in the case of teen horror and especially *Scream 4*, the 'female collective [...] offers tentative hope for the (post-)feminist future'.

Helen Warner takes on one of 2011's major comedy successes in her analysis of the critical reception of *Bridesmaids*. Examining the critical reception to the release and success of the film in both Great Britain and the United States, Warner identifies several recurrent themes that emerge within these reviews, exploring the notions of genre, gender and value that they reveal and the subject positions they shape for the film's audiences. Likewise, Katharina Lindner discusses the subject positions occupied by the female athletic body in films such as *Million Dollar Baby* (2004), *She's the Man* (2006) and *Girlfight* (2000). Given that this book was conceived in the year of the London Olympics and considering the accompanying debates surrounding gender, sport and women's physical performance, the topic of the closing chapter is perhaps more timely than ever. Contextualizing her discussion within the wider feminist debates surrounding sport, athleticism and physicality as well as within postfeminist notions of bodily self-discipline, individualism and consumption, Lindner suggests that these cinematic representations of female athletes, while empowering to young female audiences, must be considered within the commodity culture of which they are a product and within which they circulate.

Spanning a wide range of genres and film cycles, the chapters in *Postfeminism and Contemporary Hollywood Cinema* function to fuel debates surrounding the problems and possibilities of 'empowerment' as it is understood within postfeminist discourse. While the collection predominantly focuses on filmic representations of white, middle-class young women, this demographic privileging is difficult to avoid given Projansky's observation that postfeminist texts are almost always limited in this respect. Yet, chapters such as Bradbury-Rance's serve as

an antidote to the cultural erasure of non-mainstream representation within postfeminism, while Whelehan's timely discussion of popular culture's response to ageing within the contemporary historical moment attends to another startling omission. By raising attention to these problem areas within postfeminist cultural production and scholarship, and by expanding and contributing to the rich tradition of scholarly analyses of femininity and masculinity, this book gestures towards the seemingly endless potential for further debate surrounding the formation of gender identity in postmillennial Hollywood cinema.

Notes

1. Stéphanie Genz and Benjamin A. Brabon, *Postfeminism: Cultural Texts and Theories* (Edinburgh: Edinburgh University Press, 2009), p. 3.
2. Sarah Projansky and Leah R. Vande Berg, 'Sabrina, the Teenage?: Girls, Witches, Mortals and the Limitations of Prime Time Feminism', in Elyce Rae Helford (ed.), *Fantasy Girls: Gender in the New Universe of Science Fiction and Fantasy* (Lanham, MD: Rowman and Littlefield, 2000), p. 15.
3. Angela McRobbie, 'Postfeminism and Popular Culture: Bridget Jones and the New Gender Regime', in Diane Negra and Yvonne Tasker (eds), *Interrogating Postfeminism: Gender and the Politics of Popular Culture* (Durham: Duke University Press, 2007), p. 28.
4. Sarah Gamble, 'Postfeminism', in Sarah Gamble (ed.), *The Routledge Companion to Feminism and Postfeminism* (London: Routledge, 1998), p. 44.
5. Ibid.
6. Frances Gateward and Murray Pomerance, 'Introduction', in Frances Gateward and Murray Pomerance (eds), *Sugar, Spice and Everything Nice: Cinemas of Girlhood* (Detroit, MI: Wayne State University Press, 2002), p. 13.
7. Sarah Projansky, 'Mass Magazine Cover Girls: Some Reflections on Postfeminist Girls and Postfeminist Daughters', in Diane Negra and Yvonne Tasker (eds), *Interrogating Postfeminism: Gender and the Politics of Popular Culture* (Durham, NC: Duke University Press, 2007), p. 42.
8. Aapola S., Marnina Gonick, and Anita Harris, *Young Femininity: Girlhood, Power and Social Change* (Basingstoke: Palgrave Macmillan, 2005), p. 27.
9. Stephen M. Whitehead and Frank J. Barrett, 'The Sociology of Masculinity', in Stephen M. Whitehead and Frank J. Barrett (eds), *The Masculinities Reader* (Cambridge: Polity Press, 2001), p. 3.
10. Pamela Craig and Martin Fradley, 'Teenage Traumata: Youth, Affective Politics and the Contemporary American Horror Film', in Steffen Hantke (ed.), *American Horror Film: The Genre at the Turn of the Millennium* (Jackson, MS: University of Mississippi Press, 2010), p. 90.
11. See Hilary Radner, *Neo-Feminist Cinema: Girly Films, Chick Flicks and Consumer Culture* (London and New York: Routledge, 2010).
12. Ibid., p. 53.
13. Ibid.

14. Hilary Neroni, *The Violent Woman: Femininity, Narrative, and Violence in Contemporary American Cinema* (New York: State University of New York Press, 2005), p. 38.
15. Ibid.
16. Bill Osgerby and Anna Gough-Yates, *Action TV: Tough-Guys, Smooth Operators and Foxy Chicks* (London and New York: Routledge, 2001).
17. Sherrie A. Innes, *Tough Girls: Women Warriors and Wonder Women in Popular Culture* (Pennsylvania: University of Pennsylvania Press, 1999).
18. Marc O'Day, 2004. 'Beauty in Motion: Gender, Spectacle and Action Babe Cinema', in Yvonne Tasker (ed.), *Action and Adventure Cinema* (London and New York: Routledge, 2004), pp. 201–218.

Part I
Postfeminist Femininities

1

Neo-Feminism In-Between: Female Cosmopolitan Subjects in Contemporary American Film

Ana Moya

According to Elizabeth Ezra and Terry Rowden, transnational cinema respects cultural specificity as a powerful symbolic force at the same time as it transcends the national as an autonomous cultural particularity.[1] Transnational cinema, therefore, finds its scope in the gaps between the local and the global, arising in the in-between spaces of culture and problematizing the notions of national and cultural purity. Homi K. Bhabha uses the notion of 'in-between' when he argues for the need to focus on those moments or processes that are produced in the articulation of cultural differences. These 'inbetween' spaces provide the terrain for elaborating strategies of selfhood – singular or communal – that initiate new signs of identity, and innovative sites of collaboration, and contestation, in the act of defining the idea of society itself.[2]

Bhabha's argument follows on from Gloria Anzaldúa's, who dissects the notion of the borderland in her groundbreaking work in the following terms: 'Living on borders and in margins, keeping intact one's shifting and multiple identity and integrity, is like trying to swim in a new element, an "alien" element.'[3]

National borders are certainly becoming increasingly permeable as individual subjects are characterized by a mobility that, more often than not, allows them to cross those borders. As a consequence, the transnational experience is central to a large number of contemporary films. Within them, identity is often deconstructed to be reconstructed again, becoming mobile rather than fixed and, following on from postmodern notions of identity, emphasizing multiplicity instead of uniformity. This transnationalism suggests that we may have to think of

13

the world as borderless from now on, not only because national borders become progressively blurred but also because subjects constantly cross them and become, in doing so, transnational.[4]

This is especially true where the study of film is concerned. Ezra and Rowden argue that film has become a 'textual emblematization of cosmopolitan knowing and identity'.[5] Similarly, Stephen Vertovec and Robin Cohen suggest that cosmopolitanism, as a form of transnationalism, offers the possibility of handling cultural and political multiplicities, characterized as it is by a capacity to transcend the nation-state model; to mediate between the universal and the specific, the global and the local; and to be culturally anti-essentialist as well as to give voice to different and plural identities.[6] Cosmopolitanism is a defining feature of the culturally and linguistically diverse contemporary world. It invokes a vision of world citizenship and suggests that individuals today may in fact be multicultural in a similar way to that in which they become multilingual. This leads David Held to argue that cultural cosmopolitanism becomes the capacity to mediate between different cultures (national, religious or social).[7] For Held, cultural cosmopolitanism brings to the fore the fluid nature of individual identity – its capacity to reshape through the exposure to diverse cultures. Equally, Stuart Hall contends that cosmopolitanism describes the capacity to draw our cultural discourse from a plurality of sources and from varied cultural systems, affirming that it is impossible to absolutely preserve cultural identity intact, and that the mere idea is artificial and even absurd.[8]

Even so, it is important to recognize, as Ezra and Rowden argue, that 'the significance of crossing borders varies according to the identity of the traveller, most often along color-coded, gendered, and religious lines'.[9] They observe that in most American as well as European films, 'white women travelers are usually positioned as tourists, while white male travellers are presented as either figures of salvation or as James Bond-like adventurers'.[10] This female tourist is invariably a white middle-class heterosexual woman. In this way, the contemporary Hollywood cinema that Ezra and Rowden refer to here is aligned with post-feminism, which, as Sarah Projansky contends, 'celebrate[s] depictions of white, middle-class, heterosexual women's success as markers of all women's supposed success'.[11] In a similar observation, Diane Negra makes the point that 'romance in recent American cinema is implicated with the fantasy of transcendence of US borders'.[12] She analyses the interrelations between popular film and tourism in so

far as they create suitable arenas for the dissection and resolution of identity problems in the contemporary world. Negra argues that the tourist experience may be a stimulating opportunity for personal enrich-ment, for experiencing local culture through integration and also for attending to the problems of everyday life. Negra is referring here to a very specific group of women, namely that constituted by the white, middle-class heterosexual American female, proving Projansky's view that post-feminism is tied up in race and class.[13] Negra argues that when women travel, their immersion in new spaces occurs mostly via romance. The heroines are presented as rootless, and their tourist expe-rience finally results in stabilization, often in ways that 'camouflage the problems that catalyzed their identity quests'.[14] In contrast, the men these women come across in their travels bear powerful associa-tions with the land, holding a sense of identity strongly linked to their environment. The female tourist film, Negra concludes, departs from the assumption of the female body as hysterical, neurotic and holding a disrupted relationship with the natural. Ironically, this problematic body repeatedly seeks establishment through a romantic engagement with a male one presented as in close relation with the environment and by extension with the natural.

This chapter seeks to explore the relationship between trans-nationalism, feminism and film at the turn of the millennium, devel-oping Negra's discussion of romantic comedies of the 1990s. For this purpose, Hilary Radner's conception of neo-feminism seems particu-larly adequate, as it provides a suitable critical apparatus against which the transnational American romantic comedies of the present may be fruitfully read.[15] According to Radner, neo-feminism arose parallel to second-wave feminism. They both share a concern with the need for financial autonomy for women, yet while second-wave feminism advo-cated female self-fulfilment within 'a climate of social responsibility and state intervention',[16] the neo-feminist agenda supports the indi-vidualist and rationalist goals of neo-liberalism. Radner argues that neo-feminism has become one of the major influences on what is com-monly referred to as post-feminist culture, which has 'very little to do with feminism'.[17] Neo-feminism, she contends, has provided women with models to confront the complexities of present-day culture in a more successful way than feminism itself, replacing feminism's more utopian aspirations for the community of women with a focus on the individual female and her own personal aims. In this way, neo-feminism is not a tangential consequence of feminism and is instead more aligned

with neo-liberalism, indeed the dominant cultural, social and economic ethos of the early twenty-first century in the Western world. Neo-feminism stimulates and strengthens the practices of consumer culture as one of the primary means by which women may construct and express themselves in culture to attain success professionally and materially while preserving a feminine identity. Neo-feminism, she posits, points precisely to 'choice and individual agency as the defining tenets of feminine identity'.[18]

Neo-feminism has been influenced by the transnational experience. The turn of the millennium has seen the rise of the cosmopolitan female, a new autonomous and independent woman who seeks personal gratification and self-development, and for whom the transnational experience becomes another consumer commodity. The female cosmopolitan is open to choice and individual agency, and so neo-feminist cosmopolitanism becomes a new form of empowerment linked to the transnational, where the exposure to different cultural systems gives the female subject the possibility of reshaping herself repeatedly. If individual identity possesses a fluid nature with a capacity to reshape through exposure to different cultures, as Held also argues,[19] then female cosmopolitanism may become a route for the female subject towards ongoing development and fulfilment. A discussion of the transnational romantic comedies of the last decade provides a suitable arena for the exploration of the intersections between neo-feminism and cosmopolitanism in the contemporary Western world.

Cosmopolitan females in contemporary film

The first decade of the new millennium has witnessed the growth of a number of films in which the female cosmopolitan, or the experience of women and transnationalism, has become increasingly visible. This chapter focuses on two of these films, Woody Allen's *Vicky Cristina Barcelona* (2008)[20] and Ryan Murphy's *Eat Pray Love* (2010)[21] – films that dissect the role of the borderland in the shaping of female identity in a decade that has witnessed the release of films focused on and aimed at women, most notably *Something's Gotta Give* (Nancy Meyers, 2003), *The Holiday* (Nancy Meyers, 2006), *The Devil Wears Prada* (David Frankel, 2006) and *Sex and the City* (Michael P. King, 2008).[22]

Vicky Cristina Barcelona introduces us to two young American women, Vicky (Rebeca Hall) and Cristina (Scarlett Johanson), who spend a summer in Barcelona while on vacation. Vicky is an apparently conventional woman, engaged to a successful American businessman. She

plans to marry shortly after the summer and is, like the protagonists of other countless Hollywood romantic comedies, white and middle class. She is interested in Spanish (and specifically Catalan) culture, on which she is writing a dissertation. In counterpoint, Cristina is very different from her conservative friend: a dreamer and a maverick when it comes to relationships, she demonstrates an open attitude towards life and is receptive to new experiences, always welcoming the possibility of exploring alternatives. She is a rather unsuccessful actress and travels to Barcelona after recently ending a love affair. Likewise, *Eat Pray Love* presents another travelling woman through the story of Liz (Julia Roberts), a young American divorcee who takes a year off to travel to Italy, India and Bali in an attempt to make new sense of her self after a traumatic rupture and chooses an experience abroad as inspiration to restart her life again.

In both cases the female experience is at the centre of the story and is invariably a border-related one and a quest for identity. The films are border conscious; they position themselves against binaries and duality and seek to present a third perspective that is, in Naficy's words, 'multiperspectival and tolerant of ambiguity, ambivalence and chaos'.[23] They explore the notion of border subjectivity as necessarily 'cross-cultural and intercultural'.[24] *Vicky Cristina Barcelona* opens with the arrival of the two protagonists in Barcelona. From the very beginning, the film's voiceover highlights the contrast between the two friends, establishing Cristina as a dreamer, while associating Vicky and her engagement to Doug (Chris Messina) with notions of seriousness, stability and commitment. At the same time, the camera shows the girls sharing a taxi from the airport to Barcelona where, while Vicky is talking to her fiancé on her mobile, Cristina looks out of the window dreamingly. The girls are presented, then, as oppositional, and this allows Allen the possibility of looking at a tourist experience from two different positions, exploring its multiple ramifications and thus avoiding a simplistic approach to identity and transnationalism. Vicky and Cristina live at Vicky's conventionally married American friend Judy's (Patricia Clarkson) during their stay, a way of anticipating Vicky's future life. Indeed, during their first evening together Judy jokes that Vicky's conflicts will all be over when she marries Doug in the fall and especially when he makes her pregnant.

Vicky and Cristina become active tourists in Barcelona, where Vicky researches 'every aspect of Catalan life', particularly enjoying architecture, food and music. Her tourist experience thus releases her somatic nature, illustrating Negra's point that Europe becomes a space

in American contemporary female tourist narratives where the white middle-class American female may enjoy 'an easy, settled relationship to food and an untroubled somatic identity',[25] thus feeding back on the American female body as dysfunctional. In contrast with Vicky, Cristina embodies what Felipe (Javier Bardem) calls an 'in-between' in *Eat Pray Love*, someone 'who live[s] by the border because they renounce the comfort of family life in order to seek enlightenment'. Anzaldúa contends that 'Borders are set up to define the places that are safe and unsafe, to distinguish *us* from *them*'.[26] She defines borders as 'a dividing line, a narrow strip along a steep edge. A borderland is a vague and undetermined place created by the emotional residue of an unnatural boundary. It is in a constant state of transition. The prohibited and forbidden are its inhabitants.'[27] Indeed, Cristina enjoys living by the border and is on a quest, seeking the sort of enlightenment that Felipe refers to here, one defined in terms of self-knowledge and personal development and gratification. Maria Elena (Penélope Cruz), Juan Antonio's (Javier Bardem) wife, though, eventually points to the limitations of Cristina's lifestyle when she describes her as a person who lives in a state of 'permanent dissatisfaction'. In this way, the contrast between the two female characters opens an interesting debate about women and/in society in the film. Cristina may be read as an embodiment of Radner's 'single girl', which, according to Radner, is 'a utopian fantasy of a woman freed from the social and sexual constraints that appeared to have limited her mother'.[28] Her girlishness, she continues, reflects the anxieties of women within patriarchy to which she responds by keeping herself perpetually immature. Indeed, Cristina may be read as a reflection of Vicky's own struggles and concerns for the future. The neo-feminist woman becomes, in this sense, a reaction to the anxious, insecure and struggling female that Vicky represents, and which is reflected in her problematic relation with the natural, as is the case with Liz in *Eat Pray Love*.

Vicky and Cristina meet the Catalan painter Juan Antonio for the first time at a gallery show. The camera shows us Javier Bardem in a red shirt, leaning on a column and holding a glass of wine in his hands. The selection of Bardem for the role of Juan Antonio and his sartorial red suggests both his being a native (red is a Spanish colour) and his virility. Vicky, Cristina and the female audience's tourist experience acquire a new dimension from here on: sexual desire. Furthermore, before Vicky, Cristina or the audience actually meet him, Judy and Mark tell the story of Juan Antonio's marriage, which is characterized by passion, violence and primitiveness. The tourist experience takes a turn

towards the exotic from this moment on, and the film offers the female audience the possibility of opening themselves to a vicarious escape beyond their conventional existence to experiment with an adventure that will take place in what is presented as an exotic Spain where they will be invited to interrogate their own culturally conditioned lives. Allen's film, therefore, orientalizes Spain effectively through the use of space and, especially, through the use of the characters of Juan Antonio and Maria Elena (Penelope Cruz), both played by Spanish actors.[29]

Vicky and Cristina's reaction to Juan Antonio's abrupt invitation to go with him to Oviedo for the weekend to make love together is indicative of the differences between them. While Cristina has no problem with this invitation and is open to the experience, Vicky reacts conservatively and resists accepting. Vicky is afraid of Juan Antonio, which is premonitory, for contact with him will prove unsettling for her, and yet destiny holds that Cristina will fall sick while in Oviedo, which will inevitably draw Vicky and Juan Antonio together. Her sensual experience of Oviedo through her immersion in local food, architecture and music will finally unleash her desire: 'I am a little out of control,' she tells Juan Antonio after a dinner followed by an audition of Spanish guitar. Vicky finally lets herself go and sleeps with Juan Antonio, an experience that disorientates her completely: 'We had this ridiculously irrational weekend together and now I don't know where I am.'

In this way, Allen subtly employs the sensual perception of the world through sight (architecture), hearing (music) and taste (food) as catalysts to the expression of desire. Desire as in-between is explored in the film, with the borderland as an appropriate space where it unfolds and is explored. For a brief moment, Vicky allows herself to be driven by desire, actuating Judy's fantasies and becoming Cristina's double. And all the while the female audience is invited, like Vicky, to participate in this game of multiplicity. Back in Barcelona, Vicky marries Doug, allowing space for Cristina to initiate a relationship with Juan Antonio. Vicky makes her choice, in a desperate attempt to put her desire under control. Desire, otherness, will thus be suppressed. Multiplicity scares her and she seeks refuge in the home, closing herself off from the tourist adventure and leading an 'American life' while in Barcelona. She may still be in a foreign country, but she has finally chosen to reject a transformation of identity that is implored by the borderland experience.

Conversely, Cristina chooses the lifestyle that Vicky would have experienced had she not chosen to return to Doug. In this way, the audience vicariously experiments with the consequences of choosing desire instead of conformity. Juan Antonio, Cristina and Maria Elena share a

relationship where various sexual orientations are indulged, constructed by Allen as a form of cohabitation that is suffocating, allowing little space for the self to develop freely. Cristina discovers that she is as constrained as Vicky is in her life with Doug. Ultimately, both choices appear equally unsatisfactory. Cristina is thus presented as Vicky's alter ego; they are two characters, but can be read as one woman. Allen's juxtaposition serves the purpose of fruitfully exploring the multiplicity of the self by celebrating that multiplicity and yet, at the same time, pointing to its limitations. Desire is an adventure, and so the choice of the borderland is suitable and safe, just as watching the film is a safe means of exploring the postmodern multiplicity of the self.[30] Vicky will return home safely, as will her audience, but there will always be Cristina, always in-between, always travelling, a reflection of Vicky's longing, of Judy and of the audience's fantasies. *Vicky Cristina Barcelona* ultimately lays out before the audience an unresolved debate, and the film, as Negra argues in her discussion of the transnational romantic comedies from the 1990s, makes use of the tourist experience to interrogate the construction of female identity in contemporary Western discourses. In this way, and on the one hand, the borderland proves effective as it allows the necessary critical perspective while, on the other hand, the cosmopolitan experience is suitable to unfold the choices women have to confront in the contemporary world.

Eat Pray Love explores similar territory. The film is based on Elizabeth Gilbert's memoir, first published in Great Britain in 2006. The film begins with Liz telling the audience through the voiceover a story about a psychologist friend who was asked to treat a group of Cambodians. Liz's friend explains that even though the Cambodians had had very traumatizing experiences, all they wanted to talk about was their relationships. While we hear that story, Liz is cycling in Bali to visit a medicine man's house and recognizes that, like the Cambodians in the tale, she wants to talk to him about 'my relationship'. As such, the scene frames the central subject-matter of the story, as indicated by the subtitle of the original memoir: 'One woman's search for everything'. This scene is a prologue to the main story, which is structured in three blocks: Italy, India and Bali. As in *Vicky Cristina Barcelona*, space is used as a vehicle for the exploration of character. Furthermore, Italy, India and Bali are all orientalized within the film's politics of identity. As with Barcelona in Allen's production, *Eat Pray Love* employs clichés in the portrayal of the three spaces to construct them as exotic, particularly as Western (and especially American) cultural constructions and codes of behaviour are repeatedly measured against them.

Back in the United States, Liz finds herself trapped in an unhappy marriage, undergoing an identity crisis. She is contrasted with her friend Delia (Viola Davis), who is happily married and has just had a baby. Motherhood, the culmination of patriarchal marriage, is juxtaposed to travelling, to exploring unknown territories, to the borderland adventure. The juxtaposition of the two characters points to the choices open to white, middle-class women in the contemporary world. Marriage and motherhood are no longer women's destiny, though they may be women's choice. Liz is a successful writer who does not need marriage to survive financially in the world, rendering her a good example of the neo-feminist woman. Single and independent, she defines herself primarily through the practices of consumer culture, pursuing happiness through personal gratification. She, like many other affluent women in the twenty-first century Western world, can make her own life choices, and the story focuses precisely on these choices and the impact they have on women's identities. Liz finally decides to leave the United States to allow herself the opportunity of exploring both the world and her self. In this way, the film illustrates the extent to which popular culture explores 'fantasies and fears about women's "life choices" '.[31] It suggests what Angela McRobbie refers to as 'a movement beyond feminism, to a more comfortable zone where women are now free to choose for themselves'.[32] Like Radner's single girl, the glamour of consumer culture has replaced the maternal for Liz, and what she consumes is tourism. In this way, she represents the ways in which the female subject at the turn of the millennium may seek empowerment through cosmopolitanism.

The first step of Liz's journey is Italy. There, she pursues pleasure. Similarly to what happens to Vicky in Allen's *Vicky Cristina Barcelona*, Liz will unleash her sensual perception of the world through sight, hearing and taste. Architecture, food and the Italian language, particularly the sound of the language, are highlighted throughout as efficient ways to satisfy Liz's appetites. The senses are liberated and Liz lets go what is portrayed as a constrained and repressed body. And so, as Liz is seen to devour pizza while in Naples, the point is made about the pressure of American-dominant cultural discourses on the female body, which becomes a site of struggle. The film highlights the borderland experience precisely as liberating the tensions that hold bodies as problematic. All in all, the borderland experience proves fruitful for the self, and once more the female audience is invited to fuse with Liz and let go. At the same time, being in a foreign country allows Liz the necessary detachment from traditional discourses to define herself as existing on

their margins: physical distance gives way to social and psychological perspectives. Liz feels free from these forces and can find her own space. The borderland works effectively for that purpose.

In the scene at the hairdresser's, Luca Spaghetti (Giuseppe Gandini) tells Liz that she feels guilty for merely enjoying herself because she is an American. He affirms that 'Americans know entertainment, but don't know pleasure... You work too hard, you get burned out. Then you go home and spend the whole weekend in your pyjamas watching television but you don't know pleasure. You have to be told you've earned it.' Luca then explains the Italian concept of the *dolce far niente*. Luca Spaghetti's diagnosis is severe yet accurate. American society appears sick in contrast with Italy, and the film is used as critique of a number of dominant features of contemporary American experience. Italy is presented idealistically as a much more harmonious society, one where people are presented in closer relationship with the environment. Finally, in the scene where Liz and her friends play the word game, Liz tells her friends that the word for New York is 'ambition' while the word for herself is that she is 'in search of a word'. American society is once more viewed critically as it is seen through Liz's detached perspective, while her quest for identity is highlighted and the film positions itself unambiguously on the border.

After her stay in Italy, Liz travels to India to spend some time in an ashram with the aim of learning meditation. Having unleashed the senses and liberated the body from the constraints imposed on it by dominant discourses of femininity, Liz undertakes an exploration of her mind and soul. In India, she meets two interesting characters, Tulsi (Rushita Singh), a local, and Richard (Richard Jenkins) from Texas. Tulsi is a young Indian girl whose parents have arranged her marriage to a young Indian boy. Tulsi, however, wants to study and go to college. She would like to be independent and make her own choices, though this is impossible for her as she has to marry and is allowed no choice. The wedding scene, in which Liz recalls her own wedding, connects and juxtaposes the two women, effectively highlighting Liz's independence and freedom of movement while simultaneously showing the limiting nature of postfeminist empowerment as a rhetoric of choice only open to white, middle-class women. As Liz's friend states during the farewell Thanksgiving celebration in Italy, 'It is more difficult for a woman to feel that she has the right to make choices. It takes a lot of courage.' Tulsi's longing for independence and freedom of choice is possible for Liz, however difficult it may still be for a woman to feel she may make her own choices.

In this section of the film, the character of Liz is also juxtaposed to the character of Richard, who may be read as Liz's precursor. He anticipates Liz in her own personal quest and so can advise her and guide her in this new stage of personal discovery. The experience of India is one where the body is annulled to allow space for the mind and soul to come to the surface, and where the borderland becomes once more a suitable arena for such a purpose. As in *Vicky Cristina Barcelona,* doubling is important, and Richard becomes Liz's double, breaking through the cliché that Liz's personal crisis is inherently feminine and suggesting that it is human, and indeed universal.

Liz finally travels to Bali, as the third and final step of her personal journey. In Bali, she goes to the place where the film began and the audience has a sense that the wheel has come full circle. Liz is now at the starting point of a new life, as she has evolved through her experiences both in Italy and India. She is now ready to confront a new love experience and meets Felipe, who becomes her new lover. The borderland experience has taught Liz that she needs to make sense of herself as an individual, as a subject. Only then will she be ready to contribute positively to the community, be that the community of the family or the wider society. Liz is able to reconstruct herself through her transnational experience and so she has learned to be receptive to choice at the same time as she has learned to make sense of herself as an individual, following the ideology of our neo-liberal times. All in all, the borderland experience has proved very fruitful. The final conclusion may be that the successful female individual may also contribute positively to the construction of a better world.

Conclusion: Neo-feminism in-between

More persons than ever before in more places around the world are opting to pursue transnational lives.[33]

The two films present women travellers, and in both cases the borderland becomes a terrain where identity is deconstructed first only to be reconstructed later. The tourist experience is stimulating for the heroines in these films, triggering a personal renewal that will award the characters a new sense of balance with which they are able to confront their future life. However, the present century seems to have brought new insights into these female cosmopolitan adventures, and these films explore the experience of the borderland as one that does not affirm the protagonists' identity politics through the celebration of

marriage and maternity. Whereas in the comedies of the 1990s – and as Negra contends – this was always the case, the turn of the millennium invites audiences to concentrate on the complexities of the choices the individual female subject has to confront.

Furthermore, and as Radner's arguments surrounding neo-feminism suggest, women have become the subjects of their own lives. The single woman is at the centre of society, master of her own life and consequently making her own individual choices. In this way, and following a neo-liberal ethos, the tenets of feminine identity clearly become choice and individual agency. In line with Ruth Williams's discussion of *Eat Pray Love*,[34] these films encourage women to consume tourism as a means of personal empowerment, at least in so far as the experience may help them to assert their independence and individuality. All of these female characters see their own happiness as their personal responsibility, pursuing 'spiritual enlightenment via consumer practices'.[35] Finally, what these women will ultimately gain as a consequence of their encounters with other cultures is knowledge of their own selves, ultimately proving 'the neoliberal vision of the individual as entrepreneur of the self'.[36] Overall, the films point to the emergence of a neo-liberal female subject that defines itself as cosmopolitan, with a vision of world citizenship and proving its ability to mediate between different cultures positively. For this subject, identity is multicultural and the transnational experience is vital. The neo-feminist woman has become an in-betweener, wishing to live by the border to seek enlightenment and the power to make her own choices.

Notes

1. Elizabeth Ezra and Terry Rowden (eds), *Transnational Cinema: The Film Reader* (London and New York: Routledge, 2006), p. 2.
2. Homi K. Bhabha, 'Locations of Culture', in Sanjeev Khagram and Peggy Levitt (eds), *The Transnational Studies Reader. Intersections and Innovations* (New York and London: Routledge, 2008), p. 333; Bhabha also elaborates on the notion of in-between in a former chapter, 'Culture's In-Between', published in Stuart Hall and Paul du Gay (eds), *Questions of Cultural Identity* (London: Sage, 1996), pp. 53–60.
3. Gloria Anzaldúa, *Borderlands/La Frontera. The New Mestiza* (San Francisco, CA: Aunt Lute Books, 2007 (1987)), p. 19.
4. Other recent relevant studies in transnationalism also include Ella Shohat and Robert Stam, *Multiculturalism, Postcoloniality and Transnational Media* (New Brunswick and NJ: Rutgers University Press, 2003); Interpal Grewal, *Multiculturalism: Feminisms, Diasporas, Neoliberalisms* (Durham, NC and London: Duke University Press, 2005); Sanjeev Khagram and Peggy Levitt

(eds), *The Transnational Studies Reader: Intersections and Innovations* (London and New York: Routledge, 2008); Jopi Nyman (ed.), *Post-National Enquiries: Essays on Ethnic and Racial Border Crossing* (Cambridge: Cambridge Scholars Publishing, 2009); Steven Vertovec, *Transnationalism* (London: Routledge, 2009); Paul Jay, *Global Matters: The Transnational Turn in Literary Studies* (Ithaca, NY: Cornell University Press, 2010); Natasa Durovicova and Kathleen Newman (eds), *World Cinemas, Transnational Perspectives* (London: Routledge, 2010), for instance.

5. Ezra and Rowden, *Transnational Cinema*, p. 3.
6. Steven Vertovec and Robin Cohen (eds), *Conceiving Cosmopolitanism: Theory, Context, and Practice* (Oxford: Oxford University Press, 2002), p. 4.
7. David Held, 'Culture and Political Community: National, Global and Cosmopolitan', in Steven Vertovec and Robin Cohen (eds), *Conceiving Cosmopolitanism: Theory, Context, and Practice* (Oxford: Oxford University Press, 2002), p. 57.
8. Stuart Hall, 'Political Belonging in a World of Multiple Identities', in Steven Vertovec and Robin Cohen (eds), *Conceiving Cosmopolitanism: Theory, Context, and Practice* (Oxford: Oxford University Press, 2002), p. 26.
9. Ezra and Rowden, *Transnational Cinema*, p. 11.
10. Ibid.,
11. Sarah Projansky, *Watching Rape* (New York and London: New York University Press, 2001), p. 73.
12. Diane Negra, 'Romance and/as Tourism. Heritage Whiteness and the (Inter)National Imaginary in the New Woman's Film', in Elizabeth Ezra and Terry Rowden (eds), *Transnational Cinema: The Film Reader* (London and New York: Routledge, 2006), p. 169.
13. *Watching Rape*, p. 74.
14. Ibid., p. 174.
15. Hilary Radner, *Neo-Feminist Cinema: Girly Films, Chick Flicks and Consumer Culture* (London and New York: Routledge, 2011). There, Radner traces the origin and development of the term 'neo-feminism' (pp. 2–25).
16. Radner, *Neo-Feminist Cinema*, p. 9.
17. Ibid., p. 2.
18. Ibid., p. 6.
19. David Held, 'Culture and Political Community: National, Global and Cosmopolitan', in Steven Vertovec and Robin Cohen (eds.), *Conceiving Cosmopolitanism: Theory, Context and Practice* (Oxford: Oxford University Press, 2002), p. 57.
20. Woody Allen's *Vicky Cristina Barcelona* (Media Pro and Gravier Production, 2008).
21. Ryan Murphy's *Eat Pray Love* (Columbia production, 2010).
22. Michael Patrick King's *Sex and the City* (New Line Cinema production, 2008). The film was based on Darren Star's previous and widely successful TV series.
23. Hamid Naficy, 'Situating Accented Cinema', in Elizabeth Ezra and Terry Rowden (eds), *Transnational Cinema: The Film Reader* (London and New York: Routledge, 2006), p. 124.
24. Ibid.
25. Negra, 'Romance and/as Tourism', p. 178.
26. Anzaldúa, *Borderlands*, p. 25.

27. Ibid.
28. Radner, *Neo-Feminist Cinema*, p. 16.
29. For the concept of orientalism, see Edward W. Said, *Orientalism: Western Conceptions of the Orient* (London: Penguin, 1991 (1978)).
30. See Marina Warner, *Fantastic Metamorphoses, Other Worlds: Ways of Telling the Self* (Oxford: Oxford University Press, 2002).
31. Diane Negra, *What a Girl Wants? Fantasizing the Reclamation of Self in Postfeminism* (London and New York: Routledge, 2009), p. 2.
32. Angela McRobbie, 'Post-feminism and Popular Culture', *Feminist Media Studies*, 4: 3 (2004), p. 259.
33. Peter Koehn and James Rosenau, 'Transnational Competence in an Emerging Epoch', *International Studies Perspectives*, 3 (2002), pp. 105–127.
34. Ruth Williams, '*Eat Pray Love*: Producing the Female Neoliberal Spiritual Subject', *Journal of Popular Culture*, 3: 2 (2001), p. 4.
35. Ibid., p. 9.
36. Ibid., p. 13.

2
Querying Postfeminism in Lisa Cholodenko's *The Kids Are All Right*

Clara Bradbury-Rance

Against a backdrop of the gay marriage debate and queer fears of homonormativity, the work of Lisa Cholodenko explores (unconventional) family values, sitting comfortably within the domestic–romantic conventions of archetypal postfeminist romantic comedies but with a same-sex twist. She has been championed by newspaper critics from the left-wing *Guardian* to the right-wing *Daily Mail*, been awarded by festivals from Sundance to the Oscars, has headlined not only the London Lesbian and Gay Film Festival (LLGFF) but also the London Film Festival itself.[1] Cholodenko's *oeuvre* hence encapsulates the contradictions surrounding the figure of the lesbian on the contemporary screen who, at the threshold of the convergence between queer and feminist discourses, is marked by a burden of visibility and invisibility. As LLGFF programmer Brian Robinson recognizes, Lisa Cholodenko's success is an exception in an industry in which 'lesbian directors remain marginalised'. 'How many other lesbians can you name?', Robinson demands, 'who have made more than three narrative features?'[2] Rare indeed are those intellectually-informed, feminist-helmed, queer-centred films that prove their mainstream potential by garnering Oscar nominations. As rarities, then, the films of Lisa Cholodenko are uniquely situated to assess the intersections and interactions of postfeminism and queer theory in a contemporary society for which popular culture is a major mouthpiece. The argument that follows investigates Cholodenko's formula for a successful lesbian film, the centrality to postfeminism of the rhetoric of family values, and the bid for access to that centrality by queers who can.

Cholodenko majored in gender studies at college and describes herself as a one-time 'radical leftie liberal'.[3] After moving from Hollywood to New York to undertake a Master of Fine Arts degree in Screenwriting and

Directing at Columbia University, and making several shorts and her first feature *High Art* (1998) in Manhattan's urban setting, Cholodenko moved back to the West Coast to settle in Los Angeles (LA) in order, in her words, to 'orient [her]self towards a world where [having a family] could happen'.[4] *High Art* tells the story of a group of impoverished queer artists living and fucking in a Manhattan loft apartment and the sexual and artistic entanglement between Syd (Radha Mitchell) and Lucy (Ally Sheedy). Her next film, *Laurel Canyon* (2002), was produced after the relocation to LA and explores the seduction of straight-laced Alex (Kate Beckinsale) into the music and drug-fuelled world of her bisexual mother-in-law, Jane (Frances McDormand). The director's most recent film, *The Kids Are All Right* (2010), contemplates the domestic dramas of lesbian parents Nic (Annette Bening) and Jules (Julianne Moore) and the relationship their long-disregarded sperm donor, Paul (Mark Ruffalo), develops with their children, Laser (Josh Hutcherson) and Joni (Mia Wasikowska).[5]

Midway through this film, we witness a scene which disorientates our preconceived frames of reference. In *The Kids'* climactic dinner party scene, the authoritative Nic, having brought to light by accident her partner Jules' affair with sperm donor Paul, must sit back down with the family at Paul's dinner table and act as if nothing has changed. For almost a full minute the camera focuses in on Nic as the sound of her companions' chatter becomes distorted, leaving only a dull ache of sound forcing upon the audience the heavy consequence of Nic's discovery. She is distanced from her intimates; she is in a personal sonic dimension which blurs our reading of the film as normatively structured. In this moment Nic becomes unstuck from the fixity of her job, of her marriage, of her family; her grip on familial stability becomes untenable as her children grow up and away and her partner finds her independence. This model of cinematic queerness (where queerness is not merely non-heterosexual but non-normative: in Sara Ahmed's words, that act of 'not following the straight line') shakes up the film's readability as a mere 'family values movie' (a term the director has short-sightedly used to describe it).[6]

One popular criticism accuses Cholodenko, in making the relatively mainstream success *The Kids*, of selling out to the commodity of the American family and indulging in its sway over viewing figures and the hearts of American audiences. 'Such a cosily reassuring message could have been devised to delight midwestern Tea Party moms', reproves critic David Cox, 'whatever their views on lesbianism'.[7] If only the parents of angsty teenagers Laser and Joni were not two women, *The Kids*

would present quite the showcase of normative family relations. The film ostensibly queers the family structure, yet if we look beyond the lesbian as the default figure of subversion we uncover instead a regressive normalization of queerness. What Eve Kosofsky Sedgwick sees, for instance, as the representational luxury of *The L Word* – which ran for six seasons and brought not only one lesbian character but a whole community to widely-viewed primetime television – nevertheless extends its appeal to straight viewers of *Sex and the City* ('Same Sex. Different City.' reads its tag line) and is anything but edgy: 'a really anarchic character like Karen Walker (Megan Mullally), the omnisexual Goddess of Misrule on NBC's *Will & Grace*, would smash to smithereens the sedate genre conventions of *The L Word*', says Sedgwick.[8] The 'guy-friendly' lesbians of the postfeminist screen are, say Diane Negra and Yvonne Tasker, 'simultaneously fetishized and celebrated', forever 'mediated through a *curious heterosexual gaze*' (my emphasis).[9] If *The Kids* does present a model of queerness it is not simply by way of depositing lesbian characters into a domestic arena: there is much more at stake here.

It is Cholodenko's singularity as a successful lesbian filmmaker – both a 'certified lesbian' in the eyes of B. Ruby Rich and a 'formidable auteur' as described by Sundance festival programmers – that positions her at the crux of the postfeminism-queer interstice.[10] Readings of her films have hardly graced the pages of academic writing. Yet in a collection on *Postfeminism and Contemporary Hollywood Cinema*, Cholodenko is a unique and pivotal presence, a filmmaker who straddles feminism and postfeminism, independent and mainstream, high art and popular culture, and who thereby unsettles the very terms that mark our debate. Both postfeminism and queerness are terms of necessarily contemporary cultural value that have been widely discussed independently but rarely in tandem. This chapter focuses that breadth of research into a single-director study aimed at the specificities of lesbian narrative and aesthetic in a medium that has been governed by dichotomies of sexual orientation, politics and high/popular art. The thrust of my argument thus questions the extent to which these oppositions, with queerness and postfeminism at the fore, can coexist in a cinematic culture peppered with a critical tendency towards binary opposites despite a reality riddled with ambiguity.

Postfeminism/queerness

Is 'postfeminism' made up of a unified collective, a consensus against the oppressive patriarchal structures of society? Or does it have a

different agenda, which sees other women, rather than men, as the oppressors? The term undoubtedly signifies all of these things and none of them; what is definable about postfeminism is its undefinability. Postfeminism does not owe itself to the label of 'movement'; it is not helmed by a canonical manifesto. However, it is possible to identify, in the work of scholars who survey postfeminist culture, certain codes and motifs that occur again and again in postfeminist texts. Negra and Tasker, two of the primary contemporary commentators on postfeminism, define the main contours of the phenomenon as 'a set of assumptions, widely disseminated within popular media forms, [...] to do with the "pastness" of feminism'.[11] Stéphanie Genz and Benjamin A. Brabon stress that their omission of the hyphen that occasionally separates 'post' from 'feminism' in the term has the precise intention of avoiding that 'semantic rift' that may arise from linguistic separation.[12] Furthermore, Genz and Brabon state that postfeminism should be endowed with a 'certain cultural independence' from feminism as a 'conceptual entity in its own right'.[13] There is a contradiction here, however, as the term 'postfeminism' thus subsumes feminism into its conceptual sphere, rendering it obsolete both semantically and politically. This is the exact concern of several feminist scholars who demand to know, as Amelia Jones et al. do for instance, 'what is "post" but the signification of a kind of termination – a temporal designation of whatever it prefaces as ended, done with, obsolete?'[14] This chapter adopts the critical feminist approach of Negra, Tasker and Jones, hence taking issue with the very notion of 'post-ing' feminism at all.

Defined here as a paradoxical set of imperatives, postfeminist filmic discourses demand that women embrace professional competitiveness while prioritizing domestic life, exhibit sexual independence while foregrounding the search for heterosexual romance, and embrace consumerism while remaining loyal to non-market values.[15] While ostensibly a far cry from the canon of postfeminist culture that includes *The Devil Wears Prada* (David Frankel, 2006), *Bridget Jones's Diary* (Sharon Maguire, 2001) and *Sweet Home Alabama* (Andy Tennant, 2002), we can observe the enactment and the critique of many of these same trends in Cholodenko's films: the engendering of sexual liberty and the anxieties it provokes, the upsetting of the work/life balance, the inequalities resident in patriarchal relationships, the uncertainties of geographical dislocation.[16] These are arguably feminist concerns as well as postfeminist traits; where postfeminism differs is in introducing the domestic imperative as a solution to these anxieties. We can observe, too, the tussles Cholodenko's *oeuvre* plays out between these themes

and the queer desires that unsettle otherwise normative constructions. As Negra and Tasker state, women's agency in this contradictory postfeminist culture is just an illusion, wherein women are constructed as 'subjects only to the extent that [they] are willing and able to consume'.[17] Cholodenko's films are acutely aware of countless such mediums: be it drugs, organic food, sex or art, consumption is at the core of her characters' motivations.

Thus we start to realize that consumerism holds great sway over issues of both gender and sexuality in the contemporary climate of postfeminist sexuality.[18] It is this emphasis, moreover, that marks the unlikely alignment of postfeminism and queer. For Dereka Rushbrook, contemporary society's allocation of queer space is one in which 'cultural capital can be displayed by the ability to negotiate different identities, to be at ease in multiple milieus, to maneuver in exoticized surroundings'.[19] As Yvette Taylor states about lesbians in particular, 'queer opportunity may be available to middle-class urban dwellers but [not to] lesbians living on the breadline'.[20] The house, car(s) and accessories of *The Kids'* middle-class domesticity, for instance, are not only unwanted, but un*affordable*, by many queers. Queerness must therefore be embraced as a conflicted term and one that shapes and is shaped by the complex and contradictory relationships of its subjects. As Glen Elder, Lawrence Knopp and Heidi Nast define it, queerness 'does not universalize the experience of those who do not practice heterosex, but highlights the contextual nature of that oppositional (and usually non-heteronormative, non-monogamous) desire'.[21] In their terms, queer is primarily 'a term of political engagement and not necessarily an identity'; in my terms queer is, moreover, *necessarily not* an identity.[22] By putting it in dialogue with postfeminism, I highlight the problematics of queer's often assumed synonymous relationship to homosexuality (or to non-heterosexuality), and scrutinize its pertinence to Lisa Cholodenko's position in and against postfeminist popular culture.

What about the parents?

If the anti-feminist manifestation of postfeminist culture cannot forestall the prevalence of dominant queer women such as lesbian parents Nic and Jules, at least it can lessen their cultural impact and counteract their perceived threat to the patriarchy by placing them in the shadow of their (mandatorily straight) children. According to Lee Edelman, every relationship is shadowed by the importance of the Child (and by 'Child'

he means not a particular child, neither a religious nor a secular idol, but the phantasm of childhood that haunts society). We work, play and fuck for the so-called benefit of futurity, for the benefit of leaving a legacy, an inheritance, of spreading our seed. We cannot imagine the present without a 'fantasy of the future', Edelman says, and this futuristic fantasy is always imbedded with the importance of the Child.[23] The kids are all right, says the film; do we not care whether the parents are all right too?

The eponymous subjects of *The Kids* maintain a certain priority over the film's narrative drive, and the film's title anticipates such a prioritization. The film's main tension arises from an affair between mother Jules and her children's recently-discovered sperm-donor, Paul, a liaison foregrounded by the children's discovery and embrace of him as a new member of the family. The dramas surrounding Nic and Jules' relationship are from start to finish engineered by kinships that have the children at their centre. The opening credits sequence introduces Laser and Joni rather than their parents, whom we first meet a lengthy three full minutes into the film. Throughout the film Nic and Jules' potentially very intimate conversations are directed at the kids rather than at each other; everything is reflected through the importance of the children to both mothers. For instance, in what is arguably the film's most heart-wrenching scene, Jules' apology for her adultery is not directed at her betrayed lover Nic, but to the children: 'I feel sick about it because I love you guys, and I love your mom', she says to Joni and Laser. Joni and Laser proceed to eavesdrop on a climactic argument between their mothers, suspending the foregrounding of the parents' need for an intimate unaccompanied conversation. The erotic signification of the homosexual relationship is consistently filtered through the next generation, the partnership only relevant as a parenting operation. In this way the film doubtless says something about parenting in general. But it is Cholodenko's choice to frame lesbianism in the film *solely* in terms of this parenting endeavour (the only lesbian sex scene between Nic and Jules is cut between shots of their kids as they search in the dark for the file on their biological father) that risks antagonizing queer critics like Lee Edelman.

Queerness, according to Edelman – via a Lacanian notion of queer negativity – is the essential affront to this politics, the affront to what he calls 'reproductive futurism'.[24] His belief is that 'politics (as the social elaboration of reality) and the self (as mere prosthesis maintaining the future for the figural Child), are what queerness, again as figure, necessarily destroys'.[25] This 'self', in whose feminine embodiment postfeminism is so deeply invested, is, for Edelman, but a contemporary

phantasm, a 'mere prosthesis maintaining the future for the figural child'.[26] This echoes concerns over postfeminism's promoted feminine – and, here, maternal – ideal of womanhood; indeed *No Future*'s accusations seem particularly pertinent to women, whose sense of self is often held in abeyance by society until confirmed by the arrival of a child.[27] Nic and Jules' subjectivities are suspended, the film suggests, when not aligned as vehicles of parenthood. Edelman offsets this by condemning queer to the fundamentally anti-family realm, meanwhile implying a misogynistic aversion to the maternal body as exhibitor of the reproduction that femininity promises.[28] This argument thus rejects any campaigns for gay marriage, adoption or reproductive rights, and *The Kids'* lesbian parents, and by turns Cholodenko's reputation, are condemned to accusations of submission to the fantasy of reproductive futurity. Nic and Jules, in these Edelmanian terms, have taken positive queer representation so far as to make of it a narcissistic game of proving queer reproductive potential. In an angry diatribe about Nic's overbearing expectations, Joni yells 'now you can show everyone what a perfect lesbian family you have!' Nic has striven not just for *any* perfect family but for a 'perfect *lesbian* family'. She is determined, her daughter implies, to prove her ability as a lesbian parent to bring up, in the face of prejudice, successful, healthy children just as a straight parent supposedly would. Her character presents, then, an example of the woman whose sense of self is finally validated not by her professional success as a doctor but by the feminine testimonies of motherhood.[29]

Lesbian mothers are an affront to much queer theory in the vein of Edelman's queer negativity not only because they are seen to embrace dominant reproductive structures, argues Cheshire Calhoun, but also because they are assumed to be heterosexual. As 'lesbianism and motherhood are culturally imagined to be incompatible', she says, 'lesbian motherhood facilitates the closeting of lesbian existence'.[30] In *The Kids*, however, motherhood is *contrary to* the lesbian assimilation so despaired of and feared by some radical lesbian feminists: Nic does not sacrifice her sexual politics for the sake of motherhood, but wears that politics on her sleeve.[31] Her desire (articulated by Joni) to present her perfect family as a lesbian one does not closet lesbian existence: on the contrary, it promotes a proud lesbian parenthood that nevertheless submits to postfeminism's mantra of motherhood.

Here is this chapter's key proposition in a nutshell: that lesbianism does not *necessarily* equate to queerness. Can *The Kids'* proud lesbian family submit to postfeminism and simultaneously be labelled queer? Perhaps it can. Contrary to Edelman, Calhoun insists that 'the idea that

bidding for access to the family necessarily means bidding for access to the traditional family is not a supportable assumption'.[32] The prevalence of adoption, *in vitro* fertilization and other parenting options suggests that 'choice', as Calhoun speculates, 'increasingly appears to be the principle determining family composition'.[33] This contract of choice is reminiscent, however, of the myth of postfeminist liberation, which allows women many options, but always within a dominant framework: as Negra and Tasker suggest, queerness has been 'effectively co-opted [into postfeminist culture] through a rhetoric of choice', all the while 'stripped of its original confrontational political agenda'.[34] This 'choiceoisie' (to use an epithet employed by both Stéphanie Genz and Elspeth Probyn) induces women to believe that they can choose to have it all, when in reality they are still bound by the capitalist, patriarchal imperative to choose the *correct* set of clothes, the *correct* femininity, the *correct* lifestyle.[35] Women may work, but in a workplace represented as a site of romantic potential rather than career fulfilment; women may be single, but never believed to be contentedly so. The many choices open to would-be parents are, in fact, bound by the compulsory social contract that demands they choose to have children in the first place (and cunningly convinces them that it is in fact a choice and not an obligation). Edelman has identified the reproductive teleology of contemporary society. Such a teleology is easily applicable to the postfeminist condition that forces women into constant anxiety but allows relief from the rat race for the childbearing woman to enjoy her blissful pregnancy and subsequent path to 'full womanhood'.[36] While entitling for the pregnant woman whose body, in another era, might have been rendered a taboo, this standardization of womanhood is worryingly dismissive of women who choose not to have children.

It seems to be no coincidence that the prelude to Jules' affair with Paul in *The Kids* is a discussion in which she realizes – and celebrates – Paul's physical similarity to his biological children. 'I'm sorry...', she says, as she stops in the middle of a sentence and exclaims, with a mixture of bewilderment and affection, 'I just keep seeing my kids' expressions in your face.' Her later attraction to him is, we may surmise, not only a symptom of needing more attention, as she tells Nic, but of an intrigue about the power of biological (read: familial) closeness. A vision of the family as a biological mission statement may not automatically fit the image of Cholodenko's liberal lesbian filmmaking. We cannot help but notice the significance, however, of her *oeuvre*'s shift between the non-biological communitarian attraction portrayed in *High Art* and the literally physical (and biological) attraction portrayed in *The Kids*.

Within this domestic rhetoric, moreover, how might *The Kids* recuperate queerness in some other way?

What queer sex looks like?

As Harry Benshoff has indicated, the term 'family values' has been constructed as a 'semantic club with which to bludgeon all things homosexual, attempting to separate queer people and their concerns from the realm of "morality" allegedly represented by the traditional nuclear family'.[37] What does it mean, then, that in a featurette made for the DVD release of *The Kids*, Cholodenko states that the film is, more than anything else, a 'family values movie'?[38] *The Kids* presents an endeavour to promote lesbian visibility in a post-*L Word* era that boasts more lesbian representation than ever before but still not enough.[39] Nic and Jules' 'perfect lesbian family' is anti-assimilationist because it is proud. It is also, however, normative, in financial, class and relationship terms, if not in gender ones, with its communal dinnertimes and unquestioned amenities (two cars, a table laden with salad tossers and pepper grinders, references to a preference for a specific bottle of wine rather than the generic red or white). Nic gets in from work to find dinner on the table and her joyful family waiting for her; she and Jules kiss with modest tenderness and there are smiles all round. Suzanne Ferriss and Mallory Young wonder whether the 'primacy of romance' exhibited in films such as this one – which, following their argument, could well be inscribed with the 'chick flick' caption – offer not a 'true "queer" alternative to the heterosexual romance' but rather a mere reshaping of 'lesbian desire to fit a heterosexual romantic [and financial] model'.[40] Reducing Jules' dilemma in *The Kids* to a leaning towards normativity, however, would be too easy an explanation for a far more complicated situation.

While there is in all of Cholodenko's films a sense of tension or embarrassment surrounding parental sexuality – a common trend in postfeminist texts such as *Something's Gotta Give* (Nancy Meyers, 2003) and *It's Complicated* (Nancy Meyers, 2009) – this embarrassment is, in *The Kids*, not about sexual orientation, gay or straight, but about sexual expression full stop.[41] Both Joni and Laser are frank with each other and their friends about their lesbian parents. 'Like in two [women]?' Paul asks Joni, in initial surprise upon learning about the purchasers of his sperm. 'Like in gay' she scathingly retorts, leaving him stuttering 'right on, cool, I love lesbians' and then visibly reeling from embarrassment at his lack of sophistication. By having a sexual affair with a man Jules

is, then, not escaping her *lesbian* sexuality; she is escaping, it seems, her non-orientation-specific *normative* sexuality.

In Judith Halberstam's terms – which posit so-called 'queer time' as a fundamental rejection of 'reproduction and family, longevity, risk/safety, and inheritance' – we can see Jules' (and Syd and Alex's in *High Art* and *Laurel Canyon* respectively) adultery narratives as signs of defiance of the heterosexual, or homosexual but nevertheless normative, cycles of home-making, marriage and reproduction from which they have come.[42] Assuming that 'lesbian sex' requires inherently different skills and expectations from those she is used to, *High Art*'s Syd asks her new lover Lucy 'should I pinch you or bite you or something?' In a rebuff of this naive earnestness, Lucy simply tells Syd '[you can] if you want to', and mocks Syd's 'is that hard enough?' by switching their positions and asking 'is that soft enough?' In *The Kids*, after her initial bafflement at the confrontation with male genitalia – 'Oh! Well! *He-llo*!' she hilariously exclaims upon unzipping Paul's trousers – Jules is apparently turned on by queering *heterosexual* sex. 'Oh yeah, pull my hair', she pleads in one scene, as she slaps Paul round the face. If we posit queerness as an affront to postfeminism, the adultery narrative is one such possible point of rebellion, where a resort to adultery is coupled with the soliciting of a kind of sex that is different from the character's personal version of the norm. 'While postfeminist discourse insists on lauding the "many options" women now have', says Suzanne Leonard, 'the adultery narrative provides, in counterpoint, a far more pessimistic account of the ways in which so many of the sites of female fantasy – the job, the marriage, the family – are still institutions with their own problematic histories'.[43] Not only does it reveal the problematic histories of heterosexual and normative institutions, however; the adultery narrative is also bound to reveal its own problematic present. While it is presented as a choice – and for Syd and Jules perhaps it is, while for Alex in *Laurel Canyon* the pressure laid on by her male wooer is not insignificant – it is also, as Leonard duly acknowledges, a negative force that causes, in each of Cholodenko's films, loss and distress.

Leonard furthermore highlights the workplace as a site of adultery. The adultery narrative is a frequently employed illustration of 'public anxiety about female work', blaming as it does the disruption of domesticity on women's return to work.[44] Indeed all of the adultery narratives that take place in Cholodenko's films come about as a result of women's position with regards to work. Nevertheless, even in rejecting domesticity, the adultery narrative highlights, in acknowledging adultery's negative value (it is always accompanied by some degree of

turmoil), the fact that the *desirable* narrative outcome is for the woman to return to her original partner. Both Alex and Jules go back to their partners at the ends of their films while Syd is left punished by grief for her betrayal. Having refused Edelman's promotion of queer negativity, this argument does not attempt to defend the potential (paradoxical) 'positive' negativity of adultery. If, however, neither monogamy nor the escape from it are potential agents of a queerness that can triumph over postfeminism's reconfiguration of women's sexuality, then where does the queerness lie in Cholodenko's films?

Defining the (postfeminist) self in queer terms

The subtitle of Negra's book, 'Fantasizing the Reclamation of Self in Postfeminism', alludes to two phenomena: the postfeminist obsession with renewing femininity in the wake of feminism and, as such, clearly defining a postfeminist self; and Negra's hope, as a feminist scholar, of reclaiming a notion of female self that isn't submerged in the neo-traditionalism of postfeminism.[45] Postfeminism is thoroughly caught up in the production of a personal 'self' – necessarily fantasized because never realized – that fits the promotion of a public 'self' imposed by patriarchal capitalism's regulatory images of ideal femininity. As Hilary Radner writes, the ideal feminine self comes about through the pos-session of socially and culturally redeemable facets of materialism.[46] How then might we go about retrieving – and representing – a lesbian sense of self in postfeminism? Edelman sees queerness as the ultimate affront to contemporary society's insistence on the reproductive impera-tive as the only path to the attainment of the self. Postfeminist society's phantasmagoria contrives, for women in particular, the pressure to achieve motherhood as the only satisfaction of true selfhood. In these postfeminist terms as they have been laid out in this chapter, women are not women – are not subjects, are not people – unless they are also mothers. Unless they are mothers or lovers, that is: the quest for love is represented as an equally resonant approach to true womanhood, neces-sitating a sexually desirable form of femininity that leads inevitably to reproductive romance.

The family is not a new cultural obsession, nor a new thematic preoc-cupation of cinema or of its unashamedly capitalist-driven appendage, advertising. One of the main appeals to mass audiences of cinema has been its (albeit highly dramatized) representation of daily life which, in its only acceptable form, revolves around the pursuit of, content-ment with, or protection of a family of our own. It is tempting to

consider Cholodenko's films as complicit in the postfeminist mentality that privileges family and romance over profession and independence in the pursuit of selfhood. Indeed, the odds are stacked against her. The final sections of both *The Kids* and *Laurel Canyon* are about female characters' attempts to seek redemption for their (perceived) wrongdoings. In *The Kids* Jules publicly reproaches herself for her affair with Paul as she stands up in front of her family and wails 'sometimes you hurt the ones you love the most, I don't know why'. At first forgiveness is uncertain, but eventually the film's final car journey, following Joni's delivery at university, has Nic offer a gesture of clemency. Smiling at Laser's suggestion that they should not break up because they're 'too old', the two women hold hands and their son, whose final word has effectuated reconciliation and familial security, grins, beckoning the advance of the film's final credits. There is redemption, Cholodenko's films insinuate, for women who repent; there is redemption, moreover, for women who act in accordance with their familial commitments.

It is left for the audience to decide, however, what Cholodenko's view is – and what ours should be – of these women's 'fuck ups' and 'mistakes'. Just because they seek – or are offered – redemption, should we discard them as normative subjects unworthy of our queer feminist attention? There is always the danger of overly eulogizing the escape of characters from the binds of motherhood towards the supposed liberty of an unencumbered feminist self. The menopausal woman, the single woman, the adulterous woman and the lesbian woman are not necessarily any more recognizably feminist than the heterosexual, married, mothering woman. In many ways, moreover, the films do challenge society's patriarchal structures. In *The Kids*, for instance, Nic's aggression towards Paul frequently takes the form of bitterness about his gender, her verbal addresses to him consistently equating masculinity with negativity. When he criticizes her for being overly restrictive of Joni, Nic dismisses his observation because of his lack of parenting experience. 'I need your observations like I need a dick in my ass', she shouts. Crucially, in these scenes Paul is positioned very much on the outside: verbally, spatially and cinematically. Nic and Jules occupy the space of one frame while he stands opposite them, unable to enter their territory. Similarly, when he comes to the house towards the end of the film in order to reconcile with Jules and the kids, he remains outside, never allowed to cross the threshold, as Nic exclaims 'you have got some balls, mister...let me tell you something, man, this is not your family. This is my family.' As opposed to the abundance of family representations that posit the male as fundamental to family construction and life, Paul

is outcast from the family structure because of his male gender. This segregation reverses *The Kids'* problematic but temporary return to the biological and reconciles (non-heterosexual) reproductive futurism with an advert for same-sex solidarity.

Crossing over

Consumerism, already flagged as the iniquitous core of postfeminist society, highlights the most controversial paradoxes not only of postfeminism but also of queerness. Even as queer politics and theory are aligned against the capitalist state as a notorious oppressor of freedom of sexual identity, they are actually reliant on it for its financial, social and cultural backing and for its enabling of visibility. Privacy, like consumerism, is the inevitable undoing of queerness; the private sphere allows for freedom of expression of identity and sexuality even as it enforces the closeting denial of pride in that same identity. With globalization threatening the domestic security of the local, the domestic sphere and its enforcement through privacy are being remodelled everywhere we look. Borders are being put up around us and the truly progressive (queer?) people are the ones who are pushing them down.

'The box-office triad of high art, rough trade and a tragic death never fails', Rich insisted in 2000, 'however queer the particular application'.[47] Rich's assertion is arguably out of date, however; it is now Cholodenko's *The Kids* instead which, without any of the high art–rough trade–tragic death, box-office criteria that *High Art* yields, satisfies a newer and more postfeminist ideal of box-office potential: romantic comedy. A romantic comedy, no less, that is available for consumption by queers, too. These films could/would not have been made 30 years ago; they are a product of postfeminist screen culture. Cholodenko's is a cinema of contradiction, one that straddles postfeminism and queerness. This chapter has conceived of that contradictoriness as the performance of what is ultimately an absolute queer act, one of resisting categorization.

Cholodenko is stuck in the tangle of paradoxes that is queerness in a postfeminist society. Yet her ambiguity and contradiction, and her potential to divide audiences, are all part of an endeavour (perhaps unconscious) to bridge the dichotomies that divide queerness not only from postfeminism but from so much popular culture that is dismissed as normative. Cholodenko's films exhibit many of the outlined traits of postfeminist culture that seem by their very nature to be pitted in opposition to feminist and queer convictions: female temporal anxiety;

demonization of purportedly overbearing mother figures; the ultimate privileging of familial – if not biological – relations over friendship-based communities; the girling of femininity and the glorification of youth and naivety; and the representation of older women (who defy that girlification) as jaded. Representation does not equate to complicity, however. Cholodenko's films challenge the patriarchy even as they represent it. There are so many paradoxes at work: we (where 'we' are feminists/queers expecting a certain 'integrity' in feminist/queer film-making) want Jules to return to Nic in defiance of a male patriarch, yes; surely we also, however, want her to stay with Paul in order to defy Nic's own patriarchal system of family. In short, Cholodenko can't win. Women are criticized by postfeminist society for being overly maternal but also for not being maternal enough; women are criticized by queer communities for choosing to be maternal at *all*. Cholodenko's is a cinema of contradiction. In this way she occupies that cinematic and political threshold space which allows her to straddle genres, political movements, and notions of selfhood, queerness and femininity, even as it risks her reputation of integrity in a queer community that resents, for instance, the heterosexual connotations of the romantic comedy genre that *The Kids* exhibits.

Although contrary to postfeminism's insistence on fixity, consumer capitalism – on whose back postfeminism stands – depends precisely on an insecurity concerning the self. The conclusions of Cholodenko's films, whose resolutions rely on forgiveness, suggest that this paradox cannot be resolved but rather has to be accepted and tolerated. This acceptance of our own – and others' – flaws promotes queerness in yet another way, by rejecting the idea of a perfected self and a goal-oriented (read: future-oriented) narrative/life. As Peter Wollen states, 'texts can be studied not only in their universality (what they all have in common) but also in their singularity (what differentiates them from each other)'.[48] Thus the arguably least queer of Cholodenko's works, *The Kids*, is perhaps the most capable of queering Cholodenko's *oeuvre* in another way, by diverting the 'straight' (as in the expected and typical, i.e. in this case 'queer') path of her career. Cholodenko thus, instead of yielding to the mainstream, queers authorship in formal terms by making a film that is *different* from high art (the film and the medium). Ultimately we could consider the arch of Cholodenko's career to represent a heterogeneity in authorial persona, and a refusal to submit to a very postfeminist prerequisite, that which stipulates the creation of a 'self' that is fluent, definable and categorizable.

Notes

1. Festival nominations: Sundance Institute, 'Sundance Archive: *The Kids Are All Right*' (2010) http://history.sundance.org/films/6672 (accessed 21 August 2011); 83rd Academy Awards, 'Best Picture Nominations' (2011) http://oscar.go.com/nominations (accessed 21 August 2011); Newspaper and Magazine Reviews: Peter Bradshaw, '*The Kids Are All Right* – Review', *Guardian*, 28 October 2010, p. 10; Sophie Mayer, 'Film of the Month: *The Kids Are All Right*', *Sight and Sound*, (November 2010) http://www.bfi.org.uk.sightandsound/review/5677 (accessed 21 August 2011); Chris Tookey, 'Mum's the Word: *The Kids Are All Right* is a Very Moral Comedy About Family Values', *Daily Mail*, (29 October 2010) http://www.dailymail.co.uk/tvshowbiz/reviews/article-1324644/The-Kids-Are-All-Right-review-A-VERY-moral-comedy-family-values.html (accessed 21 August 2011).
2. Brian Robinson, 'The Pride and the Passion: 25 Years of the London Lesbian and Gay Film Festival', *Sight and Sound* (April 2011) http://www.bfi.org.uk/sightandsound/ feature/49705 (accessed 21 August 2011) (para. 11 of 17).
3. Rachel Cooke, 'Lisa Cholodenko: "I Wanted to Make a Film That Was Not Sanctimonious or Sentimental" ', *Guardian*, (3 October 2010), p. 8.
4. Ibid.
5. *High Art*, dir. by Lisa Cholodenko (October Films: 1998); *Laurel Canyon*, dir. by Lisa Cholodenko (Sony Pictures Classics: 2002); *The Kids Are All Right*, dir. by Lisa Cholodenko (Alliance Films; Focus Features: 2010), hereafter referred to as *The Kids*.
6. Sara Ahmed, *Queer Phenomenology: Orientations, Objects, Others* (Durham, NC: Duke University Press, 2006), p. 70; *The Journey to Forming a Family*, produced by Colleen A. Benn, Marian Mansi and Julie Harter (Universal Studios. 2010).
7. David Cox, 'The Kids Are All Right. But Are They?', *Guardian: Film Blog*, (2010), p. 12.
8. Eve Kosofsky Sedgwick, 'Foreword', in *Reading the L Word*, ed. by Kim Akass and Janet McCabe (London: I.B. Tauris, 2006), pp. xix–xxiv (pp. xxi–xxii); *The L Word*, created by Ilene Chaiken (USA: Showtime, 2004–2009); *Sex and the City*, created by Darren Star (USA: HBO Original Programming, 1998–2004); *Will & Grace*, created by David Kohan and Max Mutchnick (USA: NBC, 1998–2006).
9. Yvonne Tasker and Diane Negra, 'Introduction: Feminist Politics and Postfeminist Culture', in *Interrogating Postfeminism: Gender and the Politics of Popular Culture*, ed. by Yvonne Tasker and Diane Negra (Durham, NC: Duke University Press, 2007), pp. 1–25 (p. 21).
10. B. Ruby Rich, 'Queer and Present Danger', *Sight and Sound* (March 2000) http://www.bfi.org.uk/sightandsound/feature/80/ (accessed 13 October 2010); Sundance Institute, 'Sundance Archive: *The Kids Are All Right*' (2010) http://history.sundance.org/ films/6672 (accessed 21 August 2011).
11. Tasker and Negra, p. 1.
12. Stéphanie Genz and Benjamin A. Brabon, *Postfeminism: Cultural Texts and Theories* (Edinburgh: Edinburgh University Press, 2009), p. 3.
13. Ibid.

14. Amelia Jones, Susan Bee, Mira Schor and Johanna Drucker, ' "Post-Feminism": A Remasculinization of Culture?', in Amelia Jones, Susan Bee, Mira Schor and Johanna Drucker (eds), *M/E/A/N/I/N/G: An Anthology of Artists' Writings, Theory and Criticism* (Durham, NC: Duke University Press, 2000), pp. 7–23 (p. 8).

15. See for example: Angela McRobbie, *The Aftermath of Feminism: Gender, Culture and Social Change* (London: Sage, 2009); Dianne Negra, *What A Girl Wants? Fantasizing the Reclamation of Self in Postfeminism* (London: Routledge, 2009); Sarah Projansky, *Watching Rape: Film and Television in Postfeminist Culture* (New York: New York University Press, 2001).

16. *The Devil Wears Prada*, dir. by David Frankel (20th Century Fox: 2006); *Bridget Jones's Diary*, dir. by Sharon Maguire (Universal Studios: 2001); *Sweet Home Alabama*, dir. by Andy Tennant (Touchstone Pictures, 2002).

17. Tasker and Negra, p. 8.

18. For discussions of the interrelatedness of capitalism and queerness in particular, see for instance Alexandra Chasin, *Selling Out: The Gay and Lesbian Movement Goes to Market* (Basingstoke: Palgrave, 2001); Wendy Lynne Lee and Laura M. Dow, 'Queering Ecological Feminism: Erotophobia, Commodification, Art, and Lesbian Identity', *Ethics and the Environment*, 6 (2001), pp. 1–21; Alan Sears, 'Queer Anti-Capitalism: What's Left of Lesbian and Gay Liberation?', *Science and Society*, 69 (2005), pp. 92–112.

19. Dereka Rushbrook, 'Cities, Queer Space, and the Cosmopolitan Tourist', *GLQ*, 8 (2002), pp. 183–206 (p. 189).

20. Yvette Taylor, 'Queer, but Classless?', in *The Ashgate Research Companion to Queer Theory*, ed. by Noreen Giffney and Michael O'Rourke (Farnham: Ashgate, 2009), pp. 199–218 (p. 201).

21. Glen Elder, Lawrence Knopp and Heidi Nast, 'Sexuality and Space', in *Geography in America at the Dawn of the 21st Century*, ed. by Gary L. Gaile and Cort J. Willmott (Oxford: Oxford University Press, 2006), pp. 200–208 (p. 203).

22. Ibid.

23. Lee Edelman, *No Future: Queer Theory and the Death Drive* (Durham, NC: Duke University Press, 2004), p. 21.

24. Edelman, p. 2 and throughout.

25. Edelman, p. 30.

26. Negra, *What A Girl Wants?: Fantasizing the Reclamation of Self in Postfeminism* (London; New York: Routledge, 2009); Edelman, p. 30.

27. See for instance Judith Roof, 'Generational Difficulties; or, the Fear of a Barren History', in *Generations: Academic Feminists in Dialogue*, ed. by E. Ann Kaplan and Devoney Looser (Minneapolis, MN: University of Minnesota Press, 1997), pp. 69–87.

28. Edelman, p. 30.

29. See for instance Marilyn French, *The War against Women* (New York: Ballantine Books, 1992), p. 154.

30. Cheshire Calhoun, *Feminism, the Family, and the Politics of the Closet: Lesbian and Gay Displacement* (Oxford: Oxford University Press, 2000), p. 136.

31. See for instance Only Women Press, *Love Your Enemy?: The Debate between Heterosexual Feminism and Political Lesbianism* (London: Only Women Press, 1981).

32. Calhoun, p. 155.

33. Calhoun, p. 149.
34. Tasker and Negra, p. 19.
35. Stéphanie Genz, 'Singled Out: Postfeminism's "New Woman" and the Dilemma of Having It All', *Journal of Popular Culture*, 43 (2010), pp. 97–119 (p. 103); Elspeth Probyn, 'New Traditionalism and Post-Feminism: TV Does the Home', *Screen*, 31 (1990), pp. 147–159 (p. 152).
36. Negra, p. 63.
37. Harry M. Benshoff, 'Queers and Families in Film: From Problems to Parents', in *A Family Affair: Cinema Calls Home*, ed. by Murray Pomerance (London: Wallflower, 2008), pp. 223–233 (p. 223).
38. Benn, Mansi and Harter, *The Journey to Forming a Family*.
39. *The L Word*, created by Ilene Chaiken (Showtime: 2004–2009).
40. Suzanne Ferriss and Mallory Young (eds), *Chick Flicks: Contemporary Women at the Movies* (New York: Routledge, 2008), pp. 1–25 (p. 11).
41. *Something's Gotta Give*, dir. by Nancy Meyers (Columbia Pictures; Warner Brothers Pictures: 2003); *It's Complicated*, dir. by Nancy Meyers (Universal Pictures: 2009).
42. Judith Halberstam, *In a Queer Time and Place: Transgender Bodies, Subcultural Lives* (New York: New York University Press, 2005).
43. Suzanne Leonard, ' "I Hate My Job, I Hate Everybody Here": Adultery, Boredom, and the "Working Girl" in Twenty-First-Century American Cinema', in *Interrogating Postfeminism*, ed. by Tasker and Negra, pp. 100–131 (p. 123).
44. Leonard, p. 111.
45. Negra, p. 1.
46. Hilary Radner, *Neo-Feminist Cinema: Girly Films, Chick Flicks and Consumer Culture* (London: Routledge, 2011), p. 6.
47. Rich, para. 9.
48. Peter Wollen, *Signs and Meaning in the Cinema* (London: British Film Institute, 1969), p. 93.

3
The Slut That Wasn't: Virginity, (Post)Feminism and Representation in *Easy A*

Katherine Farrimond

Drawing on the work of Angela McRobbie, Rosalind Gill and Christina Scharff identify a form of double address within postfeminist culture, suggesting that 'what is distinctive about postfeminist culture is the way in which a selectively defined feminism is both "taken into account" and repudiated', and that this constitutes a 'double entanglement [which] facilitates both a doing and an undoing of feminism'.[1] As 'postfeminism' is a complex and fraught term, weighted with contradictory and confusing meanings and definitions, for the purposes of this chapter, I employ the construction (post)feminism as an indicator of such cultures of 'bothness' which situate themselves as a part of and apart from feminism. The (post)feminist cultural text takes a selective approach not only to feminism as a political position and cultural history but also to related cultural narratives, such as understandings of sexuality, and politically fraught generic forms such as the romantic comedy or rom-com. Such texts demonstrate a selective approach to feminist sensibilities, selecting certain aspects of normative models of gender and sexuality to interrogate, while validating others. In this chapter, I discuss one recent example of such texts, *Easy A* (2010), which provides a useful example of the ways in which cultural texts operate along these (post)feminist lines, offering neither a clearly defined progressive response nor a straightforwardly conservative reaction to ideas around sexuality and empowerment. Like many texts associated with postfeminism, it is preoccupied with the problems of young, straight, white, middle-class, Western women and certainly demonstrates an investment in maintaining this version of femininity as a central concern, as well as valorizing heteronormative,

monogamous narratives of romance and straightforward understandings of virginity.[2] However, while *Easy A* maintains the dominant order in these ways, it is also a film which is interested in challenging the double standards operating around young women's sexuality, which does not assume that all choices are made in a vacuum, free from societal inequality and cultural expectations, and which does begin to interrogate conventional ideas about the performance of sexual experience and desire and the discursive construction of sexual identities. In these ways, *Easy A* functions as a significant example of (post)feminist political duality.

In the film, Olive (Emma Stone) starts an inaccurate rumour that she has lost her virginity. Having observed the rapid spread of the rumour and the credulity with which it is received by her peers, and following a previous experience in which she lied about kissing Todd (Penn Badgley) to protect his reputation at school, Olive agrees to stage a sexual encounter with Brandon (Dan Byrd), a boy from school whose life is being made miserable by homophobic bullying. Once everyone believes that Brandon and Olive have slept together, Brandon's homosexuality is no longer suspected and he can live out the rest of his time at school in peace. When other social outcasts learn of Olive's actions, she discovers that she can make a material profit (in the form of gift cards of wildly varying value) by allowing her male peers to claim they have had sex with her in order to boost their credibility. As a result of this, Olive's social standing in the school plummets, and she is branded a slut, despite never having had sex. Alongside this narrative thread, the school plays host to the Cross Your Heart Club, a conservative Christian group whose members pledge to remain pure until marriage. The club is led by Marianne (Amanda Bynes), who sees it as her duty to either save Olive from her promiscuous ways, or have her removed from the school. Unfortunately, one member of the club, Marianne's boyfriend Micah (Cam Gigandet), has been sleeping with Mrs Griffith, the school guidance counsellor (Lisa Kudrow), and contracts chlamydia from her. Not wanting to get Mrs Griffith into trouble, and willing to trade on Olive's reputation as the school slut, Micah tells everyone that it was Olive who infected him. Eventually, Olive decides to tell everyone the whole story via a webcam broadcast, which forms the narrative frame of the film, before finally beginning a real relationship with Todd, who has never believed the rumours about Olive's sexual exploits.

Easy A's engagement with complex (post)feminist double addresses begins with its self-conscious generic positioning. The film locates itself both within and outside the rom-com genre, and in doing so

occupies an ambivalent position in relation to heteronormative notions of romance.[3] While the film, as a high-school rom-com, is generically connected with films like *The Breakfast Club* (1985), *Say Anything* (1989), *Can't Hardly Wait* (1998) and *She's All That* (1999), and indeed incorporates clips from some of these earlier examples, *Easy A* also attempts to distance itself from these ostensibly simpler narratives. The teenage protagonist Olive twice notes that her life is not like conventional representations of romance, first when she explains that she is not eternally in love with 'George', her first fictional conquest, because she is not 'a gossip girl in a sweet valley of the travelling pants'. Later in the film she expresses her desire for her life to be like 'an 80s movie', and cites a number of iconic romantic gestures from teen films of the period before noting that her experiences are very far removed from these fictional examples, and that 'no, John Hughes did not direct my life'.[4] However, at the end of the film, Olive's love-interest Todd appears at Olive's house and re-enacts several of these gestures at once, which frames such gestures as desirable and pleasurable. These self-conscious manoeuvres flag up *Easy A* as both part of and separate from the teen romance film, allowing the film to dismiss or take up particular generic tendencies at will, to be in nostalgic thrall to the romantic gestures of John Hughes' films while dismissing the lack of realism in such texts, to refuse the idea of sex as an indicator of a grand passion while embracing the grand gesture and the happy heterosexual ending. As a result of this explicitly selective attitude to the conventions of the rom-com, *Easy A* does not employ an entirely conservative position in relation to sexuality in spite of its generic positioning. Kathleen Rowe Karlyn describes the 'teen-inflected romantic comedy [which] has become the standard genre of a girl's coming of age in recent years' as a '[cinematic] toxin', and adds that 'it has also been central to the formulation of postfeminism, a difficult-to-define phenomenon that re-considers consumerism, romance and other girly pleasures as potential means of female empowerment'.[5] Rowe Karlyn's vision of the rom-com as toxic disregards the capabilities of such texts to unpack normative constructions of sexuality and romance. Although the rom-com can be connected with a lack of progressive potential, and the genre's impulse towards monogamous heteronormative coupling certainly consolidates these problems, I contend that *Easy A*'s (post)feminist tendencies demonstrate an engagement with conservative understandings of sexuality and also raise important questions about the role of the teenage girl within a postfeminist culture in which sexuality and performance are so closely connected. In what

follows, I first explore how (post)feminist duality operates in the film's engagement with the politics of virginity, before moving on to consider *Easy A*'s exploration of performed sexuality and postfeminist notions of sexual display and empowerment.

Interrogating contemporary virginity

Before beginning my exploration of the film, it is first necessary to outline some of the recent developments in virginity studies which complicate the notion of virginity and which inform my reading of *Easy A*'s depiction of virginity and performed sexuality as (post)feminist. Despite its apparent simplicity, the term 'virgin' denotes a potentially complex identity position, particularly for women. This complexity has been the subject of a diverse range of feminist scholarship over the past 15 years as the critical investigation of virginity has developed in unprecedented ways. In medieval and early modern studies, scholars including Kathleen Coyne Kelly, Theodora A. Jankowski and Marie H. Loughlin have engaged in work which interrogates representations and conceptions of virginity in these periods, drawing on feminist and queer theory to do so.[6] More recently, scholarship has emerged which charts understandings and definitions of the term from the earliest records to the present day, with two such texts appearing in 2007, Hanne Blank's *Virgin: The Untouched History* and Anke Bernau's *Virgins: A Cultural History,* while Bonnie Maclachlan and Judith Fletcher's edited collection *Virginity Revisited: Configurations of the Unpossessed Body* and Tamar Jeffers McDonald's collection *Virgin Territory: Representing Sexual Inexperience in Film* engage with textual representations of first sexual experience and its loss.[7] In 2010, Harvard University hosted a conference for feminist academics, journalists and bloggers entitled 'Rethinking Virginity', which included panels on queer and sex positive virginity. Similar attention has been given to the subject in popular feminist and queer writing in response to the increasingly visible focus on female virginity by the Christian Right in the United States, most notably in the form of Jessica Valenti's *The Purity Myth* (2009).[8] These various works encompass readings of virginity through biological, historical, political, religious, feminist, cultural and queer lenses, and suggest that critical understandings and interrogations of virginity have never before been so nuanced and multifarious.

These recent feminist interventions into the question of virginity have focused not only on the way in which it functions as an oppressive framework which works to control and define women by their sexuality,

but also on questioning the nature of virginity itself. For example, one of the most interesting developments in this recent wave of scholarship has been the attention given to confronting and dissecting the mythology surrounding the hymen as a totem of female virginity. Similarly, emphasis has been placed on the significance of reading the term through a queer lens, to ask, as one online resource puts it: 'what the fuck is gay sex anyway?', and these reassessments of virginity outside the focus on heterosexual intercourse raise considerable questions about sexual experience and the definition of 'virgin'.[9] Most conventional definitions of virginity and its loss collapse when challenged by queer sexuality, and indeed any sexuality that is not solely defined by heterosexual vaginal intercourse. Finally, scholarship is emerging which opens up the possibility of what Blank calls 'process-oriented' models of virginity, in which the category of 'virgin' is seen as fluid, rewritable and defined by the subject, rather than by some objective and essential definition of sexual inexperience.[10] These emphases create an important space for the role of performance, masquerade, affect, feeling and instinct, for a critical understanding of virginity and its loss: in short, for complex and fluid definitions which are not limited to the first time a vagina is penetrated by a penis. What this wealth of research on the subject of (predominantly female) virginity points towards is a desire to dispel or complicate notions of virginity which are informed by heteronormative definitions of sex and sexual experience, and by biological interpretations of the virginal body.

Given the current occupation with virginity in both feminist writing and American culture more generally in the wake of the push towards abstinence-only sex education initiated by the Bush administration post-2000, it is inevitable that popular culture also offers a response to these concerns. Narratives around virginity have emerged in a range of cultural texts, particularly those focused on white American teenagers. For example, plots based around organized virginity pledges, pacts and clubs have appeared in mainstream teen television, in the form of *Glee*, episodes of popular crime dramas *CSI* and *Law and Order*, and the indie teen horror film *Teeth* (2007), and these texts often focus on the apparent impossibility of maintaining such pledges.[11] *Easy A* offers a particularly rich addition to this body of work, as it explores virginity from several angles: Olive's misrepresented virginal status, the Cross Your Heart Club's virginity pledges, and the gap between Micah's sexual experiences and his claimed virginity. *Easy A*, then, is a film preoccupied with constructions and interpretations of virginity, and with the ways in which understandings of a person's sexual experience or lack thereof can

dramatically affect perceptions of their identity within contemporary Western cultures, particularly among teenagers.

(Post)Feminist virginity and self-identification

The contrast between Olive's experiences and sense of her own sexual identity, and the interpretation of her sexuality by her peers is striking. Olive has never had sex, explicitly describes herself as a virgin at the end of the film, and makes self-deprecating jokes with Brandon and her parents about her lack of sexual activity, referring, for example, to her bedroom as 'where the magic happens. And as you well know, by "magic" I mean "nothing"'. Despite this, peers at school repeatedly describe her as a slut, skank and whore because of their perception of her level of sexual activity and knowledge. This disparity between self-identification and the descriptions of others indicates the beginnings of an opening up of the category of 'virgin', a possibility which is further developed when the depiction of Olive's virginity is reversed in the conflict between the claims of virginal identity and the medical evidence of a sexually infected body found in Micah's narrative arc.

These tensions around virginity gesture towards the complex models of sexuality being developed in the theoretical accounts of virginity outlined above. In the introduction to *Virgin Territory: Representing Sexual Inexperience in Film*, Tamar Jeffers McDonald describes virginity as 'a lack of experience, a zero', and explains that cinema has long been fascinated with the complexity of representing the absence that is virginity.[12] What *Easy A*'s representation of Olive offers is a movement beyond this notion of virginity as a zero or absence, but instead suggests that, virginity itself may be a presence, a set of constructed meanings and discourses. In particular, the film is concerned with how, for teenage girls living in a postfeminist culture based on the performance of sexuality, it is possible to occupy multiple identity positions at once, to be both virgin and whore, a girl who has never had sex with another person, but who nonetheless is thought of as 'the school slut'.

The film also demonstrates a distinct interest in critiquing and undermining organized purity movements and abstinence-only education in its treatment of Marianne and her friends. While the film's characters are generally witty, self-conscious and nuanced, Marianne's commitment to her cause is depicted as a hyperbolic and deeply misguided extremism, completely lacking in self-awareness, a representation which is consolidated by Bynes' gleefully campy performance. While the film does not make explicit reference to abstinence-only education, the

satirical treatment of the reactions of devoutly Christian characters to mainstream educational strategies – Nina (Mahaley Hessam) proudly describes *The Scarlet Letter*'s Hester Prynne as 'a skank' in an English lesson, while Olive reminds Marianne that the reason they did not attend the same 'religions of other cultures' class was because Marianne 'called it science fiction and refused to go' – gesture towards the kinds of extreme and censorious approaches to education associated with advocates of abstinence-only sex education from the Christian Right in the United States.[13] *Easy A* then, in line with many of the other contemporary film and television texts outlined above, works to question and undermine purity movements and abstinence-only education, suggesting instead a more moderate approach to teenage sexuality.

However, despite this interest in opening up a dialogue which complicates conservative understandings of virginity, the film is still invested in a notion of an uncomplicated physical virginity which is rooted in heterosexual intercourse. Jeffers McDonald notes that 'virginity is not personal but social, not private but public, not natural but constructed, and not obvious but invisible'.[14] *Easy A* contradicts these ideas, and works to create an impression of virginity which is not only private and natural, but clear and concrete. While Olive's virginity may be complicated by her slutty persona, that virginity still retains its validity within the film, so that Olive is able to explain at the end of the film that she may, at some point in the future, lose her virginity to Todd. Despite the school rumour mill's disruption of conventional narratives of virginity, there is, it is implied, a clearly definable physical virginity underneath the layers of lies, rumours and performed sexuality. The film suggests that it may be possible to layer complex performances of sexuality on top of a physical state of virginity, but that this virginity will remain essential and unchanged by those performances. When Olive is sent to the principal's office for swearing at Nina in a lesson, she notes that 'even though it was my slutty alter-ego that said a bad word in school, it was *my* ass that got in trouble'. The phrasing of this indicates a clear line between the performed alter-ego and 'me', and implies that even though those performances may affect Olive's day-to-day existence, there is still a non-slutty girl underneath who is unchanged by the adoption of alternative personas. While virginity can be misrepresented, and its presence or absence claimed contrary to actual sexual experience, it is important that these contradictory narratives are recognized to be lies, obscuring a physical truth about virginity. In both Micah and Olive's cases, there is a sense that the truth about the body will rise to the surface and that the virginal status of those bodies will ultimately be revealed.

(Post)Feminism and performed sexuality

While *Easy A*'s specific focus on virginity may not go very far in breaking down conventional ideas around virginity, it does allow for a (post)feminist consideration of performed sexuality and postfeminist cultures, and I will spend the remainder of this chapter interrogating the film's engagement with these ideas. In their discussion of the television sex advice programme, Laura Harvey and Rosalind Gill, drawing on the work of Hilary Radner, note that, contrary to older narratives which value chastity as the ultimate female virtue, 'in the postfeminist, post-*Cosmopolitan* West, heroines must no longer embody virginity but are required to be skilled in a variety of sexual behaviours and practices, and the performance of confident sexual agency is central to this technology of the self'.[15] In addition to this, their analysis of sexual advice on television makes the observation that while men are given instruction in sexual practices such as cunnilingus, the advice given for women focuses more specifically on the performance of a desirable sexuality, rather than on specific techniques for giving and receiving pleasure.[16] The requirements of female sexual knowledge have, according to Harvey and Gill, shifted in recent years from an expectation of sexual innocence, to the *performance* of a particular level of sexual awareness and expertise. Yet while virginity is still fetishized in contemporary Western sexual cultures, this tends to be accompanied by the knowing performance of sexual awareness.[17] *Easy A* does not replicate this dynamic, but rather interrogates the relationship between sexuality and performed sexiness. When assessing the sexual capital of the young, white, female, Western subject, the actual level of past sexual experience is not, the film suggests, important. Instead, such assessments rely on the performance of sexuality and on the range of signifiers which create implicit meanings around sexual experience.

Jeffers McDonald argues of virginity that

the external proof of an internal state is open not only to scrutiny but also to manipulation. Once there are considered to be external signs indicative of internal states, these signs can be manufactured without the internal referent on which they are supposed to rely. In other words, once virginity can be read, it can be faked.[18]

While this argument has some validity within the film, particularly in terms of Micah's virginity, *Easy A* suggests that, for girls at least, it is

the physical and corporeal signs of sexual experience rather than virginity that are all too familiar and easy to fake. When rumours initially begin to circulate about Olive, she notes in her voiceover that 'all I could think was "great, now I'm a tramp. I'm gonna have to get a lower back tattoo and pierce something not on my face"'. This automatic association of sexual knowledge and the aesthetic markers of that knowledge reverberate throughout the film. Olive is able to successfully create the image of herself as a slut, despite not having sex either before or during the timeframe of the film. Instead, she relies on the discourse of rumour, costume and gesture to construct the impression of herself as sexually experienced. This is made evident from the initial stages of the film, so that as soon as rumours begin to hover around Olive, her style shifts with it, her clothes become tighter and darker, and she begins to wear high heels and more obvious jewellery. Brandon describes her developing look as 'whore couture', and chastises Olive for 'perpetuating' her image as the school slut. The film, then, is explicit in drawing attention to the role of performance in constructing female sexual identity in postfeminist culture.

The development of Olive's style culminates in her response to the knowledge that people at school are calling her names based on their perceptions of her behaviour, as she exclaims, 'people thought I was a dirty skank? Fine! I'd be the dirtiest skank they'd ever seen'.[19] This declaration leads to the adoption of a wardrobe of shiny tight leggings and corsets decorated with red 'A's in a self-conscious parody of the treatment of Hester in *The Scarlet Letter*. That this impression of sluttiness is heavily fabricated through costume is emphasized by a furious cutting and sewing montage in which Olive physically constructs these outfits, and which is accompanied by a non-diegetic soundtrack of The Dollyrots' cover of Joan Jett's *Bad Reputation*. The first line of this song – 'I don't give a damn about my reputation' – may claim to disregard reputation entirely, but the juxtaposition of these lyrics with Olive's furious construction of a new image only serves to emphasize the way that she is in the process of (bad) reputation-building. This costuming is accompanied, particularly in the scene where her look is debuted, by a parody of flirtatious behaviour and gesture. Olive is filmed walking through the school in slow motion, as the mixed male and female crowd parts before her with expressions of amazement and disgust respectively.

She delivers uncharacteristically inane lines to boys in a breathy voice, and provocatively licks mashed potato off a spoon in the cafeteria, before quickly reverting to her previous persona when she bumps into her English teacher, suggesting, again, a highly constructed form of

sexual identity. The effect is consolidated with the choice of outfit in this first scene in 'A' costume, in that the tight black trousers, black corset and red accents function as a reference to Sandy's (Olivia Newton John) final 'made-over' costume in *Grease* (1978), particularly given that both looks are debuted in outdoor high school settings in both films. Just as Sandy's costume is an explicitly constructed image of sexual knowledge and availability, so Olive's ensemble acts in the same way in *Easy A*. The suggestion of sexual knowledge can, the film suggests, be performed and created through the adoption of appropriate sartorial, bodily and linguistic style. The performance of sexual knowledge and availability is presented as something that Olive has complete control over here, echoing postfeminist discourses about the empowering nature of sexual display for young women.

Although Olive is not the only character whose sexual experiences do not match her public performance of her sexuality, the film locates the active performance of sexual knowledge firmly as a strategy available to and employed by young women. The scene in which Olive and Brandon stage their sexual liaison, and the scenes leading up to this event, act as clear evidence of this situation. While Olive just made up the man she claimed to have slept with, Brandon does not have this option as he feels that no one would believe him, and so has to provide a more physical kind of proof. Later, when they pretend to have sex, it is clear that Olive has a much better idea of how to create a convincing impression of highly vocal heterosexual intercourse, as Brandon relies on her direction to assist in his performance, and she has to correct his 'mistakes' repeatedly throughout the event. Even though it is suggested that Brandon has more sexual experience than Olive because of his knowledge of a range of invented sexual acts and positions, Olive, the virgin, is still able to 'do' sexual activity in a way that Brandon is not. Young women, the film implies, have a greater capacity for performed sexuality than young men, whose attempts to perform sexual promiscuity need to be validated by the more convincing presence of a slutty girl.[20] Just as costume, discourses of promiscuity and gesture function as aids to reading the body of the teenage girl as sexually active, for the teenage boy to be read in the same way, it is necessary for the body of the boy to be viewed in association with the available girl. What this suggests is that the perception of the teenage girl's sexual identity within contemporary postfeminist culture is inextricably tied up with performed sexuality. While virginity may be performed, its signs are much less clearly created and understood than those of sexual knowledge and promiscuity.

However, as I suggest in the introduction, *Easy A* presents a (post)feminist response to female sexual empowerment, and while my discussions of Olive's sexual expression above may imply a version of apolitical postfeminist sexual identity, the film itself complicates this image. *Easy A* demonstrates an interest in conceptions of agency, and does so in a way that is not limited to a straightforward reiteration of the postfeminist notion that performed sexuality is inherently empowering. Rowe Karlyn suggests that 'the Third Wave's affirmation of sexual agency [...] assumes a teen girl's ability to experience sexuality in circumstances not characterized by exploitation or unequal social power'.[21] Setting aside the interchangeability of third-wave feminism and postfeminism here,[22] this statement offers a concise summary of one of the dynamics most commonly associated with postfeminist rhetoric around empowerment: that it advocates the harnessing of sexual display and performance for empowerment, but does not recognize the systems of oppression and power imbalance circulating around young women's sexuality. *Easy A* does not simply shore up these exhortations towards power-through-sexuality, but rather draws attention to the volatile and often hostile environments in which young women negotiate their own sexuality. While Olive is able to construct a particular version of sexuality for herself, the film repeatedly demonstrates that she is never entirely in control of the image she has created or how it will be received and exploited by others, and by young men in particular.

The two clearest instances of this occur around issues of consent and misrepresentation. In the first, Evan (Jameson Moss) tells Olive that he heard what she did for Brandon, and asks her to do the same for him. She initially refuses, and he retorts with 'I don't need your permission, you know', adding that 'at the rate you're going, I don't see how people will not believe it'. In this instance, as well as a second incident later in the film, when Micah lies to protect Mrs Griffith and tells everyone that Olive gave him chlamydia, and Mrs Griffith informs Olive that no one will believe her side of the story above that of a grown-up member of the school faculty, what is significant in these episodes is the way that Evan, Micah and Mrs Griffith all build, or threaten to build, a new version of Olive's public sexuality without her consent. Olive's own performance of sexual promiscuity up until these points in the film may enable these narrative developments, but these scenes are not simply instances of the boy who cried 'wolf' (or in this case, the girl who cried 'slut'), but rather examples of how young women are not permitted to govern and define their own sexuality.

The idea that no one would believe Olive's side of things suggests that a discursively constructed sexual identity is particularly vulnerable to

being usurped and controlled by more powerful privileged figures, in this case young men and older women. Sexual display is not presented as inherently empowering in this film. While her decision to tell 'the right side' of the story via a webcast allows Olive to regain control of the dialogue around and definition of her sexual identity, this is not before she demonstrates the mechanisms of power to which teenage girls' sexuality is subject. The film suggests, then, that sexuality may be highly constructed, and sometimes consciously and actively performed, particularly by young women in postfeminist culture, but that this does not make its impact upon their lived experiences any easier to control, or any less significant.

Screening technological resistance

Elsewhere I have discussed the representation of the teenage femme fatale in recent Hollywood film, and suggested that such figures, as in films like *Cruel Intentions* (1999) and *Pretty Persuasion* (2005), offer a response to both the material conditions that teenage girls experience within postfeminist culture, and the body of literature that suggests that girls are 'in crisis' because of these conditions.[23] In that chapter, I argue that the femme fatale offers a limited potential for exploring the problems faced by young women. *Easy A*, by contrast, suggests an alternative way of engaging with these problems while not requiring its teen protagonist to ultimately be punished for her participation in the practices of performed sexuality required to survive within a contemporary patriarchal culture that expects much of but values little about teenage girls. Olive is not 'in crisis' as a result of postfeminist expectations of young women so much as she is actively negotiating those expectations and managing her role within that society. Olive may be rejected by the school community because of her excessive performance of sexual knowledge and availability, but she is then able to restore order, and her reputation, by utilizing the facilities around her, namely the hypocritical desire of everyone who has shunned her for her assumed promiscuity to see that promiscuity in action, the social capital of the still-popular Todd, and contemporary forms of communication in the form of the webcam and live online broadcasting technologies. By using a suggestive musical number with Todd at a school pep rally as the supposed 'preview' to a live webcast of her having sex with him, Olive is able to pique the interest of her peers enough to get them to log on to watch her explain all about her recent deceptions, performances and behaviours.

This narrative turn is significant because it demonstrates the particularly (post)feminist response to the problems Olive faces. Her

self-empowerment relies upon a burlesque-style musical performance – a medium directly associated with the complex politics of femininity, sexual display and (post)feminist empowerment – and the promise of further and more explicit sexual displays. However, despite this, the film's conclusion does not conform to the notion that sexualized display is unproblematically and inherently empowering for young women. Instead, Olive is able to utilize the societal fascination with young women's sexual performances as a starting point, rather than as the sum total of her self-empowerment strategy, in order to explain her version of events. Olive is able to challenge the uncomplicated postfeminist relationship between empowerment and sexual performance by first raising that dynamic through her musical number, and then undermining it by insisting on a simple, straight-to-camera monologue. The use of the webcast is also significant here because it refuses familiar contemporary narratives in which teenage girls are constructed as victims of social networking and other communications technologies.[24] Instead of using these resources to post nude photographs of herself – a move which is usually represented as naïve – or to continue to construct her sexually experienced persona online, Olive uses the available technology to tell her story, to point out double standards, cruelty and hypocrisy she has experienced, and to draw attention to the scrutiny the teenage girlhood is subjected to and to point to the role that her peers' voyeuristic interest in her sexuality has played in her social ostracism.

Towards the end of the webcast, Olive addresses her audience directly by saying, 'and here you all are, waiting outside the bedroom door for me to kiss Todd, listening to me pretend to have sex with Brandon, paying me to lie for you, and calling me every name in the book'. This accusation occurs in the form of a voiceover accompanying a montage of Olive's peers watching the webcast, and neatly foregrounds the role of her peers not only in her persecution – 'calling me every name in the book' – but in voyeuristically making judgments about her sexuality and so contributing to its complex construction. This conclusion to Olive's adventures in slutdom is not unproblematic as it suggests both that she owes the world a full explanation of her experiences, and that there is an essential truth to her sexual identity – virginity – that exists underneath the layers of corsetry and performance, but despite this, the film does offer a means of moving past the postfeminist emphasis on empowerment through sexual display to utilizing this dynamic in a nuanced, reflexive, complex and (post)feminist way.

Easy A, then, offers a representation of young female sexuality which both shores up and disrupts conservative ideas about virginity, promiscuity and sexual display. Conventional notions of virginity

are gently challenged but ultimately supported, yet despite this, questions about the possibility of occupying the identity positions of both virgin and whore reverberate throughout the film. Sexual knowledge is revealed to be something that is highly performed and discursively constructed, but which is particularly expected of and accessible for young women. Ideas around the empowering nature of sexual display are certainly addressed, but rather than presenting an uncomplicated vision of sexualized performance as inherently positive for women, the film considers the affect such ideas have on the lived experiences of teenage girls and acknowledges the context of inequality and unbalanced privilege in which such discourses operate. The film may be a rom-com which relies on heterosexual coupling as the ultimate happy ending, but it also offers its teenage protagonist a way of speaking up, voicing her concerns, and employing the tools so often associated with the postfeminist naivety of young women to forge her own solution to the problems she faces. *Easy A* cannot be read as a clearly and explicitly feminist text, nor is it an apolitical postfeminist rallying cry for the benefits of sexualized display. Instead, it reveals an often uncomfortable dynamic of (post)feminist duality, in which conservative mores sit alongside radical interrogations of contemporary sexual politics.

Notes

1. Rosalind Gill and Christina Scharff, 'Introduction' in *New Femininities: Postfeminism, Neoliberalism and Subjectivity*, ed. by Rosalind Gill and Christina Scharff (Basingstoke: Palgrave, 2011), pp. 1–20 (p. 4).
2. For more on the limits of postfeminism in terms of race, sexuality and class, see Sarah Projansky, *Watching Rape: Film and Television in Postfeminist Culture* (New York and London: New York University Press, 2001).
3. The rom-com genre has frequently been theorized as a form which privileges normative models of sexuality. For example, Peter William Evans and Celestino Deleyto argue that 'the genre tends to privilege the eternal, unchanging nature of romantic love and to gloss over those aspects from the surrounding culture which threaten it'. Peter William Evans and Celestino Deleyto, 'Introduction: Surviving Love' in *Terms of Endearment: Hollywood Romantic Comedy of the 1980s and 1990s*, ed. by Peter William Evans and Celestino Deleyto (Edinburgh: Edinburgh University Press, 1998), pp. 1–14 (pp. 1–2).
4. Emma Stone's star persona is to some extent constructed around such ironic and self-reflexive nods to cinematic structures. In the recent rom-com *Crazy Stupid Love* (2011), her character Hannah makes reference to 'the PG 13 rated version of tonight', and insists that she is 'R Rated sexy'.
5. Kathleen Rowe Karlyn, 'Film As Cultural Antidote', *Feminist Media Studies*, 6:4 (2006), pp. 453–468 (p. 458).
6. Kathleen Coyne Kelly, *Performing Virginity and Testing Chastity in the Middle Ages* (London and New York: Routledge, 2000), Theodora A. Jankowski, *Pure*

Resistance: Queer Virginity in Early Modern English Drama (Philadelphia, PA: University of Pennsylvania Press, 2000); Marie H. Loughlin, *Hymeneutics: Interpreting Virginity on the Early Modern Stage* (Lewisburg, PA: Bucknell University Press, 1997).

7. Hanne Blank, *Virgin: The Untouched History* (New York: Bloomsbury, 2007), Anke Bernau, *Virgins: A Cultural History* (London: Granta, 2007); Bonnie MacLaughlan and Judith Fletcher (eds), *Virginity Revisited: Configurations of the Unpossessed Body* (Toronto, ON: University of Toronto Press, 2007); Tamar Jeffers McDonald (eds), *Virgin Territory: Representing Sexual Inexperience in Film* (Detroit, MI: Wayne State University Press, 2010).

8. Jessica Valenti, *The Purity Myth: How America's Obsession with Virginity Is Hurting Young Women* (Berkeley, CA: Seal Press, 2009).

9. See Anon 'What the Fuck Is Gay Sex Anyway', *Brightest Young Things* (11 June 2010) http://www.brightestyoungthings.com/articles/what-the-fck -is-gay-sex-anyway/ (accessed 5 February 2012) and Kelly, *Performing Virginity and Testing Chastity in the Middle Ages*, pp. 140–141.

10. Hanne Blank, 'The Process-Oriented Virgin' in *Yes Means Yes: Visions of Female Sexual Power and a World without Rape*, ed. by Jaclyn Friedman and Jessica Valenti (Berkeley, CA: Seal Press, 2008), pp. 287–298; See also Shelley Cobb's discussion of *Elizabeth*, in which Elizabeth I's virginity is depicted as a political strategy rather than a description of sexual inexperience. Shelley Cobb, 'Was She or Wasn't She? Virginity and Identity in the Critical Reception of Elizabeth (1998)' in *Virgin Territory: Representing Sexual Inexperience in Film*, ed. by Tamar Jeffers McDonald (Detroit, MI: Wayne State University Press, 2010), pp. 201–222.

11. As Martin Fradley argues elsewhere in this collection, horror and the chick flick romance film are frequently positioned as generic opposites, and yet postfeminist horror and romance often engage with similar themes and cultural phenomena.

12. Tamar Jeffers McDonald, 'Introduction' in *Virgin Territory: Representing Sexual Inexperience in Film*, ed. by Tamar Jeffers McDonald (Detroit, MI: Wayne State University Press, 2010), pp. 1–14 (p. 2).

13. For more on US abstinence-only sex education, see Valenti, *The Purity Myth*, pp. 111–120.

14. McDonald, 'Introduction', p. 2.

15. Laura Harvey and Rosalind Gill, 'Spicing It Up: Sexual Entrepreneurs and The Sex Inspectors' in *New Femininities: Postfeminism, Neoliberalism and Subjectivity*, ed. by Rosalind Gill and Christina Scharff (Basingstoke: Palgrave, 2011), pp. 52–67 (p. 56).

16. Ibid., pp. 60–61.

17. See, for example, the pre-marital star personas of Britney Spears and Jessica Simpson, and more recently Miley Cyrus, as well as the existence of online features such as complex.com's slideshow of 'hot' female celebrity virgins. Tara Aquino, 'Pure Fire: The 10 Hottest Celebrity Virgins', *ComplexGirls* (9 September 2010) http://www.complex.com/girls/2010/09/pure-fire-the -10-hottest-celebrity-virgins/gallery# (accessed 5 February 2012); For an assessment of Spears' hot virgin persona, see Anna Watkins Fisher, 'We Love This Trainwreck!: Sacrificing Britney to Save America' in *In the Limelight and Under the Microscope: Forms and Functions of Female Celebrity*, ed. by Su Holmes and Diane Negra (New York and London: Continuum, 2011), pp. 303–332.

18. McDonald, 'Introduction', p. 6.
19. This impulse towards a hyperbolic confirmation of this gossip is indicative of the complex power afforded to the slut. Although Olive is aware that her reputation at school is rapidly diminishing, she is also keenly aware of the power within postfeminist culture of being noticed and discussed. It is additionally significant that Olive's interpretation of 'dirty skank' gestures more towards the DIY, explicitly politicized appropriation of pastel colours and underwear-as-outerwear favoured within some 1990s third-wave feminist and Riot Grrrl movements. Olive's styling choices may suggest sexual experience and availability, but they also speak to middle-class aesthetic preferences – she is not, for example, peroxide blonde, deeply fake-tanned or sporting visible hair extensions. As her father notes, she may look like a stripper, but 'a high-end stripper, for governors or athletes' – and (post)feminist notions of empowerment through sexual display. Olive, therefore does not entirely sacrifice her cultural capital in her choice to be a 'dirty skank'.
20. Other examples of the centrality of sexual performance, particularly in terms of the social pressures to wear 'slutty' clothing, to representations of girls in contemporary American film include the makeover narratives in *Jawbreaker* (1999) and *The House Bunny* (2008); Cady's glaring contrast with the other girls' fancy dress costumes in *Mean Girls* (2004). To return briefly to *Crazy Stupid Love*, Jacob's conscious presentation of himself as a sexual object for the female gaze is so unusual in contemporary Hollywood as to be remarkable.
21. Karlyn, 'Film As Cultural Antidote', p. 463.
22. For useful discussions of the connection between the third-wave and postfeminism, see the 'Introduction' in *New Femininities: Postfeminism, Neoliberalism and Subjectivity*, ed. by Rosalind Gill and Christina Scharff (Basingstoke: Palgrave, 2011), pp. 1–20 (p. 3); Stéphanie Genz and Benjamin A. Brabon, *Postfeminism: Cultural Texts and Theories* (Edinburgh: Edinburgh University Press, 2009), pp. 156–165.
23. Katherine Farrimond, 'Bad Girls in Crisis: The New Teenage Femme Fatale' in *Women on Screen: Feminism and Femininity in Visual Culture*, ed. by Melanie Waters (Basingstoke and New York: Palgrave, 2010), pp. 77–89.
24. See, for example, Jessica Ringrose's discussion of teenage girls' Bebo pages, in which she suggests that such online spaces allow 'increasingly normalized hypersexualized and pornified discourses and visual imagery [to] circulate rapidly', and condemns the growing pressure for teenage girls to perform explicit sexuality in these online spaces. Jessica Ringrose, 'Are You Sexy, Flirty, Or A Slut?: Exploring "Sexualization" and How Teen Girls Perform/Negotiate Digital Sexual Identity on Social Networking Sites' in *New Femininities: Postfeminism, Neoliberalism and Subjectivity*, ed. by Rosalind Gill and Christina Scharff (Basingstoke: Palgrave, 2011), pp. 99–116 (p. 101); See also Andrea L. Press, 'Feminism and Media in the Post-feminist Era', *Feminist Media Studies*, 11:1 (2011), pp. 107–113.

4
The Girls of Zeta: Sororities, Ideal Femininity and the Makeover Paradigm in *The House Bunny*

Joel Gwynne

The reconstruction of femininity has become one of the dominant themes of popular culture in the twenty-first century, and nowhere is this more evident than in the prolificacy of makeover narratives in postfeminist media culture. Stéphanie Genz and Benjamin A. Brabon have located the emergence of the makeover paradigm as a 'crucial feature of postfeminism whereby the "idiom of reinvention" can be applied to every aspect of our social world'.[1] Brenda Weber has noted the specifically gendered audience of makeover narratives, positioning them as a 'mainstay of advice columns and entertainment literature targeted at women'.[2] While Weber emphasizes the marketing strategies that media cultures employ when extolling the makeover paradigm as an empowering force that affirms 'the pleasures and possibilities of transformation, rejuvenation, and alteration for everyone',[3] Estella Tincknell illustrates the problematic relationship between female agency and reconstructions of femininity:

> Perhaps it should not be surprising that the achievement of a limited social and political autonomy in the twenty-first century for (admittedly, mainly white, middle-class, Western) women has been paralleled by a renewed discursive emphasis on femininity as a pathological condition, this time recast as a relentless drive for physical perfectibility.[4]

Understood in this context, postfeminist female agency is contingent upon adhering to a particularly specious form of feminine desirability enacted by and through the makeover paradigm. The makeover

experience can, therefore, be positioned as not only insidious on its own terms, but even as emblematic of the 'profoundly toxic character of neoliberalism's recuperation of feminism', most apparent in the television makeover genre that 'promises to make women look better while making [them] feel worse'.[5]

The makeover paradigm can be understood as toxic due to both its promises of (false) empowerment and its ubiquity. Makeover narratives emerged in the genre of the feature film long before the popularization of reality television programmes such as *10 Years Younger* (2004–2008), for both classical Hollywood cinema (*Now, Voyager* [Rapper, 1942]; *My Fair Lady* [Cukor, 1964]) and more recent productions (*Pretty Woman* [Marshall, 1990]; *She's All That* [Iscove, 1999]) bear witness to the longevity of the commercial construction of the makeover as a 'liberating' process. Makeover narratives retain enduring appeal largely due to their formulaic patterns, and Sarah Gilligan defines these narratives as repetitive constructs characterized by 'the make-under, the makeover, and the final revelation/affirmation', transformations through which the female protagonist will 'achieve social mobility, popularity, and the "prize" of (a new or rekindled) heterosexual romance'.[6] The mere fact that makeover narratives perpetually focus on centralizing feminine transformation as a means of attracting male attention ensures that the dominant genre of makeover cinema is the chick flick, in which self-reinvention often occurs at the expense of feminist agency. As Suzanne Ferriss notes: 'makeover films are a dependable subgenre of chick flicks, where superficial external changes are signs of an internal moral transformation' in which the female protagonist 'admits she needs love and companionship despite her apparent commitment to social and intellectual independence'.[7] Makeover films thus occupy a contentious and contradictory space that is conspicuously postfeminist in its mobilization of notions of empowerment through consumption, fun and female friendship, while simultaneously espousing conventional – if not reactionary – gender regimes.

This chapter discusses one particular film in the genre of teen romantic comedy, *The House Bunny* (Fred Wolf, 2008), and considers how its constructions of femininity and fashion intersect with popular culture, consumerism and postfeminist rhetoric. *The House Bunny*, I argue, centralizes the makeover paradigm as crucial to the development of a new, ideal feminine/feminist subjectivity that repudiates not only many of the core tenets of second-wave feminist politics but also popular conceptualizations of postfeminist sexual empowerment and 'raunch culture'. In particular, this chapter will demonstrate how the film constructs

young women's complicated engagement with feminist history, tenta-
tively positioning desirable feminine identity as one posited between
the asexual and hypersexual extremes embodied in popular culture's
representation of second-wave and postfeminist identities respectively.
Prior to doing so, however, the chapter will first contextualize the rela-
tionship between postfeminism as a cultural condition and the emer-
gence of new femininity, the latter a central component of makeover
narratives.

New femininity and contesting feminisms

If the makeover paradigm is synonymous with chick flicks and
postfeminism as a cultural condition, then it is perhaps not surprising
that, given the widely documented relationship between postfeminism
and 'Girl Power', constructions of new femininity often emerge in the
context of chick flicks specifically aimed at a female teenage demo-
graphic. Sarah Projansky notes incisively that 'the current proliferation
of discourse about girlhood literally coincides chronologically with the
proliferation of discourse about postfeminism',[8] and *The House Bunny*
affirms contemporary Hollywood cinema's fascination with girlhood as
a potentially powerful site of feminine agency. In fact, the film begins
with direct reference to the agentic potential of transformation, for the
audience first meets the protagonist, Shelley Darlington (Anna Faris),
as an unattractive child growing up in an orphanage. After the onset
of puberty, however, Shelley transforms into a desirable young woman,
begins her modelling career and eventually gains entry into the Playboy
Mansion. Now living with an ersatz family network for the first time in
her life, beauty is thus positioned as the means to attain love and social
acceptance.

Yet, Shelley is forced to leave the mansion on her 27th birthday –
considered too old to be a Playboy bunny – and finds an alternative
home and role as housemother to Zeta Alpha Zeta, an ostracized college
sorority populated by young women who identify as feminists. Through
the representation of Shelley's Playboy bunny persona, the film not
only positions youth culture, hypersexuality and anxieties surrounding
female ageing as central to the narrative, but in doing so also provides a
framework for examining the relationship between new femininity and
the sexualization of Western cultures. In the construction of the Zeta
sorority as antithetical to new femininity, the film provides avenues
for the exploration of alternative forms of feminine/feminist identity,
especially for young women who choose to repudiate postfeminism's

summoning of sexualized femininity as a form of liberation. This pursuit of new expressions of female subjectivity is the central source of the film's humour, and if postfeminism can be defined as a process in popular culture in which 'the feminist gains of the 1970s and 1980s are actively and relentlessly undermined' while 'appearing to be engaging in a well-informed and even well-intended response to feminism',[9] then *The House Bunny's* utilization of comedy is important. As humour often serves to 'indicate points of acute cultural uncertainty or difficulty',[10] it is through comedy – and most notably irony – that the film positions new femininity as a problematic site of both empowerment and disenfranchisement. Prior to exploring the manner in which the film employs comedy to negotiate new femininity through the makeover paradigm, it is important to locate the emergence of this new conceptualization of female identity in both popular culture and scholarship.

In *Reclaiming the F Word* (2010), Catherine Redfern and Kristin Aune comment that 'Many cultures now assume that something is fundamentally wrong with the natural female body and that women are duty-bound to reshape [themselves]'.[11] In accordance with longstanding narratives that inculcate the importance of female desirability, the global media in recent years has employed the makeover narrative to further entrench the notion that female desirability is a goal to be relentlessly pursued. As Hilary Radner decrees, this process of 'becoming' feminine is framed by postfeminist media culture as a form of liberation, inviting women to reject the notion of a 'stable, untested and fixed' self and embrace female identity as 'subject to a multiple and on-going process of revision, reform and choices'.[12] This is precisely why the agency of the postfeminist female subject is always contingent upon commercial consumption, and in her now canonical thesis statement Rosalind Gill declares that 'the autonomous, calculating self-regulating subject of neo-liberalism bears a strong resemblance to the active, freely choosing, self-reinventing subject of postfeminism'.[13] New femininity can therefore be recognized as a form of empowerment enacted by the financially emancipated neo-liberal consumer-citizen through a self-regulation and self-presentation/ objectification of the body, which ultimately serves to reconfigure traditional femininity. As Yael Sherman notes, if traditional femininity connotes sex object, then new femininity 'connotes competent subject', and if 'traditional femininity is associated with the sin of vanity', then neo-liberal femininity 'implies that one is actively self-responsible'.[14]

Scholars have placed new femininity at the centre of the sexualization of Western cultures, with Feona Attwood declaring that '[d]iscourses

of sexual agency have been seen as central to the development of new femininities, part of a broader shift in which "older" markers of femininity, such as homemaking skills and maternal instincts, have been joined by those of image creation, body work and sexual desire'.[15] New femininity can thus be understood as a subversive subject position in its ostensible rejection of the passivity and dependence associated with traditional femininity. Yet, it is important to emphasize that this positioning ultimately represents modification rather than repudiation. Shelley Budgeon observes that even though 'women must be assertive, autonomous, and self-determining' under neo-liberalism, they 'must also retain aspects to traditional femininity, including heterosexual desirability and emotional sensitivity to others'.[16]

In *The House Bunny*, the ideal feminine subject is negotiated between the contested extremes of, on the one hand, a postfeminist hypersexualized 'raunch culture' and, on the other, a distinctly stereotypical, pleasure-denying feminist identity. The film begins by appearing to celebrate the contemporary United States as a 'post-feminist' space in which feminism is unnecessary and women are financially and sexually empowered. The film's exposition locates the Playboy Mansion as a site of sisterhood, presenting those who populate it as somatically and emotionally fulfilled by a lifestyle centred on friendship, sexual visibility and pleasure. In a display of postfeminist sisterhood now ubiquitous in contemporary Hollywood cinema, the audience witnesses a montage of consumptive empowerment in which Shelley and her bunny friends indulge themselves with treatments in a hair salon, perform group exercise together, and are photographed by paparazzi while shopping. All three scenes express the notion that a sexualized feminine identity is liberating and pleasurable, even if sustaining one requires (1) financial resources and capital, (2) perpetual self-discipline and (3) constant media visibility. For Shelley, the exigencies of 'new femininity' are not difficult to overcome, for her identity as a Playboy bunny facilitates all three. Her materialistic lifestyle is supported by the global Playboy brand and her no-expenses residence in Hugh Hefner's mansion, yet this position of financial liberation is dependent upon disciplined body management to ensure that she remains sexually attractive and media visible to the brand's consumers. Her lifestyle is in many ways highly limiting – perhaps an example of what Diane Negra and Yvonne Tasker have termed 'silent visibility'[17] – and Shelley is indicative of postfeminism's recuperation of 'the woman as pinup, the enduring linchpin of commercial beauty culture' who offers 'new rationales for guilt-free consumerism, substantially reenergizing beauty culture'.[18]

Given the narrow terms of postfeminist empowerment – further suggested by Negra and Tasker's view that postfeminism is, as typified by Shelley, 'white and middle class by default'[19] – it is hardly surprising that the Playboy bunny figure has been reclaimed from the territory of second-wave derision and reinscribed as a symbol of postfeminist agency. Negra has shrewdly observed that postfeminism 'revives the "truths" about femininity that circulated in earlier eras – women are bitches, golddiggers, "dumb blondes", spinsters, shrews and sluts'[20] as a means of asserting women's political and rhetorical 'freedom' from the alleged political correctness of second-wave feminism. In *The House Bunny*, Shelley's occupation of the 'dumb blonde' stereotype is never truly deconstructed – although this comes into focus at the end of the film – for her lack of intelligence is perceived to be irrelevant, its significance negated by the myriad other ways in which she empowers herself. As Genz and Brabon make clear, in postfeminist culture women's empowerment is 'directly linked to their feminine identities and their ability to redefine the meanings of and objects related to femininity'.[21] In this climate, intelligence is deemed inconsequential, and does not take precedence over other forms of empowerment. This is apparent in Shelley's juxtaposition with the young women of Zeta, who are them-selves constructed as conforming to a number of derogatory stereotypes surrounding second-wave feminism. This construction is illustrated in many ways, most obviously through attire. The women of Zeta are presented as bookish, wearing pencil skirts and long grey cardigans. Natalie (Emma Stone) conforms to the stereotype of the librarian, wear-ing black thick-rimmed glasses with her hair styled in a high ponytail, while Carrie May (Dana Goodman) is incredibly tall, broad-shouldered, uncommonly strong and never wears deodorant. The character of Mona (Kat Dennings) conforms to feminist stereotypes not only through her rejection of femininity – short hair, no make-up and multiple facial piercings – but also in her politics, referring to Shelley as an 'archaically superficial reflection of the male fantasy'.

It is unclear whether the Zetas are alienated by their peers and unpop-ular on campus due to their intelligence and feminist identities or if, conversely, it is their unpopularity as individuals that has driven them to pursue alternative forms of female identity and sisterhood. Whichever it may be, the film makes it clear that feminism and popularity are mutually exclusive in youth culture. Indeed, due to this unpopularity – 'We get no pledges, and everyone kind of thinks we're losers' (Natalie) – the Zetas are in danger of losing their house if they do not transform and win more pledges. By placing feminist identities on the periphery of

youth culture, the film engages with an important question implicitly raised by Harmony (Katherine McPhee): 'So in order to be in a sister-hood, now we have to be popular?' The film suggests that an articulation of many of the fundamental values of second-wave feminism is highly unpopular in postfeminist culture, simply because contemporary sister-hood is constructed as predicated on shared female pleasure through the cultivation of a sexualized feminine identity. This is demonstrated most conspicuously when Shelley and Natalie conceive of ways to win the attention of pledges. While Natalie suggests that popularity and social acceptance can be attained through holding either a 'Palaeolithic bake sale' or 'starting a beekeeping club', Shelley – 'an expert at parties and boys' – suggests something 'a little more sexy'. Shelley is aware that the process of becoming popular in youth culture requires women to demonstrate an active sexuality and, accordingly, she proposes a Zeta House Car Wash. As a former Playboy bunny, Shelley feels entirely comfortable washing a car semi-naked, yet the manner in which she encourages the Zetas to join in is highly ironic: 'Wash these cars you sexy bitches! They are filthy and so are you.' In an allusion to porn cul-ture – in which female sexuality is relegated to the space of dirt and transgression – Shelley's words represent both complicity and critique; conforming to the limiting sexualized role young women often per-form in order to gain social acceptance while remaining critical of this strategy through parodic (over)performance.

In their response to Shelley's car wash, the Zetas corroborate stereo-types surrounding second-wave feminism. Mona declares, 'Did she just call us bitches?', while Tanya (Kimberly Makkouk) states incredulously, 'Did she just call us sexy?' In the suggestion that the Zetas' feminist prin-ciples ensure hostility towards, and astonishment at, being perceived as sexual, the film affirms Imelda Whelehan's observation that popular culture locates feminism as the 'preserve of only the unstable, mannish, unattractive woman who has a naturally difficult relationship to her own femininity'.[22] Entrenching this stereotype, *The House Bunny* makes perpetual reference to the Zetas' alienation from their bodies and their lack of sexual subjectivity. After witnessing Shelley emerge completely naked from the shower, Natalie comments: 'I don't think some of the girls in this house have even seen their own bodies naked, so they prob-ably don't wanna see your perfectly engineered boobs.' Likewise, when taking part in a karaoke competition – encouraged by Shelley as 'Boys like singing. It's sexy' – the Zetas perform Madonna's 'Like a Virgin'.

The representation of the Zetas can therefore be seen as part of a wider paradigm in postfeminist culture whereby political feminism is

perniciously misrepresented, and this hostility towards feminism is also perceptible in the way the film approaches subjects such as date rape and sexual assault. In a scene at the beginning of the film, the in-house bartender at the Playboy Mansion comments to Shelley, 'I actually added something to your orange juice.' A cocktail aficionado, Marvin is referring to vanilla extract, yet Shelley misunderstands and assumes he means a date rape drug such as the muscle relaxant Rohypnol: 'Oh Marvin, thank you so much for telling me. I usually don't find out until much later.' Shelley's blasé response to sexual assault is also illustrated in a later scene, in which she is apprehended by a police officer for unlawful spitting. The police officer assumes she is drunk, and asks her to blow on a breathalyser. Shelley misunderstands, believes the officer wants oral sex and lowers her head down to his waist. Shelley thus shows herself to be highly submissive to institutional authority – 'I was just doing what he said. He was in a uniform and everything' – and her frivolous response to issues surrounding the abuse of women by the state's institutional apparatus can be read as a further indication of the film's distancing from feminist politics. This refusal to take core feminist issues seriously can perhaps be attributed to popular culture's positioning of intelligent and serious women – invested in public and political affairs – as intensely unattractive. As Shelley is conventionally beautiful, she is thus positioned as a polar opposite within this logical economy, as mindless and politically disengaged. Thus, in order for the Zetas to gain popularity, they seek to become like Shelley by rejecting their androgynous and asexual identities, as well as their intelligence and political sensibilities. The makeover paradigm becomes, over the course of several scenes, central to this process of postfeminist disavowal.

Makeover, make-under: From feminism to new femininity

The feminist sensibilities of the Zetas are not only oppositional to Shelley's Playboy persona but also to the sensibilities of Phi Iota Mu, a more popular sorority who 'have great parties' and who 'boys actually like'. Shelley is tasked with the job of making the Zetas worthy competitors, and is in the perfect position to function as a mentor capable of propelling the Zetas towards an embracement of new femininity and social acceptance: 'We need 30 pledges and I know how we can do it . . . By making you guys the hottest girls on campus.' While the use of 'guys' to denote girls may be deliberate – perhaps another allusion to the Zeta's alienation from femininity – it is also representative of the manner in which 'guys' has become colloquially deployed as term that

represents 'everyone', implying that in order for women to be taken seriously in postfeminist culture they must become 'one of the guys'. Even though the film's makeover narrative serves to enact the Zetas' transition from androgyny to femininity, it also serves to construct them as 'one of the guys' by endorsing the visual presentation of the body as a marker of constant sexual availability. The first step in this process involves Shelley convincing the Zetas that their bodies should function as sites of male attention, and that this self-objectification is central to emotional well-being. While the Zetas are initially resistant, Shelley persuades by espousing the neo-liberal rhetoric of new femininity: 'Feeling good on the inside is all about looking good on the outside.' She validates the contradictory logic of the makeover narrative in which the recognition of a more 'authentic' self requires the elision of the natural body. In this conceptualization of selfhood, the natural body is pathologized as a barrier to women's emotional fulfilment.

The logic of the makeover narrative is grounded in the assumption of a troubling division between self and body which can be rectified through both hard work and compliance to an external expert. In the context of *The House Bunny*, the Zetas' journey to social acceptance is entirely dependent on acquiescing to Shelley's expert advice, yet what is perhaps most interesting is the manner in which this dependency is reinscribed as independency. Stéphanie Genz comments that, 'women seeking cosmetic surgery are portrayed as "enterprising" selves who are engaged in a project of self-realization and actively use their determination to change their bodies and improve their lives'.[23] This is precisely why many sequences in the film reiterate the message that while the Zetas do ultimately submit to conventional standards of feminine beauty, they do so in a manner that is both pleasurable and socially advantageous. A submission to the rigours of the makeover process is valorized as a temporary sacrifice performed in order to secure more tangible, long-term rewards. This sacrifice involves dramatically modifying appearance, lifestyle and value systems. As Weber points out, makeover narratives promote the idea that 'to be unique and special, one must look and act like everyone else',[24] and *The House Bunny* affirms this by forcing the Zetas to perform modes of display which correspond with postfeminist 'raunch culture' and are adversative to their own politics. As part of the Zetas' 'training', Shelley instructs, 'We need to get all dressed up, and then we need to go to a club, and drink fruity drinks and dirty dance with each other.' When Mona asks why, Shelley responds: 'To bond, y'old grumpy!' Shelley's vision of sisterhood

constitutes little more than developing friendship and female collaboration in the sexual presentation of the body, while Mona's resistance to this form of 'empowerment' once again corroborates her role as a feminist intent on spoiling the party.

In order to understand the complicity of the film's makeover paradigm in the construction of 'raunch culture', it is important to centralize both the term and critical responses to it. While Ariel Levy has situated 'raunch culture' in the milieu of postfeminist backlash – 'embracing raunch so casually is a way for young women to thumb our noses at the intense fervor of second-wave feminists'[25] – the term is also understood as part of a wider paradigm pertaining to the sexualization of Western cultures and the mainstreaming of the sex industry. Commentators and critics such as Natasha Walter, Feona Attwood and Brian McNair have written extensively on the subject, and concerns surrounding the 'pornografication' of cultures are crystallized by Katherine Kinnick's observation that 'the line between pop culture and porn culture is blurring, as the sexual themes, language, and production techniques that have made porn a multi-billion dollar industry are increasingly, and intentionally, cropping up in mainstream music, movies, TV and video games'.[26] Even though *The House Bunny's* makeover narrative is in many ways conventional – centralizing the transformation to femininity through manicure, pedicure, hair styling and lessons in applying cosmetics – it also pursues a more sexualized agenda. Shelley commands the Zetas to 'show skin in the four major regions: Arms, legs, belly and cleavage', and declares that a woman's eyes are not the windows to her soul but are 'the nipples of the face', affirming a movement away from romantic to sexual scripts. Her comment that 'dressing sexy is all about skimplifying' can be understood in terms of critical responses to Hilary Radner's concept of a 'technology of sexiness'. For Radner, 'the task of the Single Girl is to embody heterosexuality through the disciplined use of make-up, clothing, exercise and cosmetic surgery, linking femininity, consumer culture and heterosexuality'.[27] Extending this argument, Laura Harvey and Rosalind Gill comment that 'heroines must no longer embody virginity but are required to be skilled in a variety of sexual behaviours and practices, and the performance of confident sexual agency is central to this technology of the self'.[28]

In *The House Bunny*, the requirement for the heroine to be sexual is most discernible through the transformation of Joanna (Rumer Willis). In an intertextual allusion to the film *Forrest Gump* (Zemeckis, 1994), Joanna – who wears a metal back brace due to a long-term injury despite

the fact that her injury has already healed – sees a man on whom she has a crush walking along the street. Inspired by Shelley's transformative dictum, 'You're a butterfly now, not an earthworm', Joanna runs after the man and a slow-motion sequence dramatizes the disintegration of the back brace to reveal her cleavage. The scene suggests that – due to Shelley's guidance and an adherence to the makeover paradigm – Joanne is now a sexually empowered woman who has discarded the restrictions imposed by her marginalized identity within the subordinate spaces marked 'disabled' and 'feminist', both of which are positioned as factors that denied the self-recognition of her beauty. In fact, by disavowing feminist politics and embracing the idealized female body, the makeover process undertaken by the Zetas wholeheartedly affirms postfeminist sexual visibility in a manner that appears to be thoroughly internalized by the women, demonstrated by Natalie's comment, 'So this is what it feels like not to be invisible.'

The transformation from second-wave politics to postfeminist sensibility is most noticeable in scenes showcasing the Aztec party, in which the Zetas attempt to gain popularity by demonstrating that they can be as wild as their competitors, Phi Iota Mu. The Aztec party also serves as a focal point in the narrative, demonstrating how Natalie's reconfiguration of femininity is essential to securing the affection of Colby (Tyson Ritter), her long-term love interest. At this point in the film, Natalie's appearance has entirely transformed, and she reveals skin in the 'four major regions' while dressed as an Aztec slave girl. Yet, significantly, the external makeover has yet to precipitate an internal makeover, and Natalie's intelligence and academic orientation prove to be obstacles in securing Colby's attention. After Natalie remarks that the 'Aztec' statues acquired by Shelley for the party actually originate from Easter Island, Shelley reminds her, 'You're too smart. Boys don't like girls who are too smart.' Natalie checks herself, commenting, 'I don't know anything about the Aztecs, you know, or their culture. But I know they had fun', demonstrating that within postfeminist culture an investment in pleasure is understood as the pre-eminent form of female empowerment. The scene underscores why many contemporary feminists locate postfeminism's celebration of hyperfemininity as particularly insidious. As Yael Sherman notes:

> If the performance of femininity requires one to hide intelligence and intention, then beauty will be associated with frivolous, seemingly stupid women. Beauty and intelligence become opposed through social interaction under these structural and cultural constraints. In other words, as some theorists argue, enacting femininity can work to reinforce women's subordinate and dependent status.[29]

The Aztec party thus marks, for the Zetas, not merely the enactment of femininity but an inversion of their entire feminist ethics. The party culminates in a ceremony of mock virgin sacrifice, and Natalie's submersion in lava jelly is symbolic of her repudiation of a sexually repressed and feminist former self and rebirth into postfeminist culture. It is clear, then, that what makes this transformation 'empowering' is the pleasure gained from winning social acceptance. The rejection of feminist sensibilities is therefore mobilized by the construction of second-wave feminism as negative and socially withdrawn, and postfeminism as pleasurable, confirming Kathrina Glitre's view that 'neoliberalism and the postfeminist sensibility encourage self-indulgent pleasure to be mistaken for empowerment, as if the mere fact that a woman enjoys doing something means this pleasure is, in some sense, "feminist" '.[30]

While this appears to be the ideological message of the Zetas' transformation, it is important to acknowledge that physical transformation 'completes' the Zeta women. Simply put, as women who were already intelligent, witty, amusing and kind, it only took a renovation of style and appearance to transform them into young women who the audience would be able to identify with as models of female power. Significantly, *The House Bunny* proceeds to emphasize – through the 'make-under' of Shelley – that the visual presentation of the self is most certainly *not* the only characteristic a woman needs in order to empower herself. An examination of Shelley's 'make-under' reveals the film's opposition to sexualized new femininity and its commitment to resolving some of the problems raised by postfeminism's positioning of physical transformation as constitutionally empowering in its own right.

To appreciate the film's problematizing of new femininity as liberating, it is necessary to contextualize the make-under narrative. In her discussion of Daisy von Scherler Mayer's *Party Girl* (1995), Suzanne Ferriss describes the deployment of the 'reverse-makeover' as 'the vehicle for the female character's moral development'.[31] In *The House Bunny*, the make-under serves to undermine the prescriptive forms of agency offered by sexualized new femininity, yet within a conventional framework that pursues heterosexual romance. While there remains no doubt in the mind of the audience regarding Shelley's morality – the film frequently underscores her acts of kindness – her lack of intelligence and inability to hold a conversation with Oliver (Colin Hanks), her love interest, suggests that the popularity afforded by her sexualized identity is not without consequence. Oliver is constructed as a well-educated, well-mannered and good spirited middle-class male, and his

occupation as the manager of a retirement home positions him as a caring, sensitive man far removed from mainstream hegemonic masculinity. While the sexualized identities that the Zetas adopt secure their popularity with frat boys on the college campus, Oliver is a man apart. When he and Shelley meet for a first date, she realizes that all of her 'tricks' have no effect, commenting: 'I don't think he likes me. I did sexy, I did other guys want me...I did every angle in the book.' Natalie responds, 'What if Oliver is, like, one of those guys who wants to have a conversation with a girl before he hooks up with her?', and Oliver's positioning as antithetical to conventional masculinity is illustrated by Shelley's response: 'He's gay?!' In order to attract Oliver, Shelley is forced to begin a process of intellectual transformation that requires not only a formal re-education but a physical make-under in which the Zetas desexualize Shelley's appearance. In doing so, the film reproduces the stereotype that intelligent women must present themselves as asexual and unattractive, yet it also recognizes the real-world limitations of postfeminist empowerment in which the presentation of a sexualized femininity is packaged as all a woman needs to be socially and professionally successful.

Gilligan observes that the make-under narrative 'plays an essential role in establishing the signifiers of dowdy and aberrant femininity', in which 'the subject begins as "madeup", before being "made-under" to appear more "natural" (and thus desirable)'.[32] Makeover and make-under narratives signify the precarious territory that young women occupy in attempting to navigate societal values that encourage sexual self-presentation but discourage the expression of sexual desire and sexual activity. While the Zetas were initially highly unpopular due to their lack of both femininity and sexual currency, Shelley is limited by her abundance of both. This is exacerbated by the fact that, unlike the Zetas, she does not possess the intellectual faculties to dilute and disarm her overt sexuality. She thus acquiesces to the academic guidance of the Zetas, and attends lectures on James Baldwin, John Cheever and Anton Chekhov after being encouraged to 'tone down the sexuality' and 'talk about politics and religion' when she next meets Oliver. Shelley's make-under requires her to dress conservatively – just as the Zetas did at the beginning of the film – and to memorize their perspectives on world affairs ('A nuclear non-proliferation treaty should ease tension in Asia'). Even though Shelley's transformation is unconvincing and unnecessary – she fails to impress Oliver on the second date, but wins his heart regardless through her enduring kindness – her desexualization within the narrative is a clear sign that the film is not, in fact, working towards a

celebration of postfeminist notions of empowerment, but rather towards the affirmation of a more substantial comprehension of sisterhood and agency.

Conclusion: Critiquing postfeminism, affirming sisterhood

Angela McRobbie astutely notes that, 'the new female subject is, despite her freedom, called upon to be silent, to withhold critique in order to count as a modern sophisticated girl'.[33] In lieu of the critiquing female subject, the pervasive mode of irony within *The House Bunny* functions to emphasize the limitations of young women's empowerment while appearing to celebrate and support a reactionary status quo. The film makes this point on many occasions – both implicitly and explicitly – in its construction of new femininity. At the start of the film, Shelley reflects on her aspiration to become a Playboy centrefold: 'Being a centerfold is the highest, most prestigious honour there is. It says, "I'm naked in the middle of a magazine... Unfold me"'. Shelley's hyperbole encourages the audience to trivialize and ridicule her values and ambition, and by extension offers a critique of the manner in which young women are sold the notion that the sexual presentation of the self is the highest accolade a woman can hope to attain. This critique of the commodification of women's sexuality can be paralleled with the film's critique of consumption as women's primary route to empowerment. At one point in the narrative, we witness Shelley and her playmate friends selecting dresses in a prestigious boutique. The cashier charges the clothes to the Playboy Mansion tab, to which Shelley declares: 'Aren't we just the luckiest girls in the whole world?' The cashier's response is affirmative, but expressed in a tone of pity and sadness. From this scene, the audience is once again not encouraged to celebrate Shelley's lifestyle, but rather to trivialize it and share, with the cashier, an acute awareness of the conditional terms of such empowerment.

The film's critique of the positioning of women's agentic powers as premised upon and enabled by the consumption of products and services – especially those frequently associated with femininity/ sexuality – can also be paralleled with a more prominent critique of the exclusive nature of postfeminism as 'white and middle class by default'[34] and localized in youth culture. Illustrating the temporal agency of new femininity, Sarah Hentges comments that when young, Caucasian women become '40-year-olds with diluted "girl power" [...] and still lack a sense of self, voice, confidence and identity, where are they to find these things?'[35] *The House Bunny* asks a similar question, for while

Shelley's appearance bestows financial and social rewards this comes to an end when she turns 27 or, as another character states, '59 in Bunny years'. The temporality of youth and beauty as forms of empowerment are visible when Shelley leaves the Playboy Mansion and is forced to return all company property, including her pink Toyota Prius. The scene in which Shelley drives away from the mansion in a brown station wagon is emblematic of the manner in which any deviation from the implied mandates of glamour modelling results in financial disenfranchisement to those invested in the industry. By the close of the film, this message is explicitly stated, with Shelley declaring, 'If one day when your looks have gone, if everything you have is based on looks then, well, you've got nothing.' Thus, while *The House Bunny* appears to be thoroughly committed to mobilizing the notion that new femininity is woman's primary mode of agency, it remains attentive to the real-world limitations of this conceptualization.

Connected to this idea is the film's critique of new femininity as disempowering to those who fall outside of the dominant culture's narrow parameters of beauty. This is most apparent at the close of the film after the Zetas have attained popularity as a consequence of their physical transformation. Now in a position to be highly selective regarding who joins their sorority, their selection process involves deriding the appearance of applicants, as demonstrated by Harmony: 'I just don't know about this one. I kind of feel we've created this image. I just don't feel like she's gonna fit in.' After Lilly (Kiely Williams) highlights the negative effects of their physical transformation – 'I can't believe Zeta's become just like Phi Iota Mu' – the women turn on Shelley, Dr Frankenstein to their postfeminist monster: 'You've turned us all into stupid bimbos!' The film therefore reifies a positive message: that while reclaiming femininity may result in social gains, it comes at the expense of more inclusive notions of sisterhood.

The implications of this are important. Christina Scharff has observed that, 'new feminisms do not sufficiently interrogate the social constellations that initially gave rise to the felt need for a new feminist politics',[36] while Diane Richardson similarly locates postfeminism as 'feminism without the politics'.[37] Furthermore, Genz and Brabon have commented that the new feminist as popularized in postfeminist media culture is not presented as a 'politically active individual',[38] but rather as a professional woman interested in nothing except designer clothes and taking care of her body. The young women in *The House Bunny* appear to confirm such observations, yet the film's critique of new femininity,

postfeminism and 'raunch culture' signals the role of popular cinema in feminist consciousness-raising. The film's movement between celebrating and repudiating postfeminism creates a textual ambiguity that forces the audience/critic to pay close attention to the narrative denouement for a resolution of this uncertainty. It is therefore important to close this chapter by asking a crucial question: 'To what extent does *The House Bunny* actually validate sensibilities that could be positioned as feminist?'

While it would, perhaps, be too ambitious to declare that *The House Bunny* promotes a philosophy that comprehensively affirms the tenets of third-wave feminism, it does nevertheless promote a number of positive values that are discursively congruent with the third-wave's understanding of feminism. At the end of the film, the Zetas recognize the importance of not only sisterhood and individuality, but also balance the rewards of new femininity against the limitations of consumerism and sexual visibility. While declaring that 'Zeta was founded on the tenets of sisterhood, friendship and philanthropy', they affirm the third-wave's centralization of hedonistic pleasure by '[adding] kick ass parties to the list'. In their desire to be 'half Shelley, and half who we really are', the Zetas comprehend the empowering possibilities of new femininity while retaining feminist values at the core of their personal philosophies. Most striking of all, however, is the manner in which *The House Bunny* ends with a clear rebuke of postfeminist media culture. Offered the opportunity to become 'Miss November' on the condition that she returns to the Playboy Mansion, Shelley rejects the proposal, stating 'I can't leave my Zeta girls.' In choosing to remain with the Zeta sisterhood at the expense of financial reward and media visibility, both Shelley and the film promote female fellowship as the primary route to agency. If 'neo-feminism' is often understood as following a trajectory that circumscribes the 'individualist and rationalistic agenda of neo-liberalism',[39] then *The House Bunny* refreshingly infuses 'traditional' feminist values into this conceptualization.

Notes

1. Stéphanie Genz and Benjamin A. Brabon, *Postfeminism: Cultural Texts and Theories* (Edinburgh: Edinburgh University Press, 2009), p. 127.
2. Brenda Weber, *Makeover TV: Selfhood, Citizenship and Celebrity* (Durham, NC and London: Duke University Press, 2009), p. 1.
3. Ibid.
4. Estella Tincknell, 'Scourging the Abject Body: Ten Years Younger and Fragmented Femininity under Neoliberalism', in *New Femininities: Postfeminism,*

Neoliberalism and Subjectivity, ed. by Rosalind Gill and Christina Scharff (Basingstoke: Palgrave Macmillan, 2011), p. 83.

5. Ibid.
6. Sarah Gilligan, 'Performing Postfeminist Identities: Gender, Costume and Transformation in Teen Cinema', in *Women on Screen: Feminism and Femininity in Visual Culture*, ed. Melanie Waters (Basingstoke: Palgrave Macmillan, 2011), p. 167.
7. Suzanne Ferriss, 'Fashioning Femininity in the Makeover Flick', in *Chick Flicks: Contemporary Women at the Movies*, ed. by Suzanne Ferriss and Mallory Young (London and New York: Routledge, 2008), p. 41.
8. Sarah Projansky, 'Mass Magazine Cover Girls: Some Reflections on Postfeminist Girls and Postfeminist Daughters', in *Interrogating Postfeminism: Gender and the Politics of Popular Culture*, ed. by Diane Negra and Yvonne Tasker (Durham, NC: Duke University Press, 2007), p. 42.
9. Angela McRobbie, *The Aftermath of Feminism: Gender, Culture and Social Change* (London: Sage, 2009), p. 11.
10. Yvonne Tasker, 'Enchanted (2007) by Postfeminism: Gender, Irony and the New Romantic Comedy', in *Feminism at the Movies: Understanding Gender in Contemporary Popular Cinema*, ed. by Hilary Radner and Rebecca Stringer (London and New York: Routledge, 2011), p. 73.
11. Catherine Redfern and Kristen Aune, *Reclaiming the F Word: The New Feminist Movement* (London: Zed Books, 2010), p. 24.
12. Hilary Radner, *Neo-Feminist Cinema: Girly Films, Chick Flicks and Consumer Culture* (London and New York: Routledge, 2011), p. 6.
13. Rosalind Gill, 'Postfeminist Media Culture, Elements of a Sensibility', *European Journal of Cultural Studies*, 10:2 (2007), p. 157.
14. Yael D. Sherman, 'Neoliberal Femininity in Miss Congeniality', in *Feminism at the Movies: Understanding Gender in Contemporary Popular Cinema*, ed. by Hilary Radner and Rebecca Stringer (London and New York: Routledge, 2011), p. 82.
15. Feona Attwood, 'Through the Looking Glass?: Sexual Agency and Subjectification Online', in *New Femininities: Postfeminism, Neoliberalism and Subjectivity*, ed. by Rosalind Gill and Christina Scharff (Basingstoke: Palgrave Macmillan, 2011), p. 203.
16. Shelley Budgeon, *Third Wave Feminism and the Politics of Gender in Late Modernity* (Basingstoke: Palgrave Macmillan, 2011), p. 54.
17. Diane Negra and Yvonne Tasker, 'Feminist Politics and Postfeminist Culture', in *Interrogating Postfeminism: Gender and the Politics of Popular Culture*, ed. by Diane Negra and Yvonne Tasker (Durham, NC: Duke University Press, 2007), p. 3.
18. Ibid.
19. Ibid., p. 2.
20. Diane Negra, *What a Girl Wants?: Fantasizing the Reclamation of Self in Postfeminism* (London and New York: Routledge, 2009), p. 10.
21. Genz and Brabon, p. 77.
22. Imelda Whelehan, *Overloaded: Popular Culture and the Future of Feminism* (London: The Women's Press, 2000), p. 18.
23. Stéphanie Genz, 'Under the Knife: Feminism and Cosmetic Surgery in Contemporary Culture', in *Women on Screen: Feminism and Femininity in Visual Culture*, ed. Melanie Waters (Basingstoke: Palgrave Macmillan, 2011), p. 129.

24. Weber, p. 3.
25. Ariel Levy, *Female Chauvinist Pigs: Women and the Rise of Raunch Culture* (London: Pocket Books, 2006), p. 74.
26. Katherine N. Kinnick, 'Pushing the Envelope: The Role of the Mass Media in the Mainstreaming of Pornography', in *Pop-Porn: Pornography in American Culture*, ed. by Mardia J. Bishop and Ann C. Hall (Westport, CT: Praeger Publishers, 2007), p. 7.
27. Hilary Radner, 'Queering the Girl', in *Swinging Single: Representing Sexuality in the 1960s*, ed. Hilary Radner (Minnesota: Minnesota University Press, 1999), p. 15.
28. Laura Harvey and Rosalind Gill, 'Spicing it Up: Sexual Entrepreneurs and The Sex Inspectors', in *New Femininities: Postfeminism, Neoliberalism and Subjectivity*, ed. by Rosalind Gill and Christina Scharff (Basingstoke: Palgrave Macmillan, 2011), p. 56.
29. Sherman, p. 82.
30. Kathrina Glitre, 'Nancy Meyers and Popular Feminism', in *Women on Screen: Feminism and Femininity in Visual Culture*, ed. Melanie Waters (Basingstoke: Palgrave Macmillan, 2011), p. 28.
31. Ferriss, p. 41.
32. Gilligan, p. 169.
33. McRobbie, p. 18.
34. Negra and Tasker, p. 2.
35. Sarah Henteges, *Pictures of Girlhood: Modern Female Adolescence on Film* (Jefferson, NC: McFarland, 2006), p. 10.
36. Christina Scharff, 'The New German Feminisms: Of Wetlands and Alpha Girls', in *New Femininities: Postfeminism, Neoliberalism and Subjectivity*, ed. by Rosalind Gill and Christina Scharff (Basingstoke: Palgrave Macmillan, 2011), p. 265.
37. Diane Richardson, *Rethinking Sexuality* (London: Sage, 2000), p. 7.
38. Genz and Brabon, p. 68.
39. Radner, 2011, p. 9.

5
Ageing Appropriately: Postfeminist Discourses of Ageing in Contemporary Hollywood

Imelda Whelehan

In this chapter, I will explore how Hollywood represents older women, faced as they are with the presence of some formidable ageing stars and with the growing awareness that mature women make up a significant part of the audience demographic. Mindful of E. Ann Kaplan's assertion that 'it is in the interest of patriarchal culture to keep alive the myth that, after menopause, women have no particular function and therefore can be passed over for young women who still depend on men',[1] I will consider the combined impact of ageism and sexism in film in the context of popular postfeminist discourses of ageing.

Postfeminist discourse has little to say about ageing, focusing as it does on the 'girl' and the girling of popular culture, but as Diane Negra avers, it 'thrives on anxiety about aging'.[2] Such discourses seem to celebrate older women, especially those high-profile celebrities who work, have children and command large salaries; but they are most valued when they maintain a grasp on their youthfulness. Celebrity magazines encourage surveillance of the female body, just as reality TV shows such as *10 Years Younger* imply that the pursuit of youth is a social obligation for women. Terms such as 'letting herself go' applied to women who look their age (or older) position visible ageing as deliberate neglect, as if careful husbandry can forestall these signs. Identifying and rendering abject those women who refuse to 'act their age' has become something of a sport: media-savvy audiences now possess the skills to easily spot cosmetic surgery or an airbrushed photograph. Women who were once cast as sex symbols are particularly vulnerable to ageist abuse: Madonna, now over 50, presents problems because her performances have always been and remain overtly sexual, yet, as is discussed in relation to older

women on screen, mature sexuality must remain within set parame-
ters. Madonna's performances and particularly continued crotch shots
have inspired disgust and the nickname 'The Vadge', both reducing
the star to her sexual parts and rendering them abject. Additionally,
non-airbrushed images of Madonna recently circulated online provoked
the worst kind of ageist trolling.[3] Sexualized performances that were
once seen as empowering and still inspire a new generation of fans are
now deemed grotesque, and this repulsion seems to lie in knowledge of
Madonna's real age rather than in the body she displays. Producers and
consumers of popular culture have reached a bizarrely schizophrenic
impasse in which older women rarely pass scrutiny because there are no
positive meanings that reconcile post-menopausal women to the body;
the numerical fact of their age generally renders them not fit to be seen.
Ageing stars are implicitly exhorted to leave their 'sexiness' at the door
of menopause or face ageist slurs.

The culture of youthfulness pervades Western media and has done so
since at least the early twentieth century. Significantly, it has shaped the
film industry since its inception. As Heather Addison notes, 'through-
out the late 1910s and 1920s, the popular press, including motion
picture fan magazines, consistently emphasized Hollywood's youthful-
ness'.[4] Youthful actors supported a film industry in its infancy, and
enhanced the sense of its newness and vitality; the large screen was not
kind to flaws and imperfections easily disguised in stage performance, so
a female actor's star could be falling by her mid-20s. This celebration of
youth and beauty generated an increasing interest in dieting, health and
even plastic surgery, so that early Hollywood 'became the lens through
which the desires of consumer culture were clarified and focused and the
most potent characteristic of that lens was youth'.[5] Needless to say, this
cult of youth specifically targeted women and heralded an increasing
medical discursive interest in the pathologization of age, resulting in
menopause becoming more closely associated with decline and decay,
and ageing represented as linked to loss: of power, beauty and sexuality.

In this chapter, I will explore the pathologization of age, as well as
the essentializing of women through a foregrounding of biological func-
tions, and a linking of such functions to behavioural and emotional
norms. I will concentrate on a selection of recent Hollywood movies,
moving from the depiction of the working mother, the post-menopausal
lover and the ageing 'chick'. For the purposes of brevity I shall not
explore depictions of old age in this chapter, though I have made some
allusions to this elsewhere.[6] Instead, I will focus on the period of time
when women slip into invisibility, and on actresses who in their youth

played lead dramatic/romantic roles. It is hard to attribute an exact age to this transition to aged invisibility, but it happens once reproduction is completed and/or menopause takes place; any time from the mid-30s to the post-50s. This issue of exact age and its representation on screen is further problematized through a Western cultural obsession that encourages women to look younger than they are, with the result that our 'actual' age has little to do with how we look. The widespread availability of cosmetic procedures, ranging from skin peels and Botox to more invasive surgery, makes it difficult for actors to age gracefully without such interventions as 'real' signs of ageing are consigned to the realms of the abject. I will argue that 'real' ageing is constantly under erasure in Hollywood, and it becomes increasingly difficult for older female actors to avoid being typecast as moms, sexless crones or cougars. I shall focus on a handful of films – *I Don't Know How She Does It* (Douglas McGrath, 2011), *Sex and the City 2* (Michael Patrick King, 2010) *It's Complicated* (Nancy Meyer, 2009) and *Mirror Mirror* (Tarsem Singh, 2012) with some reference to other films and actors.

At the current time there are a number of important, actively employed/media-visible women actors who began their careers in the 1970s and 1980s, such as Meryl Streep, Glenn Close, Helen Mirren, Sharon Stone, Susan Sarandon, Sigourney Weaver, Goldie Hawn, Diane Keaton, Sarah Jessica Parker and Kim Cattrell. Most of these stars are still considered bankable properties, but as post-reproductive women they are problematic romantic leads. In the case of Goldie Hawn and Diane Keaton, for instance, they have been playing 'older' women since *The First Wives' Club* (1996). Earlier in *Death Becomes Her* (1992), Meryl Streep and Goldie Hawn take an elixir of life to compete for the attentions of Ernest Menville (Bruce Willis) only to find that immortality leaves them grossly disfigured. Even when these powerful and successful women perform in leading roles, the process of ageing is inscribed upon their performance, often by sending up popular associations of ageing femininity with weight gain, unattractiveness, forgetfulness and shrewishness. Additionally, as Shelley Cobb observes, the careers of such stars are sometimes intertextually woven into films about women's generational conflict such as *Monster-in-Law* (Robert Luketic, 2005) or *The Devil Wears Prada* (David Frankel, 2006) to exploit tensions between old 'feminist' and new 'postfeminist' behaviours. As Cobb illustrates, 'the older actor's stardom is used as shorthand for a politicized and "outdated" mode of feminism that is based around the caricature of the career-obsessed and/or neurotic woman'.[7] Between post-reproductive years and old age lies a twilight period in Hollywood

where women's battles are focused primarily on their own imminent decline.

I shall explore how the notion of ageing is either foregrounded in the narrative or haunts it in some other way, and how its effects – both positive and negative – are a major preoccupation of women-centred films. In addition to exploring some enduring prejudices against the ageing woman, this chapter will show that the material presence of powerful women in Hollywood is effecting some positive changes which are part of postfeminist conceptions of power and choice, as well as testament to the legacy of feminist political lobbying. In addition to analysing visual representations of older women, I will interrogate the ways older women in film are used to focus on homosocial relationships, personal development, endurance and power. After analysing the selected films I will return to the problematic notion of postfeminist discourse and the difficulty, if not impossibility, of considering the figure of the ageing women within its compass.

Midlife bodies

Rose Weitz's empirical research into the portrayal of middle-aged women in Hollywood revealed that 'midlife women's bodies are more often displayed as objects of humour than as objects of desire'.[8] While she submits that films largely accept that midlife women should enjoy sex, she notes that this primarily occurs within committed relationships 'within "age-appropriate" couples, and among white, middle-class, slim women'.[9] Mature women of colour rarely feature at the centre of mainstream Hollywood films and the white women who continue to appear in top billing are, as Weitz implies, slim as well as suitably youthful in appearance. The mature female visage is not always an acceptable face on the large screen, particularly in film genres such as the romantic comedy as femininity is connoted by youthfulness, slenderness and girl-like freshness. Images of the young mother are at the boundaries of what is acceptable, not least because motherhood and sexuality, while inevitably linked, are symbolically incompatible. Post-motherhood and fertility there is only menopause, which brings with it images of loss (of fertility, sexual allure and libido) and decline (a health 'problem' that needs to be treated with invasive hormone therapy).

While men and women share physical marks of the transition from teenage to adulthood via the physiological signs of puberty, there are no landmarks of ageing for men quite as final and redolent with meaning as that of menopause. While there are medical explorations of

what happens to the ageing man, the notion of the 'male menopause' remains a recent invention, a concept which in film terms focuses on the trappings of the 'midlife crisis' – the use of Viagra and purchase of performance cars and motorbikes. 'Menopause' literally refers to the cessation of menstruation; what is interesting is how this medical fact and its accompanying and varying symptoms are interpreted. If 'menopause' for men means potential loss of sex drive and anti-monogamous identity quests, for women the losses are visibility in media images, medicalization of a normal physiological process, and being bombarded with advertisements which promise the reversal of visible signs of ageing, using youthful women to advertise them.

Third-wave feminists and other commentators on the second wave of feminism have identified a number of blind spots in feminism – including to race, class, motherhood and sexuality – but interestingly age is rarely specifically highlighted, despite the fact that some of its leading lights and progenitors, such as Simone De Beauvoir, Betty Friedan and Germaine Greer wrote about menopause and old age. While it is clear that feminism of the 1970s was a youthful movement, containing a majority of students and young women, more recently it is characterized as 'old' in terms of its ideas and its social currency, a view reinforced by that fact that the leading proponents of feminism's golden age are themselves entering old age or dying.[10] The theoretical position of second versus third-wave feminism as 'old' versus 'new', situates second wavers as clucky, interfering or judgmental; similarly postfeminist discourse is often cast as feminism's lightened-up other, able to celebrate its own contradictions and lock itself into the joys of mainstream culture and politics. Third-wave feminism's more youthful and playful self is cast in the light of unruly daughter to politically serious second-wave feminism. In this equation age detracts, spoils and scrutinizes whereas youth excites and restores. This construction of third-wave feminism as by definition young, raises questions about what will happen as this generation of feminists age. As Astrid Henry ponders, 'if Generation X feminists are no longer third wave once they reach thirty-five, what wave are they part of? Does aging make one second wave?'[11] Perhaps underlying the challenge to authority implied in the generational metaphors used to distinguish feminism's waves there is a fundamental fear of ageing, of becoming the feminist mother, that has yet to be fully explored.

As Kathleen Rowe Karlyn notes, 'age is a culturally created identity category that defines us, as well as a concept that applies to the entire lifespan. Yet, just as ideology applies the concept of race only to the

non-white, age belongs mainly to the old.'[12] As Karlyn further observes, age comes earlier and differently to women, but it is always associated with narratives of decline so that 'meaningful cross-generational conversation among girls and women has also been stymied by a massive set of cinematic conventions establishing mothers as having nothing to say'.[13] While older women potentially represent experience and knowledge in film, the silencing of the mother reveals ambivalence about baby-boomer women's empowerment through feminism, and disgust for or rejection of the mother's ageing body on screen (were it to be displayed or brought to the fore via sexual desire). This cinematic dynamic is analogous to the rejection of political feminism in postfeminist discourse.

Having it all?

Meryl Streep's portrayal of fashion magazine editor Miranda Priestly in *The Devil Wears Prada* (David Frankel, 2006) offers a potentially groundbreaking representation of a woman over 50 'wielding power while wearing wonderful clothes'.[14] A woman who, despite her Queen Bee appearance, gives Andy Sachs a foothold in the world of news journalism, and in the course of the film demonstrates the cost of high achievement for women in terms of perceptions of their femininity as mediated through ideals of successful marriage and socially functioning children. A more recent portrayal of high-flying financier Kate Reddy (Sarah Jessica Parker) in *I Don't Know How She Does It* (Douglas McGrath, 2011) takes the spectator into the home as well as the boardroom to show a working mother all too clearly torn between the public and private spheres. Kate Reddy is not only the Have It All but also the Do It All mum, a cause of wonderment among her peers; although it soon becomes clear that these expressions of disbelief are barely-concealed expressions of contempt at the perceived selfishness of Kate and the unnaturalness of her love for her work. The film does have a 'political' dimension in that the spectator leaves the cinema in no doubt that the world of work still constitutes a man's world where women have to fight tooth and nail, as individuals, for every small victory. Towards the end of the film it seems as if Kate has achieved her dream of the work/life balance when her boss accepts that she won't travel interstate on a weekend and that she must go and build a snowman with her daughter (as Philip French points out this is one moment of gender role reversal which recalls the scene when Mr Banks (David Tomlinson) goes off to fly a kite with his children in *Mary Poppins* (1964)[15]).

While the critiques of the patriarchally defined world of work are hard to ignore in *I Don't Know How She Does It*, they are also safely cordoned off from the narrative proper into freeze-frame monologue. Most of these monologues are performed by Kate herself, her women friends, or (for maximum irony) by the young and thrusting Stekhanovite Chris Bunce (Seth Meyers). Voiceover creates intimacy with the audience outside the main narrative, but the cost is that these very cogent critiques of work take place at one remove. There remains space for a critique of Kate in the narrative proper: why does she have to take everything on? Beavering away in the background is a seemingly virtuous, blameless husband who fixes last-minute childcare and changes nappies without a murmur, except that it is implied by the reactions of other characters that he exceeds his brief. Furthermore, he is affectionately tolerant of Kate's inability to perform her other wifely 'duties' of sexual congress and is depicted watching her sleep after another trip away from home. True to so many elements of postfeminist discourse in popular film, the husbands are supportive and it is left to other women to assess the working mum's performance and find it wanting. In this case the stay-at-home mums (unsympathetically cast as pampered slackers who spend every waking school day moment at the gym) pronounce the harshest judgments of all. Given their lack of credibility or virtue in the context of the film, the spectator is encouraged to cast about for a solution to the tenacity of the gendered workplace only to find that neither individual women nor men are to blame. Kate's friend Alison suggests that men are simply incapable of performing a maternal role, arguing that 'until you program a man to notice when you're out of toilet paper, the project is doomed'. The mental lists Kate makes during stressful sleepless nights keep the family afloat; it is only when husband Richard (Greg Kinnear) latterly produces a laboriously handwritten list of his own that the film can move to a happier although unresolved conclusion. With both working mothers and stay-at-homers cast in such negative (and schizophrenic) terms Richard remains the only model of functional parenting and this inability for films to resolve the tensions of the 'have it all' woman characterize postfeminist popular film.

Singleton Momo acts as Kate's alter-ego, offering a sceptical view on married life characterizing Kate 'like she's on parole' because of her need to check in with Richard to confirm every work commitment. When Momo accidentally falls pregnant and is on the verge of having an abortion, it is Kate who makes an impassioned case for the joys of motherhood, even though both Momo and the audience fail to be convinced that it is anything but hard, soul-destroying labour. Richard's

mother overtly blames Kate's devotion to her career as the cause of her two-year-old son's inability to speak, and he becomes the symbolic focus of everything she sacrifices as she weeps after missing his first haircut. Contrary to most other characters' views of Kate's domestic skills, business partner Jack Abelhammer (Pierce Brosnan) falls in love with her because of her maternal attributes, and in doing so provides the core narrative shift in the film as it tries to rebalance the value of motherhood with twenty-first century woman's inalienable right to a career. He eavesdrops as she sings to her daughter over the phone and it is he who asserts that 'studies show women make better investors', reaffirming gendered distinctions in behaviour even as he makes the case for Kate's superior professional skills.

I Don't Know How She Does It revisits one of the most confused themes of postfeminist discourse – the problem of 'choice' for women either between motherhood and a career or to take the plunge and try to have it all in a commercial world that is portrayed as virtually untouched by feminism. The use of close-up freeze-frame monologues by selected characters to anticipate the story and to frame our response come to be seen as off-screen whinges about work which are doomed never to be articulated in front of the boss or in the space of gendered equality policy.[16] These asides draw the implied female spectator in; it is assumed that they are, or will, share the same experience, but need to be educated into the impossibility of social change. So while 'feminist' accounts of the workplace are written into the film, a postfeminism defuses their political power by having them articulated 'off stage'. Described by Xan Brooks as the 'salute to the oppressed middle classes' which suffers from 'a crucial lack of jeopardy'[17], Kate's threatened oblivion in the high achieving world of finance is averted by one female-positive patrician colleague and a snatched moment of mother–daughter quality time.

Singledom interrupted

Kate's experience of working motherhood is echoed in the grown-up film versions of the successful long-running HBO series *Sex and the City* (1998–2004). While the TV series concluded with the promise of a satisfactory end to singledom for most of the characters, the films explore the politics of marriage and monogamy, with and without children. While the first film adaptation, *Sex and the City* (Michael Patrick King, 2008), toys with the prospect of Carrie's marriage to Big and ends on a celebratory note with Samantha's 50th birthday, the second film *Sex and the City 2* (King, 2010) cannot avoid the subject of ageing. Carrie

and Big, two years on, are an 'old' married couple with Big rather too keen to stay home and watch cable television; Charlotte's dream of 'natural' motherhood, realized in the conception and birth of her second daughter, is turning into a nightmare as the child never stops crying; but it is Samantha who slides most obviously and comically into caricature. Showing all the supposed symptoms of menopause (hot flushes, mood swings, loss of sex drive) her bad behaviour in Abu Dhabi causes her to be expelled from the hotel and the United Arab Emirates (UAE), back to the accepting (and by comparison in terms of the film's narrative, less patriarchal) culture of the United States, where she can once more gain access to her hormone-replacement drugs and thus regain her sexual vitality. Samantha's menopause is played for laughs throughout the film and undermines her role as a sexual radical in the TV series once and for all. Having boasted in her past that it is possible to have sex like a man, Samantha finds herself in danger of turning into one as the menopause threatens to rob her of her femininity: when her stash of 'vitamin' pills is confiscated on arrival in the UAE she predicts she will be growing a beard by the end of the week. Prior to this luxury trip with her friends she has already been insulted by a shop assistant who declares that a dress she covets 'may be a little young', to which Samantha replies 'I am fifty fucking two and I will rock this dress.' At a premiere she finds herself wearing the same dress as Miley Cryrus, but it is the younger woman who defuses the potential embarrassment by embracing her in front of the press, confirming that age-appropriate behaviour is to be ultimately judged by the young.

Nonetheless, and mindful of the fact that in one scene the four friends sing Helen Reddy's feminist anthem 'I am Woman' at a karaoke party, what it means to be 'a woman' is problematized by having Samantha's ageing body moved to centre stage. The conclusion shows Samantha rediscovering her libido, but this particular franchise cannot avoid the impact of the passing of time since its television release in 1998, and the second film rehearses the problems of representing women of a certain age as the central focus of a film, moreover a 'chick flick'. Is *Sex and the City 3* a real possibility, or is the only way backwards given that the actors themselves are ageing beyond the critical Hollywood cut-off point? *Sex and the City 2* opens with a flashback to a younger Carrie Bradshaw new to the streets of New York and offers an explanation of the way she met each of her three best friends, Charlotte, Miranda and Samantha, with each actress appearing in brief flashback cameo. This offers fans both a backstory and a foreshadowing of the forthcoming TV series, *The Carrie Diaries*, which can capitalize on the success of the

original series while injecting new life into it via the casting of a new group of younger actors.

Sex and the menopausal woman

As Sarah Jessica Parker has proved by her appearance in *I Don't Know How She Does It*, her life as a lead actor is not yet over. Meryl Streep, taking the romantic lead in *Mamma Mia* (Phyllida Lloyd, 2008) and *It's Complicated* (Nancy Meyers, 2009) in her 60s, seems to dispel the notion that older women in Hollywood are consigned to either character acting or invisibility. In *It's Complicated* Streep plays Jane, a seemingly well-adjusted 50-something divorcee who accidentally begins an affair with the ex-husband who left her in her 40s for a younger woman. The audience is encouraged to enjoy the piquancy of this reversal of the usual adultery plot and the triumph of the older woman, but at the same time the affair draws attention to the deficiencies behind Jane's seeming composure. An early scene shows her visiting a plastic surgeon, ostensibly to have him fix one drooping eyelid. His assertion that both her eyelids droop equally (and therefore that this is a sign of ageing only cured by an invasive and painful facelift) causes her to beat a hasty retreat from the office only to bump into her ex-husband who is having fertility treatment to help him impregnate his younger new wife. Both ex-spouses are the victims of a culture which fetishes youth and the ability to perform both sexually and reproductively. The reality of their and their friends' white, middle-class, prosperous lives is one of serial monogamy and messy divorces, and as Deborah Jermyn asserts while the film sends up ageing for its own humorous ends, it 'manages to turn a momentary spotlight on some of the absurd gendered disparities surrounding ageing and romance today and to look afresh at how they have been normalised'.[18]

For Jane, the affair with her ex allows her closure and an understanding of the value of her own independence. This is shown by the renovations to her house and the anticipation of the room of her own, which she discusses with her architect and second suitor Adam (Steve Martin). It is implied that she is beyond marriage or future partnership, witnessed by her refusal to have 'his and her' basins installed in her new bathroom. Her affair with Jake exposes her once more to his egocentrism, whereas her blossoming relationship with Adam is characterized by a blending of masculine and feminine characteristics floating free from gender ascription. Jane helps Adam prune his wardrobe via a Skype conversation where he performs the 'fashion parade' as if they

were chick flick girlfriends; she provides food and nurtures in ways that connote the maternal, but also remind us that she runs a successful bakery business.

Age can wither her

All the films so far discussed, despite their entanglement in the double-think of postfeminist discourse, aim to offer positive and provocative portrayals of the older woman even when age only seems able to connote decline and retreat from femininity. In each case, the films show women who are 'good for their age' and triumphant, even in the face of tenacious patriarchal societal logic. The recent adaptation of the Grimms' *Snow White* fairy tale, *Mirror Mirror* (Tarsem Singh, 2012) begins with the disruptive claim that it is the stepmother's story, as the queen (Julia Roberts) narrates the tale of how she became Snow White's stepmother. Her narrative is a lament for lost youth in the queen's exhortations of her mirror; in this version the mirror has a life of its own, locked away in a parallel world through which the queen passes to make her pact with her more youthful reflection at a huge moral cost. Julia Roberts, at 45, seems rather young to be channelling her inner crone, but in this 'untold story' she seems to be following the lead of Michelle Pfeiffer in *Stardust* (Matthew Vaughn, 2007) who at 49 played a witch-queen attempting to capture and devour the heart of the young Yvaine in order to remain youthful. The queen's cruelty against Snow White is an offence against motherhood as much as womanhood, and the two are played as sexual rivals for the attentions of Prince Alcott. To try and seduce the prince the queen endures some punishing beautification procedures – including being smeared in bird dung, having her lips stung by bees and having maggots tipped over her body. As she dresses for her planned wedding later on, we see her being forcefully squeezed into a cane corset. As in the previous films discussed, holding on to our youth is seen as desperate and futile; the end result is to confirm that the move into middle age equates with numerous forms of physical and possibly mental decline. In the queen's final attempt to kill Snow White by offering her the poisoned apple, the savvy postfeminist Snow White cuts the apple up and offers it back with the words 'age before beauty'. Under the crone's cloak we glimpse the heavily made-up Roberts covered in deep wrinkles. Now she performs age in such a way that we recall her still striking beauty; but as much as we applaud her youthful appearance we also recognize that Hollywood in the twenty-first century has

no place for over-40s in a lead role. As if in acknowledgement of this, the queen ultimately admits that it is Snow White's story after all.

The number of films which depict older women centre stage are still in the minority, but those which feature some of the biggest female stars of recent decades act both as a homage to the hard-won independence of such figures and a confirmation that their continued onscreen presence is the exception which proves the rule. Once the prospect of biological fertility has passed, Hollywood seems ambivalent about the power or appropriateness of the post-menopausal sexually-active woman. It is true that older women can be played by older actresses than in preceding decades – we need only remember that Anne Bancroft was 36 when she played Mrs Robinson in *The Graduate* (Mike Nichols, 1967) and that she was only six years older than Dustin Hoffman, who played her younger lover. In this context Streep is right to crow that 'It's incredible – I'm 60 and I'm playing the romantic lead in romantic comedies! Bette Davis is rolling over in her grave. She was 42 when she made *All About Eve* [Joseph L. Mankiewicz, 1950] and she was 54 in *What Ever Happened to Baby Jane?* [Robert Aldrich, 1962].'[19] Romance narratives have proved most generous in this respect and Deborah Jermyn notes that 'the romcom has provided older women actors with star billing at exactly the point in their career when we might expect them to slip down the credits into supporting roles or to disappear from our screens altogether'.[20]

Other genres are providing interesting spaces for the representation of the older women, not least in the reprise of Courtney Cox and Neve Campbell as the ultimate Final Girls in *Scream 4* (Wes Craven, 2011) where for once the older women outwit the younger ones. Sigourney Weaver's gesture to her Ripley role in *Avatar* (James Cameron, 2009) suggests that fantasy as well as horror provides a liberating space for the reimagination of the older woman, freed from the biologically-inflected construction of the post-menopausal woman in romance and drama. As Sandra Coney reminds us, 'Aging in men is normal; menopause is not. Our biology renders us abnormal.'[21] And while it does, realist film narratives will tend to perpetuate this fundamental 'truth' – this despite the fact that, as noted earlier in this chapter actors such as Meryl Streep, Diane Keaton and Goldie Hawn have been anticipating their obsolescence for some considerable time.

The ageing female body challenges both mainstream notions of femininity, and feminist deconstructions of it, given that both are predicated on youthfulness and fecundity. There are of course models of the old wise woman – a reappropriation of the negative and victimized

witch, someone who is beyond sexuality and at most operates within a grandmotherly mentoring role; but what of the passage from fertility to age? At some point the mother loses her sexual vitality and in both fairy tale and rom-com must give way to the younger woman. These high-profile women in Hollywood by their continued presence in lead roles highlight this chasm between youth and old age for women on screen. As yet each of them is remarkable for staving off age, by not looking their age in a process of 'chronology disavowal' to use Patricia Mellencamp's words: women are allowed to be middle-aged on screen, but not to look it.[22] The more the youthful-ageing woman is celebrated on screen the more such films are haunted by the 'realities' of ageing as understood by the efforts taken to prevent it; the ageing woman is cast as deteriorating and sickening, a shadow of her former self, travelling a path somewhere between biological masculinity and death. Film and the mass media continue to celebrate the youthful white feminine body, the closer to puberty the better, as freshness and flawlessness are valued over sexual experience and knowledge.

The classic woman's film of the 1940s showed women doing battle against their mothers or mother figures in the search for love and self-definition; their separation from their mothers usually being their inauguration into mature, married love and potential motherhood – *Now Voyager* (Irving Rapper, 1942), being a fascinating case in point. Mothers as antagonists to their own daughters' progress to motherhood are well-known and dangerous images, but the focus on the daughters' rite of passage obscures the portrayal of the settled married mother whose reproductive days are over; writers since before Andrew Marvell's 'To His Coy Mistress' have noted that with the blossoming of womanhood comes the onset of age, decay and loss of desirability. Betty Friedan noted that even within a feminist informed society and

despite continued reports of advances in our life expectancy, there was a curious *absence* – in effect, a blackout – of *images of people over sixty-five*, especially older women, doing, or even selling, anything at all in the mass media. On the other hand, there was an *increasing obsession with the problem of age* and how to avoid it personally.[23]

Even high-profile feminists could not address this problem and Friedan reports that Gloria Steinem, then editor of *Ms*, admitted they couldn't get advertisers to feature older women even though they tried to include articles about this group.[24]

Daughterhood is powerful?

I mentioned earlier that second-wave feminism was a youthful movement, and Betty Friedan, in her 40s during its inception, was unusual. As recent debates about third-wave and postfeminist theoretical perspectives dominate gender studies, it is once again youth rather than age that is centre stage. As numerous commentators interrogate the language of generational conflict which permeates contemporary feminist discourse, it is the perspective of the 'young' or new generation which gains dominance as if in acceptance that the 'old' feminists have been too harsh on their daughters. The croning of second-wave feminism has other unintended consequences, in that it erases any focus on feminism and older women. Just as the youthful character of second-wave feminism of the 1960s was seen as one reason for the absence of discussion of issues such as motherhood, both second- and third-wave concerns with the young deny feminism a future: feminist critiques simply have no application beyond menopause. Women's ageing is erased as it was at the height of feminism even by those old enough to remember those heady radical days. For Diane Negra, 'age friction is certainly a regular feature of postfeminist representational culture',[25] where older women are demonized and where the ages of women peter out and blur after motherhood; while older women are visible in central film roles, it is in postfeminist celebration of the 'ageless consumer' in a 'fantasy of age transcendence that rests ... on an intensified stigmatization of those who show the effects of an ageing process'.[26]

For some years it has been predicted that a steadily ageing population will demand a focus on the old and what it means to be old. At the same time, Hollywood has matured and is slowly realizing that it may not be entirely appropriate to target primarily the teen boy in the hope that teen girls and older 'girls' will also consume the products. The rise of celebrity culture means that few of us are insulated from popular gossip about female stars, their bodies, their children and their relationships. Actors such as Meryl Streep, Susan Sarandon, Diane Keaton and Goldie Hawn, sometimes grandmothers and assuredly 'crones', can no longer play the ingénue or lead romantic chick flick role; yet they and countless women who comprise the film and celebrity gossip audience want to see such women on screen. They represent a postfeminist model of success and independence, not least because some of them produce as well as act, and offer hope for a more wholesale intervention into what is seen as a male-dominated industry traditionally most unkind to and controlling of women. The high profile of such women and their

multi-award-winning careers enables them to take lead roles as older women, and to some extent film narratives to build around the fact of their age and seniority. The roles they play and the influence they have on the shaping of such roles evoke positive responses and potential box-office success – possibly the only way to pave the way for further and more challenging depictions of the ageing woman.

Age is a tricky concept at the best of times in that it is a process we undergo from birth and yet it carries differing connotations according to gender. The post-reproduction, peri/post-menopausal woman lies behind the youthful central femininity. The liminal point at which youth is compromised is not fixed but begins for each individual actor with the question about whether they have 'had work done'. Their film roles often dramatize these debates initiated in the celebrity gossip columns and they are debates that no older woman in Hollywood can evade. Sexuality becomes rigidly associated with age even though numerous researchers point out that sexuality is not bounded by the biological fact of menopause. Since the early twentieth century, medical research has demystified the menopause for many, but the medical industry has extended its core meanings well beyond the end of menstruation to signify it as a condition to be managed until the end of life. Contemporary film spectators like to see their favourite mature women cheat age, inhabiting as they do the aspirational culture of 'middle youth', which defers middle age later into life, bolstered by the miraculous healing properties promised by exercise, weight control and judicious dietary regimes. Recent feminist critiques offer a sophisticated enhancement of Joan Riviere's understanding of femininity as masquerade, but still offer no model of behaviours for older women other than as veering between the visibility of 'passing' as their younger selves before disappearing into the mists of menopause.

Popular postfeminism, as I have implied, can offer little enlightenment due to its focus on youth and its girling of female cultures. For many, including myself, postfeminism might be manifested as a challenge to the perceived orthodoxies of feminism's socially-aware second-wave, which simultaneously chooses to 'forget' why radical feminism happened. Hilary Radner disputes this model of feminist amnesia to posit one which suggests that a strand of 'neo-feminist', consumer-friendly discourse emerged from the work of self-help gurus such as Helen Gurley Brown, and had no significant interaction with feminism's second wave. Radner asserts that 'though neo-feminism can be said to challenge patriarchal structures, it does so in the name of capitalism'.[27] As she implies, femininity is more frequently associated with

girlishness in postfeminist or neo-feminist discourse, so that femininity itself becomes something to salvage from feminism's destructive force, and in having been saved and celebrated, by incorporating some of the power of feminist rhetoric in a capitalist-friendly individualist form of power feminism, it reinforces the myth that feminism robs women of something essential to their psychic well-being. Ideal-type femininity as deconstructed by feminists in the second wave and as represented for Radner in the Bond Girl is 'a girl in a state of perpetual imma-turity'.[28] The thorny problem of ageing on film is constantly deferred by the makeover in the romance that 'offers a desirable and attainable identity, biological age notwithstanding, to the predominantly over-25 female audience'.[29] While postfeminist discourse holds on to a notion of youthful femininity in an attempt to understand what feminism lost for women in its challenge to the patriarchal status quo, it does so, as Stéphanie Genz reminds us, by illustrating 'the incoherence and inconsistencies of being feminist, feminine, and female in the early twenty-first century'.[30] Genz focuses on the ultimate young (but nec-essarily ageing) singleton, Bridget Jones. While Bridget Jones on the one hand wages war on the smug marrieds who represent the enactment of traditional gender roles, what is given less attention is the implicit terror of ageing shaping the singleton narrative and offering emotional justification for monogamy as a way of avoiding loneliness and a role beyond gendered social definitions. For Genz, ultimately the chick lit narrative negotiates the contradictions of contemporary womanhood treading a path between embracing feminism's socio-political victo-ries and celebrating 'femininity' as an artefact rescued and preserved from the sex wars whose meaning and purpose is still to be fully understood.

The older female actors who offer powerful interpretations of older women's lives in contemporary Hollywood films may well be slowly changing the ways in which it is possible to represent women on screen. Certainly against the traditional assumption that high grossing films must be made with the male gaze in mind, the more recent increase in home viewing of films through rental and DVD purchase changes the ways in which box-office success can be understood. The films them-selves must engage the spectator in the strength of story, but in addition, as Margaret Tally notes,

The celebrity interviews thus form a kind of 'super-text', that allows middle-aged female audiences to both identify with these actresses as mothers with active careers, as well as celebrate the fact that these

women have been able to hold onto their beauty and sexuality, in the face of an industry that would make them feel old and unattractive.[31]

The persistence of stars such as Meryl Streep, Glenn Close and Goldie Hawn offers a positive image of the older woman that allows a female audience to sometimes read against the grain of the narrative thrust. In an era where 'train-wreck' celebrities such as Lindsey Lohan and the late Amy Winehouse dramatize the perils of youthful fame and prosperity, older women in Hollywood offer a path through the maze of postfeminist doublethink simply by enduring and, as in *Scream 4*, offering the potential for the values and survival skills of the 'mothers' to outlive and vocally contradict the challenges of the daughters.

Notes

1. E. A. Kaplan, 'Trauma and Aging: Marlene Dietrich, Melanie Klein and Marguerite Duras', in *Figuring Age: Women, Bodies, Generations*, ed. by K. Woodward (Bloomington, IN: Indiana Press, 1999), p. 190.
2. Diane Negra, *What a Girl Wants?: Fantasizing the Reclamation of Self in Postfeminism* (London: Routledge, 2009), p. 12.
3. Kristyn Gorton and Joanne Garde-Hansen, 'From Old Media Whore to New Media Troll', *Feminist Media Studies* 2012, DOI: 10.1080/14680777.2012. 678370.
4. Heather Addison, ' "Must the Players Keep Young?": Early Hollywood's Cult of Youth', *Cinema Journal*, 45: 4 (Summer 2006), pp. 3–25 (p. 6).
5. Ibid.
6. Imelda Whelehan, 'Not to be Looked at: Older Women in recent British Film', in *British Women's Cinema*, ed. by Melanie Bell and Melanie Williams (London: Routledge, 2010), pp. 170–183.
7. Shelley Cobb, ' "I'm Nothing Like You!" Postfeminist Generationalism and Female Stardom in the Contemporary Chick Flick', in *Women on Screen: Feminism and Femininity in Visual Culture*, ed. by Melanie Waters (Basingstoke: Palgrave Macmillan, 2011), p. 31.
8. Rose Weitz, 'Changing the Scripts: Midlife Women's Sexuality in Contemporary U.S. Film', *Sexuality and Culture*, 14 (2010), pp. 17–32 (p. 17).
9. Ibid., p. 27.
10. For example, Betty Friedan died on her 85th birthday in 2006; Shulamith Firestone in August 2012.
11. Asrid Henry, *Not My Mother's Sister: Generational Conflict and Third-Wave Feminism* (Bloomington, IN: Indiana University Press, 2004), p. 34.
12. Kathleen Rowe Karlyn, *Unruly Girls, Unrepentant Mothers* (Austin, TX: University Texas Press, 2011), p. 243.
13. Ibid., p. 12.
14. Ibid., p. 92.
15. Philip French, 'Review: *I Don't Know How She Does It*', *Guardian* (17 September 2011).

16. A similar 'ventriloquizing' of feminist principles occurs in the remake of *The Women* (2008) and is discussed by me in 'Remaking Feminism: Or Why Is Postfeminism So Boring?', *Nordic Journal of English Studies*, 9:3 (2010), pp. 155–172.

17. Xan Brooks, 'Review: *I Don't Know How She Does It*', *Guardian* (15 September 2011).

18. Deborah Jermyn, 'Unlikely Heroines? "Women of a Certain Age" and Romantic Comedy', *Cineaction*, 85 (Winter 2011), pp. 26–33 (p. 32).

19. Quoted in Vanessa Thorpe, 'Hollywood Finally Abandons Its Prejudice against Older Women in Romantic Roles', *Observer* (20 December 2009), http://www.guardian.co.uk/film/2009/dec/20/hollywood-sex-older-woman-weaver (accessed 19 March 2012).

20. Jermyn, p. 26.

21. Sandra Coney, *The Menopause Industry* (North Melbourne, VIC: Spinifex, 1993), p. 53.

22. Patricia Mellencamp, *High Anxiety: Castastrophe, Scandal, Age and Comedy* (Bloomington, IN: Indiana University Press, 1992), p. 286.

23. Betty Friedan, *The Fountain of Age* (London: Jonathan Cape, 1993), p. 3.

24. Ibid., p. 6.

25. Negra, p. 75.

26. Ibid., pp. 71–72.

27. Hilary Radner, *Neo-Feminist Cinema: Girly Films, Chick Flicks, and Consumer Culture* (London: Routledge, 2010), p. 33.

28. Ibid., p. 42.

29. Ibid., p. 264.

30. Stéphanie Genz, 'Singled Out: Postfeminism's "New Woman" and the Dilemma of Having it All', *The Journal of Popular Culture*, 43:1 (2010), pp. 97–119 (p. 109).

31. Margaret Tally, ' "She Doesn't Let Age Define Her" : Sexuality and Motherhood in Recent "Middle-Aged Chick Flicks" ', *Sexuality and Culture*, 10:2 (Spring 2006), pp. 33–55 (p. 40).

Part II
Postfeminist Masculinities

6
Hollywood Fatherhood: Paternal Postfeminism in Contemporary Popular Cinema

Hannah Hamad

Contemporary Hollywood cinema is rife with representations of fatherhood since paternalized protagonists have become an increasingly and often overwhelmingly omnipresent feature of popular film in the early twenty-first century, while the currency of fatherhood as a defining component of ideal masculinity has emerged as a dominant cultural trope of postfeminism, and a structuring paradigm of mediated masculinity. This chapter addresses articulations of fatherhood in recent popular cinema which are discursively congruent with the sensibilities of postfeminist culture, exploring the ubiquity and centrality of fatherhood as the anchoring trope of contemporary Hollywood masculinities.

The summer of 2002 marked a watershed moment for what subsequently became the pronounced and widespread paternalization of Hollywood's cinematic output, when it saw the release of a small but significant cluster of films, all of which conspicuously pushed issues of fatherhood to the discursive fore. The films that comprised this group were Steven Spielberg's man-on-the-run science-fiction action thriller *Minority Report*, Sam Mendes' historical gangster melodrama *Road to Perdition* and M. Night Shyamalan's moody alien invasion drama *Signs*. All were high-grossing and wide releases, star vehicles and genre films. All showcased big name directors, and all featured narratives in which the goal of the protagonist was causally and hyperbolically linked to his fatherhood. *Minority Report* starred Tom Cruise as John Anderton, a guilt-ridden traumatized father, struggling to solve the mystery of his son's disappearance; *Road to Perdition* saw Tom Hanks playing against type as widowed single father Mike Sullivan, a small-town mobster hit-man

determined to protect his son from his Chicago enemies after the boy witnesses a murder; and Mel Gibson starred in *Signs* as lapsed clergyman Graham Hess, a widowed single father protecting his children from malevolent and hostile extraterrestrials. This presciently foreshadowed Spielberg's later *War of the Worlds* (2005), which enacted the same scenario, again from the viewpoint of a lone father, played by Tom Cruise. Thus, in three high-profile, star-led summer releases, using stock genre scenarios and conventional narratives, fatherhood predominates as a structuring thematic, narrative hook, and privileged identity formation for each protagonist, setting the terms and the tone for the dominant means by which Hollywood film has conceptualized postfeminist masculinities in the 2000s and beyond.

These films were indicative of an emergent representational discourse that became endemic to Hollywood storytelling, ubiquitous across the genre and budget spectrum of its output, and which has prompted a near-wholesale paternalization of Hollywood's leading men and the stories that are told through their on screen subjectivities. The thematic prominence of fatherhood in these films, far from being bounded by the texts, instead extends to the realm of the paratextual and beyond. Rather than a purely textual phenomenon, it instead permeates wider social and cultural discourse, colouring these films' marketing and critical reception and the popular commentary that circulated around their releases. This is commensurate with what Amanda Ann Klein, in her foundational treatise on the topic, outlines as the pattern of events that prompts the emergence of film cycles, which she argues takes place as part of specific historically located social and cultural discourses.[1]

In this way, for example, promotional stills and poster campaigns that presold films like *War of the Worlds*, *The Pursuit of Happyness* (Gabriele Muccino, 2006), *Martian Child* (Menno Meyjes, 2007), *Taken* (Pierre Morel, 2008), *The Hangover* (Todd Philips, 2008), *The Road* (John Hillcoat, 2009), *Due Date* (Todd Phillips, 2010), *Somewhere* (Sofia Coppola, 2010) and *What To Expect When You're Expecting* (Kirk Jones, 2012), to name only some, accentuated the paternal angles of these films, foregrounding fatherhood as a theme and prominent selling point, and anchoring their marketing, as postfeminist fatherhood has risen to discursive prominence for leading man masculinities in popular film culture to a near totalizing extent. In each case, widely mediated images heavily used in the films' campaigns signified the postfeminist fatherhood of their protagonists through their designs, and via the paternally charged (often tactile) affective displays on show. The promotional poster for *The Pursuit of Happyness*, to take one emblematic

example, is noteworthy in this regard. It depicts a besuited father, played by Will Smith, who is the only billed star on the poster, looking down and smiling upon his young son, with whom he is holding hands, and who reciprocates affection by leaning on his father's arm, head first. The boy is played by Smith's real-life son Jaden, which of course was a massive boon to this marketing campaign's centralization of postfeminist fatherhood as spectacle. Publicity for this film frequently zoned in on the on screen/off screen father and son pairing of Will and Jaden Smith. One prominent example was *Entertainment Weekly*'s December 2006 lead story, featuring a cover portrait of a beaming Jaden Smith with his arms flung around the neck of his beaming father.[2] This was consistent with the thematic and narratological centrality of fatherhood in the film itself, which, adapted from the memoir of the same name by Chris Gardner, narrates the American Dream from the perspective of a lone father. When his wife (Thandie Newton) leaves, Chris takes up the mantle of single fatherhood while struggling to make a living as a sales person. His dedication as a father is unwavering, as he determinedly sees his son through a period of homelessness before realizing his professional potential as a stockbroker. The prominence of the paternal thematic is further compounded in the poster by its white background, which conveys no other imagery except a bright light shining behind their clasped hands, and forces fatherhood as spectacle to the top of the hierarchy of discourses at work here. Widely mediated depictions of fatherhood on the promotional posters for *Road to Perdition* and *The Road* are also notable for their strikingly similar imagery. Both depict a hand-in-hand father and son, walking together through driving rain, and framed at identically canted angles. Viewed alongside one another, these posters are almost duplicates of one another. This suggests to me that the tried and tested currency of selling movies with postfeminist fatherhood was such that by the 2009 release of *The Road* it was possible to conceive a marketing campaign centred upon lone fatherhood and make judicious intertextual references to spearheading earlier campaigns, like that of *Road to Perdition*, via imagery, framing and composition.

This, I would argue, corresponds with a broader discursive turn towards fatherhood as ideal masculinity in postfeminist culture. The contemporary Hollywood fatherhood film is a production cycle and cultural trend that can thus be usefully understood in relation to the postfeminist context from which it emerged. It articulates a gender discourse of postfeminist fatherhood, which is ideologically disingenuous with regard to its relationship to feminism. At the same

time as appropriating a role traditionally occupied by women, through a surface discourse of involved and sensitive male parenting called for by feminists, postfeminist fatherhood films also shore up traditionally gender bifurcated hierarchies of agency, subjectivity and power through a common-sense veneer of postfeminist cultural logic which makes fatherhood not only culturally negotiable, but also an attractive and desirable conceptualization of masculinity. In this way, contemporary Hollywood fathers are enabled to have their postfeminist cake and eat it too, as fatherhood narratives allow for the privileging of masculine subjectivities, and the concomitant elision of motherhood, to be renormalized. Frequently this takes place in the absence of the cultural double standards germane to postfeminist femininities, as the cultural currency of 'having it all' (now an anachronism of postfeminist femininity – because postfeminist culture has long averred that women cannot) has found renewed license, as cultural formations like the Hollywood fatherhood film render it ever more apposite and applicable to postfeminist masculinities.

In thus conceptualizing postfeminist fatherhood, I take as my starting point Angela McRobbie's now canonical thesis statement, that

> post-feminism positively draws on and invokes feminism as that which can be taken into account, to suggest that equality is achieved, in order to install a whole repertoire of new meanings which emphasise that it is no longer needed, it is a spent force.[3]

From there I turn to Yvonne Tasker and Diane Negra's assertion that 'postfeminist culture works in part to incorporate, assume, or naturalize aspects of feminism',[4] thereby appearing, disingenuously, to negate the imperative for feminist critique. I hence adopt the mandate of these authors to interrogate postfeminist culture and the Hollywood fatherhood film from a feminist political purview.

Writing in 2007, Tasker and Negra gestured towards the critical need in feminist film and media studies to 'undertake the work of beginning to theorize postfeminist masculinity'.[5] Attempts have been made to conceptualize postfeminist masculinities in popular film and media culture, and these have tended to differently align them with one or the other side of a binary of reconstructed/unreconstructed masculinity, or indeed gestured towards the extent to which they attempt, coherently or otherwise, to occupy both subjectivities in an ostensible double bind of postfeminist masculinity. But even since the publication of foundational works such as Bonnie J. Dow's 'The Traffic in Men and the Fatal

Attraction of Postfeminist Masculinity',[6] scholars of postfeminist culture like Karen Boyle and Elana Levine have continued to note the relative dearth of feminist film and media studies critiques and treatments of postfeminist masculinities,[7] especially relative to the now sizeable and increasingly rich body of work on postfeminist femininities in popular film and television cultures. This article therefore aims to contribute to the ongoing project to conceptualize postfeminist masculinities in popular film and media, and interrogate what is at stake politically for feminism in culturally conceiving of and viewing contemporary masculinities through the lens of postfeminist fatherhood.

Changing masculinities and fatherhood after second-wave feminism

Second-wave feminism was instrumental in prompting social and cultural re-evaluations of separate spheres parenting, and the role of fathers in the lives of their children. The feminist-inspired cultural reimaginings of masculinity that followed would be the starting point for a series of discursive shifts over time, which manifested culturally in various ways, including via the representational discourse of Hollywood cinema. These have led to the naturalization of involved fatherhood as the paradigmatic template for ideal masculinity in postfeminist popular film culture, and it has taken place through paternally inflected negotia tions of all manner of variations and iterations of cinematic postfeminist masculinities.

An early indicator of the discursive traction of these feminist calls for revised and more equitable approaches to the labour share (practical *and* affective) of parenting, and a formative example of cultural responses to their currency and resonance, came with the initial publication in 1974 of Warren Farrell's *The Liberated Man*. This was a de facto mission statement for what, in the context of the time, was understood to be a polemical call-to-arms for the adoption by men of a feminist masculinity. A major part of this, according to Farrell's treatise, required a reconceptualization of fatherhood that accorded with the aims of feminism, where parenting roles were concerned. In this way, his imperatives for fathers to be more actively and equally involved in the daily practicalities of child rearing,[8] and to eschew approaches to fatherhood characterized by aloof, distant authoritarianism by, for example, being more emotionally demonstrative with their children,[9] corresponded with some feminist rhetoric then circulating that championed progressive gender egalitarian parenting.

However, in light of Farrell's more recent backtracking complicity in the 'backlash'[10] against feminism by trumpeting the cause of beleaguered masculinity,[11] the feminist credentials of his foundational take on masculinity after second-wave feminism seem shaky in retrospect. Articulations of 'redefined'[12] fatherhood, of the kind expounded by Farrell and his contemporaries, have since been reified in postfeminist popular film culture. This has taken place in a manner frequently at odds with the persistently gender-bifurcated social realities of parenting in postfeminism, and one that is evasive and circuitous with regard to the feminist politics of fatherhood. From a contemporary standpoint, his imagined reconceptualization of fatherhood is better understood as proto-postfeminist.

Farrell's proposed model of redefined fatherhood was hence a significant cultural precursor to some of the ideologically disingenuous and highly financially successful cinematic articulations of fatherhood that followed second-wave feminism in the late 1970s and early 1980s. These include films such as *Kramer Vs. Kramer* (Robert Benton, 1979) in which an inept lone father transforms his parenting and his relationship with his son when the mother leaves, and *Mr Mom* (Stan Dragoti, 1983) in which gendered parenting roles are comically inverted to effect the transformation of the father from inept mother substitute, to paragon of ideal masculinity. These canonical examples would themselves become the cultural touchstones and urtexts, both for the cycle of fatherhood films that followed in the late 1980s and early 1990s, and thereafter for contemporary Hollywood's narratives of postfeminist fatherhood.

Emergent discourses of postfeminist fatherhood in 1980s and 1990s Hollywood

In popular cinema these discourses of changing masculinities were most prominently mediated through a much discussed cycle of family comedies centred upon the pitfalls of male parenting in a domestic environment with recently rethought mores regarding domestic division of labour and the gender specificity of parenting roles. The most well-known entries in this cycle were the aforementioned *Mr Mom*; *Three Men and a Baby* (Leonard Nimoy, 1987) in which the deficient masculinities of the eponymous protagonists are recuperated through their haphazard parenting of an unexpectedly acquired baby girl, and which Modleski canonically read as popular culture's foundational tract on paternal postfeminist masculinity,[13] as well as later *Parenthood* (Ron Howard, 1989), *Look Who's Talking* (Amy Heckerling, 1989), *Kindergarten Cop* (Ivan Reitman, 1990) and *Junior* (Ivan Reitman, 1994). Often

overlooked – and not without reason as they were not the runaway box-office successes that some films from this cycle were – some lesser-known and discussed examples included *Paternity* (David Steinberg, 1981), *Ghost Dad* (Sidney Poitier, 1990), *Cop and a Half* (Henry Winkler, 1993) and *Fathers' Day* (Ivan Reitman, 1997), all of which followed the pattern of attempting to create humour from a narrative of inept but subsequently transformed and ameliorating fatherhood.

In line with one of the cultural functions of comedy to appear to 'challeng[e] norms, hierarchies, and established systems',[14] the aforementioned are all comedic family films. However, notwithstanding the efficacy of negotiating these shifting mores of masculinity through the safe representational space of the family comedy, a larger cultural conversation was taking place at this time about sensitive masculinity, meaning that the discursive terrain occupied by this gender discourse was broader than this symptomatic film cycle. Another notable 1990s example, from the purview of genre, was the turn towards the paternal in the action film, seen over the course of the decade, as fatherhood coloured the characterization of central characters and narratives of, for example, *Terminator 2: Judgement Day* (James Cameron, 1991), *True Lies* (James Cameron, 1994), *Independence Day* (Roland Emmerich, 1996), *Ransom* (Ron Howard, 1996) *Air Force One* (Wolfgang Petersen, 1997), *Con Air* (Simon West, 1997), *Dante's Peak* (Roger Donaldson, 1997), *Face/Off* (John Woo, 1997), *The Lost World: Jurassic Park* (Steven Spielberg, 1997), *Volcano* (Mick Jackson, 1997), *Armageddon* (Michael Bay, 1998), *Lethal Weapon 4* (Richard Donner, 1998), *Lost In Space* (Stephen Hopkins, 1998) and *Mercury Rising* (Harold Becker, 1998). As has been argued by scholars like Karen Schneider and Yvonne Tasker,[15] the 1990s paternalization of these action films at once enabled the reification of patriarchal family values alongside an apparent accommodation of changing mores regarding ideal masculinity. This took place through their paternally signified, and therefore 'sensitive', leading men, thus offsetting what would otherwise be the problem of negotiating the troublingly recidivist masculinities on show. The 1990s were thus key years in the formation of emergent discourses of postfeminist fatherhood in Hollywood, giving rise to a plethora of such representations. Further, the decade was also significant for the spike in scholarship on mediated masculinities.

Postfeminist fatherhood and contemporary Hollywood

Just as scholars have argued the case for a discursive shift in popular cinematic masculinities in the nineties towards qualities like sensitivity and emotionalism, I argue that the emergent discourses of postfeminist

masculinity in popular cinema at that time were solidified, normalized and naturalized by the early 2000s. The ensuing decade gave rise to a more confidently articulated multiplicity of postfeminist masculinities across the genre and budget spectrum of Hollywood's output, which were anchored by the structuring masculine identity paradigm of father-hood, and its omnipresence across an abundance of narratives of pater-nity. Hollywood fatherhood in the twenty-first century thus cannily navigates the mores of its postfeminist socio-cultural context, thereby negotiating its hegemony.[16]

Chiming with the symptomatic ubiquity of representations of father-hood in Hollywood, the last few years have correspondingly witnessed the emergence of a glut of new scholarly literature on the gender politics, sociology, psychology and practice of contemporary father-hood, which attempts, in different ways, to account for its discursive prominence and socio-cultural visibility in this historical moment. Meanwhile, the cultural trend of articulating postfeminist masculinities in paternal terms has also noticeably permeated the realms of medi-ated public sphere commentary and debate. This has given rise to a new popular cultural lexicon of paternally inflected sound bites and buzz phrases, some of which are notable reappropriations of mater-nally inflected equivalents circulating (if not already debunked) in postfeminist culture. Here, the move in postfeminism towards enabling men's parental leave is 'The Daddy Track'.[17] Downshifting fathers who forego workplace advancement and economically driven external signifiers of success and wealth are said to evince the 'new daditude'.[18] The effortlessly multitasking and breadwinning domestic hero double-shifters, simultaneously navigating the public and private spheres to equally admirable levels of unflappable efficiency, are succinctly and repeatedly referred to as 'superdad'.[19] And a rhetoric circulates that speaks directly to the extent to which postfeminist fatherhood is being positioned as desirable to women through its framing as 'hot' and 'sexy'.[20] Terms and epithets like these are commonplace in popular discourse surrounding fatherhood and are indicative of the ease and comfort with which postfeminist culture now aligns its conceptualiza-tions of ideal masculinity with fatherhood, as Hollywood cinema has multifariously done over the last decade.

Writing in the mid-2000s on Hollywood's changing takes on father-hood since the post-war 1940s, Stella Bruzzi acknowledged the 'variety as well as quantity' of films that centralized fatherhood in the current and preceding decade,[21] citing as examples mainstream movies like *Big Daddy* (Dennis Dugan, 1999), *The Family Man* (Brett Ratner, 2000)

and *About a Boy* (Chris Weitz and Paul Weitz, 2003), all of which recuperate the deficient masculinities of their protagonists through fatherhood. Since then, Yvonne Tasker has pointed to 'male parenting as a prominent feature of postfeminist media culture',[22] and contemporary Hollywood films like *Daddy Day Care* (Steve Carr, 2003), which qualifies the postfeminist masculinity of Charlie Hinton's (Eddie Murphy) stay-at-home fatherhood by entrepreneurializing it in the form of a father-run day-care centre, and *Cheaper By The Dozen* (Shawn Levy, 2003), in which Steve Martin is hyperpaternalized as father of 12, Tom Baker. Nicola Rehling has similarly observed the popular cinematic 'trend of representing straight white masculinity as paternity', and hence 'Hollywood's current fascination with fatherhood',[23] which she exemplifies with reference to films like *Finding Nemo* (Andrew Stanton, 2003), a narrative of protectorate fatherhood from the perspective of a widowed single father, and *The Incredibles* (Brad Bird, 2004), which revalidates the emasculated fatherhood of Bob Parr (Craig T. Nelson) by aligning it with super-heroism.

Correspondingly, a central contention of this article is that in the early twenty-first century, Hollywood has produced a proliferation of distinctly identifiable cycles and sub-cycles of films that discursively prioritize fatherhood in the representation, narrative, characterization, marketing and promotional activities of the films that comprise them, and the view from 2012 suggests that these cycles are not yet spent, as new iterations of the postfeminist fatherhood film continue to emerge that both perpetuate extant discourses of fatherhood and develop the cycle such that it continues to remain culturally viable.

Cycles and sub-cycles of postfeminist fatherhood films in contemporary Hollywood cinema

The emergent field of 'cycle studies' offers a useful approach to understanding and attempting to account for the abundance of narratives of postfeminist fatherhood in recent popular cinema. This is due to the emphasis it places on the relationship between contextual factors, the emergence and popularity of film cycles, and the cultural and social discourses circulating around and through them. In this way, it is a productive entry point into exploring the relationship between postfeminist culture and the contemporary Hollywood fatherhood film.

As Steve Neale states, 'the terms "trend" and "production trend" have in recent years figured prominently as alternatives or additions to "genre" as means by which to chart the different strands in Hollywood's

output',[24] and he cites Tino Balio as a noteworthy early spearhead for discussing groupings of films in this way.[25] Latterly, this approach to studying Hollywood production trends has been significantly developed by Amanda Ann Klein, in her foundational work conceptualizing the film cycle, mapping the terrain of American film cycles over time, and explicating the relationship between cycle studies and genre studies.[26] As Klein states:

> the formation and longevity of film cycles are a direct result of their immediate financial viability as well as the public discourses circulating around them, including film reviews, director interviews, studio-issued press kits, movie posters, theatrical trailers, and media coverage[...]A film cycle will form only if its originary film – the film that establishes the images, plot formulas, and themes for the entire cycle – is financially or critically successful. That is, the originary film must either draw a large audience or become a subject of discussion in the media. The buzz (financial or critical) surrounding the originary film convinces other filmmakers to make films that replicate the successful elements of that film, thus forming a cycle.[27]

As indicated at the outset, I understand the contemporary Hollywood fatherhood film as having originated from a financially successful cluster of big-budget, saturation release, auteur helmed, A-list star vehicle, summer tent-pole movies; although discursively linked to the aforementioned cycles that preceded it. In line with Klein's thesis on how film cycles emerge, the 2002 clustered release, box-office success, and cultural resonance of *Minority Report*, *Signs* and *Road to Perdition* caused the proliferation of films about fathers and fatherhood to become a media talking point.

In July of that year, upon the United States release of *Road to Perdition*, the *New York Times* movie critic A. O. Scott discussed a then current group of films he identified as thematically centralizing 'onscreen paternity', also citing *Gladiator* (Ridley Scott, 2000), *The Patriot* (Roland Emmerich, 2000), *In The Bedroom* (Todd Field, 2001) and *Minority Report* as entries.[28] He discussed their 'deep similarities of theme and symbolism' noting the use of the most bankable male stars to portray these screen fathers, naming Russell Crowe, Mel Gibson, Tom Cruise and Tom Hanks. He remarks upon the extent to which they appear to be playing 'against type'. However, with hindsight, we can understand these films as contributing factors in what would become a full-on paradigm shift in Hollywood's articulation of ideal masculinity via its

roster of male stars. This saw the wholesale paternalization first of the images of this group of stars, and subsequently of a seeming multitude of male stars and celebrities at all levels of marquee value and bankability. This extended beyond Hollywood, and cut across the spectrum of noughties media culture, as I have elsewhere demonstrated to be the case.[29]

Then, in August 2002, again in response to the plethora of cinematic articulations of fatherhood that were then emerging out of Hollywood, 'Fathers in Film' was the topic of an hour-long roundtable discussion on Chicago Public Radio's current affairs talk show 'Odyssey'. Host Gretchen Helfrich introduced the show with the following explanatory set-up, singling out the clustered release of this trio of films as the impetus for the debate:

> A cop haunted by his son's murder; a hitman struggling to protect his family from violence; a lapsed priest trying to save his children from aliens – these are just some of the challenges facing movie dads this summer, as Hollywood brings us extreme parenting.[30]

Each of the films that comprised this cluster of star-led genre narratives is symptomatic of a turn towards embodied fatherhood in the screen *oeuvre* of each star, as Cruise, Gibson and Hanks had all previously played different iterations of postfeminist fatherhood in iconic formative films that prefigured this cycle, in *Jerry Maguire* (Cameron Crowe, 1996), *Ransom* and *Sleepless in Seattle* (Nora Ephron, 1993), respectively; and they would go on to do so subsequently in, for example, *War of the Worlds*, *The Beaver* (Jodie Foster, 2011) and *Extremely Loud & Incredibly Close* (Stephen Daldry, 2011), respectively. Further, each is indicative of at least one thematically congruent, genre specific, or trope oriented sub-cycle within the umbrella cycle of narratives of postfeminist fatherhood.

For example, *Signs* and *Minority Report* both prefigured the ensuing cycle of paternalized narratives of social disintegration and apocalypse, such as *The Day After Tomorrow* (Roland Emmerich, 2004), *War of the Worlds*, *I Am Legend* (Francis Lawrence, 2007), *The Happening* (M. Night Shyamalan, 2008), *The Road*, *2012* (Roland Emmerich, 2009), *Knowing* (Alex Proyas, 2009), *Skyline* (Brothers Strause, 2010) and *Take Shelter* (Jeff Nichols, 2011), all of which centralize protectorate fatherhood in narratives that place fathers and their children in extreme and exceptional circumstances that test the limits of their paternal credentials. Writing in the mid-2000s, Kirsten Moana Thompson argued that such

narratives of apocalypse provide an apt device for popular cinema to 'return to an idealized fantasy of family values',[31] enabling a circumvention if not an outright repudiation of some of the more pluralistic ways in which understandings and different formations of the family can be conceived in postfeminism, as well as facilitating the recuperation of hitherto outmoded conceptualizations of masculinity and fatherhood. This sub-cycle thus effectively renegotiates a return to more traditional notions of this epitomic identity paradigm of masculinity centred upon uncompromising protectiveness. Ideologically related to this cycle is another, which the success and cultural resonance of *Signs* also prefigured, and this is a cycle of paternalized homes-under-siege films, which also includes *Cold Creek Manor* (Mike Figgis, 2003), *Hostage* (Florent Emilio Siri, 2005), *Firewall* (Richard Loncraine, 2006), *Law Abiding Citizen* (F. Gary Gray, 2009) and *Trespass* (Joel Schumacher, 2011), and which emerged congruent with a masculinist post-9/11 cultural logic of protecting the family homestead. *Road to Perdition* can also be counted among the glut of Hollywood historical epics that James Russell argues constituted a prominent film cycle and resurgence of the genre in the 1990s and early 2000s.[32] I would further argue that it came as part of a distinctly paternally themed sub-cycle augured by *Gladiator*, and that subsequently included *The Patriot*, *Troy* (Wolfgang Petersen, 2004), *Cinderella Man* (Ron Howard, 2005), *Apocalypto* (Mel Gibson, 2006) and *Valkyrie* (Bryan Singer, 2008), and which through period settings exemplifies the tendency in postfeminism to locate and idealize masculinities in and of the past. This sub-cycle thus locates latter-day postfeminist fatherhood in both colonial and depression era America, ancient Greece, Mesoamerica in the time of the conquistadors, and even Nazi Germany, going so far as to paternalize the well-worn World War II narrative of the 'good Nazi', as the goodness of Klaus von Stauffenberg (Tom Cruise) is signified by his tactile affective displays towards his children. *Road to Perdition* was also a significant early entry in what would become a cycle of male melodramas and tragicomedies of (frequently widowed) single fatherhood. The 'originary film' (to use Klein's term) that set the benchmark for the widowed single father paradigm of postfeminist masculinity was of course *Sleepless In Seattle*, while the benchmark for the male melodrama of postfeminist fatherhood was set by films like *Forrest Gump* (Robert Zemeckis, 1994) and *Jerry Maguire*. The current cycle has so far included *Finding Neverland* (Marc Forster, 2004), *Jersey Girl* (Kevin Smith, 2004), *The Pursuit of Happyness*, *Dan In Real Life* (Peter Hedges, 2007), *Grace Is Gone* (James C. Strouse, 2007), *Martian Child*, *World's Greatest Dad* (Bobcat Goldthwait, 2009), *The Boys Are Back* (Scott

Hicks, 2009), *The Descendants* (Alexander Payne, 2011) and *We Bought a Zoo* (Cameron Crowe, 2011), and stands as a striking example of one of many postfeminist appropriations of traditionally feminine cultural forms, in service to the efficacy and negotiability of postfeminism's latter-day recentralization of masculine subjectivities, as lone father protagonists go on emotional journeys through their respective narratives, culminating in strengthened bonds with their children.

Postfeminist fatherhood in Hollywood today: The view from 2012

According to Klein's rationale, 'most film cycles are financially viable for only five to ten years. After that point, a cycle must be updated or altered in order to continue to turn a profit.'[33] Ten years on from the release of the group of films I proposed at the outset to be the 'originary'[34] cluster that kick-started the widespread normalization of postfeminist fatherhood as ideal masculinity in contemporary Hollywood, the economic and cultural viability of the cycle shows little sign of waning.

For example, at the time of writing, the number one film at the UK box office is the British produced *The Woman In Black* (James Watkins, 2012).[35] The film, a period supernatural thriller starring Daniel Radcliffe as a widowed single father, haunted by the malevolent spirit of an aggrieved mother, is an adaptation of a Susan Hill novel, which has markedly foregrounded and heavily accentuated the fatherhood of the protagonist, relative to the understatedly paternally inflected narrative of the literary source material,[36] and adhering to the cultural imperative for ideal masculinity in contemporary popular cinema to be articulated in paternal terms. This is indicative not only of the fact that this phenomenon of mediated masculinity is not limited to the output only of Hollywood but also of the fact that the postfeminist fatherhood film is another manifestation of the 'discursive harmony'[37] between Anglo and American postfeminisms, and hence the congruity between the construction and articulation of postfeminist fatherhood in British films such as this, and comparable American-produced fare.

Further, at the tail end of 2011, Melena Ryzik, writing in the *New York Times*, noted that 'there's a preponderance of struggling (but hot) single fathers'[38] in her roundup of the year in American independent cinema, citing the desirability of the single fatherhood enacted by George Clooney in *The Descendants*, Brad Pitt in *Moneyball* (Bennett Miller, 2011) and Matt Damon in *We Bought a Zoo*. Similarly, Sasha Stone, writing for *Awards Daily*, cited the same three films, noting that

among the year's crop of Oscar hopefuls, there were a slew of 'single fathers' and 'vanishing mothers', as if this had not been the state of play across the spectrum of Hollywood's less Oscar-worthy output for the duration of the preceding decade. She proceeds to valorize what she evidently reads as their paternalized ideal masculinities:

> One of the threads running through this year's Oscar race is the single father who must pull things together for the sake of his kids[...]Stories about single dads are all the rage this year partly because films don't really get made without a strong male star driving them[...]Meanwhile, I'm into these men, these single dads who cry, these superheroes who want to save the world and make it a better place. All three of them do in their own way.[39]

Thus, ten years on from the summer of 2002, and the cluster of films that most visibly kick-started Hollywood's turn towards the paternal, the longevity of the cycle is manifest, and the fatherhood film shows no signs of losing ground in terms of cultural viability. If anything it is gaining ground in terms of cultural capital, as it has crossed over first from the realm of the comedic, then into the broader mainstream where a cross-section of Hollywood's output reveals its representational recurrence throughout, and now into the realms of middlebrow, independent and art-house cinemas. Epitomic of this development is the paternal thematic at the heart of Terrence Malick's much discussed, as maligned as it was lauded, metaphysical treatise on fatherhood, *The Tree of Life* (2011). So, the postfeminist fatherhood film, notwithstanding the 'quality' credentials of a forerunner example like *Road to Perdition*, is therefore now acquiring a hitherto denied level of cultural legitimacy, due ostensibly to its conspicuous incursion into the realms of the middlebrow, the chord it is apparently striking with audiences of crossover art-house films like *The Descendants*, and the discourse of 'quality' that accompanies any discussion of films identified as Oscar-worthy. This, as indicated above, has prompted critics and popular commentators to sit up and take notice of this representational recurrence in screen masculinities, a decade on from, not even its inception, but its top-down pervasion of high-end Hollywood cinema.

Meanwhile in Hollywood, the multiethnic spectacle of postfeminist fatherhood on display in *What To Expect When You're Expecting* appears to offer a superficial challenge to the discursive dominance of whiteness in narratives of postfeminist fatherhood, the status quo of which is further evidenced by the ghettoization of African American and Latino

fatherhood within the realm of the family comedy. This can be seen in films like *Daddy Day Care, Johnson Family Vacation* (Christopher Erskin, 2004), *My Baby's Daddy* (Cheryl Dunye, 2004), *Are We There Yet?* (Brian Levant, 2005) and *LiTTLEMAN* (Keenen Ivory Wayans, 2006). Or in Will Smith films like *The Pursuit of Happyness* and *I Am Legend*, which are shrouded in disingenuously colour-blind discourses of the post-racial. *What to Expect When You're Expecting* is inspired by a self-help manual of the same name, intended for expectant mothers. Yet even in this seemingly unlikely case, the film and the ancillary materials circulating around it manage to shift the discursive emphasis considerably towards fatherhood and masculinity, which can be seen in one of the film's most widely mediated promotional images. The movie poster in question depicts a line of fathers purposefully pushing strollers down the street together, in a culturally apposite discursive intersection of homosociality and postfeminist fatherhood, manifest in the tagline 'There is no judging in "Dudes Group"'. The cultural logic and political efficacy of popular cinematic postfeminist fatherhood as a means by which to at once 'account' for feminism and reify new hegemonic masculinities, therefore remains steadfast.[40]

Having said this, it is possible to identify seeds of backlash being sown at the margins of the mainstream as films like *There Will Be Blood* (Paul Thomas Anderson, 2007), *The Wrestler* (Darren Aronofsky, 2008) and *Crazy Heart* (Scott Cooper, 2009) staunchly resisted the possibility of redemption for their flawed and self-destructive paternally signified protagonists; while the knowing hyperbole of the anti-super-heroism of Nicolas Cage's 'Big Daddy' in *Kick-Ass* (Matthew Vaughn, 2010) could augur a turn towards irony in treatments of postfeminist fatherhood, bearing out Klein's contention that before backlash against a film cycle, there sometimes comes parody.[41] Nonetheless, this, and whether the (ultimately misplaced) Oscar-buzz that surrounded 2011's postfeminist fathers will be the last Hollywood hurrah for postfeminist fatherhood as ideal masculinity remains to be seen.

Notes

1. Amanda Ann Klein, *American Film Cycles: Reframing Genres, Screening Social Problems and Defining Subcultures* (Austin, TX: University of Texas Press, 2011), p. 9.
2. Neil Drumming, 'Will Smith's Pursuit of "Happyness" May Lead to Oscar', *Entertainment Weekly 911* (2006), http://www.ew.com/ew/inside/issue/0,, ewTax:911,00.html (accessed 31 August 2012).

3. Angela McRobbie, 'Post-Feminism and Popular Culture', *Feminist Media Studies*, 4:3 (2004), p. 255.
4. Yvonne Tasker and Diane Negra, 'Introduction: Feminist Politics and Postfeminist Culture', in *Interrogating Postfeminism: Gender and the Politics of Popular Culture*, ed. by Yvonne Tasker and Diane Negra (Durham, NC and London: Duke University Press, 2007), p. 2.
5. Ibid., p. 14.
6. Bonnie J. Dow, 'The Traffic in Men and the Fatal Attraction of Postfeminist Masculinity', *Women's Studies in Communication*, 29:1 (2006), pp. 113–131.
7. Karen Boyle, 'Feminism Without Men: Feminist Media Studies in a Post-Feminist Age', in *Feminist Television Criticism*, 2nd edition, ed. by Charlotte Brunsdon and Lynn Spigel (Maidenhead: McGraw Hill Education/Open University Press, 2007), p. 183; Elana Levine, 'Feminist Media Studies in a Postfeminist Age', *Cinema Journal*, 46:4 (2009), p. 143.
8. Warren Farrell, [1975] *The Liberated Man* (New York: Berkley Books, 1993), p. 119.
9. Ibid., p. 118.
10. Susan Faludi, *Backlash: The Undeclared War Against Women* (London: Chatto & Windus, 1991).
11. See for example, Warren Farrell, *The Myth of Male Power* (New York: Simon & Schuster, 1993); Warren Farrell, Steven Svoboda and James P. Sterba, *Does Feminism Discriminate Against Men?: A Debate* (Oxford and New York: Oxford University Press, 2008).
12. Farrell, *The Liberated Man*, p. 118.
13. Tania Modleski, *Feminism Without Women: Culture and Criticism in a 'Postfeminist' Age* (New York and London: Routledge, 1991), pp. 76–89.
14. Modleski, *Feminism Without Women*, p. 86.
15. Karen Schneider, 'With Violence If Necessary: Rearticulating the Family in the Contemporary Action-Thriller', *Journal of Popular Film and Television*, 27:1 (1999), pp. 2–11; Yvonne Tasker, 'The Family In Action', in *Action and Adventure Cinema*, ed. by Yvonne Tasker (London: Routledge, 2004), pp. 252–266.
16. R. W. Connell, *Gender and Power: Society, the Person and Sexual Politics* (Cambridge: Polity Press, 1987).
17. Jeffrey Winters, 'The Daddy Track', *Psychology Today*, 34:5 (2001), p. 18; Leslie Morgan Steiner, 'The Daddy Track', *Washington Post* (31 March 2006); Anne Jarrell, 'The Daddy Track', *Boston Globe* (8 July 2007).
18. Sharon Jayson, 'Today's Guys Parent with a New Daditude', *USA Today* (17 June 2008), p. 1. Thanks to Diane Negra for this article.
19. David Brindle, 'Men Under Pressure to Become Superdads', *Guardian* (16 July 1999); Sandra Tsing Loh, 'Let's Call The Whole Thing Off', *The Atlantic* (July/August, 2009), p. 125; Roman Krznaric, 'Man About The House', *Guardian* (14 January 2012).
20. Hannah Hamad, ' "Hollywood's Hot Dads!": Tabloid, Reality and Scandal Discourses of Celebrity Postfeminist Fatherhood', *Celebrity Studies*, 1:2 (2010), pp. 154–157.
21. Stella Bruzzi, *Bringing Up Daddy: Fatherhood and Masculinity in Post-War Hollywood* (London: BFI, 2005), p. 153.

22. Yvonne Tasker, 'Practically Perfect People: Postfeminism, Masculinity and Male Parenting in Contemporary Cinema', in *A Family Affair: Cinema Calls Home*, ed. by Murray Pomerance (London: Wallflower, 2008), p. 176.

23. Nicola Rehling, *Extra-Ordinary Men: White Heterosexual Masculinity in Contemporary Popular Cinema* (Lanham, MD: Lexington Books, 2009), p. 65.

24. Steve Neale, 'Introduction', in *Genre and Contemporary Hollywood*, ed. by Steve Neale (London: BFI, 2002), p. 4.

25. Tino Balio, *Grand Design: Hollywood as a Modern Business Enterprise, 1930–1939* (New York: Scribners, 1993).

26. Klein, *American Film Cycles*, pp 25–59.

27. Ibid., p. 4.

28. A. O. Scott, 'Fathers and Sons and Hollywood Law', *New York Times* (21 July 2002).

29. Hamad, 'Hollywood's Hot Dads', pp. 151–169.

30. Gretchen Helfrich, 'Fathers in Film', *Odyssey*, Chicago Public Radio (9 August 2002).

31. Kirsten Moana Thompson, *Apocalyptic Dread: American Film at the Turn of the Millennium* (Albany, NY: State University of New York Press, 2007), p. 153.

32. James Russell, *The Historical Epic & Contemporary Hollywood* (London and New York: Continuum, 2007).

33. Klein, *American Film Cycles*, p. 4.

34. Ibid.

35. 'United Kingdom and Ireland and Malta Box Office Index', *Box Office Mojo*, http://boxofficemojo.com/intl/uk/ (accessed 6 March 2012).

36. Susan Hill, *The Woman In Black* (London: Hamish Hamilton, 1983).

37. Tasker and Negra, 'Introduction', p. 13.

38. Melena Ryzik, 'In Film, So Many Men on the Verge of a Crisis', *New York Times* (1 December 2011), p. 1. Thanks to Diane Negra for this article.

39. Sasha Stone, 'Oscars 2011: Single Fathers and the Vanishing Mothers', *Awards Daily* (27 November 2011), http://www.awardsdaily.com/2011/11/oscars-2011-single-fathers-and-the-vanishing-mothers/(accessed 7 April 2012).

40. McRobbie, 'Postfeminism and Popular Culture', p. 255.

41. Klein, *American Film Cycles*, pp. 14–15 and pp. 175–178.

7

'Chuck Flick': A Genealogy of the Postfeminist Male Singleton

Benjamin A. Brabon

When is a man a man? This question has become one of the primary concerns of a group of films that have recently been labelled 'lad flicks' or 'lad movies'.[1] Defined as 'a hybrid of "buddy movies", romantic comedies and "chick flicks", which centre on the trials and tribulations of a young man or men as they grow up and make their way in the world' (Hansen-Millar and Gill 36), 'lad movies' respond in part to the much debated 'crisis in masculinity'.[2] Exploring the fragile (un)certainty of what it means to be a man in the twenty-first century against a backdrop of economic instability and contested capital, 'lad movies' appear to extend 'a compelling "invitation" to men to "put aside childish things" and join the adult heterosexual world' (Hansen-Millar and Gill 47). In this essay, I want to move away from the notion of the 'lad' – with its links to adolescent (working-class) male identity – and refocus instead on the now infamous and eponymous 1990s subject category of the 'Singleton'. Epitomized by Bridget Jones and Ally McBeal, the Singleton has been discussed at length in relationship to the postfeminist woman who is caught between a romantic fantasy for a Byronic hero and a feminist-inspired ambition to have a successful career.[3] Within this context, I am interested in how the Anglo–American single man – or what I prefer to classify as the 'male Singleton' – echoes his postfeminist sister in films that I characterize as 'chuck flick'.[4] Unlike his female counterpart, the male Singleton and the postfeminist masculinity that defines him have received a paucity of critical attention.[5] While Hansen-Millar and Gill acknowledge in passing the associations between 'laddism' and a 'post-feminist' style – previously identified by Benwell in *Masculinity and Men's Lifestyle Magazines* (2003) – their reading of the postfeminist connotations of twenty-first century masculinity is largely underdeveloped and limited to pre-feminist, backlash scenarios that situate the

single man within the milieu of media panic about male achievement and men's inability to take up their roles as husband/father/provider.[6]

Contrastingly, in my reading of the Postfeminist Male Singleton (PMS) I want to address the social and economic pressures that shape and challenge contemporary forms of masculinity. I suggest that like the female Singleton, the PMS questions a number of social, cultural and economic expectations and norms that link the successful construction and performance of gender with the interlocking systems of capitalism and patriarchy. This chapter begins by locating the PMS in relation to earlier forms of single manhood – such as the bachelor, the 'new man', the 'metrosexual' and the 'new lad' – and compares his plight to that of the female Singleton. As I argue, the compound nature of contemporary masculinity has developed out of a series of competing social and economic hybrid scripts that have become enmeshed to form conflicting and conflicted identities – postfeminist masculinities. The postfeminist man is 'a melting pot of masculinities, blending a variety of contested subject positions' (Genz and Brabon 143). Essentially, as I have suggested elsewhere, he is 'defined by his problematic relationship with the ghost of hegemonic masculinity as he tries to reconcile the threat he poses to himself and the social systems he tries to uphold' (Genz and Brabon 143). Here, 'retro' and 'neo' forms of masculinity act as the strophe and antistrophe of postfeminist manhood, as progressive male subject positions are haunted by the threat of 'backlash' and invocations of older forms of masculinity are re-signified by pro-feminist interventions.

The chapter then moves to an analysis of Tom Dey's 2006 chuck flick *Failure to Launch* – starring Matthew McConaughey as Tripp and Sarah Jessica Parker as Paula – in order to tease out the emotional, familial and financial contradictions at the heart of the film and at the core of postfeminist masculinity. Focusing on Tripp's journey of discovery to find the answer to what it means to be a man – with its Robert Bly flavoured attempts to recapture the 'deep masculine' – I examine his identity within the context of the PMS's efforts to reconcile the tensions between heterosexual romance and homosocial bonding, alongside bachelor-esque bravado and a failure of capital.[7] In so doing, I argue that the PMS is unable to fulfil his patriarchal duties due to the incapacitating social and economic topography of late capitalism – in a world where first-time buyers from the middle classes, who are the primary focus of chuck flick, find it impossible to step onto the property ladder, and job security across the social spectrum is uncertain – and thereby relinquishes his long-held position of power and independence.

At the heart of this postfeminist paradox is the disclosure of the multivalent performance of gender identity that is central to the film's narrative conclusion, which sees the anticipated 'chuck flick' resolution of heterosexual union with the 'chick' played out as a piece of reality television. Addressing the performative framework of gender identity in which *Failure to Launch* revels, the chapter closes with an analysis of the economics of this 'staging' that sees the male and female Singleton brought together only to turn their back on the traditional marker of hegemonic masculinities' dominion – the home – through an individual lifestyle choice that connects with postfeminism's neo-liberal politics of subjectivity.[8]

From bachelor to postfeminist male Singleton

I want to start by giving a brief historical overview of mid-twentieth to early twenty-first centuries single masculinities and highlighting a number of key masculine identity categories that have informed the construction and understanding of manhood since World War II. In many ways, the PMS owes as much to these earlier types of masculinity as he does to his Singleton sister, the 1990s 'chick', often epitomized by Helen Fielding's archetypal postfeminist heroine Bridget Jones. Responding to a shifting 'post-traditional' landscape – characterized by 'dramatic changes in basic social relationships, role stereotyping and conceptions of agency' (Genz and Brabon 1) – the trajectory of Bridget Jones's *Bildungsroman* is characteristic of the path of the postfeminist Singleton, as she moves 'rudderless and boyfriendless through dysfunctional relationships and professional stagnation'.[9] However, what is equally significant in this problematic and often awkward negotiation of 'singledom' is a growing awareness of economic emancipation that gives rise to a sense of agency and choice. As Bridget Jones asserts, 'we are a pioneer generation daring to refuse to compromise in love and relying on our own economic power' (Fielding 21). Here, romantic uncertainty – encapsulated by the Singleton's recurring angst of 'dying alone and being found three weeks later half-eaten by an Alsatian' (Fielding 20) – also provides an opportunity, fuelled by financial independence, to open up the historically rigid framework of gendered convention. Although 'Bridget is groping through the complexities of dealing with relationships in a morass of shifting roles, and a bombardment of idealized images of modern womanhood', the female Singleton is also potentially empowered by relative economic security and the possibilities it affords.[10]

In contrast, the cultural history of the male Singleton marks a different trajectory and hinges upon a loss of economic power, where the questioning of hegemonic structures of social and political authority – and men specifically – fosters new uncertainties that are represented as destructive/deconstructive. The evolution of the single man from what might be recognized as the pinnacle of the bachelor lifestyle of the late 1950s – as promoted in *Playboy* – to the doubts and anxieties of the PMS in the 2000s – captured by the chuck flick – demarcate the male Singleton's divergence from his 'chick' sister. In the 1950s and 1960s, the bachelor's confident expression of masculinity confirmed that 'this was a man who was affluent and independent, with a sense of individuality crafted around fashionable display and the pleasures of commodity consumption – yet this was also a man who took care that his aesthetic tastes marked him out as avowedly heterosexual and resolutely "manful" '.[11] In *Playboy*, the strength of the bachelor's heterosexual identity and 'manliness' was reinforced through pornographic content, defusing any potential challenge to his masculinity through his interest in fashion, style or home furnishings. The *Playboy* pin-up made it acceptable for male readers to engage in bachelor activities historically marked out as feminine pursuits such as cooking and interior design because the naked female body re-engaged the male gaze, therefore strengthening heterosexual masculinity and the perception of being 'manly'. For the bachelor, pornography served to re-signify the resonance of feminine associations that might undermine his sense of masculinity. The focus of these seemingly disjunctive connections extended into the living space of the so-called 'bachelor pad': 'A place where men could luxuriate in a milieu of hedonistic pleasure [...] [it was] the spatial manifestation of a consuming masculine subject that became increasingly pervasive amid the consumer boom of the 1950s and 1960s' (Osgerby 100). The bachelor defied tradition and contested 'the firm expectation [...] that required men to grow up, marry and support their wives. To do anything else was less than grown up, and the man who wilfully deviated was judged to be somehow "less than a man" '.[12] The growing wealth and economic power of the middle classes sat awkwardly with the bachelor's pursuit of consumer pleasure and his challenge to more traditional middle-class values. In effect, he unravelled middle-class masculinity's historic ties to the family unit – and what might be classified as a sense of moral responsibility – by representing 'a construction of bourgeois masculinity that was firmly located in the "feminine" realm of commodity culture' (Osgerby 101). However, as the economics of middle-class masculinity changed in the latter decades of the twentieth century, the

bachelor and his pad became an oddity, increasingly signifying a site of arrested development, an anti-social identity/space where pornography does not necessarily act to confirm heterosexual masculinity but rather to underline the male Singleton's 'failure to launch'.

The first step in this 'degeneration' of the outwardly confident displays of masculinity expressed by the bachelor – and his increasing sense of anxiety and crisis – can be witnessed post-second wave in the early 1970s through the 'new man'. In his initial manifestations, the 'new man' is conceived as nurturing and responsive to the demands of feminism. Where the bachelor of the 1950s and 1960s was self-centred and pleasure seeking, this 1970s version of the 'new man' is ostensibly sensitive, compassionate and family-focused. Captured in the iconic Spencer Rowell photographic poster *L'Enfant* (1987), he is 'attempting to put his "caring and sharing" beliefs into practice in his daily life'.[13] For Chapman this attempt is an impossibility that offers a façade to mask a lack of change:

> The 'new man' is many things – a humanist ideal, a triumph of style over content, a legitimation of consumption, a ruse to persuade those that called for change that it has already occurred [...] [W]hile the 'new man' may well have provided some useful role models for those redefining their masculinity [...] [he] is an ideal that even the most liberated man would never lay claim to.[14]

This veneer of sensitivity was thin and short-lived, quickly giving way to a more hedonistic incarnation of the 'new man' in the 1980s that reconnected masculinity explicitly with its commodity form. In this ongoing process of recoupling, the growing disjunction between the signifier and signified – images of masculinity and men – became increasingly apparent. In particular, the economic and social divisions that are accentuated by the 'new man' – between images of white, middle-class and affluent forms of masculinity and 'real' men – make the 'new man' into 'a distant and alien representation of masculinity, decidedly "other" from the day-to-day lives of the majority' (Genz and Brabon 137). Although the 'new man' is often identified as 'a patriarchal mutation, a redefinition of masculinity in men's favour, a reinforcement of the gender order, representing an expansion of the concept of legitimate masculinity and thus an extension of its power over women and deviant men' (Chapman 247), he also had a destructive and divisive impact upon men simply because he marked a proliferation of male subject positions – many of which were unobtainable for the majority of men – and an expansion of a rhetoric of choice that served to destabilize

hegemonic forms of masculinity that had historically been represented as static and unquestionably singular.

Within this context, the arrival of two new forms of masculinity in the early 1990s further highlighted the bipolar condition of masculinity and the tensions between image and economic reality that had seen unemployment in the UK peak at 3.2 million in the mid-1980s.[15] Appearing in the popular press and media in 1994, the 'metrosexual' and the 'new lad' confirmed that masculinity was evolving with a dual directionality that took the form of, on the one hand, the affluent, sexually ambivalent, image-focused and predominantly middle-class 'metrosexual', and on the other hand, the 'new lad' – 'laddish', fun-loving, sexist and working class.

For Mark Simpson, the 'metrosexual' is 'a young man with money to spend, living in or within easy reach of the metropolis [...] He might be officially gay, straight or bisexual, but this is utterly immaterial because he has clearly taken himself as his own love object and pleasure as his sexual preference.'[16] Although there are similarities between the metrosexual and his 1950s bachelor forerunner – such as masculine consumerism – the metrosexual's seemingly ambiguous sexuality and body-orientated emphasis marks him out as a consumer as well as a product/object of consumption. The metrosexual is the 'essence of masculinity: the desired male body' and he signals a shift in the gaze and the commodity status of masculinity as media texts adopted techniques that have 'long been understood by advertisers in the gay press who have often employed photos of headless idealized male bodies'.[17] The metrosexual had a trans-social and trans-global appeal, but the lifestyle choices that were linked to his identity were often limiting and inaccessible to the majority of men. At a time when manufacturing jobs historically coupled with 'male' labour were in decline, the metrosexual further re-signified the male body as an object of consumption aligned with a transforming workplace that was becoming increasingly 'feminized'. Although archetypal metrosexuals like David Beckham seem to defy prescribed sexual and ideological roles – appearing as an inclusive form of masculinity – the metrosexual certainly did not speak to the economic conditions of working-class masculinity in the early 1990s. In this respect, the metrosexual was out of tune with the lives of millions of men and marked a point of disassociation that spoke indirectly to a growing critical discourse on a 'crisis in masculinity' that centred on all aspects of boys'/men's lives, from girls outperforming boys in school to male body dysmorphia.[18]

Out of this rhetoric of 'crisis', the 'new lad' invoked a pre-feminist form of masculinity that celebrated carefree laddish behaviour and

embraced 'footie', sex and booze. According to Gill, 'the "new lad" offers a refuge from the constraints and demands of marriage and nuclear family. He opened up a space of fun, consumption and sexual freedom for men, unfettered by traditional adult male responsibilities.'[19] In this way, he can be seen as a throwback to the 1950s and 1960s bachelor, who also shunned these 'male responsibilities' in the pursuit of hedonistic habits, but unlike the bachelor who was associated with post-war economic growth in the United States, the 'new lad' is very much a symbol of working-class masculinity aligned with economic and social disenfranchisement in the early 1990s, particularly within the setting of Great Britain where over 10 per cent of the labour force was unemployed. Likewise, whereas the metrosexual did not speak directly to the working classes, the 'new lad' 'reconciled, at least artificially, the tension between the playboy and the narcissist or, to put it more simply, it reconstructed personal consumption and grooming as acceptable parts of working-class masculinities'.[20] Ironically then, the 'new lad' achieved a far greater affinity with 'feminized' models of consumption than the 'new man', even while shunning seemingly more sensitive forms of masculinity and espousing a retro-sexist refrain. Perceived as honest and 'authentic', the 'new lad' imagined at the launch of *Loaded* magazine in April 1994 appealed to a broader social base of men: the 'man-on-the-street', the '98 per cent of the male population'.[21]

Developing out of the accumulative and enduring hybridization of masculinity through the bachelor, 'new man', 'metrosexual' and principally the 'new lad', the PMS is not a feature of a remasculinization of contemporary Anglo–American culture – a forthright repudiation of second-wave feminism that can effortlessly be recognized as part of the backlash – but, instead, an uneven and diffident subject position that is doubly coded. As the next section of this chapter contends in relation to *Failure to Launch*, the PMS attempts to reconcile the conflicting pressures of patriarchal responsibility and laddish freewill, heterosexual conjugality and homosocial bonding. He is as brand and style conscious as the metrosexual, while simultaneously navigating the legacy of his roots in the 'deep masculine'. Moreover, he is evidently rancorous about the 'wounded' status of his masculinity that has not only been altered by second-wave feminism, but also by his changing economic status in the new global economy. In summary, the 'postfeminist man' is distinguished by his awkward rapport with hegemonic masculinity – that exists in a latent, at times nostalgic but always unattainable, form – as he attempts to navigate the danger he presents to himself and the social and economic system he simultaneously sustains and is alienated by.

Chuck flick

Failure to Launch tells the story of Tripp (McConaughey), a 35-year-old man who shows no interest in leaving his comfortable life with his parents and needs the intervention of relationship expert Paula (Parker) to finally 'launch' into self-sufficiency and leave the parental home. While *Failure to Launch* has been identified by some critics as a 'lad movie', in my eyes it makes more sense to discuss it as a chuck flick because – unlike films such as *Wedding Crashers* (2005) and *Role Models* (2008) – it involves the meeting of archetypal postfeminist Singletons.[22] In addition, *Failure to Launch* represents significantly different gender relations to those explored in 'lad' films, as Tripp's sense of masculinity is not threatened by a lack of self-esteem or the potentially destructive state of arrested development that the notion of pubescent 'laddishness' inadvertently implies. On the contrary, central to the film's narrative is the manipulation of the relationship between Tripp's 'laddish' persona and his resistance to 'fleeing the nest' as the economic conditions of masculinity combine with a suppressed emotional trauma that becomes fundamental to understanding his status as a PMS.

Contrary to the film's title, for Tripp, being a single man is not the result of a 'failure' on his part to be socially acceptable – nor does it stem from low levels of self-confidence – but it is a lifestyle choice that has specific advantages in a world where the economics of capitalism no longer favour hegemonic forms of masculinity in an uncontested manner. As Tripp reiterates throughout *Failure to Launch*, he likes 'to come home to a nice place', a place that in an increasingly competitive American labour market is out of his price bracket. It is readily acknowledged by friends of Tripp's parents that their own son's 'failure to launch' is due to the fact that their 'place is much nicer than anything he can afford', and it is this context of financial dispossession that provides the macroeconomic framework to begin to understand the PMS. In particular, his parents' house serves to accentuate the economic disjunction between the generations as home ownership in the twenty-first century is no longer the cornerstone of patriarchal endeavour but instead a weighty burden or a financial impossibility. Tripp's father's 'forty years in a suit' as a traditional figure of hegemonic masculinity and patriarchal achievement have reaped substantial rewards, but the suit no longer fits Tripp's generation. Instead, Tripp is left with an understanding of the role that society historically has asked him to play as a white middle-class heterosexual man, but without the financial means, willingness or drive to accomplish it. At the same time, he enjoys and benefits from the image that his parents' home affords for

his own sense of self as a PMS. In keeping with the image-conscious world of the early twenty-first century, the home is a readily identifiable façade of success that Tripp is able to exploit to impress potential girlfriends, even though – unlike his father – he has not put in the hard graft that is required to achieve and maintain this marker of financial and patriarchal accomplishment. His relationship with the familial home thus confirms that the PMS is a form of patriarchy 'lite': it looks the part but does not benefit from nor is it burdened by the weighty capital of economic and professional success that firmly anchored previous generations of American masculinities.

The evolution of Tripp's masculinity throughout the film underlines the hybrid and conflicted nature of postfeminist masculinity. For example, in the early scenes the legacy of the 'yuppie' is confirmed by Tripp's Porsche 911, the archetypical accessory for this 1980s young urban professional. However, the perceived affluence and economic independence of this 'yuppie' connection is swiftly undermined by the revelation that he lives at home with his parents. Once again the cultural and social resonance of an image is essential to the identity of the PMS, to the point where the value of the image (and its underlying associations) as an external marker of wealth and success underpins the superficiality of the relationships Tripp has with women. While he uses the mask of the comfortably large family home as a signifier of middle-class affluence to manipulate his girlfriends' perception of him, the house also becomes the means for Tripp to rid himself of unwanted female proximity. As his mother explains, he only brings women home when he wants to break up with them, as their realization of Tripp's economic/masculine failure – this is not a home he has 'made' for himself but one that he shares with, and is still owned by, his parents – inevitably results in a loss of female interest. Thus, Tripp knowingly exploits the disjuncture between (economic) appearance and reality to maintain a lifestyle of 'fun' and homosocial friendship, not based on competition and financial achievement – the traditional markers of successful masculinity – but on shared, 'New Age'-inspired experiences of yoga, surfing and rock climbing. Tripp and his friends embrace a life of leisure and consumption by adopting a performance of masculine accomplishment that is meant to both entice and deter.

In effect, performance is at the heart of Tripp's existence and gender relations in general in the film. Paula's role as a professional interventionist who teaches 'special needs kids' – hired by Tripp's parents to get him out of their house – serves to accentuate the existing gender performativity within Tripp's world by simulating a romantic

relationship. Confirming Butler's contention that 'all gendering is a kind of impersonation and approximation', an 'imitation for which there is no original', Tripp 'performs' a succession of masculine 'types' in his sexual encounters with women.[23] His trajectory rehearses a series of male subject positions associated with the single man, as explored in the previous section of this chapter. For example, the yoga class that he attends with his friends resonates with the sensitive 'new man' while his daredevil love of 'fun' is characteristic of the 'new lad'. Moreover, his friends – Ace and Demo – contribute to the postfeminist styling of masculinity within the film as the 'geek' and 'rambling man' respectively and complete this triangle of single men who choose to 'still live at home' and 'are shunned for [their] lifestyle'.

This unconventional and self-selected network of friends is of course reminiscent of other 'Singleton families' who choose a single lifestyle against what chick-lit poster child Bridget Jones calls, 'Middle-England propaganda' (Fielding 402). Although this group of single men engage in 'laddish' pursuits such as video gaming and paintballing, and in 'Bly-esque' male bonding activities firmly imbedded in the great outdoors, they are not archetypal lads but conform more closely to the typical characteristics of the PMS. In particular, Tripp is far from being the sexist and pleasure-seeking lad, and he is neither maladjusted nor emotionally challenged. He is identified by Paula as 'smart, sweet and funny' and 'a fascinating case. He doesn't fit the usual profile. I actually don't see why he still lives at home. He has got a good job; he has got normal social skills; he's attractive; he's really sweet.' As a PMS, Tripp is self-conscious and aware of the power of his status as a single middle-class white man and he enthusiastically deploys what others see as his arrested development – a man in his 30s who still lives at home – in order to maintain his desired lifestyle. What his parents, and Western society in general, classify as dysfunctional, Tripp celebrates as a life-management choice that allows him to seemingly keep control of his relationships and preserve a bachelor-esque level of fun in his life. However, the psychology of Tripp's use of his dysfunctional status is also underpinned by the traumatic and 'real' death of his former fiancée, Amy. Tripp is emotionally wounded by her death and as a result, he relies upon the performance of masculine 'types' – and its distancing effect – to retain an exclusive grip on his sense of the 'real'. His life-mantra may invoke fun but there is a deeper emotional sensitivity here – beyond fun-loving 'laddishness' – that frames his relationships with women and is also confirmed by his 'fatherly' relationship with Jeffrey, Amy's son.

These connections between (self-)control and performance are central to the film's process of disentangling the multilayered identity of Tripp as a PMS. For example, at the point when Paula believes she has 'got him. He's as good as moved out', Tripp is already telling Ace and Demo that 'It's over. She's got to go [...] The fun's gone.' At one level, this resonates with the 'new lad's' reluctance to commit to patriarchal responsibilities and a continued pursuit of hedonistic entertainment, but at another level, Tripp's 'failure to launch' is about an excessive amount of soul-searching that is linked to his conception of masculinity. Although Tripp is scarred by Amy's death, his unwillingness to move on in his relationship with Paula is connected to his masculine ideals. As he discusses his dream 'old wooden boat' with Paula, it becomes clear that Tripp conceives of masculinity in terms of a pioneering spirit that is pre-industrial, raw and seemingly authentic – a frontier form of masculinity that is deeply imbedded in an American narrative of national identity. His longing for a hand-crafted, non-high-tech boat is an extension of a masculine self that is 'a part of something. It's like you are connected to the original seafaring people who set sail into the unknown and said "holy crap" that is a big wave.' Here, Tripp appeals to a pre-industrial community of male pioneers, untainted by the competitive divisiveness that marks late-capitalist masculinities. The trappings of consumer culture seemingly are stripped away and his bachelor- and lad-esque performances are exposed as void signifiers delineated by the service economics of late capitalism. For Tripp, men are no longer pioneers and explorers but rather corporate slaves who 'borrow' lifestyle images – like Tripp borrows a boat to impress Paula on their first date – to create fleeting romantic attachments that are defined by vivid but empty displays of masculine power linked to capital. Even his attempts to commune with nature through Bly-esque explorations of the 'deep masculine' are destructive and fail to define him as he is bitten by a chipmunk, a dolphin and the aptly named 'chuckwalla' on his outdoor pursuits with his friends. In this way, the fun of male bonding that Tripp tries so hard to preserve is not everything it is made out to be and, as Demo confirms, Tripp's 'life is fundamentally at odds with the natural world'.

These disjunctions, ambiguities and contradictions classify Tripp as a PMS as he both extends and hybridizes the subject positions of the bachelor, 'new man', 'metrosexual' and 'new lad'. The multidirectionality of his masculinity captures a postfeminist aesthetic that delights in the paradoxes of postmodern subjectivity. Postfeminism – as I have argued elsewhere – 'engages with the postmodern notion of the dispersed, unstable subject and opens up the feminist realm for the articulation

of "other" voices and identities' (Genz and Brabon 28). Within this context, Tripp can display sensitive concerns and support for his mother as she expresses her fears about her future 'Tripp-free' retirement years with his father, and at the same time celebrate being the 'rebound' guy who enjoys no-strings-attached sex. For the PMS, these contradictions are not incompatible, but instead viable subject positions. However, they do not make for simple and straightforward renditions of masculinity and they fail to fall readily into the historic categories of what it means to be a man.

Arguably, it is only through Paula's status as a female Singleton that Tripp as the PMS is fully realized. In fact, Paula and Tripp act as mirror images of each other as both of them defy expectations of the romantic fantasy of heterosexual union. The final staging of their relationship through the enforced encounter played out as a piece of reality television confirms this association. Tripp is physically disempowered by being tied up by his friends, locked in a closet and filmed by secret cameras so that he cannot avoid meeting Paula, which in turn serves to further accentuate the wounded status of his masculinity. Although Paula apologises, she is quick to remind Tripp that his 'life was in an extended stall pattern', to which Tripp responds, 'I found a woman I cared about and she turned out to be a total fraud.' In this respect, they are a perfect match because they are both frauds and as such their deception lays bare the markers of a wider gender performance at the very core of white middle-class heteronormative romance. The breakdown of the public and private spheres that this observed 'Big Brother'-style encounter affords seemingly facilitates access to the 'real' where Tripp's and Paula's performances give way to the underlying principles of Butler's conception of gender performativity.[24] In so doing, Tripp confirms that even though his image conforms to the romantic fantasy of the female Singleton, he is not that guy, and the closing scenes are representative of a departure from the normative script. Sailing into the sunset on a boat named 'Miss Paula' – that in itself problematizes the financial source used to purchase the vessel – Tripp and Paula turn their back on the archetypal family home in pursuit of the endless deferral of the historic patriarchal narrative that ties men (through debt) and women (through housework) to the home. Gender and domestic stereotypes are set afloat literally in these open waters as they drift away from the traditional haven of middle-class nuclear family life towards a yet unknown future that might harbour alternative masculine/feminine identities and roles. The life that 'Miss Paula' provides not only recaptures the pioneering spirit of adventure that Tripp associates with his

ideal form of masculinity but also the postfeminist Singleton's mantra of choice as something potentially dangerous and empowering. In this way, Paula and Tripp seem to represent the ultimate Singleton couple – finally in tune with nature and no longer in need of any form of buoyancy aid. Yet, the image of both Singletons drinking champagne on a yacht also points towards the fact that this 'in-between' ocean space is not a realm of unbound possibilities available to everyone in a recession-stricken economy but an exclusive lifestyle choice underpinned by class and race privilege and unburdened by domestic responsibilities.

Failure to Launch and the chuck flick genre in general demonstrate how the PMS is the conglomeration of a series of seemingly irreconcilable masculine gender scripts that can function simultaneously in debilitating and inspiring ways. The PMS is evidently not only wounded by the impact of feminism and the emotional sufferings of past relationships – however traumatic – but also the significant financial burden of the legacy of the father/patriarch and the less favourable economic conditions of masculinity in the early twenty-first century. At the same time, the PMS reveals that being single is a neo-liberal lifestyle option that does not necessarily have to signify in dysfunctional directions, but instead can liberate the individual from the restrictive expectations and constraints of hegemonic forms of gender identity. That this will not be a straightforward and all-encompassing liberation from culturally and socially imbedded gender norms is made apparent by the 'compulsory individuality' and exclusivity that underlie the Singleton's way of life.[25] The 'emancipation' of the Singleton is dependent on a range of class, race and economic benefits that belie its proclaimed position as a 'pioneer generation' and alternative subjectivity (Fielding 21). The male Singleton in particular is unwilling to engage in any strenuous and meaningful activity that might force him to give up his fun-filled and spontaneous lifestyle. Unlike male pioneers of the past, the PMS is content to navigate into an unknown future, comfortable in his non-commitment, economically unmotivated and emotionally uninterested in heading towards the shores of married domesticity and duty. In this sense, he can be distinguished from his female counterpart who, as Genz puts it, is defined by her desire to 'have it all' and her struggle to 'integrate "it all" into her life and combine her job aspirations and material success with her desire for a rewarding home life, her feminist beliefs in agency and independence with the pleasures of feminine adornment and heterosexual romance'.[26] By contrast, the male Singleton is unconcerned by these attempts to reconcile the seemingly irreconcilable and indifferent to carving out a

subject position that would permit the rewriting of gendered scripts. In this sense, the PMS's assertion of non-hegemonic masculinity is disabled from wider social reform by his complacency and reliance on the taken for granted privileges that hegemonic manhood affords white middle-class men. Ultimately then, the PMS might not want to effect change because, frankly, he does not need to.[27]

Notes

1. See David Hansen-Millar and Rosalind Gill, ' "Lad Flicks": Discursive Reconstructions of Masculinity in Film', in *Feminism at the Movies*, ed. by Hilary Radner and Rebecca Stringer (New York: Routledge, 2011), pp. 36–50. Hereafter referred to in the main text as Hansen-Millar and Gill.
2. For more on the 'Crisis in Masculinity', see Roger Horrocks, *Masculinity in Crisis: Myths, Fantasies, Realities* (Basingstoke: Macmillan, 1994); Jeff Hearn, 'A Crisis in Masculinity, or New Agendas for Men?', in *New Agendas for Women*, ed. by Sylvia Walby (London: Palgrave Macmillan, 1999), pp. 148–168; Anthony Clare, *On Men: Masculinity in Crisis* (London: Chatto and Windus, 2000); Brenton J. Malin, *American Masculinity Under Clinton: Popular Media and the Nineties 'Crisis in Masculinity'* (New York: Peter Lang, 2005).
3. See Stéphanie Genz, *Postfemininities in Popular Culture* (Houndmills, Basingstoke: Palgrave Macmillan, 2009). In particular, Chapter 7 – 'Making It on her Own: The Singleton' – provides a detailed account of the postfeminist Singleton.
4. This is best understood as the male equivalent of 'Chick Flick' and focuses on the Postfeminist Male Singleton (PMS).
5. See Benjamin A. Brabon and Stéphanie Genz, *Postfeminist Gothic: Critical Interventions in Contemporary Culture* (Houndmills, Basingstoke: Palgrave Macmillan, 2007) and Stéphanie Genz and Benjamin A. Brabon, *Postfeminism: Cultural Texts and Theories* (Edinburgh: Edinburgh University Press, 2009). Hereafter referred to in the main text as Brabon and Genz and Genz and Brabon respectively.
6. Bethan Benwell, ed., *Masculinity and Men's Lifestyle Magazines* (Oxford: Blackwell Publishing, 2003). Hereafter referred to in the main text as Benwell.
7. For more on the 'Deep Masculine', see Robert Bly, *Iron John: A Book About Men* (Shaftesbury: Element, 1991).
8. For more on the connections between postfeminism and neo-liberal political subjectivity, see Stéphanie Genz, 'Third Way/ve: The Politics of Postfeminism', *Feminist Theory*, 7:3 (2006), pp. 333–353.
9. Helen Fielding, *Bridget Jones's Diary* (London: Picador, 1996), p. 78. Hereafter referred to in the main text as Fielding.
10. Helen Fielding qtd. in Imelda Whelehan, *Helen Fielding's Bridget Jones's Diary: A Reader's Guide* (London and New York: Continuum, 2002), p. 17.
11. Bill Osgerby, 'The Bachelor Pad as Cultural Icon: Masculinity, Consumption and Interior Design in American Magazines, 1930–65', *Journal of Design*

History, 18:1 (2005), pp. 99–113 (p. 100). Hereafter referred to in the main text as Osgerby.

12. Barbara Ehrenreich, *The Hearts of Men: American Dreams and the Flight From Commitment* (London: Pluto, 1983), pp. 11–12.

13. John Beynon, *Masculinities and Culture* (Buckingham and Philadelphia, PA: Open University Press, 2002), p. 164.

14. Rowena Chapman, 'The Great Pretender: Variations on the "New Man" Theme', in *Male Order: Unwrapping Masculinity*, ed. by Rowena Chapman and Jonathan Rutherford (London: Lawrence and Wishart, 1988), pp. 225–248 (p. 226, 228, 247). Hereafter referred to in the main text as Chapman.

15. See Donna Peberdy, 'From Wimps to Wild Men: Bipolar Masculinity and the Paradoxical Performance of Tom Cruise', *Men and Masculinities*, 13:1 (2010), pp. 1–24.

16. Mark Simpson, 'Meet the Metrosexual', in *Salon.com*, 22 July 2002. Available at http://www.salon.com/2002/07/22/metrosexual/ (accessed 17 July 2012).

17. Mark Simpson, *Male Impersonators* (London: Cassell, 1994), p. 107.

18. For more on these debates see Graeme Paton's recent article 'Girls Outperforming Boys in "Masculine" Subjects', *Telegraph*, 5 July 2012. Available at http://www.telegraph.co.uk/education/educationnews /9376466/ Girls-outperforming-boys-in-masculine-subjects.html# (accessed 17 July 2012).

19. Rosalind Gill, 'Power and the Production of Subjects: A Genealogy of the New Man and the New Lad', in *Masculinity and Men's Lifestyle Magazines*. ed. by Bethan Benwell (Oxford: Blackwell Publishing, 2003), pp. 34–56 (p. 47).

20. Tim Edwards, *Cultures of Masculinity* (New York: Routledge, 2006), p. 42.

21. *Press Gazette* qtd. in Ben Crewe, 'Class, Masculinity and Editorial Identity in the Reformation of the UK Men's Press', in *Masculinity and Men's Lifestyle Magazines*, ed. by Bethan Benwell (Oxford: Blackwell Publishing, 2003), pp. 91–111 (p. 94). Hereafter referred to in the main text as Crewe.

22. See Hansen-Millar and Gill. They label *Failure to Launch* as a 'Lad Flick' but they do not elaborate on its credentials as a member of this genre.

23. Judith Butler, 'Imitation and Gender Insubordination', in *The Lesbian and Gay Studies Reader*, ed. by Henry Abelove, Michele Barale and David Halperin (London and New York: Routledge, 1993), pp. 307–320 (p. 313).

24. See Judith Butler, *Gender Trouble: Feminism and the Subversion of Identity* (London and New York: Routledge, 1990). For Butler, the gendered body has 'no ontological status apart from the various acts which constitute its reality' (136).

25. See Anne Cronin, 'Consumerism and Compulsory Individuality: Women, Will and Potential', in *Transformations: Thinking through Feminism*, ed. by Sarah Ahmed, Jane Kilby, Celia Lury, Maureen McNeil and Beverley Skeggs. (London: Routledge, 2000), pp. 273–287.

26. Stéphanie Genz, 'Singled Out: Postfeminism's "New Woman" and the Dilemma of Having It All', *The Journal of Popular Culture*, 43:1 (2010), pp. 97–119 (p. 98).

27. I would like to thank Stéphanie Genz for her insightful comments on the qualities of postfeminist masculinity in the chuck flick genre.

8
The Chick's 'New Hero': (Re)Constructing Masculinity in the Postfeminist 'Chick Flick'

Amy Burns

Both 'postfeminism' and 'chick culture' are terms which require explanation – a challenge considering that the first is rife with debate and the second is inextricably linked to the first. As yet there is no concise definition or recognized designation of the postfeminist label, which is both claimed and used by different groups in different ways: as a classification, self-identification and/or an accusation, 'flung by or at people named "feminists"'.[1] Since various manifestations of 'postfeminism' have already been examined in this collection, it is unnecessary to outline these discussions again here, but it is appropriate to designate the version of postfeminism which relates to discussions of chick culture.

Chick culture has become a dominant force because women are now recognized as an autonomous group within contemporary culture – due in large part to the successes of second-wave feminism – and so can be addressed as consumers and subjects in their own right. The highly popular commercial texts of chick culture are specifically created for female consumers about the female subject: the 'chick' heroine who is alternately 'embraced and criticized as the poster-child of postfeminism'.[2] So it is here, in contemporary chick popular culture and in the media discussions which surround it, that postfeminist discourses take place and postfeminist ideology is constructed. This postfeminism is neither a political 'third wave' nor an anti-feminist 'backlash' but, as Stéphanie Genz explains, a 'complex resignification that harbours within itself the threat of backlash as well as the potential for innovation'.[3] This is evident in contemporary chick culture where the empowered 'postfeminist' subject is constructed within 'contradictory postfeminist discourses' where feminism is 'simultaneously taken for granted and repudiated'.[4]

Since its development in the mid-1990s, chick culture has prompted a large amount of critical analyses, which discuss both its connection with postfeminism and the ways in which its texts depict femininity, construct female identity and agency, or represent female friendships, careers and/or lifestyles. Even though the vast majority of these texts feature a heterosexual romance narrative and integral male characters, there has been little work that explores how these texts represent male identity and masculinity.[5] This is especially troubling, because many of these narratives are told from the female point of view, and may therefore spend even more time constructing and representing masculinity than they do femininity. In order to examine the wider significance of chick cultural texts, these representations must also be considered. In doing this work of establishing how these texts construct masculine identity and which masculinities are favoured, it is possible to interrogate further the social and political implications of these ideological representations. I have found, as Mark Rubinfeld claims, that these texts are 'essentially stories of masculinity and femininity with roles and rules that ensure femininity is subordinated to masculinity',[6] and the 'New Hero' figure that I will outline in this chapter – which is the persistent portrayal of masculinity found in contemporary chick flicks – is the particular masculine role which ensures the representation of feminine subordination in this genre.

Objectifying and consuming masculinity

> He is lovely. Love looking at Him asleep. V. sexy broad shoulders and hairy chest. Not that sex object or anything. Interested in brain. Mmmm.[7]

Bridget Jones's Diary (1997) is continually credited as the foundational text which established the 'chick lit' genre and the wider chick culture.[8] Bridget's hero, Mark Darcy, is readily on display in this extract and despite her claims to the contrary, she is clearly objectifying him. In the decades since Laura Mulvey's seminal argument that 'pleasure in looking has been split between active/male and passive/female' as the 'determining male gaze' is projected onto the displayed woman, a change has occurred.[9] The men in chick texts are clearly there to be looked at by women, creating a notable representation of the female gaze in contemporary popular culture. Furthermore, as Laura Brunner explains with regard to another foundational text of chick culture, the television series *Sex and the City* (1998–2004):

[Men] are presented as objects for consumption for both the charac-
ters and the female audience [...] Part of the innovation of *Sex and
the City* is that playgirls are now commodifying and evaluating men
[...] The show contests cinematic and television convention, revers-
ing the usual trend of the male subject as the consumer of the female
object of desire.[10]

This commodification of men is not just the case for *Sex and the City*, but
this groundbreaking series paved the way for all chick texts. Crucially,
there is a two-fold representation of men to both female characters and
the female audience, just as Mulvey identified the displayed woman who
functioned as 'erotic object for the characters [... and] the spectator'.[11]
But these two groups of women do not only commodify these men,
they also consume the male subject, and by extension they consume
the ideological representation of masculinity which he portrays. Chick
flicks are notably formulaic in construction and usually conform to
established conventions regarding characterization; masculinity is no
exception.[12] It is my contention that five 'facets' of masculinity are
coded as superior in these films, and these combine to construct an
idealized male character who must then work to 'rescue' the heroine
in one of four ways. This character type is persistently depicted as the
leading man in contemporary chick flicks, and I have assigned him the
title of the 'New Hero'.

The new hero

As second-wave feminism has questioned the cultural, social and polit-
ical order of men and women, 'masculinity has been placed under
the spotlight [...] as never before' and, in much the same way as
postfeminism and chick culture, the extensive and unrelenting surge
of critical theory and cultural observation written on masculinity in
recent years is difficult to summarize concisely.[13] Ultimately, as Michael
Kimmel states, there is no one all-encompassing 'masculinity' because
the term represents 'a constantly changing collection of meanings
that [...] is neither static nor timeless', meaning we must speak of
'masculinities'.[14] Yet, R. W. Connell ascertains that while there are many
masculinities there is usually a version of masculinity which is culturally
exalted as the 'successful' way of being a man in every given context,
and although this 'hegemonic masculinity' is 'not a fixed character
type, always and everywhere the same', other masculinities are 'rendered
inadequate and inferior' by comparison.[15] Significantly, the position

of hegemonic masculinity is 'always contestable [...embodying] the currently accepted answer to the problem of legitimacy of patriarchy, which guarantees (or is taken to guarantee) the dominant position of men and the subordination of women'.[16] Within contemporary chick flicks the New Hero holds the hegemonic status as the culturally exalted version of acceptable masculinity in this context.

In some ways, the New Hero is a reimagined and reconstructed version of the 1980s 'new man' archetype; a highly visible cultural icon of that decade which enjoyed hegemonic status across a wide range of representational spaces. John Beynon identifies two strands with which to approach the 'new man': the 'nurturer' (men as sensitive, emotionally expressive and domesticated) and the 'narcissist' (men as ambitious fashion- and body-conscious consumers), and these strands 'have been woven together in the public mind into a pot-pourri, nebulous new man-ism', elements of which he claims 'now feature in contemporary versions of hegemonic masculinity'.[17] Although the New Hero of contemporary chick flicks does contain an essence of Beynon's 'new man-ism' within the construction of his character, it is imperative that he also performs the role of the New Hero: to rescue the chick heroine of the film. Gill and Herdieckerhoff have noted the 'rescue' function in a number of chick lit novels,[18] and Suzanne Ferriss suggests that contemporary women have 'a renewed desire to be rescued by men from the complications of life as an independent woman'.[19] Indeed, I would contend that the 'rescue' is now a standard feature in contemporary chick flicks and therefore the New Hero must prove himself in this area as well as in his conformity to the normative facets of masculinity.

The New Hero can be found readily on 'display' in contemporary chick flicks, as he is presented to both female characters within the text and the female audience as an 'object for consumption'. *The Holiday* (Meyers, 2006) demonstrates this dual presentation through the depiction of Graham (Jude Law). Throughout his first scene, Graham is watched by an unnamed woman in the film as he walks through a pub; later he returns to the pub where heroine Amanda (Cameron Diaz) is waiting for him. She sees him first and is shown watching him while he looks for her. Amanda also watches Graham as he drives and is unable to look back at her, and the film uses fantasy sequences from Amanda's perspective in which Graham is seen through her eyes. Even the still photo used for the film's promotional poster and DVD cover shows Amanda looking at Graham as he looks down. Whether for sexual objectification, romantic longing, wish fulfilment or escapism, this man is quite clearly to be looked at and consumed by women. Through a close reading of

The Holiday, and with reference to a range of other contemporary chick flicks including *You've Got Mail* (Ephron, 1998), *Notting Hill* (Michel, 1999), *How to Lose a Guy in 10 Days* (Petrie, 2003) and *The Proposal* (Fletcher, 2009) among others, this chapter will first identify the five 'facets' of masculinity found in the New Hero and then go on to out-line the four types of 'rescue' which he performs. I will conclude the chapter with a discussion of the ideology bring promoted through the New Hero character, and argue that through such a persistent portrayal of this hegemonic ideal, the female consumers of these films are subject to a subtle undermining of feminism as the traditional gender order of patriarchy is upheld and reinforced.

Constructing the new hero

Graham of *The Holiday* is the quintessential New Hero, exhibiting all five facets of masculinity found in this character type. In order to 'qualify' as a New Hero a male character must conform to at least three of these attributes, including the fifth 'compulsory' quality of devotion to the heroine. Given Graham's exemplary accomplishment in all five areas, he will be the starting point for this analysis.

Attractiveness

> Amanda: Considering you just showed up and you're insanely good-looking and probably won't remember me anyway, I'm thinking we should have sex. If you want.

The New Hero is usually attractive, and by this I mean he satisfies the currently accepted aesthetic standards of 'attractive' masculinity and conforms to contemporary cultural trends of styling, as presented and promoted within the media and consumer culture. Although Amanda declares outright that Graham is 'insanely good-looking', chick flicks cannot generally state that a man is attractive. Instead, they work to show this to the audience by depicting the character being looked at by women on the screen, implying that he is *worth* looking at, as outlined above with Graham. Similarly, Andrew (Ryan Reynolds) in *The Proposal* is watched by various women as he runs to work, as well as by his female coffee barista, who also gives him her phone number; and Ben (Matthew McConaughey) in *How to Lose a Guy in 10 Days* is watched by a number of women as he enters his office. It therefore seems reasonable to sug-gest that these men are 'attractive' given how women look at them

appreciatively, but this technique is coupled with a further 'showing' of attractiveness by frequently displaying the uncovered male body.

Gill et al. claim that recently 'a significant change has occurred, in which men's bodies *as bodies* have gone from near invisibility to hyper-visibility', and this is certainly true of chick flicks.[20] Graham's topless body is shown during a bedroom scene of *The Holiday*, yet Amanda's body remains covered; this also happens in *Music and Lyrics* (Lawrence, 2007), *He's Just Not That Into You* (Kwapis, 2009) and *Valentine's Day* (Marshall, 2010). Men are regularly shown changing their shirt or showering in chick flicks – notably in *How to Lose a Guy in 10 Days*, *Sweet Home Alabama* (Tennant, 2002), *A Lot Like Love* (Coles, 2005) and *Just Like Heaven* (Waters, 2005) – and this process usually allows for a lingering shot of the toned male torso. Further, in each of these scenes the male character is also being watched by one or more female characters, even though in *A Lot Like Love* where the female character is also changing her clothes, her body is not shown.

Perhaps the most extreme example of the difference between the depiction of female and male bodies in chick flicks is in *The Proposal*. Both Ryan Reynolds' and Sandra Bullock's uncovered bodies are shown during a shower scene, and, as with those already noted, Reynolds' male body is intentionally displayed to the audience through a series of screen shots of his toned arms and torso, yet Bullock's female body becomes the tool for physical comedy. Even when they bump into each other fully naked, as Bullock's character scrambles to hide behind furniture and cover herself up, Reynolds' body remains on view as he calmly ties a towel around his waist. As well as emphasizing the attractiveness of the New Hero, this scene is also an example of how chick flicks often portray female characters as silly, clumsy or even in a state of frenzy – and this despite Bullock's character being a successful and determined businesswoman. I will return to this point when I discuss the New Hero's role as rescuer.

The masculinity of the New Hero is inextricably linked with the 'attractive' male body and the vast majority of New Heroes conform to this aspect of masculinity. There are, however, occasional films which do not overtly emphasize this feature – for example, *Sliding Doors* (Howitt, 1998), *You've Got Mail* and the second narrative in *The Holiday*, featuring Miles (Jack Black). In these films though, the New Hero has to 'win' the heroine from an anti-hero who is perhaps better looking in the sense of the current culturally accepted standard of attractive masculinity, but does not fulfil the fifth 'compulsory' aspect of the New Hero character: to be devoted to the heroine.

Success and its signifiers

Amanda: What kind of an editor are you?
Graham: A very mean one.

The New Hero is regularly constructed as having a successful career. Men in chick flicks rarely just 'work'; they are executives, lawyers, creatives, politicians, journalists or even tennis players, and each one is depicted as being highly successful in their field, winning business contracts, legal cases, record deals and artistic commissions, elections and, for the tennis player, the Wimbledon tournament.[21] The New Hero's career success usually means he also has financial 'success' and in many films signifiers of the New Hero's wealth are prominently displayed – cars, clothing, houses or gadgets. At times these signifiers of wealth can be used to imply a successful career even when it is not explicitly stated, as with Graham; while the audience is told he is a book editor, and he discusses his job with Amanda, it is his expensive Range Rover and large Surrey home which confirm his success. The same is true of Miles in the same film. He is shown working from home with an extensive range of high-end technical equipment to compose music for a film; this in itself projects an image of success, which is reinforced by his expensive watch and flashy sports car.

A further signifier of the New Hero's 'success' is the wearing of a suit, as both Graham and Miles do in *The Holiday*. Tim Edwards explains that 'the suit still maketh the man most completely [...] it remains a potent symbol of success'.[22] The suit is often used in chick flicks to construct a representation of 'success', particularly in a film's opening scenes when the character's identity is being established, as in *The Proposal*, *Definitely Maybe*, *The Family Stone*, *You've Got Mail*, *Love Actually* and *The Wedding Date* (Kilner, 2005). The most extreme use of the suit as signifier is in *Two Weeks Notice* (Lawrence, 2002) where the New Hero character played by Hugh Grant wears a suit in almost every scene. Significantly, in the first of the few scenes when he is not wearing a suit, he stands in his closet in the process of choosing one and literally hundreds of suits are hung around him in an extreme emphasis of this particular character's 'success'.

While 'success' and the suit can be factors in constructing the New Hero, as with 'attractiveness' they are not imperative. 'Success' must be balanced correctly with the New Hero's other attributes, lest he become swallowed up in success. When the male and female lead characters are arguing in *You've Got Mail* prior to them forging a relationship, the final blow she attacks him with is to say 'you're nothing but a suit'. Clearly, if

masculinity is reduced to *only* success it is not acceptable, hence the assertion that the New Hero must embody at least three of the five constructive facets of the character. Success is important, but he cannot be only this; other contributory factors must make up the New Hero.

A broken heart

Amanda: Are you D-I-V-O-R-C-E-D?
Graham: No. W-I-D-O-W-E-R.

Graham is clearly broken-hearted. When Amanda asks if he is divorced, spelling the word as the children are listening, he spells 'widower' in reply, yet is unable to even look up as he does. He later admits to Amanda: 'I'm afraid of what another person might do to who we are and how we get from one day to the next.' Graham is not the only widower in chick flicks – he is accompanied by the New Heroes of *Just Like Heaven*, *New In Town* (Elmer, 2009) and *Failure to Launch* (Dey, 2006) – although in this film Tripp (Matthew McConaughey) was engaged but not yet married when his partner died.

Broken-hearted New Heroes are also constructed through a previous partner having chosen to leave the relationship, often for another man, as in *Bridget Jones's Diary*, *27 Dresses*, *Love Actually* and *Runaway Bride*. These men have proven they are capable of loving greatly but are now limited by their broken hearts, so the narrative works to restore this ability through the love of the heroine.[23] A complication to this is when it is the heroine herself who, knowingly or unknowingly, has broken the New Hero's heart, as in *13 Going on 30* and *Sweet Home Alabama*, but in these films the heroine is able to make up for her past mistakes and the two are reunited. Perhaps the most broken-hearted hero of all is Will (Hugh Grant) in *Notting Hill*. Not only has his wife left him at the start of the film, but the heroine, Anna (Julia Roberts), then leaves him twice. Yet even here Will is able to overcome his broken heart and the film culminates in Will and Anna's marriage.

Mark Rubinfeld suggests that the broken-hearted redemption plot in romantic comedy serves a 'commercial and ideological function [...] to emotionally appeal to females by emphasizing the female's emotional appeal'.[24] However, it seems more appropriate to contest that in chick flicks the broken-hearted New Hero emotionally appeals to females, both characters in the text and the audience, by emphasizing the *male's* emotional availability and capability – an example of how the New Hero reconstructs traits of the emotionally expressive 'new man' of the 1980s.

Father-figure/domestic god

> Graham: I'm a full-time dad. I'm a working parent. I'm a mother and
> a father [...] I spend my weekends buying tutus. I'm learning to
> sew. I'm Mr. Napkin Head!

The nurturing and committed father and/or culinary-skilled 'domestic
god' is thriving in chick flicks, as outlined by Graham's list of domes-
tic accomplishments as a single father, and this facet also shows how
the New Hero is developing traits which were originally constructed
in the 'domestically competent' 'new man', who was 'fully involved
in domestic tasks, including child-rearing'.[25] Alongside Graham there
are other single fathers in *Definitely Maybe*, *New In Town* and *Enchanted*
(Lima, 2007) and there are also 'father-figures' – men who are not bio-
logical fathers, but care for children nonetheless – in the films *Failure to
Launch*, *You've Got Mail*, *No Reservations* (Hicks, 2007) and *What Happens
in Vegas* (Vaughan, 2008).[26]

Other New Heroes, while not necessarily appropriating the 'father-
figure', are shown to be comfortable in domestic spaces fulfilling
domestic roles, most notably in the film adaptations of *Bridget Jones's
Diary* and *Sex and the City* (King, 2008). Both Mark Darcy (Colin Firth)
and Mr Big (Chris Noth) happily cook for their respective heroines in
the private space of the kitchen, which has long 'been read in gendered
terms' as a 'feminine space'.[27] Critics have noted recently that 'images
of men cooking are now commonplace in Western popular culture' yet
this is contrasted with the fact that 'sociological research [shows] that
women rather than men primarily plan for, purchase and cook food in
the home'.[28] Along with this is the difficulty of finding any 'convinc-
ing evidence that there has been a change in the amount of practical
work men actually do as fathers', suggesting perhaps that although the
New Hero represents this 'facet' of the father-figure/domestic god, lived
reality is somewhat different.[29]

Lauren Jade Thompson discusses the complexities of gendered domes-
tic spaces represented in romantic sex comedies at length in Chapter 9
of this collection, concluding that masculinity struggles to find its 'true
home' in the domestic realm. Not so in chick flicks, where this facet
forms a distinct part in the construction of the New Hero identity, and
along with the broken heart and the final compulsory facet of devotion
to the heroine, emphasizes how the New Hero is being presented to the
female consumers of chick flicks as a male who is comfortable exhibiting
traditional female emotion and inhabiting traditionally female spaces.

Compulsory devotion and an openness to declare it

> Graham: I have another scenario for you – I'm in love with you. I apologise for the blunt delivery, but as problematic as this fact may be, I'm in love with you [...] I can't figure out the mathematics of this, I just know I love you.

The most important facet of the identity of the New Hero – one that is compulsory for all – is that he is shown to be in love with the heroine and wholly devoted to her, if not at the beginning of the text, certainly by the end. Declarations of love are common in chick flicks, often given in the form of an extended speech like Graham's, as in *Letters to Juliet*, *Wimbledon*, *Two Weeks Notice* or *Made of Honour* (Weiland, 2008), or at times expressed through a song, as in *A Lot Like Love* and *Music and Lyrics*. Even in films where the couple have bickered, argued or seemingly hated each other throughout, by the end the New Hero will be devoted to his heroine, as in *27 Dresses*, *The Proposal*, *What Happens in Vegas*, *You've Got Mail*, *Just Like Heaven* and *How to Lose a Guy in 10 Days*.

This final facet will ensure the heroine is partnered with the correct man – the New Hero – rather than a man who may appear to be the right one, but is in fact an anti-hero (as discussed above in the context of the facet of attractiveness). These anti-heroes, however attractive or successful they may be, will never measure up to the New Hero because they are clearly shown as being unable to love her or commit to her, usually due to their being overly self-involved. The New Hero is thus presented as the ideal leading man, and becomes the archetypal chick-flick hero.

Performing the rescue

There is a further compulsory element in the construction of the New Hero character, demonstrated through the role he must play in the narrative of 'rescuing' the heroine. There are four main types of rescue and the New Hero will perform at least one, but, like Graham, some may perform all four.

Teacher

> Graham: I think you should get dressed. We should take a drive, get some lunch and get to know each other.

Chick flicks which use a 'teacher' rescue portray heroines who require educating and a New Hero who provides the education needed. This

education can take a variety of forms, but will always result in the heroine's increased success and/or happiness, along with an indebtedness to the New Hero for his assistance.

The heroine may need educating about the world she inhabits – for example, the heroines of *New In Town, No Reservations* and *13 Going on 30* need educating about their respective 'worlds' of Minnesota, cookery and the future (this heroine has time-travelled forward and has no recollection of the interim 17 years). Alternatively, the heroine may need to be taught about her role within the world she inhabits, and the New Hero will regularly give career advice to the misguided heroine, as in *You've Got Mail, Letters to Juliet* and *How to Lose a Guy in 10 Days*. The main task for the New Hero 'career advisor' is not necessarily to inform the heroine of what she should do, although at times he will do this, but rather he is required to encourage and persuade her that she is good enough to achieve her career aspirations. In *You've Got Mail* the hero suggests the heroine should write a children's book, and she goes on to pursue this career, claiming that it was partly the hero's 'insight into her soul' which helped her to do so. That he was also the one to put her out of business, which gives her the time to write the book, is never explicitly discussed.

A further development of the 'teacher' rescue is the New Hero providing a 'voice of reason' for the heroine. This is found in *27 Dresses*, *Sliding Doors* and *Kate and Leopold* (Mangold, 2001) where the hero must rationally point out the irrationality of the heroine's life choices and explain how the heroine should change in order to be happy and/or successful. The advice given by the New Hero's 'voice of reason' is inherently rational and practical, which is the emphasis of the teacher rescue. This rescue implies the heroine is lacking in knowledge, understanding or common sense, and therefore must be educated by a knowledgeable, rational hero, perpetuating the traditional stereotype of the 'hysterical' feminine who requires 'the enlightened reason of the male'.[30]

Benefactor

Graham: I realise I come as a package deal – three for the price of one.

Diane Negra recognizes the benefactor role in *Two Weeks Notice* and *Maid in Manhattan*, commenting that in these films female aspirations are 'fundamentally unachievable without wealth and a male patron'.[31] In 'benefactor' rescues, the heroine will benefit from the New Hero's wealth and/or influence. Although in the case of the two films identified by Negra the heroine has a desire to help others, in most cases it is the

heroine herself who will gain from this rescue. The benefactor rescue can be as simple as the New Hero inspiring an idea which goes on to 'save' the heroine's career, as in *A Lot Like Love* or *13 Going On 30*, or as large as the New Hero buying the heroine her dream home as in the first *Sex and the City* film, rescuing the heroine from prison as in the second *Bridget Jones* film (Kidron, 2004), or providing the heroine with a life of luxury and leisure as in *Kate and Leopold*.

Another way the heroine can benefit from the 'benefactor' rescue is connected to the facet of the New Hero as 'father-figure/domestic god'. In these narratives the heroine is portrayed as gaining a family and the role of motherhood, depicted in *The Holiday*, *New in Town* and *Enchanted*. Significantly, in both *The Holiday* and *New in Town* the heroine is represented throughout the film as a career woman who has perhaps neglected her personal life, and there is an implication that she will be 'restored' not only by her relationship, but by the family she will inherit through it. These benefactor rescues exemplify established gender roles both in this way and also by emphasizing the traditional concepts of the 'breadwinner' and the 'kept woman' as the New Hero becomes the means by which the heroine will obtain whatever she may 'need' and/or desire.

Doctor

> Graham: You are quickly becoming one of the most interesting girls I've ever met. Look at you. You're already better than you think.

Much has been written regarding female illness in film, in particular by Mary Ann Doane who suggests that the 'sick woman in bed' is commonplace in the traditional 'woman's film' and in these films 'the heroic male figure, a locus of wisdom and safety as well as eventual romance, is a doctor'.[32] While chick flicks continue this traditional representation of the sick woman saved by the heroic male 'doctor', there have been developments in the way this occurs, most notably that the New Hero is now rarely, if ever, actually a doctor. Yet in *The Perfect Catch* (Farrelly and Farrelly, 2005), *50 First Dates* (Segal, 2004) and *Just Like Heaven* the New Hero assumes this role – in *Just Like Heaven* this is to the extent of literally saving the heroine's life, administering CPR while real doctors simply stand by and watch.

Another type of care the New Hero can offer is that of a therapist or counsellor for a traumatized or confused heroine, as in *The Holiday*, *Music and Lyrics* and *27 Dresses*. Although there is a similarity here to the 'voice of reason', in these examples the advice given is less about

rationality and more about assurance, care and support. Even in films where the heroine is already seeing a therapist, such as *No Reservations* and *The Holiday* (the second narrative with Kate Winslet), the heroine is only able to fully deal with her emotional issues when she is counselled by the New Hero. Winslet's character is offered therapy by both her New Hero and another male character, to whom she says 'I've been going to a therapist for three years and she's never explained anything to me that well' – significantly, her therapist is female. The 'doctor' rescue makes clear the frailty of women, a long-established cultural convention, and suggests that women require male strength and support to overcome their weaknesses.

Guardian angel

Amanda: Why did you stay?
Graham: Because you asked me to.
Amanda: I did, didn't I? Did I beg at one point?

This final rescuer category encompasses the many narratives where the New Hero saves the heroine from a bad situation; he may do so in any number of ways, but it is consistently clear that he is the one needed to rescue her. In *The Proposal, Notting Hill* and *Sweet Home Alabama* heroines require 'rescuing' from their career, which, although very successful, is represented as negatively affecting the heroine, and in *A Lot Like Love, Made of Honour* and *27 Dresses* heroines are 'rescued' from being in love with another man.

A number of recent films have featured a single woman deciding to have a baby through either surrogacy or artificial insemination – for example, *Baby Mama* (McCullers, 2008), *The Back-Up Plan* (Poul, 2010) and *The Switch* (Gordon and Speck, 2010). Yet even though in each film the heroine has chosen to have a baby alone, the New Hero is depicted as 'rescuing' her from single motherhood, regardless of whether he is actually the child's father. This act of rescue not only suggests an inadequacy in women but perhaps also offers a critique of recent developments in reproductivity: that women are now able to have children *without* direct or continuing involvement from a man is presented negatively. These films are firmly situating reproduction within the context of a heterosexual relationship, reinforcing conventional ideas of 'family'.

Finally, a heroine may simply need rescuing from herself and destructive patterns of behaviour, as in *The Holiday* (both narratives), *How to Lose a Guy in 10 Days* or *Runaway Bride*. The women in these films are portrayed as being unable to help themselves as they are trapped by

pride, fear or their own past mistakes; once again they can only be saved by the rationality, strength and stability of the New Hero.

Conclusion

> [New man] is a fraught and uneven attempt to express masculine emotion [...] full of inconsistencies and contradictions [...but] the new liberalised image of men [...] looks nice and it's *what women want*.[33]

Rutherford made this claim that the 'new man' is 'what women want' in the late 1980s, regardless of the concurrent critique that such a man did not exist, but was 'an ideological construct'.[34] Yet, even though he did not actually exist 25 years ago when 'new man' was at his hegemonic peak of cultural status, aspects of this character are still being reimagined within the contemporary cultural incarnation of New Hero. Obviously, without further ethnographic research with the female viewers of these films nothing can be stated imperatively, but given the continuing popularity of these chick flicks and their New Heroes, there is certainly weight to once again claim that this is the version of masculinity that women want.

However, another option, perhaps more likely, is that rather than these texts *fulfilling* female desire and pleasure by portraying the New Hero archetype, they are in fact *forming* female desire and pleasure by consistently using this representation. It could be that women believe they want this particular ideology of masculinity – the New Hero – precisely because the popular cultural texts they are consuming have constructed this. Crucially though, if searching for a 'new man' in the 1980s was considered by many to be futile,[35] is the New Hero equally elusive? It is rather implausible to presume that a man exerting at least three facets of the New Hero character would happen to appear in a woman's life at exactly the time she requires a teacher, benefactor, doctor or guardian angel to rescue her. So, are chick flicks simply perpetuating the New Hero as an ideological construct, all the while aware of the irony that real life does not offer such a man? After all, irony has been recognized as a staple ingredient of postfeminist culture.[36] Or is it conceivably more feasible that these texts are offering women a fictitious version of what is 'impossible' to find in real life, a kind of consolation prize and a chance to escape? Roberta Garrett suggests as much: 'Lacanian approaches to the romance fantasy have long pointed to its compensatory function: it exists to provide the consoling illusion

that true oneness with "the other" is possible'.[37] Perhaps contemporary women *know* this is a fantasy, that these men don't actually exist and there is no New Hero who will step in and save the day, but these films are a means to escape the lived reality of this. Further, consumers can rely on these films for this escapist experience precisely because of their formulaic construction: the consistency of the New Hero characterization and the rescue narrative could offer a pleasurable familiarity and stability to the consumer. As Joanne Hollows explains:

> In a postfeminist landscape in which it is often manifest that contemporary femininity is multiple and complex, the desire to temporarily [experience something] [...] simpler and less contradictory than the present, can also appear to offer a sense of escape from the pressures of managing and ordering both everyday life and feminine selves.[38]

The New Hero paradigm offers this 'simpler and less contradictory' version of reality to the consumers of these films, allowing them a chance to vicariously experience and enjoy this masculine 'ideal' and the rescue process through the heroines of these films. But if this is the case, there is a need to question what exactly the New Hero means for postfeminism and gender politics. What does this pervading ideology advocate to contemporary women about the role of men in their lives? What does the New Hero's hegemonic status mean for feminism?

A key point in Connell's theory of hegemonic masculinity is that men rarely embody the current version of the hegemonic ideal, but all men will benefit from its existence through the 'patriarchal dividend' – the advantage that all men can claim subordination of women because of the power assumed by hegemonic masculinity.[39] Rowena Chapman recognized this concept at work within the 'new man' figure:

> The new man is many things – a humanist ideal, a triumph of style over content, a legitimation of consumption, a ruse to persuade those that called for change that it has already occurred. Another more sinister possibility is that he is a patriarchal mutation, a redefinition of masculinity in men's favour, a reinforcement of the gender order, representing an expansion of the concept of legitimate masculinity, and thus an extension of its power over women.[40]

If 'new man' demonstrated this more sinister possibility, so does New Hero. Through persistently representing the New Hero, chick flicks are working to reinforce the ideology of patriarchy to contemporary women

and substantiate the traditional gender order, as women are portrayed as deficient, incompetent or simply incomplete without a man. Therefore, as Connell suggested, this hegemonic ideal works to benefit all men regardless of whether or not they personify the New Hero.

Diane Negra notes a number of ways in which postfeminism has 'forcibly renewed conservative social ideologies', and concludes that 'the overwhelming ideological impact that is made by an accumulation of postfeminist cultural material is the reinforcement of conservative norms as the ultimate "best choices" in women's lives'.[41] Having examined the representation of masculinity in these popular chick flicks, it is clear that these postfeminist cultural texts do not reinforce conservative norms as just the best choice for women, but as simply *the way things are* – specifically that women are weak and men are strong, that women are irrational and men are rational, that women are ultimately lacking and in need of rescue. Here, there are no choices at all, just the inevitability of the inferiority of women.

The New Hero relentlessly pervades contemporary chick flicks, promoting a traditional, conservative, potentially anti-feminist ideology to the female consumers of these texts. Ferriss and Young conclude that, regardless of any surrounding issues, women will go on consuming these films (and therefore the representation of masculinity within them) as 'most viewers of chick flicks are likely to never consider the political ramifications of postfeminism'.[42] Perhaps though, it is not that politics are not considered, but that this in essence *is* postfeminist chick culture: a persistent undermining of feminist goals and gains, neatly packaged in a glossy, consumer-driven fantasy which has little to do with the actuality of the real-life issues of contemporary women.

Notes

1. Misha Kavka, 'Feminism, Ethics and History, Or, What is the "Post" in Postfeminism?', *Tulsa Studies in Women's Literature* 21:1 (Spring, 2002), p. 32.
2. Stéphanie Genz and Benjamin A. Brabon, *Postfeminism: Cultural Texts and Theories* (Edinburgh: Edinburgh University Press, 2009), p. 1.
3. Stéphanie Genz, *Postfemininities in Popular Culture* (Basingstoke: Palgrave Macmillan, 2009), p. 24.
4. Rosalind Gill and Elena Herdieckerhoff, 'Rewriting the Romance: New femininities in Chick Lit?', *Feminist Media Studies* 6:4 (2006), pp. 499–500.
5. This body of work includes but is not limited to Suzanne Ferriss and Mallory Young, *Chick Flicks: Contemporary Women at the Movies* (London: Routledge, 2008) and *Chick Lit: The New Women's Fiction* (London: Routledge, 2006); Joanne Hollows and Rachel Moseley, *Feminism in Popular Culture* (Oxford: Berg, 2006); Caroline J. Smith, *Cosmopolitan Culture and Consumerism in Chick*

Lit (London: Routledge, 2008); Diane Negra, *What a Girl Wants? Fantasising the Reclamation of Self in Postfeminism* (Abingdon: Routledge, 2009); Stacey Abbott and Deborah Jermyn, *Falling in Love Again: Romantic Comedy in Contemporary Cinema* (London: I.B. Taurus, 2009); Stephanie Harzewski, *Chick Lit and Postfeminism* (Charlottesville, VA and London: University of Virginia Press, 2011). Two recent articles have examined masculinity within chick culture to some extent: Diane Negra, 'Structural Integrity, Historical Reversion, And The Post-9/11 Chick Flick', *Feminist Media Studies* 8:1 (2008), pp. 51–68; Laura A. K. Brunner, 'How Big is Big Enough?', *Feminist Media Studies* 10:1 (2010), pp. 87–88.

6. Mark Rubinfeld, *Bound to Bond: Gender, Genre and the Hollywood Romantic Comedy* (London: Praeger, 2001), p. xv.

7. Helen Fielding, *Bridget Jones: The Edge of Reason* (London: Picador, 1999), p. 4.

8. While the 'chick flick' label existed prior to this particular incarnation, the positive reclamation of the chick flick within the wider chick culture alongside chick lit and other cultural forms, has perhaps restored interest for contemporary women in this increasingly popular genre.

9. Laura Mulvey, 'Visual Pleasure and Narrative Cinema', *Screen* 16:3 (1975), p. 11.

10. Brunner, pp. 87–88.

11. Mulvey, p. 11.

12. Chick flick 'formula' is discussed in Claire Mortimer, *Romantic Comedy* (London: Routledge, 2010).

13. Quote: John Beynon, *Masculinities and Culture* (Buckingham: Open University Press, 2002) p. 5. This body of work includes but is not limited to Beynon; Harry Brod and Michael Kaufman, *Theorizing Masculinities* (London: Sage, 1994); Rowena Chapman and Jonathan Rutherford, *Male Order: Unwrapping Masculinity* (London: Lawrence and Wishart, 1988); R.W. Connell, *Masculinities* (Cambridge: Polity, 1995); Tim Edwards, *Cultures of Masculinity* (Abingdon: Routledge, 2006); Michael Kimmel, *Manhood in America* (Oxford: Oxford University Press, 2006); John MacInnes, *The End of Masculinity* (Buckingham: Open University Press, 1998); Lynne Segal, *Slow Motion* (Basingstoke: Palgrave MacMillan, 2007).

14. Kimmel, p. 5.

15. Connell, pp. 76–77; Beynon, p. 16.

16. Connell, pp. 76–77.

17. Beynon, pp. 120–121.

18. Gill and Herdieckkherhoff, p. 495.

19. Ferriss and Young (2006), p. 88.

20. Rosalind Gill, Karen Henwood and Carl McLean, 'Body Projects and the Regulation of Normative Masculinity', *Body and Society* 11:1 (2005), p. 39.

21. Executives: *How to Lose a Guy in 10 Days*, *Definitely Maybe* (Brooks, 2008) and *The Family Stone* (Thomas, 2005); Lawyers: *Bridget Jones' Diary* (Maguire, 2001) and *Letters to Juliet* (Winick, 2010); Creatives: *The Holiday*, *Sweet Home Alabama*, *Music and Lyrics* and *13 Going On 30* (Winick, 2004); Politicians: *Maid in Manhattan* (Wang, 2002) and *Love Actually* (Curtis, 2003); Journalists: *Runaway Bride* (Marshall, 1999) and *27 Dresses* (Fletcher, 2008); Tennis player: Obviously, *Wimbledon* (Loncraine, 2004).

22. Tim Edwards, *Men in the Mirror: Men's Fashion, Masculinity and Consumer Society* (London: Cassell, 1997), p. 22.
23. This 'Broken-Hearted Redemption' is discussed at length in Rubinfeld (2001).
24. Rubinfeld, p. 13.
25. Beynon, p. 120.
26. As with Diane Negra, I feel it is appropriate to include *Enchanted* as a chick flick. See Negra's *What a Girl Wants? Fantasizing the Reclamation of Self in Postfeminism* (London and New York: Routledge, 2009), pp. 12–14.
27. Kerstin Fest, 'Angels in the House or Girl Power', *Women's Studies* 38:1 (2009), p. 59
28. Kate Cairns, Josée Johnston and Shyon Baumann, 'Caring About Food: Doing Gender in the Foodie Kitchen', *Gender and Society* 24:5 (2010), p. 591.
29. Segal, p. 29.
30. Sandra M. Gilbert and Susan Gubar, *The Madwoman in the Attic* (New Haven: Yale University Press, 2000), p. 53.
31. Negra (2008), p. 54.
32. Mary Ann Doane, *The Desire to Desire* (Indianapolis, IN: Indiana University Press, 1987), p. 63.
33. Jonathan Rutherford, 'Who's That Man' in Rowena Chapman and Jonathan Rutherford, *Male Order: Unwrapping Masculinity* (London: Lawrence and Wishart, 1988) , pp. 32, 34, emphasis added.
34. Pierrette Hondagneu-Sotelo and Michael Messner, 'Gender Displays and Men's Power: The "New Man" and the Mexican Immigrant Man' in Harry Brod and Michael Kaufman, *Theorizing Masculinities* (London: Sage, 1994), p. 206.
35. Imelda Whelehan, *Overloaded: Popular Culture and the Future of Feminism* (London: The Women's Press Ltd, 2000), p. 6
36. Roberta Garrett, *Postmodern Chick Flicks* (Basingstoke: Palgrave Macmillan, 2007), p. 208; Angela McRobbie, 'Postfeminism and Popular Culture', *Feminist Media Studies* 4:3 (2004), p. 262.
37. Garrett, p. 11.
38. Joanne Hollows, 'Feeling like a Domestic Goddess: Postfeminism and Cooking', *European Journal of Cultural Studies* 6:2 (2003), p. 195.
39. Connell, 79.
40. Rowena Chapman, 'The Great Pretender: Variations on the New Man Theme' in Rowena Chapman and Jonathan Rutherford, *Male Order: Unwrapping Masculinity* (London: Lawrence and Wishart, 1988), p. 247.
41. Negra (2009), pp. 47, 4.
42. Ferriss and Young (2008), p. 14.

9
Mancaves and Cushions: Marking Masculine and Feminine Domestic Space in Postfeminist Romantic Comedy

Lauren Jade Thompson

'I buy these nice towels, and he whacks off into them!' complains Debbie (Leslie Mann), of her husband Pete (Paul Rudd) in Judd Apatow's romantic comedy *Knocked Up* (2007). The statement illustrates a common trend in postfeminist media representations of domestic space, which sees men and masculinity as disruptive and dirty presences in feminine or familial domestic spaces. In this chapter, I use as a case study the genre of the romantic sex comedy as a platform from which to explore some of the common themes, motifs, strategies and aesthetics for representing the relationship between men, women and home within postfeminist culture. Despite observable patterns and motifs in the way in which men and domestic spaces are related within contemporary Hollywood cinema, the question of media representations of male domestic life still remains largely untheorized outside of studies such as those surrounding the figure of the male celebrity chef or the (camp) interior design tastemaker.[1] I would also contend here that the exclusion of men from theorizations of contemporary domestic life reflects wider trends within writing on postfeminist culture, in which the complex and changing position of men within this paradigm of gender is persistently overlooked. In what is obviously a highly gender-conscious discourse, there is a tendency to marginalize discussion of men and masculinity, or to treat their representation as more simplistic or less serious. For example, in her seminal article on the postfeminist sensibility, Rosalind Gill suggests that if men are participants in makeover shows, the work on the self is marked as 'less serious',

and Imelda Whelehan goes as far as to dismiss 'evidence that men as a group are suffering acutely from escalating changes in job security and employment practices' as a 'moot point'.[2] Implicit in this persistent omission of masculinity in definitions and critical examinations of postfeminist culture is the suggestion that masculinity is somehow less problematic than femininity, and that it is of comparatively less interest to feminist scholars.

Furthermore, Whelehan's account of popular cultural discourses surrounding masculinity in the 1990s focuses on two media constructions – the sensitive 1980s 'new man' and the 1990s 'new lad'.[3] She is not alone in treating postfeminist masculinities within a polarized structure, and, while I am sympathetic to (and, indeed, supportive of) the aims of Whelehan and others in highlighting the continued sexual exploitation and objectification of women in postfeminist culture, it is important to consider how masculinity is increasingly subject to its discourses. In many ways, existing accounts of postfeminism can be seen to binarize the difference between masculinity and femininity to just as great an extent as the cultural products that they criticize. This issue should be of serious concern to feminist scholars, as this critical move threatens to subtly (and often, unintentionally) reproduce older binaries of gender that see femininity as constructed and masculinity as 'natural' and unmarked.[4] Although, as Michael S. Kimmel has noted, second-wave feminism launched a successful critique of gender construction and rendered masculinity problematic, critiques of postfeminism have yet to adequately address this issue.[5] Part of my intention in this chapter, then, is to write awareness of the 'making of men' into our examinations of and attitudes to postfeminist culture.[6] This is not to overlook many of the problematic aspects of gendered culture that postfeminism reproduces in relation to women, but, if anything, to draw further attention to the problem by highlighting the disservices – stereotypes, restrictive gender roles, and marginalized positions – that postfeminist culture also ascribes to men.

Following the model of exploring the 'internal dynamic relations' of cultural process put forward by Raymond Williams, I understand postfeminist formations of masculinity as characterized by not just dominant but also 'residual' and 'emergent' characteristics.[7] In the light of this, this chapter does not attempt to define 'postfeminist masculinity' as something distinct from 'traditional masculinity', but rather to discuss the ways in which postfeminist Hollywood cinema tracks transformations in the role of men through formations that hold continuities with hegemonic, and even archaic, depictions of masculinity alongside

'new' emergent masculine images, emphases and values. In doing so, I owe a debt to Charlotte Brunsdon's work in *Screen Tastes: Soap Opera to Satellite Dishes*.[8] In the 1970s Hollywood cinema that she discusses, Brunsdon's 'Cosmo girl' must retain femininity while aspiring to sexual satisfaction and career success, while moving into traditionally masculine roles. Her position is therefore 'contradictory and fragmented'.[9] The romantic comedy texts discussed within this chapter chart the manoeuvring of (sometimes reluctant) men into the ideal subject position of postfeminism. Like the Cosmo girls of the late 1970s, the position of men within postfeminist media texts is affected by a series of material and non-material shifts in lived culture (some of which are the same as, or intensifications of, the shifts that Brunsdon identifies as underpinning the construction of her subject).[10] Thus, while films such as *An Unmarried Woman* (Paul Mazursky, 1978) deal with a protagonist's struggle to remain feminine while also being 'alert, aggressive [and] ambitious', films like *The 40-Year-Old Virgin* (Judd Apatow, 2005) demonstrate the requirement for men in postfeminist media texts to remain 'masculine' while also acquiring the emergent traits of being caring, soft, aestheticized and domesticated. What is under consideration in this chapter, therefore, is the particular formation produced by the coming into contact of traditional modes of masculinity with a postfeminist discursive context. A postfeminist formation of masculinity must necessarily be understood as relational – to images of traditional masculinity, to postfeminist images of women, and to the insistence upon heterosexual coupling that characterizes both postfeminist media discourses and the romantic comedy film. While masculine identity has previously been constructed outside of the domestic, in the public sphere, the post-industrial context of postfeminism has sharpened focus on men's private lives.

Domestic space therefore becomes the representational battleground of the 'working out' of male–female relationships in a postfeminist era and for a particular imagining of masculinity that is constructed through the private. The social changes underpinning postfeminist culture have also led to the increased visibility of an emergent figure, the 'man-child', as men become released from the responsibilities of traditional hegemonic masculinity and live out an extended youth, which Tim Havens goes as far as to argue has become hegemonic in American culture.[11] This seems at odds with postfeminist culture's insistence upon coupling, and as such there is a growing body of Hollywood films in particular that are extremely ambivalent in their attitude towards coupling, recognizing its necessity and inevitability while painting it as loss.[12]

In the films in which I am interested here, it is in the design and set-up of domestic space through which these anxieties and tensions over single and coupled masculinities are fought.

The romantic comedies under analysis here are ideal texts with which to further this argument, because they themselves represent the ungendering of a Hollywood genre previously aligned strongly with feminine culture, placing as they do a male protagonist at their centre and offering his conversion to coupled heteronormativity as what is at stake in the narrative. Unlike others who have chosen to give this subgenre a name that emphasizes its gendered difference from the (neo)-traditional romantic comedy, such as Tamar Jeffers McDonald's 'homme-com', or Gill and David Hansen-Miller's 'lad flicks', my preferred descriptor, the 'romantic sex comedy', seeks to emphasize continuity with what has been produced before.[13] The phrase is intended to position these films within a history of romantic comedy, in particular recalling the battle-of-the-sexes romantic comedies of the late 1950s/early 1960s (where domestic space was also a key battleground). The term also deliberately does not privilege men as an audience for these films, reflecting, I hope, a more dual-gendered address in line with the 'date movie' status that is integral to their success. Thus, while I agree that the romantic sex comedy is, as Jeffers McDonald argues, 'aimed at attracting a male audience', I also feel that the retention of romance and coupling as a key element in these films (as noted by most of the scholars mentioned above) represents a significant and largely unchallenged continuity with romantic comedy proper.[14] This reflects the genre's continued address to a feminine audience as well as its attempt to attract new male viewers.

As well as being located at a nexus of debates about shifting gender roles and paradigms observable both within the texts themselves and in the debates surrounding them, the films in the romantic sex comedy subgenre are also useful because of what Hansen-Miller and Gill describe as their 'aesthetic banality'.[15] The often suburban, domestic setting of the films and their emphasis on the ordinary and the everyday makes them key to understanding cultural formulations of masculinity at the beginning of the twenty-first century, particularly in relation to the concept of 'home'. Indeed, as Amy Burns suggested in the previous chapter, domestic competence and expertise is increasingly positioned as a key characteristic of the 'New Hero' of romantic comedy, an emergent feature of masculine desirability in postfeminist texts. The emphasizing of these domestic locations within the romantic comedy genre also suggests that the configuration of domestic life is central to the negotiation of heterosexual coupling at a more general social level.

Not only does the production design of many of the films in this sub-genre aesthetically foreground the gendering of domestic space but the arrangement of living space is frequently highlighted as a key concern through the dialogue, narrative or character development. Indeed, in a film such as *The Break-Up* (Peyton Reed, 2006), the entire plot centres on a war over the gendered division of space. The narrative concerns a couple who separate during the film's set-up, but must continue to cohabit their shared apartment until it is sold. As a couple, Gary (Vince Vaughn) and Brooke (Jennifer Aniston) are shown to have made compromises in order to live together in the space harmoniously. When they break up, however, their relationship to each other and the space shifts – they become two single people of different genders fighting a vicious battle over what was once neutral, shared territory. Crucially, it is the male partner, Gary, who is presented as disrupting the domestic norms that previously governed the space.

After an argument, the couple's apartment is separated into gendered areas.[16] Gary's space is characterized by contingency. The sofa-bed on which he sleeps foregrounds the temporary, makeshift nature of his habitation of the lounge. Gary persistently leaves the sofa-bed – an item of furniture designed to be folded away neatly, hidden and disguised – unfolded and unmade, a repeated motif that inscribes the disruption and disorder of both the relationship and the domestic space into the *mise-en-scène* of the film. Brooke, by contrast, is able to keep the master bedroom, which she colonizes by playing Alanis Morissette music and throwing Gary's clothes out into the hall. The arrangement and division of the space along gendered lines has several implications – the first being the feminine remains imbedded in the softness of the most private spaces of the home. Along with the master bedroom, Brooke is frequently shown in the kitchen. These two spaces represent the 'heart' of the home, suggesting femininity and domesticity as intertwined and restricting the female role to the sites most closely associated with women's sexual and domestic labour.

The bedroom is also, crucially, the only private space, the only area of their open-plan apartment that can physically be shut off from the rest, and the door to the bedroom is presented as a barrier to the reconciliation of the couple at several points in the film. The absolute privacy attributed to feminine space here, however, is contrasted dramatically with the increasingly public nature of the space that Gary inhabits. The home is presented as a site of leisure for Gary, and increasingly so as the film's narrative progresses.[17] The television, showing sports or video games, is always on when he is present in the living room, and the day

after the couple split up, he installs a pool table in their dining room. Clearly, the home can be quickly transformed into a space for masculine leisure and homosocial bonding. This representation of the masculinization of domestic space as a transformation into leisure space escalates throughout, culminating in a scene in which Gary holds a poker night in his home, complete with strippers. When Brooke returns, the lighting and *mise-en-scène* emphasize the de-domestification of the space. The living room is darkened, lit by a strobe light and disco ball; the men sit around on leather couches while a woman gyrates topless in the centre of the floor. The home has fully adopted the aesthetic of a masculine leisure space – that of a strip bar. The film therefore seems to align masculinity with the public sphere even when it is contained within the home: Brooke is closely associated with the private, closed-off spaces of the apartment, and Gary is instrumental in the transformation of their home into semi-public space.

Putting the couple's home at the centre of the narrative struggle, *The Break-Up* illustrates the extent to which domestic space is used within the romantic sex comedy both as a reflection of gendered norms and as a visual representation of the state of the romantic relationship of the protagonists. In this chapter, I am particularly interested in patterns of representation of masculine domesticity that recur throughout the romantic sex comedy genre. These include: scenarios in which men disrupt feminine or familial homes; the presentation of domestic spaces designed for and around the masculine; and the transformation of domestic space as reflective of transformations in the life of the male protagonist.

The single male situated outside of domestic order and as an actively disruptive force is a potent cultural image in relation to male domesticity, and a trope that we see repeated throughout the romantic sex comedy subgenre. For example, the narrative of *You, Me, and Dupree* (Anthony Russo and Joe Russo, 2006) sees the home of newly-wed couple Carl and Molly Peterson (Matt Dillion and Kate Hudson) invaded by Carl's single, unemployed friend Dupree (Owen Wilson). As in *The Break-Up*, the single male does not inhabit a private, partitioned bedroom, but must live in the open-plan reception room, sleeping on a temporary bed. As well as serving to exacerbate the narrative and spatial disruption caused by his presence, this arrangement of space also reinforces the idea that masculinity is out of place in the family home.

Much like Gary's sofa-bed, Dupree is unable to be 'tidied away' in order to restore the domestic order. Dupree's presence immediately

alters the design of the couple's stylish, contemporary home. He enters carrying a moosehead, ukulele and zebra-print beanbag, which from then on are installed into the production design of the Peterson's living room. The moosehead and zebra-print pattern stand out, bringing the aesthetics of wildness, hunting and nature into the domestic space. Dupree's association with these items, signifiers of residual, prehistoric masculinity, reminds the viewer of the matched semantics of bachelorhood and hunting – for example, being 'on the prowl', 'ensnaring' and 'going wild'. Dupree is surrounded by representational codes that are resolutely non-domestic. This contrast between civilized, socialized, coupled domesticity and natural, raw, single masculinity is further emphasized in a scene set the following morning, when Carl and Molly emerge dressed ready for work in dark tailoring and Dupree is sprawled-out naked on their couch. He appears *au naturel* in an artificial habitat.

Taking this reading a stage further, we might consider the significance of the two instances in the film in which Dupree is shown blocking the Peterson's toilets. While one toilet-blocking might be played for laughs, its repetition suggests that the event is significant beyond its creation of comedy. First, of course, the blockages represent further disruption to the domestic equilibrium by the single male. Further to this, however, is the underlying suggestion that Dupree's shit is literally too big to be contained by domestic plumbing. Once again, the excessive, animalistic and primal nature of his residual masculinity is at odds with the artificial environment of the home, and, since it does not belong there, threatens its destruction. This is ultimately realized within the narrative when, in another failed attempt to make use of a feminine domestic object, Dupree burns down the house with candles that he has lit in order to seduce a date. Not only has his masculine presence disrupted the home to such an extent as to obliterate it completely, but he has done so via a force that has implicit connections to the figure of ancient man – fire.

Of course, the scatological humour of Dupree's toilet mishaps also highlights a central departure of the romantic sex comedy from romantic comedy proper – the embracing of gross-out humour as part of the genre's iconography. Jeffers McDonald notes that it is in the 'evident prioritising of ... scatological and carnal motifs' that this subgenre seems most 'boldly different' from what has come before it.[18] What I would like to emphasize here, however, is just how often it is specifically the domestic arena that is disrupted by the scatological and the carnal. Indeed, many of the most memorable gags in gross-out comedy film share this context. It seems there is nothing funnier than the

contrast between the ordered, stable norms of the family home and the spectacle of the uncontrolled male body, summed up, perhaps, in the image of Jim (Jason Biggs) plunging penis-first into his mother's freshly-baked apple pie in *American Pie* (Paul Weitz, 1999). As well as offering a paradigm of gender that places masculinity and femininity in opposition, this also seems to suggest that men are out of place in the private sphere, and cannot be contained by it.

As the quoted dialogue from *Knocked Up* that opened this chapter perhaps suggests, it is also the emissive potential of male sexuality, and its disruption to the very fabric of the domestic, that is played upon in such scenes in the romantic sex comedy. The gross-out humour contained within the genre frequently relies upon the suggestion that there is no proper place for semen in the family home, and that thus it is liable to escape, stain, seep and ruin – all with hilarious consequences. As well as Debbie's towels, we might think of Rita (Wendy McLendon-Covey) in *Bridesmaids* (Paul Feig, 2011) complaining that there is 'semen everywhere' in her house and that she is forever 'cracking blankets'. In *She's Out of My League* (Jim Field Smith, 2010), Kirk admires Molly's 'gorgeous' apartment, before prematurely ejaculating on her sofa, just as her parents arrive to visit. In all of these cases, male emissive sexuality literally affects the materiality of domestic life.

The repetition of this motif indicates an underlying suggestion that masculinity, and in particular, masculine sexuality, cannot be privatized, cannot be socialized, cannot be contained by the civilizing influence of the domestic sphere. This representation is particularly salient when considered alongside the creation of Sydney's 'mancave' in *I Love You, Man* (John Hamburg, 2009), which contains a 'jerk-off station', a chair and side table with hand lotion and condoms on it. As Peter is shown around, a point-of-view close-up shot is used to draw attention to the detail of the area. The audience's assumed mixture of surprise and revulsion is initially mirrored by Peter, but the scene seeks to prove the virtues of the masturbation-station. As Sydney points out, the condoms ensure that 'there's no sticky mess to clean up', and, since women are banned from the space, no one will be offended by its presence. In the all-male space of the mancave, semen has its own place, and thus ceases to be disruptive, presenting us with a contradictory picture of postfeminist male sexuality that is more functional in the absence of women than in their presence. The emissive nature of male sexuality is used repeatedly within the romantic sex comedy as a site for humour and to highlight the disjuncture between the norms of bodily masculinity and the artificial socializing structures of domestic life.

The representational pattern of men disrupting feminine homes that emerges in the romantic sex comedy, therefore, seems to not only reassert traditional gender paradigms of feminine domestic competence and masculine domestic incompetence, but to exaggerate this further to present a picture of single masculinity as excessive, disruptive and unable to be contained by the strictures of feminine domestic order. If single men are present within the home, they are liable to (literally) explode at any time. Even when coupled, domesticated and contained, masculinity always has the potential to be a disruptive force within the family or feminine home, as in *The Break-Up* and *Knocked Up*. However, other texts in the romantic sex comedy subgenre demonstrate that while there is an aesthetic scheme for the representation of functional masculine domesticity, the achievement of such a state is only possible when the feminine is excluded, and the space and its inhabitant(s) operate to their own set of norms and values. The most common design scheme for representing functional masculine domestic space is that of the 'bachelor pad'. The bachelor pad aesthetic characterizes the domestic space of the male protagonist of several of the films within this subgenre, including Ben (Matthew McConaughey) in *How to Lose a Guy in 10 Days* (Donald Petrie, 2003), Dylan (Justin Timberlake) in *Friends With Benefits* (Will Gluck, 2011) and Jacob (Ryan Gosling) in *Crazy, Stupid, Love* (Glenn Ficarra and John Requa, 2011). Presented to the audience as an aspirational space, there is remarkable consistency in the design scheme of the bachelor pad across these films. open-plan apartments with floor-to-ceiling windows, wooden floors, sleek stainless steel kitchens, grey colour schemes and exposed brickwork. These architectural features are made noticeable partly because of the lack of clutter and personal effects visible within the space. These spaces rarely stand alone as the only homes represented within the diegesis of the films, but are often contrasted with the apartments or houses of the female protagonist, which are designed around an aesthetic entirely different to the masculine space, characterized by an aura of cosiness, softness and homeliness, created by the use of clashing chintzy patterns, decorative furniture and ornaments and an abundance of soft furnishings, blankets and cushions within the design scheme.

What is observable within the production design of the romantic sex comedy is the persistence of separate ideals of masculine and feminine domestic space, with aesthetics that are standardized yet contrasting. Both design schemes, despite their obvious and apparent differences, can be traced back to specific historical moments in the development of interior design and ideologies of domesticity.

Gender in postfeminist romantic comedy is therefore clearly articulated through the use of 'residual' cultural aesthetics. The design of the 'feminine' spaces described above seems to recall specific aesthetic ideals of nineteenth-century domestic standards, which 'prioritised comfort and display'.[19] As Penny Sparke writes in her study of the history of gendered design and the 'sexual politics of taste', 'the stereotypical idea of "feminine taste" that still pervades our estern, industrialised culture [...] has its roots in the last century'.[20] During this period, the woman of the house was its 'chief beautifier', creating this aesthetic of decoration and comfort through:

> cushioning, soft textures and surfaces, and soft blends of colours, by gentle curved forms and patterns rather than harsh, geometric ones, by visual references to the natural world rather than to the man-made world of technology.[21]

Thus, it is not just of interest here that these homes are gendered as feminine through a precise set of aesthetic signifiers that both reflect and contribute to contemporary cultural ideals of feminine domesticity. What the aesthetic also carries with it is a complex entanglement of domestic ideologies that are linked to a specific historical moment and yet at the same time, are enduring. Furthermore, both the aesthetic and the ideology that it represents have their foundations in what Sparke describes as 'the period when the concepts of "woman" and "domesticity" became, effectively, one and the same'.[22]

The aesthetic of the bachelor pads contained within these films is also linked to a specific moment in design history, one that is closely related to, and, indeed, can even be interpreted as a reaction against, the nineteenth century 'Cult of Domesticity'. The rise of modernism, in all areas of urban life, but especially in architecture and design, lead to the 'rule of a masculine cultural paradigm', a paradigm that specifically rejected 'the idea of ornament', 'decorative colour' and 'the decorative line'.[23] It is according to the principles of function, utility and universality that the bachelor apartments featured in the romantic sex comedies are designed. The deliberate and repeated exposure of bare, 'raw', industrial materials such as steel, glass, wood and brickwork within the design of the bachelor pad, as well as the colour palette of the space, characterized by browns, greys and silvers, suggests that these principles continue to be prioritized in masculine interior design. In line with the modernist commitment to Arts and Craft principles of truth in materials and in the

purity of the object, the materials are stripped down, or left undecorated, in order to display their 'natural' properties.[24]

Similar theories of functionalism in design are visible throughout the furnishings of the apartments – crafted in leather, steel and wood, and having an aesthetic of hardness and utility, rather than the softness of the furniture in the feminine home. Indeed, in *Friends With Benefits*, attention is drawn to the discomfort of the space when Dylan arrives and attempts to flop down onto his bed, but the object does not give way beneath him. Crucially, this scene is shot from the living room, showcasing the open-plan design. This spatial layout disavows the need for privacy and the partitioning of rooms, another remainder from a modernist principle that desired the erasure of 'gendered spaces' within the home and instead vaunted the extending of the interior into the public sphere. As well as the openness of space, this ambition is visible in the floor-to-ceiling windows that form the external wall of the bachelor pad apartments in *Friends With Benefits*, *How to Lose a Guy in 10 Days* and *Crazy, Stupid, Love*. These windows are an obvious visual and physical rejection of the ideology of the separation of spheres, letting the image of the public, urban city into the home and putting the apartment on display to the outside world. Masculinity, it seems, must always be public, even when it is at home.

Despite this openness to the public world, it is also the case that the bachelor apartment, deliberately, displays very little of the man's inner, emotional life. The logics of modernist design remove the space for the display of personality, taste and even, as Sparke notes, social interaction.[23] In line with the bachelor's attitude to relationships – his search for casual sex without commitment – his apartment displays no attachment. This is again presented in contrast to the feminine spaces within the same films, which are full of, perhaps even cluttered by, pictures and ornaments and, most tellingly, people: friends, sisters and mothers. The first time we see Jamie's apartment in *Friends With Benefits*, she is hosting a party, and later in the film her mother arrives and interrupts her and Dylan having sex. Anne (Renée Zellweger) in *The Bachelor* shares her flat with sister Natalie (Marley Shelton). Women's leisure and domestic space is characterized by networks of sociality and care, whereas men's have an aesthetic 'emptiness' and 'blankness' that can be seen to represent their emotional lives as, the films suggest, they avoid forming attachments. This situation will, of course, be corrected by the generically determined ending of the romantic comedy.

The space of the bachelor pad deliberately marginalizes the feminine, the decorative, the soft and the private, and instead displays utility,

form, materials and its connection to public life. The space has, therefore, equilibrium of masculinity that is presented as disrupted by the presence of the feminine. The masculinity of the space is dependent upon the absence of the feminine within it – in other words, it is contingent upon the bachelor's single status. *How to Lose a Guy in 10 Days* contains a scene that illustrates the delicate balance of the gendering of space, by showing the ease with which the masculine status quo can be disrupted by the encroachment of the feminine. As part of a masquerade to force Ben to end their relationship, Andie (Kate Hudson) deliberately feminizes his modernist-style apartment. She decorates the space with a pink bedspread, pink furry toilet seat cover and bathmat, cuddly toys, pink lacy ornaments, wedding magazines and framed photographs of herself. These items are soft, pastel and lacking obvious function beyond aesthetics (aesthetics which clash with the established design scheme of Ben's bachelor pad) – in short, they are the very antithesis of the modernist design scheme. They also represent a personalization of the space, a visual demonstration of attachment that is usually absent from the bachelor pad. Most obviously, of course, they are reminiscent of items from an exaggerated feminine design scheme.

This transformation scene uses space to represent the impossibility of the continuation of the status quo. Ben's apartment, which initially seemed to convey a solidly masculine aesthetic, can so easily be disrupted by the presence of the feminine, and its makeover foreshadows the way in which the bachelor, too, will eventually be transformed and domesticated by his relationships. Domestic space is used expressively within the romantic sex comedy not just to display the background, wealth, status and gender of the characters through the *mise-en-scène*, but also actively, as part of the narrative. The space is not a static and unchanging backdrop, but transforms to reflect plot progression, character development and to give the audience clues to upcoming narrative events – we could even say that the space is shown to 'know' what will happen before the characters themselves do. Taking this into abstraction, in many of these films the set design and its alterations are so carefully orchestrated that the narratives could be mapped through their changing design schemes, even if the characters themselves were removed from the diegesis.

The design and transformation of Andy's (Steve Carell) condo in *The 40-Year-Old Virgin* is an exemplary case of set and production design and development being used in this way. The film, like others in this subgenre, opens with the camera and character enclosed within a domestic setting, highlighting from the start the centrality of domestic

space. Andy's bedroom, where the audience is first introduced to the character, is designed to look more like an adolescent boy's room than that of an adult male, an aesthetic that permeates his entire condominium. The interior features blue checked sheets, walls covered with pictures of spaceships, an electronic drum-kit and gaming chair, and hordes of action figures arranged on surfaces in every room – even the bathroom. This apartment has the aesthetic of a space for play and leisure – for escapism – and yet Andy's actions and the spatial placement and framing of his body by the camera belie this function, as he slowly, silently and methodically gets ready for work. The composition frequently leaves half of the frame empty; Andy eats breakfast alone with his back to his empty kitchen, and is shown in his bathroom next to a bare and unused sink. The *mise-en-scène* of this opening sequence quickly and efficiently establishes, through the deployment of domestic space, several important features of Andy's character: he is immature, he has an attachment to toys but a life without play, he is fastidious, and he is lonely. The camera's intentional lingering on the emptiness of his life also works to suggest what might change throughout the course of the film's narrative – that the space might be filled – looking to the story's future as well as providing a context of the past for Andy's current status, given to us by the title, as 'the 40-year-old virgin'.

The unacceptability of Andy's house in a schema of normative domesticity is recognized by his friends but, crucially, is staged as a re-examination of the space through feminine eyes, only deemed necessary when Trish (Catherine Keener) comes to visit. The condo has previously been a largely functional space for Andy and his friends, but, after Trish's phone call announcing her impending arrival, they immediately embody a different subject position in relation to the space. Cal (Seth Rogen) suggests that, in order to prepare, they 'take everything that's embarrassing and take it all out so it doesn't look like you live in Neverland Ranch'. That they worry about the appearance of Andy's space only in relation to Trish suggests that it is through feminine eyes that male immaturity is more keenly felt. Indeed, Andy is specifically asked by Cal to internalize a feminine gaze at himself and his living space: 'You've got to see this through the eyes of a woman,' he urges. 'What's she gonna think when she comes in here?' This formulation of Andy's subjectivity gestures towards an interesting inversion of the postfeminist condition of femininity in which 'the objectifying male gaze is internalized to form a new disciplinary regime'.[26]

The scene cuts to reveal the living room of Andy's condo stripped completely empty, with bare walls, no furniture and no personal effects.

The space is made palatable here by being brought closer to the modernist, minimalist bachelor pad aesthetic. It is revealing, especially in relation to the debates around gendered design outlined above, that it is seen as more acceptable for Andy to present Trish with a completely empty apartment than it is to present her with a space that reveals 'too much' of himself. The postfeminist sensibility asks men to monitor what they put 'on display' to the world. This brings to mind Rosalind Gill's example, taken from *J17*, which instructed girls on how to send a text message to a 'lad-love' that maintained an 'I'm not so bothered aboutcha' attitude.[27] In the postfeminist era, both men and women are encouraged to perform emotional reserve. As well as supporting the persistence of older models of masculine behaviour which encourage men to hide their emotions, postfeminist paradigms of masculinity stress the importance of co-ordinating the aesthetics of display with this type of emotional control.

Andy, however, as with the bachelors in the examples described above, cannot keep his true self hidden for long in the face of true love. During the conclusions of all of these films, the expression of authentic male emotion is valorized and rewarded. There exists within postfeminist constructions of masculinity, then, a tightly moderated system of behaviour in relation to emotional life. The demands placed upon the male protagonist within the romantic sex comedy reflect wider cultural ambivalence in relation to men and emotion. The postfeminist sensibility's emphasis on self-surveillance, with its added psychological focus and requirement to 'transform oneself and remodel one's interior life' can be seen within this genre to apply to men too.[28] Thus while Gill sees women as postfeminism and neo-liberalism's ideal disciplinary subjects, these films suggest that it is male subjectivity too that is increasingly viewed as a 'project to be evaluated, advised, disciplined and improved or brought "into recovery" '.[29] Andy's work towards his 'recovery' here ultimately involves the transformation of his domestic space, selling his action figures on eBay in order to fund an improvement in his career prospects by starting his own business. The question of what the new home that Andy and Trish will make together after their marriage at the end of the film is, however, left unaddressed. Despite its use as a site of negotiation, conflict and of gendered meaning and labour throughout the narrative, at the film's conclusion domesticity suddenly becomes an invisible element of coupling. This is a common manoeuvre within many films within this subgenre. The home of the 'final couple' – the 'final home', if you will – is left as an unseen, unrealized fantasy space, perhaps because to deal with its representation would be to have

to confront all of the previous issues and conflicts around domesticity that the formation of the couple is supposed to erase.[30]

The trends and motifs in the representation of masculine and feminine domestic space in the romantic sex comedy reach a head in the space of the 'mancave'. The mancave is a central emblematic gendered domestic space within the film *I Love You, Man*, but one that, like the concept of 'bromance', has wider implications for conceptions of postfeminist masculinity. Sydney's mancave is presented as such a critical representational space that the audience, along with protagonist Peter, are taken on a tour of it. Following an establishing shot that shows the exterior of the space, painted a bright cornflower blue but visibly ramshackle, a tracking shot leads the audience through the yard with Peter and Sydney. Anticipation is built up for the revealing of the space, as Sydney is shot facing the door and camera, therefore obscuring our view of the mancave as he announces 'welcome to the Temple of Doom' – as much an address to the camera and audience as it is a diegetic address to Peter. The reference to the Indiana Jones series in the dialogue here, and the way in which the reveal is built up, constructs the mancave as a fantasy space, one that is both spectacular and juvenile.

The production design of the mancave itself represents an observable shift from the highly structured and monitored space of the bachelor pad described above. Like the bachelor pad, it is a space that explicitly excludes the feminine, both through aesthetics and organization. Unlike the bachelor pad, however, display and 'clutter' are encouraged, marking the space as suitable for male bonding, leisure and creativity. The previously feminine privilege of being able to display attachment within the domestic space is imported into the mancave. However, this is a very different kind of attachment. The furnishings and decoration within the mancave are almost exclusively related to masculine leisure, creativity and the absorption and fandom of popular culture: guitars, drum kits, amps, collections of CDs and records, stylish computers and a collection of televisions, a fridge full of beer, and walls covered in art and band posters. The composition of shots of the mancave within this scene serve not to pick out or isolate its features, but rather to display them all at once, so that the audience is overwhelmed in their attempt to absorb the 'coolness' of the space. This all-at-once-ness also has the effect of breaking down cultural hierarchies and distinctions – as displayed, for example, in the shot of a canoe paddle propped up against an abstract painting on the wall. The mancave presents us with the image of the single male as tastemaker, artist and cultural connoisseur. In contrast to the blank spaces of the bachelor pad, designed specifically to reflect little

of the interiority of the protagonist, the mancave intentionally displays too much for the audience to absorb and decode all at once.

Despite an apparent blurring of the representational strategies that govern masculine and feminine domestic space in the romantic sex comedy, the mancave retains and possibly even exacerbates the distinctions between the two. Unlike the bachelor pad, which women can enter temporarily for sex, female access to the mancave is expressly forbidden, and is written into the very name of the space. With the mancave comes a powerful reinscription of the ideology of separate spheres, but one that, in postfeminist culture, is now fought within the private, domestic realm. The distinction of separate spheres within the romantic comedy is no longer drawn through a battle over women's entry into public space, as in films such as *The Thrill of It All* (Norman Jewinson, 1963) or even *Pretty Woman* (Garry Marshall, 1990), but rather within private, domestic space itself. Both the mancave and the persistent disruption of feminine domesticity within postfeminist romantic comedy seem to suggest that masculinity is still struggling to find its true home in the changed gender paradigm that the films represent.

Notes

1. See Joanne Hollows, 'Oliver's Twist: Leisure, Labour and Domestic Masculinity in The Naked Chef', *International Journal of Cultural Studies*, 6:2 (June 2003), pp. 229–248; Rachel Moseley (2001) in C. Brunsdon, C. Johnson, R. Moseley, H. Wheatley (eds), 'Factual entertainment on British television; The Midlands TV Research Group's "8–9" Project', *European Journal of Cultural Studies*, 4:1 (February 2001), pp. 29–62; Feona Atwood, 'Inside Out: Men on the Home Front', *Journal of Consumer Culture*, 5:1 (March 2005), pp. 87–107.
2. Rosalind Gill, 'Postfeminist Media Culture: Elements of a Sensibility', *European Journal of Cultural Studies*, 10:2 (Spring 2007), p. 157; Imelda Whelehan, *Overloaded: Popular Culture and the Future of Feminism* (London: Women's Press, 2000), p. 34.
3. Whelehan, *Overloaded*, p. 5.
4. For further discussion of conceptions of masculinity as 'true' and 'authentic', see Michael Kimmel, *Manhood In America: A Cultural History* (New York: The Free Press, 1996), p. 4; R. W. Connell, *Masculinities* (Cambridge: Polity Press, 1995), p. 45.
5. Michael Kimmel, 'Invisible Masculinity', in Michael Kimmel (ed.), *The History of Men: Essays on the History of American and British Masculinities* (Albany, NY: State University of New York Press, 2005 [1993]), p. 15.
6. Kimmel, 'Invisible Masculinity', p. 10.
7. Raymond Williams, *Marxism and Literature* (Oxford: Oxford University Press, 1977), p. 121.

8. Charlotte Brunsdon, *Screen Tastes: Soap Opera to Satellite Dishes* (London: Routledge, 1997), pp. 54–66.
9. Ibid., p. 54.
10. Brunsdon points to 'changing patterns of women's employment and education; increasingly effective and available contraception; the fall in the birth rate, with changing patterns of marriage and divorce; the impact of the woman's liberation movement itself' as examples. To this I would also add an insistence upon heterosexual coupling, a decrease in job stability and the expansion of the service sector. Ibid., p. 54.
11. Tim Havens, 'Guy-Coms and the Hegemony of Juvenile Masculinity', *FlowTV* (27 October 2007) http://flowtv.org/2007/10/guy-coms-and-the-hegemony-of-juvenile-masculinity/ (accessed 28 March 2012).
12. See, for example, *The Hangover* (Todd Phillips, 2009).
13. Tamar Jeffers McDonald, *Romantic Comedy: Boy Meets Girl Meets Genre* (London: Wallflower, 2006), p. 107; David Hansen-Miller and Rosalind Gill ' "Lad Flicks": Discursive Reconstructions of Masculinity in Popular Film', in Hilary Radner and Rebecca Stringer (eds), *Feminism at the Movies: Understanding Gender in Contemporary Popular Cinema* (New York: Routledge, 2011), pp. 36–50.
14. Tamar Jeffers McDonald, 'Homme-com: Engendering Change in Contemporary Romantic Comedy', in Stacey Abbott and Deborah Jermyn (eds), *Falling in Love Again: Romantic Comedy in Contemporary Cinema* (London: I. B.Tauris, 2009), p. 158. I also see these developments in the romantic comedy genre as linked to similar transformations in the audience for the teen movie that occurred during the late 1990s with *American Pie* (Paul Weitz, 1999).
15. Hansen-Miller and Gill, 'Lad Flicks', p. 42.
16. An argument that is fought over the gendered division of labour within their home and that speaks fairly explicitly to the feminist concept of the 'dual-burden' of paid work and housework.
17. This acts, of course, in contrast to its presentation as a space of work and labour for Brooke.
18. Jeffers McDonald, 'Homme-com', p. 147.
19. Penny Sparke, *As Long As It's Pink: The Sexual Politics of Taste* (London: Pandora, 1995), p. 2.
20. Ibid., p. 15.
21. Ibid., p. 27.
22. Ibid., p. 15.
23. Ibid., p. 74, p. 106, p. 107.
24. Ibid., p. 107.
25. Ibid., p. 102.
26. Gill, 'Postfeminist Media Culture', p. 152.
27. Ibid., p. 155.
28. Ibid., p. 155.
29. Ibid., p. 156.
30. The phrase 'final couple' here comes from the work of James MacDowell on the Hollywood 'happy ending'. See James MacDowell, 'The Final Couple: Happy Endings in Hollywood Cinema' (Unpublished PhD Thesis, University of Warwick, 2011).

10

'We're Not Making Forward Progress': Postfeminist Hypermasculinity in *Heat*

Vincent M. Gaine

Michael Mann is a director who, seemingly, lives up to his surname. Over the course of a career of more than 30 years, Mann has come to be regarded as a director of films that are, according to BBC film critic Mark Kermode, 'about guys'.[1] In its portrayal of male cultural identity, Mann's 1995 crime drama *Heat* displays a hypermasculinity that spirals into an implosive vortex that has a destructive effect on social relations. The film presents gender identities and relations that are unsustainable, and the characters' insistence upon such identities and relations generates the implosive vortex. The construction of gender undertaken by the film's characters is not simply traditional and pre-feminist, but *post*-feminist, as the construction of gender includes an assumption that the goals of feminism have been accomplished. This assumption both underpins the postfeminist sensibility within the film, and excludes the possibility of dialogue between genders, leading to the eventual disintegration of human interaction. Through its portrayal of postfeminist masculinity, *Heat* demonstrates the need for dialogue between the sexes and the dangers of failing to attend to this need.

As Pam Cook points out: 'The notion of post-feminism is nothing if not double-edged: on one hand, a celebration of undeniable victories achieved; on the other, registering the occlusion of women's issues as other political priorities take precedence'.[2] Tania Modleski, meanwhile, discusses a range of texts that 'in proclaiming or assuming the advent of post-feminism, are actually engaged in negating the critiques and undermining the goals of feminism – in effect, delivering us back into a pre-feminist world'.[3] Diane Negra and Yvonne Tasker argue that: 'Post-feminist culture enacts fantasies of regeneration and

transformation that also speak to a desire for change'.[4] 'Post-feminism' as I understand it in this chapter takes two forms. The first is a sense of Western society reaching a contemporary moment that is somehow beyond the women's movement – currently we are post-feminist, looking back upon feminism as a historical movement. This position suggests that feminism is no longer necessary, and the consequence of being beyond feminism is a cultural sensibility that, to borrow from Negra and Tasker, retaliates against feminism 'to emphasize that it is no longer needed'.[5] The second form, *postfeminism*, can be defined as a cultural sensibility which assumes that important victories have been accomplished in terms of 'opportunities for women ... freedom of choice with respect to work, domesticity, and parenting; and physical particularly sexual empowerment'.[6] *Choice* is the fundamental assumption of postfeminism: women now have choice and feminism is unnecessary as a political movement for the cause of women's choice. Political activism, sociological analysis and cultural critique are no longer necessary in the face of women's suffrage, equal pay and education, and independence from male influence.

In a society that is post-feminist, postfeminism 'works to invalidate systemic critique'.[7] This invalidation of critique therefore amounts to a dismissal of feminist goals, as the critique of social and cultural institutions and practices is central to feminism. The overall goal of feminism can be summarized as the attainment of equal rights for women, and the systemic critique of contemporary (Western) culture demonstrates the non-attainment of this goal. The victories listed above are undeniable, yet grossly oversimplified and far from universal, as demonstrated by cultural, political and economic analyses performed by, among others, Modleski, Vicki Coppock, Deena Haydon and Ingrid Richter, Liz Sperling and Mairead Owen.[8] These analyses not only demonstrate that the goals of feminism have not been achieved, they also demonstrate the ongoing need for continued and sustained critique in order to further the cause of feminism.

Within Hollywood texts, the representation and portrayal of women remains problematic, as highlighted by critics such as Negra and Tasker, Cook, Carol J. Clover, Linda Ruth Williams, Lisa Purse and others.[9] Williams identifies a cycle of 'masculinity-in-crisis films'[10] in the late 1980s and early 1990s, 'narratives ... [that] are a visible response ... to ... the perceived empowerment of women'.[11] *Heat* can be added to this cycle, as empowered women are perceived as a threat to masculinity in this film, eliciting a postfeminist, hypermasculine response from the male characters. Angela McRobbie argues that 'the

strength of feminism lies in its ability to create discourse, to dispute, to negotiate the boundaries and the barriers',[12] and it is precisely this discourse that *Heat*'s postfeminist, hypermasculine men actively avoid. This avoidance leads to the disintegration of social relations, and the film dramatizes the dire consequences of this hypermasculinity. *Heat* presents a predominant 'mood of troubled masculinity... [the male characters] are twitchily uncomfortable with themselves',[13] and hypermasculinity does not bring the male characters any sense of peace or satisfaction. Central to the discomfort of *Heat*'s men is the tension between professionalism and domesticity, a struggle that domesticity consistently loses. However, the men are socially alienated by their professionalism, suggesting a causal link between the avoidance of domesticity and the decline of social relationships.

This decline could be blamed on pre-feminist rather than post-feminist gender politics. The film's genre certainly suggests this: *Heat* deals in archetypes developed and sustained across a long generic history. Studies such as those by Ian Shadoian, Fran Mason, Martin Rubin and Edward Mitchell[14] discuss the conventions of the gangster and heist films, and J. A. Lindstrom offers a useful outline of the heist crew's roles in *Heat*:

> [Neil] McCauley [Robert De Niro] chooses the plans and organizes the effort; he also knows something about metallurgy. Chris Shiherlis (Val Kilmer) specializes in explosives and breaking and entering. Michael Cheritto (Tom Sizemore) is the computer person. Trejo (Danny Trejo) is the driver and communications person, although he is replaced for the last job by [Donald] Breedan (Dennis Haysbert), an acquaintance of McCauley's from prison... Everyone involved is presented as skilled and confident – they are professionals.[15]

Heat's women are similarly archetypal. Both Justine (Diane Venora) and Charlene (Ashley Judd) are wives and mothers. Aside from an implication that Justine may own a restaurant, neither woman appears to be employed. Charlene manages the Shiherlis home with the money that her husband Chris steals as a professional thief. *Heat*'s portrayal of the late twentieth-century middle-class American family makes it clear that Justine and her daughter Lauren (Natalie Portman) are not dependent on the income of Justine's husband, Los Angeles police lieutenant Vincent Hanna (Al Pacino). Vincent is not required to support Justine and Lauren, and it is highly significant that he has no role as a provider.

Eady's (Amy Brenneman) domestic situation is slightly different but no less stereotypical. She is Neil's lover and is financially self-sufficient, employed in a bookstore while developing her own graphic design business. Her presentation highlights her femininity – soft lighting illuminating her face on the balcony where she and Neil kiss for the first time, suggesting the alternative life for Neil that she embodies. In this way, Eady's romantic femininity is presented as an alternative to Neil's disciplined masculinity. Though she is financially independent, Neil offers to support her so that she can set up a studio. While her goal is to be a successful graphic designer, his is simply to be in her company. Eady does not need Neil, but Neil needs her, and thus her narrative purpose is to be what Neil desires. Indeed, Eady is only ever seen in relation to Neil, thus underlining her role within his shadow.

Despite their apparent genre conventionality, the female characters do demonstrate a certain level of empowerment gesturing towards a post-feminist landscape. The empowerment presented is a form of typical, middle-class American entitlement, the first being entitlement to work and, more broadly, financial independence. Few of the women seem dependent upon men – Justine appears to live comfortably without Vincent's income, while Eady is self-sufficient – and this is arguably one of the postfeminist fallacies of the film, that women's financial constraints can be easily disregarded. Male financial support does appear to be necessary in *Heat*, however: Charlene seems to need the financial support of her lover Alan Marciano (Hank Azaria) in order to leave her husband Chris. More tellingly, Neil points out to Michael that his wife Elaine (Susan Traylor) 'takes good care of you', implying that she is the breadwinner and that his criminal income is surplus. Donald Breedan's employment at a diner does not appear necessary to support him and Lillian (Kim Staunton); indeed, she drives him to and from work, suggesting that she may be supporting *him* financially. Before starting his job, Donald promises Lillian that he is 'gonna do good', as in legitimate. Yet the job involves degradation of his manhood as the restaurant manager (Bud Cort) illegally exploits him, suggesting that Donald's masculinity has no place in the film's landscape. Donald is trying to leave crime behind but cannot work legally either; his eventual return to crime as a driver for Neil's crew is a reassertion of his aggressive, post-feminist masculinity. Overall, with the exception of Charlene and Marciano, it appears that female financial independence is taken for granted in *Heat*, which necessitates different roles for the men.

Sexual empowerment is also presented as a straightforward entitlement for both men and women, demonstrated by the film's sexual

relationships. The first footage of Vincent and Justine shows them having sex, while Neil and Eady's initial encounter in a restaurant leads to love-making at Eady's home. This random encounter is not presented salaciously nor judgmentally – sexual freedom is simply something that men and women are able to exercise. While Waingro (Kevin Gage) kills at least one prostitute, this functions not as a condemnation of her profession, but rather as a demonstration of Waingro's psychopathology. Furthermore, both Charlene and Justine proactively engage in extra-marital affairs, the significance of which is discussed later. The post-feminist landscape of *Heat* includes sexual freedom for women as well as men, and this freedom is exercised in most cases. It is significant, however, that aside from these early examples, sex appears little in the film, demonstrating further avoidance of intimacy by the male characters.

The examples noted above demonstrate that some of the goals of feminism are achieved in *Heat*, yet this empowerment leads to a reactionary form of postfeminist hypermasculinity. The characters of Neil and Vincent represent two differing versions of this hypermasculinity: Vincent is loud, aggressive and filled with bluster while Neil is neat, disciplined and minimalist. Indeed, the character of Neil in particular represents a development of masculinity from another film in the masculinity cycle identified by Williams: *Cape Fear* (Martin Scorsese, 1991), which also starred De Niro.[16] Nick James suggests that *Heat* intentionally echoes *Cape Fear*: 'Waingro...reminds us of De Niro, playing...Max Cady...The Max Cady connection may well be intended to make him McCauley's alter ego through the casting of De Niro'.[17] Waingro is a 'cartoon' psychopath,[18] and his echo of De Niro's earlier character indicates that this role is no longer viable. Instead, we have Neil McCauley, a professional who acts with cold, logical precision: a form of hypermasculinity that is almost robotic. Vincent Hanna is hyperbolic in the other direction, and both versions demonstrate 'masculinity as a construct',[19] a postfeminist compensatory response to (perceived) female empowerment as men fear the irrelevance of masculinity.

Heat is deeply critical of postfeminist hypermasculinity. The men of *Heat* can form relations with women, but a lack of dialogue between the genders leads to the failure of relationships. The most obvious example of this failure is the romantic dissolutions that plague the characters. Eady, Justine and Charlene are all abandoned, and these abandonments are linked to the men's unwillingness to engage in dialogue. For instance, Vincent criticizes Lauren's father (Justine's ex-husband) for not spending time with his daughter, but is himself neglectful. Upon his

return from what he simply describes as 'work', Justine protests that she made dinner for them 'four hours ago', and he is barely apologetic, replying 'I'm *sorry* if the goddamn chicken got overcooked'. Vincent deliberately plays the role of neglectful over-worked husband/father, a role that ensures maximum masculinity because, as mentioned above, he is not required to adopt the role of the provider. With his perception of being deprived of this male role in a post-feminist society, Vincent exaggerates his own masculinity into the ferocious alpha-male that neglects his family, highlighted in a subsequent scene:

> Vincent: I told you when we hooked up, baby, that you were gonna have to share me with all the bad people and all the ugly events on this *planet.*
> Justine: And I bought into that 'sharing', because I love you.... But you have got to be present, like a normal guy, some of the time, *that's* sharing. This is not sharing: this is leftovers.

Vincent's apparent acceptance of the 'bad people' and 'ugly events' as his normal company is symptomatic of his postfeminist hyper-masculinity: compensating for his redundancy as a provider, he insists that he is even more necessary as a protector against danger. Yet in doing so, he actively causes further 'ugly events' in his home life.

It is implied that Vincent is aware that his behaviour is unreasonable. His faux-apology for missing dinner is delivered with a faltering tone, suggesting a lack of conviction and awareness of his hypocrisy over criticizing Lauren's father, thus suggesting a discomfort with his clear neglect of his family, which is no better than that of Justine's ex-husband. Vincent describes the absent father at various points as 'that son of a bitch', a 'fucking jerk' and 'this large-type asshole', and he is arguably disgusted that he too fulfils these terms. Furthermore, it is clearly possible for Vincent to spend more time with his family, as he easily takes time out of his working day to drive Lauren home. For all his posturing, he clearly cares, to such an extent that when Lauren attempts suicide, she does it where Vincent will find her, her trust in him evident. Yet Vincent never considers making more time for Justine, even when he finds her preparing to go out without him. Rejected by his wife, for a single shot he appears alone in the kitchen, filled with unwashed dishes that he briefly considers washing, but instead he goes back to work, the camera panning to follow him as he departs, the domestic space literally left behind. Though he could be better integrated with his family, Vincent feels his hypermasculinity is the only way for him

to remain relevant, as balancing his domesticity and professionalism would compromise what he perceives as his identity. Vincent's refusal of this balance is shown to be deeply problematic, and he is aware that his lack of engagement with Justine is a major failure on his part.

Much like Vincent, Neil presents a postfeminist hypermasculinity that is destructive, for he ruins his relationship with Eady as assuredly as he initiates it by prizing *his* own goals and needs over that of a *mutual* goal. Chris, meanwhile, wants to maintain his relationship with Charlene, but not to the extent of making her a priority. Among the other characters, Michael Cheritto chooses 'the action' of armed robbery that is the motivation for his continued (though unnecessary) participation in the activity, because a desire for action is the response of his hypermasculinity to Elaine's postfeminist role as provider. Similarly, Donald Breedan finally defies his employer's oppression of his manhood with aggressive, forthright masculinity. And yet most importantly, it becomes clear over the course of the film that *the women do not need the men*, and will actively reject them if pushed far enough. The lack of *need* for a male presence is the single greatest empowerment that women have in this film, and it is enough to worry the men and prompt their postfeminist hypermasculinity as a performative statement of cultural identity.

Much of the hypermasculine behaviour in *Heat* is similar to the 'new laddism' discussed by Rosalind Gill and David Hansen-Miller[20] and Imelda Whelelan.[21] The 'new lad', as identified by these writers, constructs a masculine identity with adolescent behaviours and attitudes. As with the men of *Heat*, 'new laddism' demonstrates 'masculinity as a construct':[22] 'self-centred, male-identified, leering and obsessed by sport, the new lad was naughty but nice; he proved himself a domestic catastrophe, but a certain boylike vulnerability supposedly made up for his deficiencies'.[23] Gill and Hansen-Miller[24] discuss this new lad in twenty-first century 'bromance' pictures such as *The 40-Year-Old Virgin* (Judd Apatow, 2005) and *Role Models* (David Wain, 2008), and the homosocial male relationships in these films bear some similarities to those in *Heat*. While *Heat*'s men are unable to maintain relationships with women, they bond well with each other. Eady may be Neil's lover, but his closest confidant is Nate (Jon Voight). Furthermore, Neil virtually treats Charlene as a 'rival' for Chris's association.[25] When Justine goes out without Vincent, he goes back to work to have a talk with Neil, as this is the only person he feels he can relate to. Homosocial relations consistently trump heterosexual relations, and the reasons for the privileged place of inter-male association can be traced to character histories.

There is a significant age difference between the characters of *Heat* and those of the bromances that I return to below, yet the difference does not apply to the character of Chris Shiherlis, who is similar in age to Steve Carell in *The 40-Year-Old Virgin* and Paul Rudd in *Role Models*. However, both professionally and domestically, Chris is more seasoned and matured than either Rudd or Carell, by virtue of being married, having a child and also having served a prison sentence, where he met and formed a relationship with Neil. Time served represents a shared understanding among all the criminals in *Heat*, a unique kinship that binds them together. Unlike the knowingness of new laddism, there is no irony surrounding this understanding that derives from a shared history in prison. The homosocial bonds in *Heat* are not reconstituted adolescence as they are in the Apatow films; these are bonds forged by violence, mutual suffering and deprivation. While Vincent's background is obviously different in this respect from Neil's, there is sufficient resonance for a similar bond between them. Vincent served in the Marine Corps and has since been a career police officer; Neil served multiple prison sentences, including three years in solitary confinement. It could be expected that their masculine identities have been fortified as a result of these experiences, but the discomfort identified by James belies this.[26] In their exclusively male environments both men developed means of interacting with other men but no such skills in terms of their intimate relationships with women, and therefore view the lives of women as distinctly separate from their own. Furthermore, while following their masculine pursuits, the world around them has transformed into a distinctly postfeminist cultural space in the contemporary moment in which *Heat* is located. The sensibilities of these men, as well as the other members of Neil's crew, could have changed as well but, crucially, the men did not want to change, as Vincent and Neil confess to each other:

Vincent: I don't know how to do anything else.
Neil: Neither do I.
Vincent: I don't much want to, either.
Neil: Neither do I.

Their mutual acknowledgement indicates that they *choose* to do what they do, both professionally and domestically.

A significant difference between the 'new lad' films and *Heat* is genre, as *Heat* is a crime drama rather than a comedy, but character age is also a relevant factor. Whereas the protagonists of the 'bromances' discussed

by Gill and Hansen-Miller are, at most, in their mid-30s, *Heat*'s central characters are at least 20 years older. James discusses the particular meanings associated with Pacino and De Niro's star personas at the time of *Heat*'s production, mentioning that both stars were 'middle-aged' and that the 'imminence of ageing adds pathos to Hanna and McCauley's attempts to cling to their street personas'.[27] Both characters appear to be in their mid-50s, and have considerable histories that younger men have not experienced. But like the 'new lads' who forge a masculine identity as a simultaneous ironic incorporation and disavowal of feminism, so do the older men of *Heat* perform their own post-feminist backlash through exaggeration of their masculinity. They are too old to be 'new lads', but they can be what I term 'new frontiersmen'. The environment of Los Angeles is a post-industrial frontier, where the outlaw and the lawman can roam the borders between civilization and wilderness. When Vincent tells Neil that 'if it's between you, and some poor bastard whose wife you're gonna turn into a widow ... you are goin' down', he speaks of the defence of civilization and families. The fallacy of Vincent's position is borne out by the fact that his own family is, by his own admission, 'a disaster zone'. The real challenge of *Heat*'s post-feminist landscape is not on the street, but in the home, the space that these men avoid, performing their own backlash against the empowered woman. Furthermore, the new frontiersmen betray the fallacy of their own archaic identity. Neil chides Chris over his familial attachment, but later confesses to Eady that Neil himself does not know what he is doing. Before he leaves Justine for the final time, Vincent admits that 'I'm not what you want, Justine'. Indeed he is not: the only place where he wants to be is on the street; the domestic sphere is a perpetually alien site of discomfort to him.

These men's unwillingness to compromise their own hypermasculinity resonates with Carol J. Clover's observation that 'If ever a place were ripe for popular fantasies about Average White Males resigning from public responsibility, 90s California is it'.[28] *Heat* displays white males declaring themselves to be above-average through an aggressive assertion of their postfeminist hypermasculinity with '[p]omposity and self-righteousness',[29] and a willingness to throw everything away, seemingly for no other reason than because they can, such is the imperviousness of their gender identity. Neil explicates: 'Don't let yourself get attached to anything you are not willing to walk out on in thirty seconds flat if you feel the heat around the corner', and Vincent confirms Justine's assessment: 'All I am is what I'm going after'. While Chris states that 'the

sun rises and sets with [Charlene]', he fulfils Neil's philosophy when confronted with the possibility of going to prison. Indeed, Neil himself fails to follow this by recklessly pursuing Waingro when he and Eady are 'home free', just because he can. Ultimately though, he remembers his edict and abandons Eady when he sees Vincent approaching. All he needs is himself, and the men's refusal to engage with women is a means of ignoring and therefore silencing the post-feminist woman, treating her as 'other' and resisting egalitarianism and equality. *Heat* struggles to accommodate its female characters, curtailed by genre convention and its own focus on hypermasculinity, which is intrinsically self-absorbed and does not engage with femininity or the feminist struggle (not to mention other struggles and issues surrounding race and class).

With men taking little interest in them, it is perhaps unsurprising that some women turn to infidelity. Infidelity, and indeed sex in general, has a cultural and historical association with sin and betrayal, but infidelity also works as a demonstration of empowerment that women can seek sexual and indeed social and emotional fulfilment at their own instigation, rather than being passive objects to their husbands. Both Justine and Charlene have affairs, which can be read as a form of protest against the 'intimacy labor'[30] that they participate in. Susan Leonard discusses the cinematic trope of female adultery in relation to working-class boredom.[31] While few of the characters in *Heat* could be described as working class, Leonard argues that texts such as *The Good Girl* (Miguel Arteta, 2002) and *Lovely and Amazing* (Nicole Holofcener, 2001), which utilize the adultery trope as a response to the drudgery of working-class employment, also 'interrogate... the invigorating promises of marriage'.[32] Rather than marriage being 'both the greatest achievement and the producer of the greatest happiness',[33] it is often a site of stagnation and isolation. Certainly in *Heat*, marriage is anything but invigorating. Vincent does not talk to Justine about his work nor offer more than passing concern at Lauren's well-being. Charlene describes her marriage with Chris as a failure to make 'forward progress like real human adults living our lives'. Michael does not need his criminal income to support his family but is addicted to the experience. Donald assures Lillian that he can handle his miserable work situation, but takes the opportunity Neil presents to him very readily. In each case, marriages and relationships are not the overriding concerns for the male characters: fulfilling their masculinity is more important.

Crucially, no one seems to *question* this idea of marriage, except for Justine and Charlene, who do so implicitly through their affairs.

Leonard demonstrates that 'the infidelity genre [is] typically...used to uncover the hypocrisies of a restrictive social order'.[34] Unable to communicate with her husband, Justine eventually makes a grand gesture to escape through an act of undisguised infidelity. Her need to make such a gesture expresses the iniquity of the institution in which men and women do not engage in dialogue. Vincent maintains his neglectful hypermasculinity to the exclusion of Justine, his understanding of their relationship built upon his belief that he is not needed as a provider, so he devotes himself entirely to his work, leaving no room for his wife. Justine's affair with Ralph (Xander Berkeley) might appear to suggest that only through infidelity can a wife empower herself over her husband. Why could Justine not simply divorce Vincent? It may appear that Justine can only be either a dutiful wife and mother or a treacherous harlot; however, her words are telling: 'Now I have to demean myself with Ralph just to get closure with you'. Her affair is a declaration that the relationship is over. Justine asks: 'Why is it that I have to figure things out and explain them to you?', and the reason is that Vincent simply does not understand, as he performs no critique or self-reflection. Justine signals the finality of their situation through undisguised infidelity, because to do otherwise would involve actual confrontation with the absurdity of their situation, which would be the dialogue that Vincent will not participate in. The collapse of this marriage is symptomatic of the 'decay of dialogue'[35] that occurs throughout *Heat*, and a crucial part of this decay is between men and women.

Much the same is true of Charlene's affair with Marciano. Charlene asks, 'What am I doing in this rat bastard situation?' after Chris refuses to discuss the financial drain on his family caused by his gambling. Like Justine, Charlene defies her hypermasculine husband's neglect with adultery. Much as he would not engage his wife in dialogue, Chris never even suspects that Charlene is unfaithful because, like Vincent, he fails to understand his wife. Unlike Vincent, Chris *does* have a provider role and Charlene that of stay-at-home wife and mother, but again like Vincent, Chris demonstrates a self-awareness of his failure to engage in dialogue. The first scene between the Shiherlis' erupts into a quarrel over Chris's gambling. Charlene declares that, should they separate, she will take their son Dominick (Andrew and Brian Camuccio) with her. Chris begins to threaten her verbally, but falters and is unable to complete his sentence. Charlene says that Chris 'won't listen' and nor will he speak as words fail him. Charlene's eventual plea to Marciano is an act of desperation, as Chris has failed in his role for the last time when he becomes a wanted fugitive. As with Vincent, Chris's

hypermasculine refusal to engage in dialogue leads to the collapse of his marriage.

The film's treatment of Charlene demonstrates an interesting attempt to contain post-feminist female identity. Charlene abandons her husband in favour of Marciano, who delivers her to the Los Angeles Police Department, who threaten to remove Dominick from her custody unless she betrays Chris to them. The choice given to Charlene is a reassertion of patriarchal hegemony, represented by LAPD Sergeant Drucker (Mykelti Williamson) who gives Charlene two options: she must betray Chris, or find herself in prison and her son in foster care. Patriarchal hegemony restricts this transgressive woman: her child is a vulnerability that can be used to contain her, and she is, perhaps, being punished for her infidelity. Crucially, however, the film does *not* support this patriarchal position and allows Charlene to devise another option. It is dubious whether Charlene's abandonment of Chris is truly empowerment, as her only escape route is Marciano who is no longer interested in her. Her genuine act of empowerment comes when she appears to be most constrained and alone. As Chris spots her on a balcony where the police hold her, she subtly signals him to leave, her defiance of police control allowing him to escape. She does not choose her son over her husband; she facilitates the freedom of both. Charlene's choice does not negate patriarchal hegemony, but nor is patriarchy successful in containing her. Herein lies the film's discomfort over gender relations: it neither liberates nor contains women, it allows a limited choice, and supports neither feminism nor patriarchy. Charlene's gesture is coded as mournful,[36] and close-ups on her face express sorrow and fear over her actions, but also resolve and acceptance. Charlene's act is one of empowerment – she can and does make her own choice – however the limitations of her minor gesture also express the fallacy of post-feminist empowerment in *Heat*. It demonstrates the fallacy that women can simply up and leave without financial consideration, as Charlene thought she could simply leave Chris and turn to Marciano, but he is even worse. Charlene can at least keep her son, but her prospects seem very bleak. Indeed, with the dissolution of social relations between herself and Chris, both of them disappear from the film, and the final 'close-up of Shiherlis itself seems to simply dissolve into thin air as he drives off screen and the camera loses focus; we know that for now he is free, but as a nearly absent presence'.[37] Charlene similarly vanishes as their relations terminate. This is *Heat*'s critique of postfeminist hypermasculinity: the film presents gender identity and relations as unsustainable, disintegrating as part of an overall decline of social relations.

Conclusion

The failed relationships of *Heat* demonstrate the destructive nature of postfeminist hypermasculinity as depicted in the film, as well as exposing the falseness and unsustainability of 'nuclear family ideology'[38] depicted in various films. The film's society 'collapses and implodes in the end',[39] and the collapse is caused by disengagement and lack of communication. Negra and Tasker point out that 'the transition to a post-feminist culture involves an evident erasure of feminist politics from the popular'.[40] The dire consequences of this erasure are on display in *Heat*. The film delivers 'an effective parody of "me" generation attitudes...an appealing masculine fantasy to do with surrendering to dark impulses...That's what's tragic here'.[41] Indeed, it is tragic, as postfeminist hypermasculinity precludes dialogue between men and women, and consequently relationships collapse.

The essential problem that the film portrays, which the characters do not accept or perhaps even recognize, is the mutability of their world. Social relations are portrayed as no more fixed than the environment of Los Angeles, ostensibly solid through its 'concrete canyons'[42] and skyscrapers, yet in constant flux as characters are in constant motion, never settling. Justine's home, described by Vincent as a 'dead-tech postmodernistic bullshit house', is a microcosm of this environment, a 'place where people seem to appear from (and sometimes disappear into) nowhere, from spiral staircases that abruptly emerge into living spaces, from hallways that seem to connect everything and nothing at the same time'.[43] The tumultuous landscape of 1990s California is used by the film's postfeminist hypermasculinity as a wilderness in which to play out a frontier fantasy. Yet the landscape of Los Angeles steadily collapses, the disintegration reaching its apotheosis in the climax at Los Angeles International Airport, a bizarre environment that is neither journey nor endpoint. LAX is the epitome of transience, reminiscent of a frontier between wilderness and civilization, fitting for the 'dinosaur destiny'[44] of Neil and Vincent, an ephemeral place of light and sound where everything, including them, will dissolve.

Far from being a celebration of masculinity, *Heat* delivers a stark warning about the *dangers* of masculinity, particularly hypermasculinity. The film offers neither understanding nor solution to these dangers, merely a trajectory to a societal implosion and the collapse of human relations. The film's gender presentation is problematic precisely because gender relations and indeed human interactions *are* fundamentally problematic, subject to essential scrutiny and negotiation through

dialogue and engagement. Mann's later film, *Miami Vice* (2006) attempts to address the gender imbalance with a female character, Gina Calabrese (Elizabeth Rodriguez), who is the equal of her male counterparts Sonny Crockett (Colin Farrell) and Rico Tubbs (Jamie Foxx). Gina is able to fight, shoot and hold her own with the men in a way that no female character in *Heat* can. But does this not make Gina an honorary 'guy'? Does her professionalism and violence simply make her one of the boys? Notably, the other two female characters in *Miami Vice* need to be rescued by their respective lovers. Mann's female characters remain problematic throughout his career, but in *Heat* the wider ramifications of these problems expose deep social faults. *Heat* displays the sociological concerns present in the crime drama since its development in the 1930s, a development Mann himself dramatizes in *Public Enemies* (2009). *Heat* demonstrates that a failure to engage in dialogue and question human relations leads to a collapse of these relations. Furthermore, *Heat* suggests that this collapse leads to a wider implosive vortex of light and noise from which there is no coming back.

Notes

1. Mark Kermode, 'Review: *Public Enemies*', *Kermode Uncut: Public Enemies* (2009), http://www.bbc.co.uk/blogs/markkermode/2009/07/publicenemies_030709.html (accessed 16 May 2012).
2. Pam Cook, 'Border Crossings: Women and Film in Context', in *Women and Film: A Sight and Sound Reader*, ed. by Pam Cook and Philip Dodd (London. Scarlet Press, 1993), p. x.
3. Tania Modleski, *Feminism Without Women: Culture and Criticism in a 'Postfeminist' Age* (London: Routledge, 1991), p. 3.
4. Diane Negra and Yvonne Tasker, 'Introduction: Feminist Politics and Postfeminist Culture', in *Interrogating Post-Feminism: Gender and the Politics of Popular Culture*, ed. by Diane Negra and Yvonne Tasker (Durham, NC: Duke University Press, 2007), p. 22.
5. Ibid., p. 1.
6. Ibid., p. 2.
7. Ibid., p. 3.
8. Vicki Coppock, Deena Haydon and Ingrid Richter, *The Illusions of 'Post-Feminism': New Women, Old Myths* (Abingdon: Taylor and Francis, 1995); Liz Sperling and Mairead Owen, *Women and Work: The Age of Post-feminism?* (Aldershot: Ashgate, 2000).
9. Carol J. Clover, '*Falling Down* and the Rise of the Average White Male', in *Women and Film: A Sight and Sound Reader*, ed. by Pam Cook and Phillip Dodd (London: Scarlet Press, 1993), pp. 138–147; Linda Ruth Williams, 'Everything in Question: Women and Film in Prospect', in *Women and Film: A Sight and Sound Reader*, ed. by Pam Cook and Phillip Dodd (London: Scarlet Press,

1993), pp. xxiv–xxix; Lisa Purse, *Contemporary Action Cinema* (Edinburgh: Edinburgh University Press, 2011).

10. Williams, 'Everything in Question', p. xxv.
11. Ibid., p. xix.
12. Angela McRobbie, *Postmodernism and Popular Culture* (London: Routledge, 1994), p. 72, quoted in Imelda Whelelan, *Overloaded: Popular Culture and the Future of Feminism* (London: The Women's Press, 2000), p. 93.
13. Nick James, *Heat* (London: BFI, 2002), p. 8.
14. Ian Shadoian, *Dreams and Dead Ends: The American Gangster Film* (Oxford: Oxford University Press, 2003); Fran Mason, *American Gangster Cinema: From Little Caesar to Pulp Fiction* (Basingstoke: Palgrave Macmillan, 2002); Martin Rubin, *Thrillers* (Cambridge: Cambridge University Press, 1999); Edward Mitchell, 'Apes and Essences: Some Sources of Significance in the American Gangster Film', in *Film Genre Reader III*, ed. by Barry Keith Grant (Austin, TX: University of Texas Press, 2003), pp. 219–228.
15. J. A. Lindstrom, '*Heat*: Genre and Work', *Jump Cut: A Review of Contemporary Media*, 43 (2000), http://www.ejumpcut.org/archive/ onlinessays/ JC43folder/Heat.html (accessed 24 March 2012).
16. Williams, 'Everything in Question', pp. xxiv–xxix.
17. James, *Heat*, pp. 46–47.
18. Ibid., p. 47.
19. Modleski, *Feminism Without Women*, p. 5.
20. Rosalind Gill and David Hansen-Miller, ' "Lad Flicks": Discursive Reconstructions of Masculinity in Film', in *Feminism at the Movies*, ed. by Hilary Radner and Rebecca Stringer (New York: Routledge, 2011), pp. 36–50.
21. Whelelan, *Overloaded*.
22. Modleski, *Feminism Without Women*, p. 5.
23. Whelelan, *Overloaded*, p. 5.
24. Gill and Hansen-Miller, 'Lad flicks', pp. 36–50.
25. James, *Heat*, p. 41.
26. Ibid., p. 8.
27. James, *Heat*, p. 53.
28. Clover, '*Falling Down*', p. 146.
29. James, *Heat*, p. 8.
30. Laura Kipnis, 'Adultery', *Critical Inquiry*, 24:2 (1998), p. 307.
31. Susan Leonard, ' "I Hate My Job, I Hate Everybody Here": Adultery, Boredom, and the "Working Girl" in Twenty-First Century American Cinema', in *Interrogating Post-Feminism: Gender and the Politics of Popular Culture*, ed. by Diane Negra and Yvonne Tasker (Durham, NC: Duke University Press, 2007), pp. 100–131.
32. Ibid., p. 107.
33. Ibid., p. 102.
34. Ibid., p. 108.
35. Mark E. Wildermuth, *Blood in the Moonlight: Michael Mann and Information Age Cinema* (Jefferson: McFarland and Company, Inc., 2005), pp. 135–150.
36. See Wildermuth, *Blood in the Moonlight*, p. 148; James, *Heat*, p. 73; Vincent M. Gaine, *Existentialism and Social Engagement in the Films of Michael Mann* (Basingstoke: Palgrave Macmillan, 2011), p. 102.

37. Steven Rybin, *The Cinema of Michael Mann* (Plymouth: Lexington Books, 2007), p. 127.
38. Cook, 'Border Crossings', p. xvii.
39. Wildermuth, *Blood in the Moonlight*, p. 148.
40. Negra and Tasker, 'Introduction', p. 5.
41. James, *Heat*, p. 81.
42. Ibid., p. 67.
43. Wildermuth, *Blood in the Moonlight*, p. 138.
44. James, *Heat*, p. 83.

Part III
Postfeminism and Genre

11
Towards a New Sexual Conservatism in Postfeminist Romantic Comedy

Alexia L. Bowler

At the turn of the twentieth century, the re-emergence of visible feminist debate within romantic comedy is a characteristic of the genre today that was notably absent in successful films of the late 1980s and 1990s. However, as the noughties and its women have progressed, transformations in feminist thought have again begun to make their textual and conceptual presence felt. Yet, what is also apparent, in the typically conservative genre's efforts to cope with shifts in contemporary socio-sexual codes and practices, is the growing intensity of the genre's 'stand off' with feminism as it ideologically perpetuates reactionary gender regimes that reify hegemonic ideals. The complexity of young women's relationship and engagement with feminist history in contemporary popular Hollywood films, as Joel Gwynne argues in his earlier chapter, cannot be underestimated and more often than not involves a complex renegotiation and balancing of second-wave ideas and postfeminist interests. However, beyond the arguably pro-sisterhood teen chick flick, throughout its many different cycles (screwball, sex comedies and nervous romances), the romantic comedy has had a characteristically fraught relationship with feminism and feminist sexual politics, never more so than in the cycle of films that date from the late 1960s–1970s, a trend which can be repeating itself in postfeminist romantic comedy today. As such, this chapter explores the genre's renewed and arguably intensified conflict with feminism and feminist sexual politics within the contemporary postfeminist moment.

As volumes about postfeminism in academia and in cultural praxis increase, it is apparent that postfeminism is a hybridized and enigmatic cultural sensibility, signifying many things to many people, and is a

term heavily invested in our understanding of the transformations in feminism over the last century. As it is with the appellation 'feminism' itself, often portrayed as a 'territory over which various women have to fight to gain their ground' and becoming 'so unwieldy as a term that it threatens to implode under the weight of its own contradictions,' thus it is with postfeminism.[1] Conflations between labels such as power feminism and third-wave feminism render 'postfeminism' an almost unmanageable concept: it is in fact almost always defined by its instability. While some associate the term pejoratively as linked to the backlash against feminism, others consign it to a continuation of white, middle-class and interminably heterosexual feminism for the twenty-first century. Clearly, popular postfeminism engenders as many detractors as it does adherents. This is arguably due to the fact that

> Rather than being tied to a specific contextual and epistemological framework, postfeminism emerges in the intersections and hybridization of mainstream media, consumer culture, neo-liberal politics, postmodern theory and, significantly, feminism.[2]

In its dispersed nature (its saturation of popular culture and politics and as a media phenomenon, as well as its emergence and contestation in academia) postfeminism becomes a contentious and divisive concept.

Unfixed and indefinable, then, the question remains as to the nature and impact of postfeminism's multivalent and discursive modes, particularly as they are taken up in popular culture and the hegemonic cultural space that is Hollywood cinema. As Genz and Brabon recognize, postfeminism is 'both retro- and neo- in its outlook and hence irrevocably post-'.[3] As such, they understand feminism as 'neither a simple rebirth of feminism nor a straightforward abortion . . . but a complex resignification that harbours within itself the threat of backlash as well as the possibility for innovation.'[4] This chapter, then, examines the problematized nature of romantic comedy's representation of feminism (both earlier and current manifestations), drawing on Gill's concept of the postfeminist 'aura', or sensibility, which sustains the coexistence of both anti-feminist and feminist ideas within popular culture.[5] Furthermore, it follows Negra and Tasker's assertion that postfeminism supports an ' "othering" of feminism' which is constructed 'as extreme, difficult, and unpleasurable',[6] and which implodes under the weight of a postfeminism that harbours an abundance of hostile discourses towards it. Thus, in the mainstreaming of feminism, there is still uncertainty as to whether it contributes to a vibrant and discursive evolution or

its converse: a maturation of the backlash and the emergence of the feminist apologist.

With this in mind, this chapter utilizes four films, *Crazy Stupid Love* (Glenn Ficarra and John Riqua, 2011), *Friends with Benefits* (Will Gluck, 2011), *What's Your Number?* (Mark Mylod, 2011) and *No Strings Attached* (Ivan Reitman, 2011), to examine contemporary romantic comedy's relationship with feminism and sexual relations. While acknowledging the presence of multiple discourses and potential readings, it is argued here that romantic comedy constructs 'feminism' as a debilitative ideological haunting and attempts to revalidate the heteropatriarchal ideal of monogamous union. In doing so, the genre employs tropes common to postfeminism such as generational conflict, lifestyle politics and a postmodern sense of irony. Furthermore, postfeminist romantic comedy utilizes current concepts in contemporary feminist discourses, what Rosalind Gill calls a postfeminist 'sensibility' – 'the dominance of the makeover paradigm' (dealt with in Gwynne's chapter on *The House Bunny*), 'the shift from objectification to subjectification', a 'focus upon individualism, choice and empowerment', and a 'resurgence in ideas of natural sexual difference [with] a marked sexualisation [*sic*] of culture'.[7] While Gill's work assesses a wider media culture, it does provide an apposite framework for exploring representations of women's relationships with feminism in romantic comedy, which is a genre that frames feminism and postfeminism as oppositional forces grappling with one another for authentication.

Adapting (to) feminism within the genre

Debates surrounding romantic comedy and feminism are hardly new. Indeed, the inception of the sexual revolution, along with the advent of second-wave feminism in the 1960s and 1970s, precipitated an appreciable amount of disquiet about the genre's longevity and trajectory, causing Brian Henderson to predict the end of the genre's cinematic life[8] following the emergence of a cycle latterly dubbed 'nervous romances'.[9] This cycle, including Mike Nichol's *The Graduate* (1967) and Woody Allen's *Annie Hall* (1977), shattered generic boundaries and near-permanently paralysed the genre through its evocation of romantic apathy and progressive sexual attitudes, suggesting a growing ambivalence towards the possibility of the future of a 'heterosexual arcadia'.[10] Steve Neale points to the success of *Annie Hall* and *The Graduate* as being due to their timely and intense scrutiny of socio-cultural issues – raised in feminism and by newly-liberated

sexual attitudes. He states: 'the question at stake in romantic comedy is not just sexual (or just a matter of fucking)' but that it is also one of 'coupledom, compatibility and, precisely, romance; and hence of the (changing and often contradictory) social conditions, institutions, discourses and practices that define and underpin them'.[11] Similarly, Krutnik identified that the juxtaposition of the 'sexual question' and notions of 'commitment' in 'nervous romances' successfully represented challenges galvanized by feminism, 'betray[ing] a wistful nostalgia for the "whole romantic thing" while acknowledging its impossibility'.[12] Yet, it is clear that romance, as 'one of the key narratives by which we are interpellated or inscribed as subjects', has meant that romantic comedy, like romance fiction, seems 'to have shown remarkable resilience in the face of significant cultural and demographic changes'.[13] Indeed, the 1980s and 1990s refused the radical concerns of *Annie Hall* and *The Graduate*. In lieu of facing the reality of the 'lost object' of romance and the instability of institutions such as marriage, the genre tended to hyperrealize heterosexual romantic traditions. Contrary to Henderson, then, today the genre shows not only a continued prominence but also an allegiance to sibling (sub)genres: the 'chick flick' and the 'homme-com'.

Mapping the postfeminist moment in romantic comedy

Similarly, in the films examined here, the influence of the homme-com and the chick flick can be seen: traditional romantic conventions of the 1980s and 1990s have been replaced by the, often voyeuristic, foregrounding of recreational sex, bodily presentation and the discussion of the sexual subjectivity and femininity of women in contemporary romantic culture. As Jeffers Mcdonald has observed, a change of attitude emerged in the noughties homme-coms: films which prioritize the 'importance of the bodily, and particularly the sexual, elements within romance, [as well as] the scatological and carnal motifs'.[14] Yet, despite the genre's refocusing, romantic comedy displays a perceptible sexual conservatism and peculiar conflict regarding female sexual liberation, agency and femininity: the male protagonists certainly seem more comfortable in their 'sexual skins' than the women. Thus while each of the films explored here flirt with the tropes of recreational sex, women's libidinal desire and liberal attitudes, they herald a re-emergence of the belief in 'soul mates', longevity and a committed behaviour previously rejected in the 'nervous romances'. Indeed, they welcome these ideals as

an inherent and timely panacea to the radical feminism of the previous century and the crumbling, patriarchally-inscribed institutions of the late twentieth century.

While hostility towards feminism is well documented by feminist writers, Negra and Tasker note that, 'postfeminist discourses rarely express the explicit view that feminist politics should be rejected; rather it is by virtue of feminism's success that it is seen to have been super-seded'.[15] Likewise in romantic comedy the 'F-word' is rarely, if ever, mentioned. It seems that in postfeminist popular culture feminism is 'at some level transformed into a form of Gramascian common sense, while also fiercely repudiated, indeed almost hated',[16] and its absence implies both an assumed presence and irrelevance. It is a power that has, as McRobbie suggests, been 'taken into account' as a 'spent force'.[17] However, in a film that epitomizes the postfeminist moment in contemporary romantic comedy, feminism is referenced directly and underscores the increasingly deleterious centrality of feminist debates within the genre. In *Crazy, Stupid, Love,* the film sets up the re-education of an arguably emasculated loser-male. Young lothario, Jacob Palmer (Ryan Gosling), instructs his older mentee, Cal Weaver (Steve Carrell), that 'the war between the sexes is over. We won the second women started doing pole dancing for exercise', and the film charts the older man's rediscovery of his sexually powerful masculine-self, in which he first gets 'made-over' (and then 'made-under') in order to win back his estranged wife, who he believes is his soul mate.

Two observations spring to mind from Jacob's confident pronounce-ment. His cynical articulation explicitly references the perception of feminism as a mooted gender-war that no longer has any currency. As such, feminism in its entirety is considered a beleaguered and thwarted historical event, rather than a newly reinvigorated and vital presence. Indeed, in all four films, the rejection of feminism as ideology is framed as a tiresome side-show to heterosexual relations and engenders its depoliticization. However, the irony contained in the latter-half of Jacob's emphatic denouncement raises a second observation. Jacob's glib evidencing of male victory relies on his reference to an activity controversially but iconically linked to popular postfeminist culture: pole dancing. An activity that is part of raunch culture or 'do-me feminism', it blends 'the sometimes conflicting ideologies of women's liberation and the sexual revolution by heralding sexually provocative appearance and behaviour (including exhibitionist stripping) as acts of female empowerment'.[18] Here, however, it is

lampooned as verification of a flawed, or impotent, feminism that has been abandoned in favour of contemporary postfeminist discourses such as individual choice and empowerment: women's sexual empowerment is refigured as co-optation and cession to patriarchal subterfuge. In the film's logic, then, arguments promoting feminist vitality and validity are ideologically bankrupt remnants of a view out-of-step with the contemporary moment.

While *Crazy, Stupid, Love* explicitly rejects feminist politics, it is an exceptional incident and the film underwrites the risk of alienating its female viewers. Mobilizing postfeminism's familiarity with feminist critique, the film's focus on demasculinization and the relative absence of the primary female protagonists, promotes a maturation of backlash conservatism and a reinscription of the heteropatriarchal romantic nexus. For example, the aforementioned explicit challenge to feminism is followed by full-frontal shots of Jacob. However, the shot of Cal's sweaty forehead obscures Jacob's 'manhood' as he opines: 'But even though we won, they still deserve our respect, you know. We make 'em feel beautiful, actually listen to their problems, open doors for them.' This juxtaposition allows us to distinguish between Cal's lack of traditionally powerful masculinity and Jacob's confidence and unarguably attractive body while simultaneously registering the absurdity of Jacob's hypermasculine posturing, as well as his anti-feminist patter. However, Jacob's attitude is mitigated by a postmodern irony that assumes our awareness of twentieth-century feminism but simultaneously displays twenty-first century sophistication and distancing from it. Thus while Cal is positioned as a 'victim' of the demasculinization brought on by feminism, the younger postfeminist man clearly uses his knowledge of feminism as another weapon in his arsenal to pick off his sexual targets.

While at the film's close Jacob's nonchalant sexual philosophies and gender politics are up-ended, it is clear that his bad-boy-chic has its charms while Cal's emasculated persona is endearing but not especially sexually enthralling. Consequently, in the case of Cal and Emily (Julianne Moore), the film proposes innate values of endurance, stability and shared history as a powerful aphrodisiac, while for Hannah (Emma Stone) the pseudo-reconstructed, but attractive and rich male, seems ideal for the postfeminist ingénue in a postmodern culture. Certainly, Hannah's offer of a high-flying job strikes her as inferior to a romantic proposal. Thus the postfeminist romantic comedy returns us to the utopian fantasy of soul mates, true love and monogamy and vanquishes the ghost of (feminist) ideology.

Generational conflict: Rejecting feminism's legacy

The oppositional play between feminism and postfeminism in *Crazy, Stupid, Love* creates an 'othering' of feminism, manifesting a generational conflict seen in some third-wave feminist writers' disavowal of the second wave. Henry notes that, for many younger feminists, 'the disavowed identity that must be kept at bay is often second-wave feminism itself'.[19] Rather than engaging with the impact of external factors on feminism, contemporary struggles, Henry suggests, primarily shape themselves as internal skirmishes. She proposes that 'in its most extreme formulation, it is feminism that has become the enemy [and] seems to stand in the place that was once occupied by external forces against feminism. Feminism is what stands in the way of women's liberation'.[20] Interestingly, in the noughties, romantic comedy also characterized conflict as between the censorious feminism of the mother figure and her liberty-seeking daughter (*Something's Gotta Give* [Nancy Meyers, 2003] is one such example). However, more recent incarnations have presented the clash as being between young women's conflict with the surrounding aggressive sexual economy, and a tension between a notional liberation and agency (bequeathed by second-wave feminism) and the wholesale rejection of traditional and institutional hegemonic heterosexual practices (seen in the 'nervous romances'). This is something that can be seen to have an equivalent in what Negra describes as the chick flick's 'postfeminist retreatist narratives' which target single, successful, professional women as experiencing workplace fatigue.[21]

Generational conflict, which serves to problematize feminism in its totality, informs *Friend with Benefits* and pits the sexually unconventional and independent figure of Lorna (Patricia Clarkson) against the more conservative desires of her daughter Jamie (Mila Kunis). Typically postfeminist, the film conflates several versions of feminism: Lorna is the second-wave feminist who does not need a 'prince charming' and the stability of a patriarchal domestic setting. In contradistinction, she is also the ideal pro-sex feminist of the third wave and the subject, rather than the object, of sexual desire: she is vocally impressed with the 'produce' (Dylan's objectified, naked body) that Jamie has managed to find at 'the market'. Moreover, Lorna is sexually inappropriate giving Dylan (Justin Timberlake) permission to use her daughter as a 'slam-piece', even giving him her own number. Representative of an 'immature' feminism which refuses to 'act its age', Lorna describes the 1970s as a 'better time' which involved 'just sex, a little grass and a little

glue'. However, it is clear in generational terms that Lorna is a sexually liberated and freewheeling but ultimately unstable relic from the heyday of the sexual revolution and a heady feminism, who drifts in and out of Jamie's life. Arguably, Lorna is symbolic of a rejected feminism that is specifically configured as second wave through its generational aspect but which also contests feminism in its entirety through its construction of her as sexually, socially and culturally wayward. As representative of second-wave feminism, Lorna 'stands in the way of the daughter's freedom.'[22] In fact, Lorna's romantic atheism, her emotional unreliability and her sexualized subjectivity, generate in Jamie nightmarish visions of a similar trajectory.

In Negra's view, the noughties trend for postfeminist retreatism (from the public sphere) is writ large in popular women's films, setting themselves in opposition to the achievements of the second wave. Signalling the 'recovery of the self and society',[23] they undermine feminism through the creation of 'an idealized, essentialized femininity that symbolically evades or transcends institutional and social problem spots' in the return to home.[24] *Friends with Benefits* similarly underscores a generational (feminist) conflict through the tropes of the contemporary sexed female subject's pathological desire for romantic union: Lorna's suggestion of shared familial attitude, that 'the apple doesn't fall far from the tree' is a legacy disavowed by Jamie. Played mainly for laughs, Lorna is portrayed as unreliable, irresponsible and even selfish. Having relinquished her maternal responsibilities (a stable family, emotional support and fiscal responsibility) she is clearly the embodiment of the 'unruly woman' of feminism. Yet the double-edged play of the postfeminist text clearly attempts both to demonize and reclaim her – displayed in the abortive attempts at mother-daughter bonding and in Lorna's *minor* recuperation as part of Dylan's romantic rescue of Jamie. Accordingly, the film allows us to take pleasure in Lorna's promiscuous banter providing we understand its limits. We understand that her position becomes untenable when she abandons Jamie midway through the film, allowing us to eschew Lorna's choices in favour of Jamie's traditional and sexually conservative outlook.

Having it both ways: Postmodernity and postfeminist romantic comedy

As Gill notes, postfeminist sensibility includes a postmodern irony and knowingness. In terms of media consumption (including that of cinema), it is a characteristic that treats its audience as

[S]ophisticated consumers, flattering them with their awareness of intertextual references and the notion that they can 'see through' attempts to manipulate them [.] Irony is used as a way of establishing a safe distance between oneself and particular sentiments or beliefs, at the same time when being passionate about anything or appearing to care too much seems to be 'uncool'.[25]

Romantic comedies similarly diffuse the tension in their oppositional sexual politics, offering modish ambivalence and humour rather than engagement with its ideological underbelly. Several of the romantic comedies under discussion here, including *Crazy, Stupid, Love*, invest heavily in this logic, mitigating their revalidation of the heterosexual and patriarchal hegemonic paradigm. As such, they counter prior feminisms' shattering of those ideological boundaries and diminish feminist perspectives (primarily those of the second wave), as well as reduce the capacity for future progress.

In *Crazy, Stupid, Love*, knowingness and irony allow Hannah to see through Jacob's cynical use of women's popular culture as a technology of seduction. Nevertheless, the transparency of technique does not make her (or the female viewer) immune to its charms. Mindful that she wants to take control of her own sexual journey and 'bang the hot guy who hit on her at the bar', Hannah demands Jacob's 'big [seduction] move'. Jacob admits that he works *Dirty Dancing* (Emile Ardolino, 1987) into the conversation:

You know the big move at the end of *Dirty Dancing*, where Patrick Swayze picks up Jennifer Grey? I can do that. So I tell girls I can do the move, I put on the song, 'Time of your Life'. I do the big move, and they always want to have sex with me.

Hannah's clearly engaged feminist sensibility is appalled by this cynical manipulation. Within a matter of minutes, however, the film challenges Hannah's (and the viewer's) feminist credentials. Indeed, the fetishization and knowledge of the technology of seduction *paves* the way for the pleasures of romantic sex and cinematic folklore, to which Hannah succumbs: *Dirty Dancing*'s deflowering of the doe-eyed and virginal 'Baby' is seen as the pinnacle of the young woman's heterosexual experience. As Negra and Tasker note, 'postfeminist culture is evidently postmodern in its character, its self-reflexivity mobilizing the terms of its own critique. Postfeminist culture does not allow us to make straightforward distinctions between progressive and regressive texts.'[26] In a similar

fashion, the work of the postfeminist romantic comedy disarms and depoliticizes its own feminist critique of sexual negotiations through knowingness, irony and a cosy humour, coupled with discourses surrounding personal choice, disavowing a straightforward condemnation of Jacob's seductive technique. However, the film simultaneously divests Hannah of her sexual autonomy and suggests that her performance of sexual agency is mere affectation, unreflective of her true desire, which is to be seduced, romanced and (ultimately) married.

Friends with Benefits similarly attempts to 'have it both ways'. Primarily, the film showcases its postmodern and postfeminist credentials through fronting its awareness of romantic comedy as a Hollywood product. The characters knowingly highlight conventions and cinematic techniques used to manipulate its audiences, and both Dylan and Jamie are enveloped in romantic comedy's cinematic references. So, while Dylan is unenthusiastic about his date's choice of music concert, in a scene reminiscent of the 'Celine Dion episode' in *How to Lose a Guy in 10 Days* (Donald Petrie, 2003), Jamie's date refuses to understand why they cannot be late for her favourite film *Pretty Woman* (Garry Marshall, 1990). Similarly, Jamie's anger regarding her latest romantic rejection is directed towards Katherine Heigl (romantic comedy's newest ingénue) in *The Ugly Truth* (Robert Luketic, 2009) as having 'lied to her'.

Corporate recruiter Jamie is especially bound by Hollywood romance's conventions and language. For example, when she gives Dylan different versions of her closing pitch to her clients, he questions her technique, asking her what makes women think that manipulation is 'the only way to get a man to do what they want'. She replies: 'History. Personal experience. Romantic comedies.' With regard to relationships between men and women, then, it seems that the language of (Hollywood) convention has tutored Jamie's own expectations and outlook. These idealized discourses saturate Jamie's outlook: from dating rules to her belief in soul mates. Similarly, her Los Angeles sightseeing trip involves sitting on the Hollywood sign – ironically getting close to the iconic sign (and perhaps the dreams it weaves) is an illegal activity that sees them both hoisted down by the authorities. Equally ironic is Jamie's 'New York' pitch to Dylan which idealizes the city via a flash mob performance of 'New York, New York': Jamie sells the idea of city life in much the same way that Dylan sells through advertising and romantic comedy sells the spectacle of heterosexual romance.

Jamie's ability to critique Hollywood romance, her enjoyment of sex, and the persona she has carved out for herself as go-getting professional, owe their origins to the urban girls of television's *Sex and the City*

(Darren Star, 1998–2004) with their swagger and confidence. However, like the postfeminist women of that franchise, the logic of the film endorses her status as 'emotionally damaged': in the sexual politics of the film, Jamie's love of romantic comedy's 'happy ending' is configured as a pathological symptom of her emotional neediness, instability and a loneliness that arises from the devastation of patriarchal values. In contrast, but in a nod to Gill's notion of the rise of discourses about natural sexual difference,[27] Dylan is configured as 'emotionally unavailable'. While Dylan sees sex as a purely 'physical act, like playing tennis... It's just a game... You shake hands and get on with your shit', the film does not allow Jamie to relinquish romance altogether. As the pair debate Hollywood cinema Jamie declares her fantasy: 'God I wish my life was a movie sometimes. When I'm at my lowest point, some guy would chase me down the street, pour his heart out and we'd kiss: happily-ever-after.' While imbedded in a tongue-in-cheek critique of the cult of romance, Jamie becomes less convincing as the film indulges in romantic spectacle at the film's close: Dylan is able to display his emotional (rather than his sexual) availability, through utilizing the tools and codes of romance in his organization of a flash mob at Grand Central Station to sweep Jamie off her feet, while Jamie is able to merge fantasy with reality (restoring our faith in the genre of 'true love' over sex, while having previously deconstructed it). Thus both *Friends with Benefits* and *Crazy, Stupid, Love* cynically employ postfeminist/postmodern knowingness and irony to discredit romantic conventions, mobilizing the critiques passed on to us via feminism and allowing us to see through those 'ideologies'. Yet both finally subsume feminism as an ideology outside a universal romantic 'reality', unable to support female sexual agency without a heteropatriarchal framework.

The pornographic sexual economy and the romantic comedy

Laura Harvey and Rosalind Gill propose that contemporary society is characterized by the 'sexualization of culture' – defined as capturing 'the growing sense of western societies as saturated by sexual representations and discourses, and in which pornography has become increasingly influential and porous, transforming contemporary culture' – that denotes an assortment of issues such as 'a contemporary preoccupation with sexual values, practices and identities; the public shift to more permissive sexual attitudes; the proliferation of sexual texts [and] the emergence of new forms of sexual experience', among other things.[28]

Indeed, discourses about sex and sexual agency are defining, if not problematic, tropes of the films discussed here. Third-wave feminism (and to an extent postfeminism) has championed the pleasures of (heterosexual) sex and the rise of a 'do-me', 'pro-sex' or 'power' feminism as a triumph over the second wave's perceived prohibitive sexual politics. As Radner explains, this 'sex-positive' feminism postulates a 'technology of sexiness', in which the 'autonomous heterosexual young woman plays with her sexual power and is forever "up for it" '.[29] Here Radner draws on what she terms Helen Gurley Brown's 'neo-feminism', first articulated in *Sex and the Single Girl* (1962).[30] Contemporaneous with the rise of second-wave feminism, Brown's 'neo-feminism', according to Scanlon, is an antecedent of third-wave feminism in this regard.[31]

According to Radner, then, Brown's logic means that woman's sexual agency lies in the 'currency of the orgasm'.[32] Her 'sexual expertise replaces virginity as the privileged object of exchange outside the law of family [and her] sexuality is part of [the Single Girl's] capital, her expertise (performance) rather than her chastity enhancing her value'.[33] However, her pleasure is valuable 'only to the extent that it operates as such within a system of mutual exchange', and Brown felt that 'to depend on a man or men, in any way, is an unwise choice on the part of the Single Girl' as 'such dependence renders "unfulfilling" sexual pleasure itself, because "sex" must arise out of mutual erotic need'[34] rather than the exchange of power in traditional patriarchy.

However, this is an attitude that is shared somewhat ambivalently in the romantic comedy whose utilization of 'pro-sex feminism' appears only to be displaced in favour of a traditional repatriation of the female sexed-subject into acceptable 'romantic' situations, and can be seen to be challenged by contemporary romantic comedy with especial resonance in *Friends with Benefits*, *No Strings Attached* and later the retro-sexist *What's Your Number?* Early on in *Friends with Benefits*, frustration with her love-life moves Jamie to ask why no one makes films about the afterlife of the romantic couple, to which Dylan responds: 'They do. It's called porn.' The film thus connects the two. It proposes a difference between porn and romance yet surreptitiously hints at their increasing conflation in postfeminist culture. Indeed, as Gill comments, many critics 'have drawn analogies between romances [in literature] and pornography', suggesting that the fetishization of 'body parts and positions' in pornography is similar to the fixation on emotion in romance and that both genres 'eroticize the power relations between the sexes'.[35] Indeed, the film makes notions of sexual power struggles noticeable as Jamie's reticent agreement to Dylan's proposal comes from a sense of romantic failure and even (somewhat incongruously)

solemnizes their 'no-relationship-just-sex' pact on her iPad Bible app as protection.

However, the mainstreaming of 'porno chic' in contemporary society renders us comfortable with the conflation of the two, and the film proposes a cynical reductionism of romance as merely the desire for sexual gratification within legitimized confines. The fact that we are ostensibly watching (and enjoying) two people have sex-without-romance, and the foregrounding of discussions of sexual technique and pleasure above emotional unity, is testament to this. As such, Dylan's view of 'sex-as-tennis' stands in opposition to the cult of romance: 'romance' typically leads to marriage (the genre's conventionally legitimized institution) which validates sexual activity. The 'romantic' dilemma particularly affects Jamie rather than Dylan, eliciting notions of natural sexual difference and fostering a peculiarly antiquated debate about the possibility of sex versus romance for women. Indeed, the film legitimizes romantic commitment as the only condition under which sexual activity can be truly enjoyed and situates women as most in need of protection from the reality of the (pornographic) sexual economy around them.

Conversely, in *No Strings Attached* this (pornographic) sexual economy initially seems to suit Emma (Natalie Portman). Based on a similar premise as *Friends with Benefits*, *No Strings Attached* has been described as a kind of *Love and Other Drugs* (Edward Zwick, 2011) 'without the disease',[36] in which sexual agency and availability is undercut by rising emotional anxieties in those women. Indeed, in *No Strings Attached*, sex competes with the concept of soul mates. Beginning with a flashback, Adam (Ashton Kutcher) and Emma meet at summer camp as teenagers. While Adam bemoans his parents' divorce, Emma announces her unconventional credentials, stating 'people aren't meant to be together forever', at which point Adam has recovered sufficiently enough to ask Emma whether he can 'finger her'. Five years on, we see postfeminism's version of sexual agency, which Gill states is only conditionally rendered; that is, 'to construct oneself as a subject closely resembling the heterosexual male fantasy in pornography'.[37] Adam and Emma are reacquainted at a frat-party where girls wearing hotpants with the word 'whore' emblazoned on them drunkenly table-dance, aiming to 'get laid' – this sexual utopia is a staple motif in many a 'frat-pack' film. Where the romantic comedy differs in its evocation of a pornographic sexual economy from other media more generally, is in its underlying conception of soul mates anticipated in the film's opening and the withdrawal of sexual play as the emotional and psychological consequences become apparent.

Indeed, *No Strings Attached* has been called 'a feminist-backlash movie'[38] in its presentation of its female lead, and the film presents each of the female characters as psychologically, emotionally and/or socially troubled: from Emma's fellow doctors Patrice (Greta Gerwig), who hooks up with villainous men, and the sexually-starved Shira (Mindy Kaling), to Adam's sexually repressed and socially inept work colleague, Lucy (Lake Bell), who is pathologically frightened of her own desires. Among these oddball women, Emma is characterized as socially abnormal – in failing to mourn her father appropriately by bringing a date to his funeral, and in her coldness towards Adam's emotions later on. As an adult, Emma privileges rationality and functional sex over emotional responses, rejecting Adam's desire for a relationship: 'What I need is someone who can be in my bed at 2am who I don't have to lie to or eat breakfast with.' As Brown's 'single girl', Emma refuses the patriarchal exchange inherent in heterosexual romantic relationships, preferring pornographic carnality to emotion, possession and need.

Her view of relationships is arguably characterized as second-wave-esque militantism, along with a cynical logic and over-intellectualization. Defiantly refusing Adam's 'period mix-tape', she states: 'I don't need you to take care of me. I take care of myself. That's what I do.' It seems that the film's version of feminism has made her 'relationship-intolerant', and she likens her aversion to relationships to an 'emotional peanut allergy' that exposes a reality she would rather conceal. She reasons: 'If we were in a relationship I would become a scary version of myself and my throat starts constricting, the walls start closing in.' In searching for a clue to Emma's 'allergy' to romance and relationships, it seems that portrayals of independent, sexually active women in Hollywood flounder, preferring to theorize women's sexual agency as the emotional and psychological imbalance of a promiscuous dilettante. The two narratives of Emma's life seem mutually exclusive, with sexualized freedom and the pornographic sexual economy contributing to the depletion of her humanity seen earlier. In *Friends with Benefits* and *No Strings Attached* the premise is that we cannot have sex without emotional entanglement, while in *Crazy, Stupid, Love* the entanglement is what is desired. If, as Joel Gwynne contends, the teen chick flick (with its formulation of new femininity) proposes a framework which attempts to balance and negotiate the demands of postfeminism's hypersexualized and active female sexuality for its younger target audience, contemporary postfeminist romantic comedy (as its elder sibling) seems insistent in concluding that the porno-graphic nature of sex-without-romance weakens women's emotional

and psychological well-being. Accordingly, in the romantic comedy, lasting fulfilment is not to be found in the orgasm but in the monolithic ideologies of Hollywood, and while the heterosexual couple may only cohabit with their sexually compatible 'best friends' (Dylan's conceptualization of his relationship with Jamie) rather than marry, in reality they cannot help but enact the cultural and psychological attitudes of the newly-minted couple.

Towards a renewed sexual conservatism

This sexual conservatism finds its apotheosis in *What's Your Number?* The film's title references a *Marie Claire* article, read by Ally (Anna Farris), in which the average woman's sexual partners is numbered to be about ten. The article proposes that sleeping with over 20 men indicates failure in love. As Ally's number is 19 she anxiously renounces her promiscuity (and ironically her search for a new job), in favour of chastity, fearing she will not find 'the one'. Instead, she sets out on an odyssey, in which she retraces her steps (stalks former lovers), in the hope of recognizing her 'prince charming' among them.

Ally's view of women's sexual activity and respectability is rather outmoded, if we remember the (arguably pseudo-) sexual libertarianism espoused in media such as *Sex and the City*, as well as a wider media culture that has mainstreamed soft porn and promoted sexual experimentation. However, it is a conservative view promoted by Ally's peer group, apparently backed up by 'research' and upheld by the anecdotal observation that: 'When you're too sexually available that's when you get low self-esteem. Next thing you know you're 45, no self-respect, no husband and no muscle tone in your pelvic floor.' Sexual conservatism extends to debates about 'age-appropriate' sexual techniques, seen when Sheila (Eliza Coupe), the film's more 'wanton' member of the group, suggests that Daisy's (Ari Graynor) wedding dress should have 'access all areas' for sexual tricks such as the 'sixty-nine'. Eileen (Heather Burns) reprimands her: 'She's not going to Sixty-nine! She's a grown up. Sixty-nines are for when you're seventeen and trying to cram everything in at once before your parents get home.' This view situates promiscuity and sexual experimentation as immature, deviant and responsible for the failure of 'normal' relationships. It belies postfeminism's embrace of women as agents of their own desire, no longer expected to follow a sexual ethics based on the heteropatriarchal codes of a pre-feminist era. This leads Ally to metaphorically and psychologically reclaim her 'virginity'; a

revirginization validated and vindicated at the film's close. Glossed as self-control and agency – of her body and over her destiny – Ally's sexual abstinence marshals postfeminist discourses of self-regulation, discipline and monitoring (seemingly justified after Ally disastrously sleeps with a colleague while inebriated, taking her 'number' to 20). As such, the film proposes that lack of self-discipline merits the withdrawal of sexual pleasure from the romantic heroine until she can direct it appropriately.

What's Your Number? parades its reversion to a sexual ethics based on double-standards, as Ally remonstrates:

> You guys all have this ideal girl in your mind. And if our number gets too high, we can't be that girl...You take her home to the family. She's smart but not smarter than you, and she bakes apple pies with your mom and plays catch with your handicapped sister. But then when you're alone she takes off her glasses, puts on a vinyl catsuit and fucks you sideways!

The 'apple pie' conception of femininity (and its pornographic darker sibling) pinpoints postfeminism's hypocritical sexual ethics and backlash politics. The existence of the 'whorish' behind every innocent-looking female is no stranger in cultural discourses regarding women, and Colin's (Chris Evans) repudiation affects a sincerity that is not present in the film's ideology. Indeed, Colin's denial is tempered by his prurient enthusiasm for this pornographic fantasy. The film undercuts Ally's politicization of the double standard, however, through her own assumption that men who care about women's sexual history are 'decent guys' and her friend's designation of Colin as her 'rapey neighbour'.

In contrast, Jake Adams (Dave Annabel) fulfils Ally's childish fantasy of 'prince charming' – in lifestyle, looks and manners. While the film constructs Ally's repudiation of Jake as a newly-awakened and liberated sexual subjectivity, it is important to remember that Colin's sexual promiscuity outmatches Ally's own. Furthermore, in Colin, the film's discourse promotes a virile masculinity that is nakedly paraded throughout. Thus the film provides Ally with a more 'suitable' partner. Similarly, while the frank discussions about sex and sexuality seemingly engage positively with a liberal sexual culture, Ally's promiscuity is underscored as an important element of its sexually conservative discourse: a last minute phone call from one of her former lovers informs her that they did not in fact have sex, allowing Colin to become Ally's 'number 20'. Having finally found 'the one', without going over an acceptable

number of sexual partners, the film returns us to romantic comedy's pathological concern with sexual stability, female sexual morality and heterosexual monogamy. As such, it adds a conservative coda to what had the potential to 'take up and twist the concerns of the previous sub-genre's films', seen in the 'nervous romances' of the 1960s and 1970s.[39]

Conclusion

By way of conclusion, I would like to end with returning to the question raised at the beginning of the chapter as to the ambiguous nature of the increasing centrality of women's relationship with feminism in the narratives of the romantic comedy. As Harvey and Gill observe in the wider media culture, debates among feminists are divided as to

> [w]hether the proliferation of representations of women as desirable and sexually agentic represents a real and positive change in depictions of female sexuality, or whether, by contrast, it is merely a postfeminist repackaging of feminist ideas in a way that renders them depoliticized and presses them into the service of patriarchal consumer capitalism.[40]

This chapter suggests that postfeminist romantic comedy's own conflict with feminism is a conflict with female sexual agency which is not directed towards heterosexual union. Indeed, it exacerbates the impression of feminism as antithetical to the contemporary zeitgeist, charging it as an 'institution' that egocentrically stamps on the head of heterosexual romantic relations, as well as being ruinous to the psychological and emotional well-being of the contemporary woman. In postfeminist romantic comedy, while heterosexual activity and desire are lauded, in line with the pornographic sexual economy of contemporary culture, self-directed (narcissistic) female agency is not. Kept in check by the ultimately sexual conservatism of a postfeminism that redirects its energy towards the maintenance of patriarchal hegemonic social and cultural practices, feminism is arguably utilized in the maturation of the backlash and creation of the feminist apologist.

Notes

1. Imelda Whelehan, *Overloaded: Popular Culture and the Future of Feminism* (London: The Women's Press, 2000), p. 78.

2. Stéphanie Genz and Benjamin A. Brabon, *Postfeminism: Cultural Texts and Theories* (Edinburgh: Edinburgh University Press, 2009), p. 15.
3. Genz and Brabon, *Postfeminism*, p. 8.
4. Ibid., p. 8.
5. Rosalind Gill, 'Postfeminist Media Culture: Elements of a Sensibility', *European Journal of Cultural Studies*, 10:2 (May 2007), pp. 147–166.
6. Yvonne Tasker and Diane Negra, 'Introduction: Feminist Politics and Postfeminist Culture', in *Interrogating Postfeminism* (Durham and London: Duke University Press, 2007), p. 7.
7. Gill,'Postfeminist Media Culture', p. 149.
8. Brian Henderson, 'Romantic Comedy Today: *Semi-Tough* or Impossible?', *Film Quarterly*, 31:4 (Summer 1978), pp. 11–23.
9. Frank Krutnik, 'The Faint Aroma of Performing Seals: The "Nervous" Romance and the Comedy of the Sexes', *The Velvet Light Trap*, 26 (Fall 1990), pp. 57–72.
10. Krutnik, 'The Faint Aroma of Performing Seals', p. 57.
11. Steve Neale, 'The Big Romance of *Something Wild*?: Romantic Comedy Today', *Screen*, 33:3 (Autumn 1992), p. 286.
12. Frank Krutnik, 'Love Lies: Romantic Fabrication in Contemporary Romantic Comedy', in *Terms of Endearment: Hollywood Romantic Comedies of the 1980s and 1990s*, ed. by Celestino Deleyto and Peter William Evans (Edinburgh: Edinburgh University Press, 1998), p. 19.
13. Rosalind Gill, *Gender and the Media* (Cambridge: Polity Press, 2007), p. 218.
14. Jeffers Mcdonald, 'Homme-Com: Engendering Change in Contemporary Romantic Comedy', in *Falling in Love Again: Romantic Comedy in Contemporary Cinema*, ed. by Stacey Abbott and Deborah Jermyn (London: I. B. Tauris, 2009), p. 147.
15. Tasker and Negra, 'Introduction', p. 5.
16. Angela McRobbie, *The Aftermath of Feminism: Gender, Culture and Social Change* (London: Sage, 2009), p. 12.
17. McRobbie, *The Aftermath of Feminism*, p. 12.
18. Genz and Brabon, *Postfeminism*, p. 91.
19. Astrid Henry, *Not My Mother's Sister: Generational Conflict and Third-Wave Feminism* (Indiana: Indiana University Press, 2004), p. 11.
20. Henry, *Not My Mother's Sister*, p. 39.
21. Diane Negra, *What a Girl Wants: Fantasizing the Reclamation of Self in Postfeminism* (London: Routledge, 2009), p. 16.
22. Henry, *Not My Mother's Sister*, p. 11.
23. Negra, *What a Girl Wants*, p. 19.
24. Ibid., p. 18.
25. Gill, 'Postfeminist Media Culture', p. 159.
26. Tasker and Negra, 'Introduction', p. 23.
27. Gill, 'Postfeminist Media Culture', pp. 147–166.
28. Laura Harvey and Rosalind Gill, 'Spicing it Up: Sexual Entrepreneurs and *The Sex Inspectors*', in *New Femininities: Postfeminism, Neoliberalism and Subjectivity*, ed. by Rosalind Gill and Christina Scharff (Basingstoke: Palgrave Macmillan), p. 53.
29. Gill, 'Postfeminist Media Culture', p. 151.

30. Hilary Radner, *Neo-Feminist Cinema: Girly Films, Chick-Flicks and Consumer Culture* (London: Routledge, 2010).
31. Jennifer Scanlon, *Bad Girls Go Everywhere: The Life of Helen Gurley Brown* (Oxford: Oxford University Press, 2009).
32. Hilary Radner, 'Queering the Girl', in *Swinging Single*, ed. by Hilary Radner and M. Luckett (Minneapolis, MN: Minnesota University Press, 1999), p. 19.
33. Radner, 'Queering the Girl', p. 19.
34. Ibid., pp. 16–17.
35. Gill, *Gender and the Media*, p. 220.
36. A. O. Scott, '*No Strings Attached*: A Firm Commitment to Casual', *New York Times Online* (29 January 2011), http://movies.nytimes.com/2011/01/21/movies/21nostringsattached.html (accessed 29 August 2012).
37. Gill, 'Postfeminist Media Culture', p. 150.
38. David Edelstein, '*No Strings Attached*: Corny, Contrived, Conservative', *National Public Radio* (2011), http://www.npr.org/2011/ 01/21/133091157/no-strings-attached-corny-contrived-conservative (accessed 29 August 2012).
39. Tamar Jeffers Mcdonald, *Romantic Comedy: Boy Meets Girl Meets Genre* (New York: Columbia University Press, 2007), p. 85.
40. Harvey and Gill, 'Spicing it Up', p. 53.

12
'Hell Is a Teenage Girl'?: Postfeminism and Contemporary Teen Horror

Martin Fradley

Released over a decade after *Scream 3* (2000), the belated fourth instalment of Wes Craven's iconic teen horror cycle begins with a characteristically arch tableau of meta-textual solipsism: an abyssian postmodern *mise-en-abime* of films-within-films-within-films. Starring attractive young female performers recognizable to the film's target demographic from popular television shows such as *The Bionic Woman* (2008), *Heroes* (2007–2008), *True Blood* (2008–2012), *Pretty Little Liars* (2010–2012), *Gossip Girl* (2007–2012), *Veronica Mars* (2004–2007), *Friday Night Lights* (2006–2011) and *The Secret Circle* (2010–2011), the protracted opening sequence features a series of bloody murders taking place within interchangeably affluent domestic spaces during a series of equally interchangeable 'girly' nights in. A film featuring meta-textual jokes about the predictable banality of meta-textuality, *Scream 4*'s (2011) baroque introduction sardonically critiques – and then knowingly recycles – the widely perceived clichés of teen horror cinema as a series of highly photogenic, but equally disposable, young women are offered up for visual gratification before the film systematically despatches them with crudely generic efficiency.

Scream 4's mordant prologue may well help explain why teen horror has found few friends among film scholars, many of whom continue to adhere to the critically orthodox view that American horror's radical-political potential has dissipated since the 1970s. Indeed, the film's ironic flippancy in many ways exemplifies the limitations of a 'politically ambidextrous' postfeminist culture.[1] Frequently described as perniciously difficult to define, Yvonne Tasker argues that postfeminism is a discursive terrain 'both highly *knowing* about sex and gender (both

cognizant of sexism and knowing with respect to sexual innuendo) and deeply invested in conventional modes of femininity'.[2] As such, the ironic tone of *Scream 4*'s opening is emblematic of postfeminist media culture: the film acknowledges the depressingly limited parameters of young women's role in popular media representation at the same time as it violently reinscribes those parameters.

Despite this self-consciousness and often explicit engagements with sexual politics, recent teen horror has attracted only limited attention from feminist scholars. This critical discrepancy becomes more pronounced when we consider that the two most influential studies of American horror cinema in the last 25 years are both unambiguously feminist in their political outlook. Published in the early 1990s, Carol Clover's *Men, Women and Chainsaws* and Barbara Creed's *The Monstrous-Feminine* are scholarly touchstones which find their influence clearly registered in contemporary teen horror.[3] As Clover herself points out in Adam Simon's excellent documentary *The American Nightmare* (2000), the youthful audiences who constitute the core demographic for contemporary American horror cinema are 'the children of feminism'. Moreover, only a short-sighted critic would fail to see the direct impact of Clover's work on films such as the *Scream* series (Craven, 1996-present), *Cherry Falls* (Wright, 2000) and *All the Boys Love Mandy Lane* (Levine, 2006), or the self-conscious mobilization of Creed's theories in, say, *Teeth* (Lichtenstein, 2007) and *Jennifer's Body* (Kusama, 2009). Yet more than two decades since their publication it is easy to see how Creed and Clover's respective methodologies are inadequate when dealing with the knowingly *post*feminist terrain of the contemporary teen horror film.

One obvious reason for this critical neglect is simply that horror cinema's core affective register – fear, vulnerability, anguish, trauma – and thematic emphasis on suffering and victimhood are anathema to both the feminist political emphasis on female agency and postfeminism's confident preoccupation with feminine pleasure, personal strength and individual success. By contrast, I argue that the affective semiotics of teen horror's key visual trope – the exhausted female victim-hero, tearful, bloodied and psychologically traumatized – holds a dark social mirror to the consumerist pleasures valorized by postfeminist culture. Exemplified in popular films such as *The Devil Wears Prada* (Frankel, 2006) and *Sex and the City: The Movie* (King, 2008), the fantastical romantic comedy or 'rom-com' makeover celebrates traditional femininity and the transformative pleasures of self-actualization while systematically evading the social realities faced by young women today.[4] If, as Joel

Gwynne argues elsewhere in this book, the iconic and enduringly pop-
ular makeover scene has come to stand as a synecdoche for the political
limitations of postfeminist media culture, then teen horror's equivalent
moment of social education has a very different ideological resonance.
In contrast with female-oriented rom-com, then, the most interesting
teen horror films powerfully invoke – to borrow Angela McRobbie's
appropriately gothic metaphor – the 'spectre of feminism'.[5] This is why
teen horror's most enduring image – the eponymous victim-hero of
Carrie (DePalma, 1976), traumatized and drenched in pig's blood on her
prom night – is so iconic. Stripped of an idealized traditional femininity,
the affective semiotics of the brutalized Final Girl bespeak a knowing
critique of the dystopic limitations of postfeminist cultural norms.

The transformative power and gothic social education of teen horror's
ritualized *anti*-makeover is clearly illustrated in the 'torture porn'
of *Captivity* (Joffé, 2007). Indeed, the film's characterizes protago-
nist Jennifer (Elisha Cuthbert) as the ideal postfeminist subject. 'Top
cover girl and fashion model', reads the DVD blurb, 'Jennifer Tree
has it all – beauty, fame, money and power.' Although only a minor
film, *Captivity* is exemplary in its brutal critique of entrepreneurial
selfhood, the film drawing direct parallels between the interpellations
of postfeminist media culture and the physical punishments enacted
by Jennifer's kidnappers. In one scene, for example, the imprisoned
actress-cum-model is force-fed blended entrails in a cruel parody of an
earlier scene in which she prepares a nourishing health drink. After
protracted abuse and torture, Jennifer belatedly escapes her captors,
but not before avenging her suffering in cathartic fashion by shooting
the most sexually exploitative of her torturers in the crotch. The film's
final shot of a fatigued and dishevelled Jennifer wandering past a huge
billboard poster of her fantasmatically reified image speaks directly to
the yawning gulf between the utopian promises of postfeminist culture
and the harsh realities of a social universe which remains characterized
by sexual imbalance.

It is hardly insignificant that key critical interventions such as
Men, Women and Chainsaws and *The Monstrous-Feminine* both take for
granted the assumption that horror is aimed primarily at the fears and
desires of the heteromasculine psyche. Grounded in Freudian-Lacanian
psychoanalytic models devised in the 1970s, neither book – despite
their valuable insights – has dated well. As such, it is important to
acknowledge that perhaps *the* key structuring element in the evolu-
tion of teen horror since the mid-1990s has been its overt address
to a young female audience. As Valerie Wee (2006) points out, it is
self-evident that the female-oriented perspective of the *Scream* films – a

cycle whose box-office success effectively reinvigorated teen horror as a key Hollywood production trend in the 1990s – contributed enormously to their popularity.[6] The *Scream* cycle's hailing of a female demographic clearly influenced the films produced in their wake. For Pamela Craig and Martin Fradley, *Scream*'s influence subsequently imbued teen horror with a refreshingly alert political sensibility 'which both refers back to and updates the proto-feminism of the slasher film's Final Girl from the late-1970s and early 1980s'.[7] Elsewhere, both Catherine Spooner and Estella Tincknell point towards an emergent 'new teen gothic' in popular film and television. Finding its most high-profile expression in cultural texts such as *Buffy the Vampire Slayer* (1997–2003), *Charmed* (1998–2006) and the successful *Twilight* movie franchise (2008–2012), this trend foregrounds elements of soap opera, such as central female characters, 'girl culture' and a thematic emphasis upon personal relationships.[8]

It is this apparent tension between the widespread disillusionment with the limitations of postfeminist media culture and the gendered political expression of recent teen horror that I wish to explore. As such, this chapter seeks to understand teen horror as both symptomatic *of*, and a potentially oppositional force in relation *to*, the socially emaciated politics of a postfeminist culture. For example, a teen horror film like *House of Wax* (Collet-Serra, 2005) illustrates the 'politically ambidextrous' nature of postfeminist expression. Effectively playing a version of herself, Paris Hilton's appearance as 'Paige' offers its viewers a dual address. The definitive exemplar of twenty-first century celebrity culture, Hilton's notorious star image is founded upon extraordinary wealth, a highly sexualized appearance, youthful interests (in shopping, cell phones, fashion) and high-profile romances.[9] Critics such as Ariel Levy have positioned Hilton as emblematic of postfeminism's emphasis upon sexual availability and hyperfemininity, with the heiress embodying a reified immersion in appearance, fashion and consumer culture.[10] Similarly characterized as hedonistic and highly sexualized, Hilton meets her predictably brutal end in *House of Wax* when Paige is impaled through the forehead with a metal rod. As the film cuts to a shot of Hilton's head sliding suggestively down the bloody pole, her assailant begins to film his victim's grotesquely sexual death-throes on a handheld camera. The sequence famously provoked cheers and applause from theatrical audiences – *House of Wax* alluding quite transparently to Hilton's widely-circulated 'sex tape' – and in some ways this reaction can be interpreted as a rejection of the fantastical illusions of postfeminist celebrity culture with the pleasure taken in the humiliation and degradation of Paige clearly predicated upon Hilton's derogated

persona. At the same time, however, Hilton's presence in the film functions to structure the restrained femininity of *House of Wax*'s 'Final Girl', Carly (Elisha Cuthbert). In contradistinction to Paige/Hilton's 'girly' persona, Carly is characterized as intelligent, sexually reserved and resourceful. Like her character in *Captivity*, however, Cuthbert's reified physical attractiveness and successful media career also mark her out as an aspirational product of postfeminist culture, a persona that *House of Wax* works to normalize by contrast with Hilton's cartoonish hyperfemininity.

To paraphrase Jacinda Read, this chapter tentatively seeks to illustrate how horror texts make sense of what it means to be young, female and (post)feminist in the early twenty-first century. While a select number of films – notably *The Craft* (Fleming, 1995) and *Ginger Snaps* (Fawcett, 2000)[11] – have been valorized by critics, here I focus on more recent films which are yet to receive the scholarly attention they deserve. The chapter is divided into three broad sections. First, I offer an overview of contemporary teen horror's persistent address to a young female demographic. Second, through case studies of *Jennifer's Body* and *Sorority Row* (Hendler, 2009) I examine teen horror's direct thematic engagements with the experiential horrors of contemporary postfeminist culture. Finally, I interrogate the postfeminist *femme castratrice* as a significant generic trope in recent films. Despite the valuable body of positive feminist writing on horror cinema, the genre's violent pop-expressionist rendering of female social experience has often fuelled critical misinterpretation and even kneejerk abhorrence. As such, it is important to emphasize that the horror genre is a cultural mode of expression which is psychologically exaggerated, often exaggerated in expression, and which functions at a high metaphoric level. As Craig and Fradley argue, these films offer 'expressionistic allegories of psychological and social *realities* [my emphasis]' which are articulated 'through the hybridized generic lexicon and melodramatic emotional resonance of contemporary teen horror'.[12] As something of a counterpoint to the broad critical emphasis on the supposed failings of the genre, then, what I wish to do here is interpret teen horror *on its own terms*.

Teen horror, genre and female address

A year after witnessing the murder of her family by a teacher who had become obsessed with her, Donna (Brittany Snow) in *Prom Night* (McCormick, 2008) prepares for that most archetypal of teen movie rituals, the high school prom. *Prom Night*'s emphasis on adolescent *rites*

de passage is underscored by Donna's psychotherapist, who informs her that 'psychological trauma often heightens during times of transition' – a comment that could easily serve as a synopsis of the core psycho-dynamic of teen horror more broadly. Tellingly, *Prom Night* repeatedly emphasizes that middle-class American life is riddled with sexism and gender power imbalance, the film insistently underscoring the ideological continuum between everyday chauvinism and the brutal violence enacted by Donna's malevolent stalker. As typifies teen horror's gendered imaginary, in *Prom Night* boyfriends are feckless and emotion-ally immature, male authority figures unreliable, and random strangers casually letch over women young enough to be their daughters. The film's interest in communicating female social experience is paramount. For example, after arguing with her boyfriend one of Donna's girlfriends bitterly complains that she also has 'killer cramps' on this all-important night. Tellingly, the moment is entirely empathetic rather than comic or voyeuristically crass. Indeed, *Prom Night*'s emphasis on emotion and female friendship serves to underscore the film's sustained thematic critique of normative masculinity.

This emphasis on young women's everyday gendered discontent is similarly foregrounded in teen horror films such as *Ginger Snaps*, the *Scream* series, *Valentine* (Blanks, 2001), *Teeth*, *All the Boys Love Mandy Lane* and *Cursed* (Craven, 2005), all of which share a thematic preoccupa-tion with intra-female relationships, the sublimation of gendered anger and the repression and/or denigration of young women's bodies and sexuality. In *Cursed*, for example, lycanthropic metaphors are deployed by way of exploring protagonist Ellie's (Christina Ricci)'s daily struggle with overbearingly possessive boyfriends and sexual harassment from male colleagues and clients alike. Indeed, so established is this gendered mode of address that an androcentric film such as *Fright Night* (Gillespie, 2011) seems a regressive anomaly. Based around the stilted Oedipal trajectory of nominal hero Charley (Anton Yelchin), the film's most interesting characters – Colin Farrell's ambiguously queer vampire; Amy (Imogen Poots), Charley's frustrated girlfriend – become mere ciphers in a masculinist tale riddled with homosexual panic and gynophobic fears about adult relationships.

For Craig and Fradley, recent teen horror reiterates the genre's endur-ing emphasis on 'heightened subjective experience and psychological perception, appealing to *emotional* rather than objective realism'.[13] Indeed, victim-identified slasher films have always expressed female anxieties about gendered power relations, fears that run the gamut from coercive amorous advances through to the brutal realities of violent

sexual assault. In turn contemporary teen horror 'deliberately engages with and celebrates the genre's long-term investment in subjectively expressing and empathizing with marginalized female experience'.[14] For example, *Scream*'s Sidney (Neve Campbell), Julie (Jennifer Love Hewitt) in the *I Know What You Did Last Summer* cycle and Donna in *Prom Night* all exhibit the recurrent post-traumatic symptoms of victims of rape and domestic abuse. As Kathleen Rowe Karlyn points out in her perceptive discussion of the *Scream* films, teen horror 'does not shrink from the realization that sex is tied to violence and power':

> Drawing on literary and cinematic traditions of the Gothic, it captures a heterosexual girl's sense of boys as mysterious and unknowable entities who, like the killer, can wear masks that disguise their true identity. For a generation that gave a name to date rape, [films like] *Scream* show how easily a trusted friend can become a potential rapist.[15]

Karlyn's use of 'girls' as a descriptor is significant. Mapping the postfeminist cultural turn across a politically fraught generational divide, Karlyn mobilizes this youthful signifier not as a term of condescension but as 'a model of femininity that break[s] new ground'.[16] This is also indicative of shifts *within* the genre. Contemporary horror films insistently foreground the female hero's experiential transformation from an uncertain young woman to an adult empowered by the gaining of feminist social and political knowledge. For David Greven, teen horror films 'are like sped-up, phallically fuelled female *bildungsromans* in which women rapidly develop into their adult versions, coming of age through frantic stress and murderous, if retaliatory, bloodletting'.[17] Although Greven is perhaps too in thrall here to Clover's theorization of horror heroines as tomboyish male substitutes, his emphasis on teen horror's allegorical expressions of *transformation* is key.

Sorority Row, *Jennifer's Body* and the horrors of neo-liberal femininity

A brief but telling moment in *Sorority Row* highlights the film's knowing critical engagement with the norms of postfeminist culture. In archetypal fashion, a young woman emerges naked from a shower nervously expecting to be confronted by an intruder. Instead, she is met by a fellow student who – after a horrified downwards glance – callously

'advises' her peer to pay more attention to her pubic grooming regime. 'Waxing's not just for whores anymore,' she gasps in disgust. Seemingly throwaway, the internalized misogyny of the comment cuts to the core of the film's depiction of postfeminist culture as a brutal Foucauldian nightmare. As Diane Negra points out, the normalization of pubic waxing – itself derived largely from the aesthetics of pornography – is predicated upon 'a commitment of time, money, and physical discomfort' to attain a form of sexual self-presentation which is 'axiomatically postfeminist'.[18] Indeed, *Sorority Row*'s critical focus is on the hegemonic operations of what Yael D. Sherman dubs *neo-liberal femininity*, 'a type of ambitious, middle-class femininity, oriented to success in both the public and private spheres'.[19] Grounded in competitive individualism and sexualized self-definition, the normalization of neo-liberal femininity illustrates the abject politics of the postfeminist turn. 'While traditional femininity connotes "sex object",' Sherman notes, 'neoliberal femininity connotes competent subject; while traditional femininity implies dependence, neoliberal femininity implies independence; while traditional femininity is associated with the sin of vanity, neoliberal femininity implies that one is actively self-responsible.'[20] What is so interesting about both *Sorority Row* and *Jennifer's Body* is the way both films offer a direct critique of this prototypically postfeminist gender regime.

Sorority Row follows six college students – Cassidy (Briana Evigan), Chugs (Margo Harshman), Ellie (Rumer Willis), Claire (Jamie Chung), Jessica (Leah Pipes) and Megan (Audriana Partridge) – as the sorority sisters of Theta Pi and their feminist house maxim: 'Trust, Respect, Honour, Secrecy and Solidarity'. When Megan dies as a result of a practical joke gone awry, the 'sisterhood' agree to hide the body: as Jessica argues, to confess their crime would 'affect the rest of our lives: every job, every relationship...'. That 'work' and 'relationships' are directly equated in Jessica's coercive rallying speech cuts to the heart of the films political critique. Indeed, even before Megan's death the sisterhood's allegiance to their house motto is exposed as meaningless: scene after scene exposes a culture of cruelly competitive barbs about sexual performance, breast augmentation and body shape. Raised during a period of social conservatism, the young American women of *Sorority Row* place their faith in the logics of free-market individualism rather than identify with collective political movements, embodying what Hilary Radner refers to as the neo-liberal woman 'acting on her own, in her best interest, in which her fulfilment can be understood as independent of her social milieu and the predicament of other women'.[21]

Sorority Row's interest in strained intra-female relationships within a dystopian postfeminist culture is underscored by the presence of 'House Mother', Mrs Crenshaw (Carrie Fisher). Fisher's age and iconic role as the assertive female hero Princess Leia in the initial *Star Wars* cycle (1977–1983) underscore the intertextual potency of Mrs Crenshaw's benevolent matriarch. While it would be simplistic to interpret Crenshaw as an unambiguous cipher for second-wave feminism, her nurturing qualities, emphasis on collectivity and covert disillusionment with the self-interested young women she has to supervise clearly mark her out, in Karlyn's terms, as a 'matrophoric' presence. When Crenshaw kindly presents her adopted 'daughters' with commemorative bracelets to remind them of the all-important bonds of sisterly friendship, they are contemptuously rejected as embarrassingly sentimental and materially worthless. Ironically, the violent misogyny of the film's killer – Cassidy's aggrieved boyfriend who wants to 'rescue' her from the clutches of the all-female Theta Pi community – is little more than a mirror of the divisive rivalry between the sorority sisters themselves. The killer's bitter dismissal of Cassidy and her friends as 'the bitches of Theta Pi' offers a precisely condensed summary of how the young women perceive each other.

Sorority Row's consistent thematic emphasis is on the pathological individualism of neo-liberal femininity, repeatedly highlighting the girls' hyperregulated appearance and devotion to the postfeminist strictures of erotic capital: all lipgloss, pneumatic cleavage and immaculately straightened hair. In particular, Chugs and Jessica are illustrative of the limited options available for young women. Promiscuous and sexually aggressive, Chugs is emblematic of the pitfalls of what Ariel Levy has influentially described as 'raunch culture' wherein sexual desirability becomes the ultimate commodity in a gendered value system. Indeed, Chugs' acquisitive use of sexuality – she trades sexual favours for prescription drugs from her male psychotherapist, for example – is presented as a pragmatic response to broader conditions of gendered inequality and dependency. Jessica, meanwhile, uses her airbrushed femininity to increase her value on the 'marriage market'. In one the of the film's most discomfiting scenes, Jessica is cruelly interrogated by her future father-in-law, a successful politician who worries that any blemish in her life history will potentially damage his career. 'I have been dreaming my whole life to marry someone *like* Kyle,' pleads Jessica with an aspirational desperation. In the film's finale, Cassidy, Ellie and Megan's sister, Maggie (Caroline D'Amore), offer a riposte to neo-liberal individualism by working collectively to ensure their survival. *Sorority Row* ends

with Theta Pi ablaze while the trio of embattled surviving sisters walk away in sexualized slow motion. The image captures both the progressive politics of the film while simultaneously underscoring the political limitations of postfeminism: with the semiotics of social struggle – the *anti*-makeover – registered across their bruised and bloodied bodies, *Sorority Row* valorizes the importance of female political collectivity through eroticized imagery. A coda set 15 months later reveals that this moment of female solidarity was only fleeting: filled with fresh-faced young women, Theta Pi has been rebuilt for the start of the academic year. In dystopic fashion, the bleak cycle begins again.

Self-consciously marketed as a 'postfeminist horror film' and notable for being written and directed by women, *Jennifer's Body* similarly focuses on female friendship and the pitfalls of neo-liberal femininity. Scripted by Diablo Cody, the writer of *Jennifer's Body* describes the film as being about 'girl-on-girl crime. *Mean Girls* [2004] taken to an extreme'.[22] Cody herself encapsulates the 'ambidextrous' politics of postfeminism. A former stripper whose best-known work, *Juno* (Reitman, 2007), was criticized as endorsing capitulation to anti-choice protestors, Cody's self-commentary is revealingly ambivalent and individualistic:

> Any feminist out there who doesn't support me gets a big 'boo' because you've got one person out there who is advocating for women in Hollywood and you're going to slag that person? If you're a feminist, you should be up my butt. I have no idea if I've helped feminism or set it back, because people see me as such a polarising figure. I hope it's the former. But if I can't even get feminists on my side, maybe I'm not helping.[23]

Jennifer's Body focuses on the mismatched relationship between Jennifer (Megan Fox) and Needy (Amanda Seyfried) who have remained best friends since childhood. With her body the focus of the film's title, Fox's highly sexualized star image was firmly established in the promotional apparatus for *Transformers* (2007), where her airbrushed image almost entirely displaced the eponymous robots. Seyfried's desexualized prettiness, meanwhile, is epitomized in films such as *Mamma Mia!* (Lloyd, 2008), *Dear John* (Hallestrom, 2010) and the tween-horror adaptation *Red Riding Hood* (Hardwicke, 2011). Like Katherine Farrimond's discussion of teen comedy *Easy A* (2010) elsewhere in this book, *Jennifer's Body* critically engages with the sexual double standard and the enduring virgin/whore dichotomy. Misrecognized as a virginal innocent masquerading as the town slut, Jennifer is abducted by a duplicitous

emo band ('basically agents of Satan with really awesome haircuts') and sacrificed to the devil in order to guarantee commercial success for the band, led by singer Nikolai Wolf (Adam Brody). The botched satanic ritual – a rape in all but name – subsequently transforms Jennifer into a demonic monster whose voracious sexuality is sublimated into the desire to literally devour young men.

Like *Ginger Snaps* and *Teeth*, *Jennifer's Body* reworks Creed's work on the monstrous female body as a form of retributive empowerment. A vampiric *vagina dentata*, Jennifer revels in her de facto castration of obnoxious young men. Unlike *Ginger Snaps* and *Teeth*, however, Jennifer's voraciously murderous acts are grounded not in a gendered (and more or less explicitly *feminist*) rage but instead in pursuit of a postfeminist obsession with *appearance*. Without prey, Jennifer becomes lethargic and unattractive; after feasting on adolescent male flesh, she is bestowed with enviably 'great hair' and a glowing complexion. Echoing the dystopic postfeminist terrain of *Sorority Row*, Jennifer's barbed dialogue similarly typifies the unbounded pleasure-seeking of postfeminist culture: attractive boys are 'salty'; breasts become 'smart bombs'; and sexual desire is articulated with corporeal precision ('you give me such a *wettie*'). Echoing *The Craft*'s 'retreatist' postfeminist morality tale, female friendship is undone by a combination of jealousy and the individualistic abuse of supernatural powers. Just as Needy is envious of Jennifer's confidently postfeminist display of sexuality, so too does Jennifer's insecurity and narcissism lead her to covet her friend's intelligence and understated sexuality. Needy eventually kills Jennifer with a Stanley knife after she fatally wounds her sensitive boyfriend, Chip (Johnny Simmons). 'It's for cutting *boxes*,' rasps Needy in one of the film's innumerable vaginal metaphors. The symbiotic connection between the two women destabilizes the more reactionary aspects of the film. A coda reveals Needy incarcerated in a psychiatric hospital but having inherited aspects of Jennifer's supernatural abilities. Transformed into a vengeful *femme castratrice*, it is Needy who takes up the proto-feminist mantle and uses her abilities to exact revenge on Nikolai and his misogynist band mates.

Teen horror and the femme castratrice

The violently individualistic conclusion of *Jennifer's Body* is symptomatic of an enduring trope in postfeminist media representation: women who embrace violence as a refusal of victimhood. In a discussion of the gender politics of retributive female violence in *Hard Candy* (Slade, 2005)

and *The Brave One* (Jordan, 2007), Rebecca Stringer offers a critique of 'the victim to vigilante narrative'.[24] Such stories, she argues, function as an uneasy conflation of feminism and conservatism:

> While the figure of the woman vigilante speaks to contemporary feminism's emphasis on women's agency, the figure of the vigilante in general is strongly emblematic of conservative perspectives on crime, their violent vigilantism at odds with the critical ethics of collective non-violent action characterizing much of the feminist effort to challenge male violence.[25]

While such films 'disrupt the sexist script of feminine victimhood', their progressive elements are rendered troublesome by their advocacy of violent vigilantism and, in turn, an elision of 'the critical ethics of *collective* feminist struggle'.[26] For Stringer, these films issue caution to the naïve conviction that media images of women as agents are always already politically progressive. Stringer's point is particularly important in relation to the often violent cultural politics of teen horror, but this is not to argue that the horror film's regular invocation of violent agency should be dismissed out of hand. It would be reductive at best to understand a film like *Jennifer's Body* as legitimizing Needy's murderous violence against Jennifer's coercive assailants with any degree of literalism; the film functions to symbolically reject the phallic logic underpinning sexual violence. As befits the Gothic tradition, teen horror's politics are expressionist and couched in a specific – often lurid and hyperbolic – generic lexicon.

All *the Boys Love Mandy Lane* provides an illustrative template for recent teen horror's violent *femmes*. Self-consciously organizing the entire narrative around the film's eponymously unobtainable object of desire, *All the Boys Love Mandy Lane* mobilizes a strategically fetishistic approach to its female hero (Amber Heard), adding formalist resonance to the film's critique of psycho-sexual surveillance and objectification. Intelligent and mature but sexually timid, Mandy is marked out from her female peers Chloe (Whitney Able) and Marlin (Melissa Black), both of whom are exemplars of neo-liberal femininity. Indeed, the unpleasant undercurrents of Chloe and Marlin's sexual acquisitiveness, preening performativity and knowing use of their physical beauty as marketable erotic capital manifests itself, *a la Sorority Row*, in barbed exchanges and competitive insults about physical appearance. In an early scene, one of Chloe's awestruck girlfriends expresses envious astonishment at her perpetually pert nipples. Chloe's satisfaction at this

sexual compliment is bleakly echoed in perhaps the film's saddest moment. During a debauched weekend at a friend's rural retreat where most of the film takes place, Chloe catches the eye of Garth (Anson Mount), the handsome ranch hand who is reluctantly keeping watch over the hedonistic teens. In a gesture that speaks volumes for the emptiness of postfeminist sexual 'empowerment', Chloe mechanically lifts her top and exposes her prized breasts in reified expression of erotic interest. Bemused, Garth simply walks on. Inevitably, *All the Boys Love Mandy Lane* ends in a swathe of cathartic violence. The film's nihilistic twist – Mandy's performative *ingenue* is actually a shrewd and manipulative sociopath – is compounded when Mandy kills her best friend and accomplice Emmet (Michael Welch) who is just as sexually infatuated with her as any of the other men. Refusing the eroticized passivity of the male gaze, the unveiling of Mandy's *femme castratrice* serves to undermine and critique the fetishistic rapture which *All the Boys Love Mandy Lane* – and, by extension, the genre more broadly – treats its female protagonist.

The recent 'reboot' of two notorious 1970s rape-revenge movies also provide interesting case studies. Like *All the Boys Love Mandy Lane,* both *Last House on the Left* (Iliadis, 2009) and *I Spit on Your Grave* (Monroe, 2010) illustrate teen horror's self-conscious engagements with the tyranny of the male gaze. Although *Last House on the Left* is compromised by its crudely regressive class politics, the film is not devoid of feminist critical intelligence. Stylishly shot, an intriguing early sequence follows teen protagonist Mari (Sara Paxton) swimming in a lake while on vacation. A protracted – and narratively unmotivated – sequence lasting several minutes sees Mari 'stalked' by a roaming camera through woods, down to the lake and into a boat house. The reflexively voyeuristic nature of the sequence is underscored when the film cuts to Mari showering after her swim. Even beyond the default allusion to *Psycho* (1960), this fetishistically soft-lit, slow-motion montage of Mari dressing – featuring fragmented close-ups of wet skin, stomach, breasts, crotch, dripping hair and sun-dappled face – is practically a step-by-step cinematic rendering of the Mulveyan paradigm. The sequence functions to interpellate the viewer as ideologically complicit with the brutal – and equally protracted – rape of Mari later in the film during which the camera is placed at ground level with Mari's face and torso, the violent objectification of her body by her assailants finding its ideological double in the fetishism of the earlier scene.

Like Mari, Jennifer (Sarah Hills) in *I Spit on Your Grave* initially seems the ideal post-feminist subject: physically attractive, independent

and marked by socio-economic privilege. Jennifer's commitment to self-improvement is signified by her self-disciplining physical exercise. Like Mari's swimming in *Last House on the Left*, Jennifer's exercise regime foregrounds the labour involved in regulating 'normative' physical attractiveness. Following her rape by a gang of local men – an attack motivated by their humiliation at Jennifer's indifference to their clumsy sexual advances – Jennifer appears to commit suicide by throwing herself into a river. The brutal semiotics of the sexual assault itself are telling: given the pervasiveness of extreme physical acts in hardcore pornography, it is barely coincidental that the violent fetishes indulged in the rape – including choking, aggressive anal sex, forced oral penetration and gonzo-style video documentation – have been ideologically normalized generic staples in contemporary adult entertainment.

In *I Spit on Your Grave*, the film's tagline suggests, 'victim becomes victor'. As Jacinda Read notes of the political trajectory of rape-revenge narratives, the melodramatic transformation of the female hero from victim to triumphant avenger 'represents one of the primary ways in which the rape-revenge film can be seen to *make sense* of feminism'.[27] Re-enacting versions of the same degrading and violent acts upon her persecutors, *I Spit on Your Grave* culminates with Jennifer castrating one of the rapists before forcing a loaded shotgun into the anal cavity of the local Sheriff (Andrew Howard), a self-proclaimed 'ass man'. Given the depressing number of rape cases which are unreported for fear of not being taken seriously, it is hardly insignificant that the ringleader of the gang rape is a police officer. The visceral power of the film is not necessarily undercut by the film's reliance on a framework of violent individualism. Indeed, the film becomes increasingly fantasmatic: Jennifer's violent 'resurrection' is rendered uncanny (Jennifer develops a preternatural ability to track, entrap and elaborately torture her assailants, for example) so that much of the second half of the film seems to encourage a supernatural interpretation. Films such as *I Spit on your Grave* and *All the Boys Love Mandy Lane* clearly allegorize a transformative awakening from the apolitical slumbers of a postfeminist culture. Rape and sexual objectification serve here as a catalyst for an expressionist violence which offers a way of talking about the violent (re-)emergence of a feminist political consciousness. For Karlyn, teen horror films offer a melodramatically violent and necessarily condensed rehabilitation of 'the repressed history of the women's movement itself and the injustices that brought it about'.[28] The films *are* brutal, often difficult to watch, and assaultively individualist in their

vengeful trajectories, but as ever in Hollywood entertainment collective and social histories are melodramatically reimagined and allegorized as personal stories.

As an exemplar of many of the most compelling aspects of contemporary teen horror, *Teeth* provides a potent combination of black humour, post-feminist knowingness and incisive social critique in its witty portrayal of high school gender politics. *Teeth* clearly demonstrates that teen horror's reliance on humour and playfulness does not simply underscore the evacuation of politics from the genre, but instead functions as a ritualized coping mechanism for the all-too-real social horrors faced by young women. In simultaneously literalizing, deconstructing and celebrating the *vagina dentata* myth, '*Teeth* presents growing up in suburban America as, in no uncertain terms, a sociosexual battleground'.[29] As protagonist Dawn (Jess Weixler) is slowly transformed from member of an evangelical chastity group to independent and physically confident young woman, *Teeth* offers a sweeping indictment of the sanctioned misogyny Dawn encounters. The virginal Dawn's first boyfriend, Tobey (Hale Appleman), attempts to rape her after his forceful sexual advances knock her unconscious; lover Ryan (Ashley Springer) appears sexually attentive but is quickly unveiled as a manipulative chauvinist; while her aggressively misogynist stepbrother, Brad (John Hensley), harbours a barely concealed desire to sexually 'conquer' her. In one of *Teeth*'s most celebrated sequences, Dawn visits a gynaecologist in an effort to understand her bodily mutation. Dr Godfrey (Josh Pais) however, is a casually lecherous monster from the *id* of patriarchal science. Patronizing and sexually abusive, Dr Godfrey's (Josh Pais) treatment of Dawn is empathetically represented as humiliating, emotionally distressing and physically painful. In gleefully lurid fashion, Dawn's growing acceptance of vaginal mastication as a pragmatic socio-sexual defence mechanism leaves a series of male assailants with severed genitals and digits. Given the film's overt feminist self-consciousness and joyous literalization of the castration metaphor, it comes as no surprise that the most emotive scenes are those between Dawn and her terminally ill mother and the revelatory sequence when Dawn is awestruck by a diagram of female sexual anatomy in a previously censored biology textbook. The film ends with Dawn hitch-hiking away from her small hometown only to once again encounter harassment and male sexual presumptiousness. Turning to the camera and offering young women in the audience a knowing smile, Dawn's *femme castratrice* embraces mythic female biology as a different kind of destiny.

Conclusion: 'You're a victim – for life?'

In a genre notorious for its formulaic predictability, it is perhaps inevitable that teen horror illustrates both the pleasures and pitfalls of a postfeminist culture. Yet these films' compulsive return to key feminist concerns bespeaks unresolved social angst. Indeed, recent teen horror films are characterized by irresolution and, by extension, a sense of horror at the absence of social and political change vis-à-vis gender relations. As I have argued, although teen horror's cultural politics are grounded in the postfeminist maxim that the personal is political, this should not be understood as a rejection of social engagement. To this end, *Scream 4* continues the series' exploration of the bonds that connect generations of women. Now the 30-something author of an 'inspirational' autobiography, Sidney seeks to 'reinvent herself' by embracing the personal agency that various assailants have systematically denied her. Of course, Wes Craven is far too knowing a filmmaker to overlook the ironies of this brand of postfeminist self-actualization. Just as commodified versions of Sidney's life history – the endless *Stab* franchise and the annual Woodsboro celebration of the first slaughter – continually reinscribe her victimhood, so too does *'Out of Darkness'*. A hopelessly clichéd title for a celebrity autobiography if ever there was one, Sidney's book serves only as an emptily solipsistic form of would-be postfeminist 'empowerment'.

The killer in *Scream 4* is eventually revealed to be Sidney's cousin, Jill (Emma Roberts), a pathologically envious younger relative who longs for the unwanted – but potentially lucrative – fame that Sidney's ordeal has brought her. Jill's neo-liberal femininity and murderously 'proactive' entrepreneurship serve as the latest example of the *Scream* cycle's condemnation of a systemically amoral culture driven by the deadened logics of market fundamentalism. If *Scream 4*'s postmodern cynicism is reaffirmed in the film's closing moments – Jill is dead but becomes deified as a victim-hero by the media – the film celebrates the solidarity of the pluralized Final *Girls* – Sidney, Gale Weathers (Courtney Cox) and local police officer Deputy Judy Hicks (Marley Shelton) – who survive by helping each other. Countering the mechanical slaughter of bickering young women in the opening tableau, the female collective at the end of *Scream 4* offers tentative hope for the (post-)feminist future. As the tellingly-named Marnie (Britt Robertson) learned in the film's opening scene after arguing that horror films are no longer worth watching, it is a mistake to ignore, or reject out-of-hand, the politics of contemporary teen horror. At its best, the genre's gender politics still cut close to the bone.

Notes

1. Diane Negra, *What a Girl Wants: Fantasizing the Reclamation of Self in Postfeminism* (London: Routledge, 2008), p. 4.
2. Yvonne Tasker, '*Enchanted* (2007) by Postfeminism: Gender, Irony, and the New Romantic Comedy', in *Feminism at the Movies: Understanding Gender in Contemporary Popular Cinema*, ed. by Hilary Radner and Rebecca Stringer (New York: Routledge, 2011), pp. 67–79 (p. 68).
3. Carol Clover, *Men, Women and Chainsaws: Gender in the Modern Horror Film* (London: British Film Institute, 1993); Barbara Creed, *The Monstrous-Feminine: Film, Feminism, Psychoanalysis* (London: Routledge, 1993).
4. See Hilary Radner, *Neo-Feminist Cinema: Girly Films, Chick Flicks and Consumer Culture* (New York: Routledge, 2011).
5. Angela McRobbie, 'Post-feminism and Popular Culture: Bridget Jones and the New Gender Regime', in *Media and Cultural Theory*, ed. by James Curran and David Morley (New York: Routledge, 2006), pp. 59–74.
6. Valerie Wee, 'Resurrecting and Updating the Teen Slasher: The Case of *Scream*', *Journal of Popular Film and Television*, 34:2 (Summer 2006), pp. 50–61.
7. Pamela Craig and Martin Fradley, 'Teenage Traumata: Youth, Affective Politics and the Contemporary American Horror Film', in *American Horror Film: The Genre at the Turn of the Millennium*, ed. by Steffen Hantke (Jackson, MS: University of Mississippi Press, 2010), pp. 77–102 (p. 87).
8. Catherine Spooner, *Contemporary Gothic* (London: Reaktion Books, 2006); Estella Tincknell, 'Feminine Boundaries: Adolescence, Witchcraft, and the Supernatural in New Gothic Cinema and Television', in *Horror Zone: The Cultural Experience of Contemporary Horror*, ed. by Ian Conrich (London: I.B. Tauris, 2010), pp. 254–258 (p. 245; p. 249).
9. See Thomas Fahy, 'One Night in Paris (Hilton): Wealth, Celebrity, and the Politics of Humiliation', in *Pop Porn: Pornography in American Culture*, ed. by Ann C. Hall and Mardia J. Bishop (London: Praeger, 2007), pp. 75–98.
10. Ariel Levy, *Female Chauvinist Pigs: Women and the Rise of Raunch Culture* (New York: Free Press, 2005).
11. For more on *Ginger Snaps* and *The Craft*, see Spooner; Craig and Fradley; and Tincknell.
12. Craig and Fradley, p. 85.
13. Ibid., p. 87.
14. Ibid., p. 90.
15. Kathleen Rowe Karlyn, *Unruly Girls, Unrepentant Mothers: Redefining Feminism on Screen* (Austin, TX: University of Texas Press, 2011), p. 102.
16. Karlyn, p. 22.
17. David Greven, *Representations of Femininity in American Genre Cinema: The Woman's Film, Film Noir, and Modern Horror* (London: Palgrave-MacMillan, 2011), p. 146.
18. Negra, p. 119.
19. Yael D. Sherman, 'Neoliberal Femininity in *Miss Congeniality* (2000)', in *Feminism at the Movies: Understanding Gender in Contemporary Popular Cinema*, ed. by Hilary Radner and Rebecca Stringer (London: Routledge, 2011), pp. 80–92 (p. 80).
20. Sherman, p. 82.

21. Radner, p. 11

22. Diablo Cody, 'Diablo Cody Dishes on New Film, Feminism, Body Image', *The-F-Word.Org: Food, Fat, Feminism*, http://www.the-f-word.org/blog/index. php/2009/08/14/diablo-cody-dishes-on-new-film-feminism-body-image (accessed 14 August 2009).

23. Cody, quoted in Hadley Freeman, 'Devil's Advocate', *The Guardian Weekend* (21 January 2012), pp. 36–39 (p. 39).

24. Rebecca Stringer, 'From Victim to Vigilante: Gender, Violence and Revenge in *The Brave One* and *Hard Candy*', in *Feminism at the Movies: Understanding Gender in Contemporary Popular Cinema*, ed. by Hilary Radner and Rebecca Stringer (New York: Routledge, 2011), pp. 268–282 (p. 269).

25. Stringer, p. 269.

26. Stringer, p. 280 (my emphasis).

27. Jacinda Read, *The New Avengers: Feminism, Femininity and the Rape-Revenge Cycle* (Manchester: Manchester University Press, 2000), p. 8 (my emphasis).

28. Karlyn, p. 116.

29. Craig and Fradley, p. 90.

13

'A New Feminist Revolution in Hollywood Comedy'?: Postfeminist Discourses and the Critical Reception of *Bridesmaids*

Helen Warner

Despite being one of the most 'enduring cinematic genres'[1] in Hollywood's history, the romantic comedy or rom-com has struggled to gain the cultural legitimacy accorded to many other ('masculine') Hollywood genres. However, in 2011 the female-fronted ensemble comedy *Bridesmaids* (Feig, 2011) received widespread critical and commercial success across the United States and Great Britain. *Saturday Night Live* (1975–) regular Kristen Wiig leads the cast as Annie, a 30-something single woman dealing with the aftermath of a failed business venture and break-up while preparing for the impending nuptials of her best friend. The film follows Annie as she struggles to perform her duties as maid of honour with a group of 'misfit' bridesmaids. As with many other 'chick flicks', the narrative is preoccupied with traditional 'feminine' themes such as female work, friendship and romance; themes which often secure the rom-com as a critically maligned genre. Yet, *Bridesmaids* escapes such censure. The film out-performed producer Judd Apatow's back catalogue (including *The 40 Year Old Virgin* [2004], *Knocked Up* [2007] and *Funny People* [2009]) at the box office and found itself the cause of much celebration among film critics.[2] Indeed, in response to claims that *Bridesmaids* is the 'female equivalent' of *The Hangover* (Phillips, 2009), the *Washington Post* remarks that, 'with any justice, its smarter – if equally silly and scatological – sister will earn pay equity and then some at the box office'.[3] Given reviewers' previous hostility toward the 'trivial' and 'feminine' themes of chick flicks, their overwhelmingly positive reception and endorsement of *Bridesmaids* invites

a closer analysis of the deeply gendered discourses utilized and created in the popular media surrounding the film and its success.

This chapter examines the Anglo–American reception of the film, including a range of popular and 'quality' presses, celebrity and women's magazines, in order to reveal the different terms in which the text is judged. As Robert C. Allen and Douglas Gomery note, reviews of texts[4] can be understood as having an 'agenda-setting function'.[5] Thus, while reviews do not determine readers' responses, they do offer an insight into how readers are cued to understand texts. In other words, they do not tell audiences 'what to think so much as [...] what to think about'.[6] In addition, as Barbara Klinger has stated, these reviews act as 'types of social discourse',[7] – that is, an examination of a text's reception provides insight into the cultural context in which films are evaluated, and the dominant systems of value in operation at the time. Such is the case in the contemporary reviews examined here. Indeed, this chapter identifies and explores several recurrent themes that emerge within the reviews, all of which are informed by and produce the 'postfeminist' climate in which they are constructed, and raise issues related to gender, genre and value, including the framing of *Bridesmaids* as a 'feminist' film; the oft-repeated claim that *Bridesmaids* somehow 'offers a male, or male-seeming dimension'[8] to the rom-com; and the continual focus on 'appropriate', or perhaps more accurately 'inappropriate', feminine behaviour.

My analysis of these reviews reflects a feminist agenda and adopts the view present in recent feminist film criticism that the chick flick, and the discursive activity that surrounds it, is 'far from politically innocent or neutral'.[9] That said, this chapter does not seek to view *Bridesmaids* or the discursive activity surrounding it as either progressive or regressive. Indeed, such a discussion rarely proves useful as it often fails to provide a nuanced understanding of the complex and contradictory ways in which popular culture interacts with/negotiates feminist politics. My interest lies in the way in which the film is framed as either/both progressive and regressive by reviewers, and my contention is that in so doing, press reviews construct an ambiguous notion of feminism and create subject positions for readers/viewers to adopt in response. Moreover, it is worth noting that a survey of the following material reveals the ambiguous, politically versatile, conflicting discourses which form postfeminist culture. Thus, this chapter adopts Rosalind Gill's understanding of postfeminism as a 'sensibility'. This approach, she argues, 'does not require a static notion of authentic feminism as a comparison point, but instead is informed by postmodernist and constructionist

perspectives'.[10] As Yvonne Tasker and Diane Negra note, postfeminism 'deploys a variety of positions with respect to feminism',[11] as it (somewhat paradoxically) dismisses, celebrates and rewrites feminist history simultaneously. In Suzanna Walters' words, '[postfeminist] discourse has declared the [feminist] movement (predictably if illogically) dead, victorious, and ultimately failed'.[12]

Drawing on Walters' rigorous discussion of postfeminism, Sarah Projansky argues that there are five strands of postfeminist discourse which emerge in the popular press. The first is linear postfeminism, which foregrounds a historical trajectory 'from prefeminism through to feminism and then on to the end point of postfeminism',[13] thereby implying that feminism and postfeminism cannot occupy the same time/space. The second is backlash postfeminism, which not only declares feminism dead but also ultimately failed. The third, 'equality and choice', foregrounds some of the gains of feminism, but in so doing suggests that feminism was 'victorious' and hence is now redundant. The fourth, (hetero)sex-positive postfeminism, constructs feminism as inherently 'anti-sex' and offers an 'improved' version of feminism that celebrates female (hetero)sexuality. The final category contends that postfeminism offers women and men the opportunity to embrace feminism. However, within this discursive strand, men are typically constructed as superior feminists. The common assumption shared by all these categories is that feminism is dead, either because, to use Walters' terms, it has been 'victorious' or 'ultimately failed'.

An analysis of the critical reception of *Bridesmaids* reveals some of these postfeminist discourses, however there is less of a sense that feminism is dead but rather that the precise meanings of feminism in the contemporary era are being debated. With this in mind, I argue that, although contradictory discourses are in play, much of the critical reception serves to, at worst, 'depoliticize' feminism and at best, set strict parameters within which it can operate. First, however, it is important to contextualize this argument within broader issues of gender, genre and cultural value.

'Chick flicks don't have to suck': Feminine genres and cultural distinctions

Genre theorists have argued that 'genres are not defined by a feature that makes all films of a certain type fundamentally similar; rather they are produced by the discourse through which films are understood'.[14] Indeed, to reduce genre to a series of textual attributes often proves

futile. On the contrary, examining the discursive activity surrounding a set of films, be it audience responses, trade journals, production notes or newspaper articles, can provide a much more nuanced account of the way in which genres are constructed and given meaning. Thus, press reviews form a crucial part of the discursive practices surrounding texts and therefore perform an important function in creating and mediating the generic identity of films.

In his discussion of horror and its audiences, Mark Jancovich suggests that 'there are at least three levels at which struggles over the cultural authority inherent in distinctions between genres take place among audiences'.[15] The first position views genre films as inherently 'popular' and 'mainstream', in opposition to art cinema which is 'free from genre'.[16] The second involves the way in which genres are pitted against one another to form a cultural hierarchy. He argues that film noir and the western are viewed as more culturally legitimate than 'feminine' genres such as the rom-com.[17] In so doing, Jancovich acknowledges the ways in which these distinctions are inescapably gendered (a point I will return to shortly). The final level at which struggles over cultural authority are enacted takes place between fans or consumers of a particular genre. For example, fans of horror may have conflicting understandings of what particular texts or textual attributes constitute the genre. There are often disputes about which texts can be included within a particular canon, and these debates are also markedly gendered. Jancovich notes, for example, that certain horror fans may view vampire films as an entirely separate category (because their association with the 'feminine' and romance threatens the masculine 'legitimacy' of horror or vice versa). While this final level may seem more applicable to a genre such as horror, which has many sub-groups, the press discourses surrounding *Bridesmaids* demonstrate that this kind of struggle also takes place within discussions of more seemingly 'straightforward' genres such as the rom-com.

Indeed, it may be the case that 'feminine' genres are considered to be too 'trivial' to debate and discuss. Nevertheless, what follows demonstrates that even a cursory glance at the critical reception of *Bridesmaids* highlights the struggles which take place when attempting to insert the film within established (although not static) systems of value. For example, the *New York Times* writes, '*Bridesmaids* is an *unexpectedly* funny new comedy about women in love' (my emphasis).[18] Here, we are reminded of the important role performed by press reviews in maintaining and/or dismantling certain cultural hierarchies. In other words, as Klinger makes clear, reviews:

signify cultural hierarchies of aesthetic value reigning at particular times. As a primary public tastemaker, the critic operates to make, in Pierre Bourdieu's parlance, 'distinctions'. Among other things, the critic distinguishes legitimate from illegitimate and proper from improper modes of aesthetic appropriation.[19]

Drawing on Klinger, Jancovich argues that reviews not only maintain cultural hierarchies with regard to legitimate taste but also seek to contribute to the construction of cultural hierarchies in relation to 'popular taste'. He proposes that, in so doing, reviews 'reflect the differing attitudes of different sections of the media to varying taste formations. In the process they focus their attention on different features and employ wildly different notions of cinematic value'.[20] To be sure, the reception to *Bridesmaids* certainly involves the latter insofar as it is generally observed that it constitutes a 'popular' mainstream Hollywood film. That said, the discourse surrounding the film is indicative of the challenges presented when attempting to position *Bridesmaids* both within the rom-com canon, and in relation to other genres within a hierarchy.

The underlying assumption present in all the material surveyed here is that the rom-com appeals to the lowest common denominator. This is a frequent preconception. In her monograph *Romantic Comedy: Boy Meets Girls Meets Genre*, Tamar Jeffers McDonald observes that 'Romcoms are viewed as "guilty pleasures" which should be below one's notice.'[21] Romantic comedies secure their 'low' cultural status because of their preoccupation with distinctly 'feminine' and therefore 'trivial' themes (love, romance and relationships), offering supposedly 'straightforward' pleasures to a (passive) female audience. As Negra reminds us, 'mainstream cinematic romances are customarily held in low cultural esteem and their review discourses often reflect the low expectations attached to them'.[22] This is certainly true of the press reviews examined within this chapter, which perpetuate pejorative connotations associated with the genre, while also refusing to offer a coherent/cogent definition of romcom. Rather, the genre is presented as a familiar, known entity which requires no such deconstruction. Often these examples are paradoxically used to provide a point of opposition to *Bridesmaids*. For example, in the British quality broadsheet the *Telegraph*, journalist Sukhdev Sandhu reassures potential audiences that '*Bridesmaids* is a film about female friendship and the search for love, but don't worry: it's not *Sex and the City*.'[23] *Sex and the City* (King, 2008) becomes a significant reference point within both American and British reviews and serves as a

'typical' rom-com. While the two texts share similar thematic terrain (the narrative revolves around an ensemble cast and the challenges that 30-something women face), *Sex and the City* is used primarily to demonstrate difference.

Entertainment Weekly (United States) and *Empire* (Great Britain) suggest that while *Bridesmaids* remains rooted in the rom-com tradition, it provides audiences with alternative pleasures from the 'typical' chick flick. *Entertainment Weekly* suggests that 'the raunchy girl talk has an earthier flow than it does in, say, *Sex and the City*',[24] and *Empire*'s comments reflect Sandhu's position in that they, too, appease any concerns felt by potential viewers that *Bridesmaids* might deliver the 'trivial' 'feminine' themes in a tired, sentimental way: 'fans of mainstream female-focused comedies have mostly been offered insipid J-Lo vehicles and *Sex and the City* movies. Thankfully Apatow has turned his attention to the fairer sex.'[25] Two interrelated points are worth noting here. First, the rom-com is presented as in need of rescue from its low cultural status (a rescue facilitated by a male, 'legitimate' authorial presence). Second, there is an implicit distinction between 'traditional' rom-coms and Apatow's previous films (most notably *Knocked Up* and *The 40 Year Old Virgin*), which, as Jeffers McDonald has argued, draw heavily from the sex comedies of the 1950s and 1960s and can thus be understood as typical rom-coms of the post-classical era.[26] Not only is *Sex and the City* therefore presented as typical of the genre, but Apatow's comedies are rendered demonstrably distinctive (despite their preoccupation with themes of romance, sex and comedy). This difference functions to reinforce the struggles of cultural authority which take place at the level of genre and make plain the distinction between the 'legitimate', male-centred comedies, and the 'trivial', 'inconsequential', female-centred comedies. However, *Bridesmaids* must still be situated somewhere within this binary, and this becomes a problem for critics.

There are two similar strategies employed within press discourses which allow critics to maintain these traditional gendered hierarchies and celebrate *Bridesmaids*. The first involves claims of genre mixing. As previously suggested, the rom-com is positioned as a seemingly 'straightforward' genre that is not often debated. This frequently leads to disparate films being grouped together under the term. While *Bridesmaids* has been discussed as both a rom-com and a chick flick, a wide range of terms have been used in press commentary in an attempt to pin down the generic identity of the film: from more traditional labels which include 'wedding movie', 'ensemble comedy', 'girl grossout comedy' and 'raunch comedy', to newly coined phrases (designed

to play on the increasingly pervasive term 'bromance'), such as 'sismance', 'femme-com', 'sistermance' and 'womance'.[27] These labels are not simply arbitrary but rather are imbued with meaning. Moreover, the multitude of terms used to describe *Bridesmaids* suggests that it does not sit well within the established rhetoric reserved for female oriented films. Consequently, *Bridesmaids* has been celebrated for 'mixing' these discursive categories.

The *New York Times* offers perhaps the most detailed account of what constitutes a rom-com insofar as it defines its difference from the 'male comedy' and outlines the character traits of a typical heroine ('sarcastic' and 'a little nutty', but rarely intentionally comical).[28] In doing so, it suggests that '[t]he novelty of *Bridesmaids* is that it merges these two genres and scrambles the usual division of labour'.[29] Equally, respected film critic Roger Ebert claims that *Bridesmaids* attempts 'to cross the Chick Flick with the Raunch Comedy'.[30] The resultant effect is that the film is elevated from the low cultural status of rom-com because it 'mixes' the feminine themes of the chick flick with the male (and therefore more legitimate) aspects of comedy. This is explicitly referenced in *Empire* magazine which claims that, 'like many a guy's comedy, [*Bridesmaids*] isn't afraid to flirt with gross-out'.[31] Indeed, this claim is also demonstrative of the second approach adopted in press discourses which allows reviewers to preserve traditional notions of cultural authority. The second strategy invoked by critics is to suggest that the film is in some way exceptional and groundbreaking, and that the use of gross-out comedy is central to this.

One of the most discussed scenes is that in which the bridal party is struck down with food poisoning. The graphic scene, which takes place in a high-end bridal boutique, invites the audience to witness Megan's (Melissa McCarthy) defecation into a hand basin while Becca (Ellie Kemper) vomits in Rita's (Wendi McLendon-Covey) hair. While the scene received a mixed reception from critics, it proved significant in setting *Bridesmaids* apart from other romantic comedies. For example, to return to Sandhu's comments above, readers are reassured that *Bridesmaids* marks a significant departure from other romantic comedies – specifically *Sex and the City* – '[because it's] heaving with gags about puking and pooing'[32] (as an aside, *Sex and the City* does in fact include a memorable scene of Charlotte [Kristin Davis] suffering an episode of diarrhoea). Similarly, the *New York Times* opens with the remark that '*Bridesmaids* ... goes where no typical chick flick does: the gutter.'[33] Both of these critics are celebratory of the gross-out spectacle – positing that the scene is in some way generically innovative. Mark Kermode, on the

other hand, is more critical of the scene. In a mainly positive review of the '*ballsy* comic hit' (my emphasis), he remarks: 'Granted, there are occasions when the guiding hand of producer Judd Apatow seems to be laid rather too heavily on the proceedings, most notably during the now infamous communal pants-pooing sequence, which marks something of a low point.'[34] Kermode's claims therefore also suggest that the scene is in some way exceptional – to the point that its inclusion in the film is not attributed to the writers, Wiig and Annie Mumolo, but to Apatow.[35] In so doing, it is suggested that the distinctly masculine gross-out comedy employed, while not celebrated by Kermode, continues to play an important role in setting the film apart from more 'feminine' genre films.

Women and comedy

The 'communal pants-pooing' scene is the focus of the majority of press reviews not simply because it supposedly marks a departure from traditional rom-com tropes but rather speaks to a wider set of anxieties regarding appropriate feminine behaviour. Such is the case in Roger Ebert's review entitled, 'Women can get drunk and be crude too'.[36] The title is indicative of the review's tone which tentatively celebrates the physical comedy of *Bridesmaids* while also expressing underlying concerns regarding women's role in comedy. To be sure, Ebert's review does not strike a 'disapproving' tone, but rather the continual focus on the physical comedy within the film, combined with the constant reminders that the cast is (almost) entirely female, suggests a sense of unease. It not only implies that there are certain societal norms which women are expected to abide by (that the film refuses to adhere to), but also serves to 'warn' contemporary (male) audiences who might have a problem with watching women refuse to perform traditional feminine identities. For Ebert, *Bridesmaids* is 'about a group of women friends who are as unbehaved as the guys in *The Hangover* [sic]'.[37] The continual comparison between both films serves to remind readers that the humour within *Bridesmaids* is primarily associated with male-oriented comedies.

The food-poisoning sequence provides the entire cast with the opportunity to enact the kind of disruptive spectacle conceptualized by Kathleen Rowe in her monograph *The Unruly Woman* (1995). Rowe identifies a recurrent character of popular film and TV genres (the unruly woman), dating back from the classical era to the contemporary period. Rowe proposes that 'the figure of the unruly woman – too fat, too funny, too noisy, too old, too rebellious – unsettles social hierarchies'.[38] She

writes, 'it is through her body, her speech, and her laughter, especially in the public sphere, [that the unruly woman] creates a disruptive spectacle of herself'.[39] It should also be noted that, throughout the film, characters are depicted as unruly – swearing, drinking and having casual sex – for comic effect.[40] Moreover, the groom's sister, Megan, embodies the corporeal excess characteristic of the unruly woman, and her costume (men's shirts and trousers combined with a pearl necklace) speaks to a form of gender transgression. Thus, in myriad ways the female cast (perhaps with the exception of Rose Byrne's character) serve as unruly women.

For Rowe, the unruly woman 'contains potential for feminist appropriation'.[41] She argues that the way in which the unruly woman dismantles traditional expectations of appropriate gender performance, combined with her public visibility, undermines patriarchal norms. However, in so doing, she suggests that the unruly woman is met with resistance. She observes with regard to one of her case studies (Roseanne Arnold) that: '[t]he prejudices that have made Roseanne Arnold such a deviation from the norm on prime-time TV have even more forcefully excluded other, potentially more disruptive, women's voices from mainstream media'.[42] Given the cultural preoccupation with self-surveillance and governance of the body, anxieties toward corporeal excess are all the more pervasive. In *Gender and the Media*, Gill suggests that this increased scrutiny is characteristic of postfeminist culture. She states that, 'in a shift from earlier representational practices it appears that femininity is defined as a bodily property rather than (say) a social structural or psychological one'.[43]

An examination of press discourse reveals both a celebration of the physical comedy (serving as disruptive spectacle) in *Bridesmaids*, and a counter narrative against its feminist potential. In other words, a process of containment is mobilized at the level of criticism. Ebert, for example, despite celebrating Wiig's comedic performance, undermines her authority by continually making reference to her position as a woman. Thus, it becomes clear that she is to be viewed as an 'exception'. Moreover, by making claims about the comedic capabilities of the women in *Bridesmaids*, he calls those very capabilities into question. Ebert claims that the film 'definitely proves that women are the equal of men in vulgarity, sexual frankness, vulnerability, overdrinking and insecurity'.[44] This debate may not have ever been under discussion; however, Ebert cues readers/viewers to think about the comedic performances in these terms. This is not an isolated example; rather, several of the press reviews frame their discussion of *Bridesmaids* in this way.

Many of the American reviews situate the film within a broader discussion of women and comedy, with the majority looking back to Christopher Hitchens' 2007 *Vanity Fair* claim that women are not funny.[45] Consequently, issues of gender are centralized. For most of these reviews it seems that this debate is located within the context of gross-out and has produced mixed responses. For some, the physical comedy validates *Bridesmaids* as a 'legitimate' Hollywood comedy, while for others it undermines female comedy as it (re)produces a hierarchy in which 'masculine' comedy is privileged over 'feminine' comedy. In *Seven* (a supplement of the *Telegraph*), Jenny McCartney asserts that, 'Judd Apatow coarsens things unnecessarily by shoehorning in an unlikely scatological scene in which the bridesmaids are simultaneously struck with a stomach bug while trying on dresses in a bridal boutique.'[46] Similarly, in a review of the year, *New York* magazine asks:

> Can we please get more of Kristen Wiig but not acting like a bro? The best moments in *Bridesmaids* aren't the guyed-up ones like women shitting in the street. There are moments of pure Wiig when she and Rose Byrne give duelling speeches or when she drives topless by her cop boyfriend while littering. *Bridesmaids* isn't Judd Apatow's biggest hit because he taught Wiig how to appeal to guys. Wiig and director Paul Feig have a stronger sense than Apatow does of how to make great female characters.[47]

As with Mark Kermode's review, the underlying suggestion here is that the visceral behaviour is coded as masculine. Judd Apatow is once again identified as the creative force behind the food-poisoning sequence – despite reports that Wiig and Mumolo penned the scene. Yet, for *New York* magazine, Wiig is accredited with authorship of the witty dialogue. Thus, her (female) comedy (rooted in the oral tradition) is coded as an appropriate – and more sophisticated – mode of 'feminine' performance.

A more adverse response to the physical comedy can be found in *Rolling Stone* magazine, suggesting that *Bridesmaids'* gross-out elements represent undesirable female behaviour which should be eradicated. Peter Travers writes: 'Frankly, the only time *Bridesmaids* loses its footing is when it acts like *The Hangover* in drag. Guys and gross make a better fit. Who needs to see bridesmaids puking up lunch and shitting their pants?'[48] Here, Travers expresses disgust towards these 'abject' moments. Indeed, his comments are indicative of the resistance with which the 'unruly woman' is often met. Similarly, the *New York*

Times recounts the food-poisoning sequence, making reference to the gendered nature of gross-out comedy. It reads, 'that may sound disgusting, perfect for the reigning naughty boys of American screens, and it is'.[49] This behaviour is suitable for/expected of the 'naughty boys' of Hollywood – presumably this refers to Judd Apatow's recent male comedies – and, by default, unsuitable for the women of Hollywood. In an interview with Kristin Wiig and co-star Maya Rudolph, *Entertainment Weekly* brings this gendered debate to the fore and explicitly remarks upon the criticisms levelled at the film. It reads, 'on sites where the trailer is running, there's some hand-wringing from commenters about how women shouldn't have to be crass to prove they're as funny as men'.[50] This comment suggests, therefore, that there are gender specific modes of performance which should be adopted by the female actors.

It is worth noting here that this counter narrative, present in much of the commentary, exists alongside celebratory claims that the film contributes to the political advancement of women in Hollywood. It is precisely these claims which inform/and are informed by a postfeminist sensibility. With this in mind it becomes clear that the discursive activity surrounding *Bridesmaids* occupies a complex position in relation to feminism. For example, the *New York Times* posited that the film had 'taken on special cultural significance'.[51] Similarly, in *Entertainment Weekly*'s review 2011, *Bridesmaids* achieves the number two position in the top ten films of the year. In the review it is claimed that, '*Bridesmaids* is so good that the female-driven, feminist intelligence that drives the project doesn't need to be mentioned. Except I think it does.'[52] In accordance with Projansky's categories of postfeminist discourse, some of the reviews are buttressed by the notion that feminism is associated with the past. However, while there is an underlying suggestion that feminism is dead, there is also the implication that *Bridesmaids* signals a revival. In his review for the *Guardian*, Peter Bradshaw commented on this phenomenon. He writes, 'a good deal has now been written about *Bridesmaids* being at the vanguard of a new feminist revolution in Hollywood comedy – a sorpack to go with the fratpack – and how, before this, women were marginalized or treated as second class turns in Hollywood'.[53] Moreover, Bradshaw's use of the term 'new' feminist revolution signals a rupture from any previous feminist activity. In admitting that until *Bridesmaids* Hollywood had operated within an unequal patriarchal system, he implies that earlier attempts to secure the equal treatment of male and female actors had 'ultimately failed'.

While the term 'feminism' is often deployed within press discourse, its precise meaning remains ambiguous. For the most part, it seems that the feminist success of *Bridesmaids* lies in its ability to undermine assumptions that women cannot be funny. For example, the *New York Times* describes the humour within *Bridesmaids* as 'liberating', while Ann Hornaday of the *Washington Post* writes that, 'Kristin Wiig plants a bawdy, brave and brashly feminist flag in the male dominated raunch-com genre'.[54] It is not made explicitly clear within the *Post*'s review precisely how *Bridesmaids* is to be understood as feminist. As with the *New York Times*, the remainder of the review celebrates the combination of slapstick – typical of raunch comedy – with witty dialogue performed by the predominantly female cast. However, it is important to note here, as Jeffers McDonald does, that while the 'raunch comedy' is traditionally understood as a male genre, it 'tap[s] into a contemporary social phenomenon' associated with women.[55] These films are therefore viewed as part of 'raunch culture' which has permeated a multitude of media forms and is, somewhat paradoxically, marketed towards young women.

Recent popular feminist writing has commented on the contemporary preoccupation with raunch culture and the complex pleasures it offers to young women. In *Female Chauvinist Pigs: Women and the Rise of Raunch Culture*, journalist Ariel Levy details the increasing pervasiveness of soft core pornography within media texts consumed by women.[56] This development is viewed by some as liberating and empowering. However, Levy, among others, suggests that the sex industry has commodified feminism and sold it back to women. Indeed, Gill cites the 'sexualization of culture' as symptomatic of postfeminist sensibilities which endorse the increasing scrutiny of women's bodies in contemporary media forms.[57] Moreover, Gill outlines the commercial incentive which drives the sexualization of culture and thus remarks upon the neo-liberalist values central to contemporary postfeminist sensibility. This particular version of feminism is bound up with raunch culture and packaged in such a way that it becomes acceptable/desirable to young women. While it is not my intention to overstate the relevance of this literature, or suggest that *Bridesmaids* functions as a marker of the sexualization of contemporary culture, I would posit that it is important to consider the ways in which the film – and the surrounding press discourses – are informed by this cultural climate.

Several of these issues chime with Projansky's definition of (hetero)sex-positive postfeminism, in which the sexual freedom of women is celebrated. As previously discussed, a consequence of this is that second-wave feminism is both constructed as 'anti-sex' and

rendered redundant. In its place, the (hetero)sex-positive strand of postfeminism offers a corrective to this failing of second-wave feminism. With this in mind, it becomes clear that any contemporary version of feminism is contained within strict parameters. Thus, to return to Hornaday's claim, it seems that the contemporary depoliticization of feminism places limits on the radical/progressive potential of *Bridesmaids*. In other words, while *Bridesmaids* may make visible its female cast, their visibility is ultimately contained and rendered safe.

Significantly, of all the material surveyed here, one review was critical of *Bridesmaids* in general, and of claims of its feminist potential in particular. The *Village Voice* offers a counter narrative to the mainstream press examined above. As an example of the 'alternative' press, the *Voice* concerns itself with highlighting the problems with the Hollywood system which prevent *Bridesmaids* from fully destabilizing gendered cultural hierarchies. Instead, it argues that the film bends over 'backwards to prove that girls can play on the same conventional comic field as boys'.[58] Moreover, the gross-out elements, which have been championed by some, are singled out as moments when the film undermines its position. It reads, 'Comedy of humiliation is one thing; a fat lady shitting in a sink is another.'[59] Thus, while the *Voice* is keen to point out the injustices of contemporary postfeminist culture, as one in which women are fundamentally disadvantaged, it adopts a similar position to that of the mainstream press which expresses concern regarding the 'unruliness' of the female cast.

Conclusion

It has long been suggested that postfeminist culture is extremely ambiguous and ambivalent with regard to its position on/within feminist politics and this is surely reflected in the discourses which circulate around *Bridesmaids*. While a publication such as the *Voice* offers one, perhaps radical, perspective, it remains as contradictory and complex as the mainstream press examined here. Nevertheless, a series of common themes identified across all the material here, suggests that a dominant discourse emerges – one which ultimately seeks to reinforce traditional systems of value. To summarize, it has been my contention that the discursive activity surrounding *Bridesmaids* ultimately works to contain the potential for feminist appropriation in such a way that is typical of postfeminist/neo-liberal sensibilities. As Tasker and Negra have argued, 'certain kinds of female agency are recognizably and profitably packaged as commodities'[60] and I would argue that the kind of female agency

provided by *Bridesmaids* has been discursively (re)packaged, whether that be through redefining generic boundaries, or through promoting a rhetoric which seeks to contain 'unruliness'.

However, this is not to suggest that a feminist appropriation of the pleasures offered by *Bridesmaids* will not take place, for, as discussed in the introduction, an examination of critical reception does not (and cannot) make a claim of audience response. Nor do I suppose that this is an intended aim of the media, or that this is in fact the only read-ing available of the material surveyed here. Indeed, the reviews are sites of ideological struggle. Finally, it has not been my intention to claim that *Bridesmaids* is, or is not, feminist. Rather, I propose that an exam-ination of the critical reception reveals the ways in which reviews play a crucial role in defining the terms through which audiences are cued to read *Bridesmaids*. To close, I return to Gill and suggest that through such an exploration we are reminded that 'the media play a powerful role in defining feminism',[61] and, I would add, in providing audiences with subject positions from which to view feminism in a postfeminist climate.

Notes

1. Claire Mortimer, *Romantic Comedy* (London: Routledge, 2010), p. 1.
2. The film reportedly grossed US $288,383,523 worldwide.
3. Ann Hornaday, '*Bridesmaids*', *Washington Post* (13 May 2011).
4. The term 'text' here, and throughout the article, is employed in the widest sense – as used in film and media studies.
5. Robert C. Allen and Douglas Gomery, *Film History: Theory and Practice* (New York: Knopf, 1985).
6. Allen and Gomery, *Film History*, p. 90.
7. Barbara Klinger, *Melodrama and Meaning: History, Culture, and the Films of Douglas Sirk* (Bloomington, IN: Indiana University Press, 1994), p. 69.
8. Peter Bradshaw, 'Review: *Bridesmaids*', *Guardian* (23 June 2011).
9. Diane Negra, 'Structural Integrity, Historical Reversion, and the Post-9/11 Chick Flick', *Feminist Media Studies*, 8:1 (2008), p. 52.
10. Rosalind Gill, *Gender and the Media* (Cambridge: Polity, 2007), p. 254.
11. Yvonne Tasker and Diane Negra, 'Introduction', in *Interrogating Postfeminism*, ed. by Yvonne Tasker and Diane Negra (London: Duke University Press, 2007), p. 8.
12. Suzanna Danuta Walters, 'Premature Postfeminism: "Postfeminism" and Popular Culture', *New Politics*, 3:2 (1991), p. 106.
13. Sarah Projansky, *Watching Rape: Film and Television in Postfeminist Culture* (New York: New York University Press, 2001), p. 67.
14. Mark Jancovich, 'Genre and the Audience: Genre Classifications and Cul-tural Distinction', in *Horror: The Film Reader*, ed. by Mark Jancovich (London: Routledge, 2002), p. 151.

15. Jancovich, 'Genre and the Audience', p. 152.
16. Ibid.
17. Ibid.
18. Manohla Dargis, 'Deflating that Big, Puffy White Gown', *New York Times* (12 May 2011).
19. Klinger, *Melodrama and Meaning*, p. 70.
20. Jancovich, 'Genre and the Audience', p. 155.
21. Tamar Jeffers McDonald, *Romantic Comedy: Boy Meets Girl Meets Genre* (London: Wallflower, 2002), p. 7.
22. Negra, 'Structural Integrity, Historical Reversion, and the Post-9/11 Chick Flick', p. 51.
23. Sukhdev Sandhu, '*Bridesmaids*, Review', *Telegraph* (23 June 2011).
24. Owen Gleiberman, '*Bridesmaids*', *Entertainment Weekly* (20 May 2011).
25. Anna Smith, '*Bridesmaids*', *Empire* (July 2011), p. 46.
26. Jeffers McDonald, *Romantic Comedy*, p. 111.
27. Karen Valby, 'Party Crashers', *Entertainment Weekly* (13 May 2011), p. 32.
28. A.O. Scott, 'The Funnywoman, Alive and Well', *New York Times* (28 May 2011).
29. Scott, 'The Funnywoman, Alive and Well'.
30. Roger Ebert, 'Women Can Get Drunk and Be Crude Too', rogerebert.suntimes.com (11 May 2011) (accessed 9 September 2011).
31. Smith, '*Bridesmaids*', p. 46.
32. Sandhu, '*Bridesmaids*, Review'.
33. Dargis, 'Deflating that Big, Puffy White Gown'.
34. Mark Kermode, 'Kristen Outgrows Her Gross-out Roots: *Bridesmaids* is Far Funnier – and More Poignant – than Judd Apatow's Usual Fare', *Observer* (13 November 2011).
35. It should be noted that in an interview with the *Guardian* writers Kristin Wiig and Annie Mumolo describe their experience of writing the 'shitting-in-the-street' scene thereby suggesting that Apatow's involvement, at least at this stage, was minimal.
36. Ebert, 'Women Can Get Drunk and Be Crude Too'.
37. Ibid.
38. Kathleen Rowe, *The Unruly Woman: Gender and the Genres of Laughter* (Austin, TX: University of Texas Press, 1995), p. 19.
39. Rowe, *The Unruly Woman*, p. 31.
40. Indeed, we are also reminded of Angela McRobbie's concept of the 'phallic girl'. See Angela McRobbie, 'Top Girls? Young women and the post-feminist sexual contract', *Cultural Studies*, 21:4 (2007), pp. 718–737.
41. Rowe, *The Unuly Woman*, p. 11.
42. Ibid., p. 19.
43. Gill, *Gender and the Media*, p. 255.
44. Ebert, 'Women Can Get Drunk and Be Crude Too'.
45. Christopher Hitchens, 'Why Women Aren't Funny', *Vanity Fair* (January 2007).
46. Jenny McCartney, '*Bridesmaids*', *Seven Magazine* (23 June 2011).
47. Jada Yuan, 'The Year in Culture: Movies', *New York Magazine* (12 December 2011).

48. Peter Travers, '*Bridesmaids* is Like The Hangover in Drag', *Rolling Stone* (12 May 2011).
49. Dargis, 'Deflating that Big, Puffy White Gown'.
50. Valby, 'Party Crashers', p. 32.
51. Scott, 'The Funnywoman, Alive and Well'.
52. Lisa Schwarzbaum, '*Bridesmaids*', *Entertainment Weekly* (23 December 2011).
53. Bradshaw, 'Review: *Bridesmaids*'.
54. Hornaday, '*Bridesmaids*'.
55. Jeffers McDonald, *Romantic Comedy*, p. 110.
56. Ariel Levy, *Female Chauvinist Pigs: Women and the Rise of Raunch Culture* (New York: Simon and Schuster, 2007).
57. Gill, *Gender and the Media*, p. 256.
58. Karina Longworth, '*Bridesmaids* Gets Screwed', *Village Voice* (11 May 2011).
59. Longworth, '*Bridesmaids* Gets Screwed'.
60. Yvonne Tasker and Diane Negra 'In Focus: Postfeminism and Contemporary Media Studies', *Cinema Journal*, 44:2 (2005), p. 107.
61. Projansky, *Watching Rape*, p. 70.

14
Blood, Sweat and Tears: Women, Sport and Hollywood

Katharina Lindner

The sports film genre is one in which girls and women are notoriously underrepresented. However, there has been a notable increase in female sports films over the last 20 years,[1] coinciding with the increased visibility of female athletes in the media landscape more generally[2] and with the emergence of postfeminist discourses, both within the media and within the context of academic debate. Within the contradictory context of, on the one hand, the transgressive and empowering potential of female athleticism, and, on the other, the sexualization and objectification of the athletic female body within the larger media context, this chapter explores the ways in which these films might challenge and/or reinforce heteronormative understanding of femininity and female sexuality. The discussion is also situated in relation to debates surrounding the increasing commodification of the sport/fitness context and around the contradictory significance of girls and women as consumers of sport- and fitness-related products that are posited as an integral part of an 'empowering' 'lifestyle'. As such, this chapter attempts to map the ways in which the intertwining of neo-liberal and postfeminist discourses[3] is variously inscribed on and embodied by the figure of the female athlete. It therefore draws on an understanding of postfeminism as a 'sensibility'[4] where notions of female empowerment are increasingly asserted through an emphasis on individualism, choice, consumption and (bodily) self-discipline. In doing so, this chapter engages with the complexities surrounding manifestations of (post)feminism with a particular focus on the sports context and the figure of the female athlete. With reference to the larger socio-cultural significance of sport, athleticism and physicality in relation to questions of female empowerment (or lack thereof), this chapter explores cinematic depictions of female athleticism in a range contemporary

sports films, including *Million Dollar Baby* (Eastwood, 2004), *Blue Crush* (Stockwell, 2002), *Stick It* (Bendinger, 2006), *Step Up* (Fletcher, 2006), *Gracie* (Guggenheim, 2007), *She's the Man* (Fickman, 2006), *Girlfight* (Kusama, 2000) and *Love and Basketball* (Prince-Bythewood, 2000).

Gender and sport

Historically, sport has been considered an exclusively masculine endeav-
our and women's initial participation in this domain has been perceived
as an 'unsettling and unwelcome intrusion into the realm of masculin-
ity'.[5] This remains the case as sport has gained importance as a social
space for men to establish their masculinity through the open display
of physical strength and the domination of others. Generally, feminist
sports studies emphasize the significance of sport to the reconstitution
of hegemonic masculinity.[6] Connell suggests that sports' homosocial
environment not only teaches boys 'how to be men' but also, on a
more symbolic level, provides a 'repertoire of images' of ideal masculin-
ity.[7] The sports context is also characterized by the careful monitoring
and regulation of the female body, meaning that female athletes tend to
be marginalized, stigmatized and/or sexualized.[8] Women's presence in
this context has been restricted to very narrowly defined feminine roles,
as sexualized spectacle and entertainment or 'reward'. This is the case
both within the context of athletic activity itself (e.g. cheerleaders, ring
card girls) and in the wider institutional and social-cultural contexts sur-
rounding sport (e.g. the wag phenomenon; sexist locker-room cultures;
the pervasiveness of pornography and prostitution within institutional
and fan cultures surrounding major sporting events). The presence of
women *as athletes* seriously disrupts the historically established gender
relations within sport. Several critics have pointed to the historically
reciprocal relationship between sport and cinema,[9] and there are some
useful parallels to be drawn between women's 'intrusion' into the
male-dominated world of sports and the entrance of female protago-
nists into the male-centred genre of the sports film, as I will elaborate
below.

Athletic activity has become one of the few remaining legitimate
outlets for violence and aggression, especially since the advent of
widespread industrialization and urbanization, but also in response to
the shifting gender roles and expectations following the feminist move-
ments of the 1960s and 1970s. Woodward attributes the significance and
popularity of sports to the increasing instability of gender identities. The

reconstitution of seemingly archaic notions of masculinity within the sports context, and boxing in particular:

> can be seen as responses to an unsettled and unsettling world of transformation and change, especially in relation to gender roles. Examples of attempts to secure the self and to establish some sense of belonging demonstrate some of the difficulties that emerge from framing identity in a sea of discursive uncertainty. Identification in a sport like boxing promises some security in knowing what masculinity means.[10]

Fight Club (David Fincher, 1999), although not, strictly speaking, a boxing film, can be read as a particularly poignant articulation of these anxieties, especially as they relate to the integration of men and masculinity into consumer culture. The recent emergence of cage fighting – the ultimate display of violence with essentially no boundaries (except those of the cage in which the fighters are let loose) – as one of the fastest-growing sports in the last decade,[11] also supports this notion, and points to the troubling implications of women's increased presence and visibility within this historically male-dominated context. If sports have gained significance as a homosocial space in which traditional notions of masculinity are reinforced, both through engagement in athletic activity itself and with regard to the possibilities for identification with heroic masculinity provided through male sports stars, the presence of women 'doing' masculinity constitutes a serious threat.

(Post)Feminism and sport: Empowering possibilities?

While sports are a context in which women tend to be marginalized and in which often archaic notions of masculinity are perpetuated, sports have also been central to feminist discourses surrounding female empowerment. The entrance of women into this traditionally male domain is, particularly from a liberal feminist perspective,[12] considered a sign of progress, with the ultimate goal being equal opportunities, access and rewards for boys and girls, men and women. There is an assumption that unequal access to sport is an important aspect of larger socio-cultural gender inequalities and the exclusion and marginalization of girls and women is seen as a form of gender discrimination. Sport and physical activity are beneficial and rewarding, not only in terms of the potential for fame and financial gain for professional athletes, but also in relation to health benefits and general well-being, including lower

rates of obesity, alcohol consumption and smoking. Girls' engagement in sport has also been linked to an increased sense of self-confidence and body ownership, as well as to lower rates of teenage pregnancy.[13] Questions concerning girls and women's access to sport (in terms of facilities, equipment and the existence of girls' and women's teams or leagues) are therefore often framed as health-related issues. Whitson additionally reminds us of 'the pleasures that can be taken in smooth powerful motions [...], in coordination and fine motor skills, in self-awareness and self-possession, in partnership and shared fun'.[14] Certain sports, in other words, particularly non-competitive sports such as jogging, aerobics and pilates, provide opportunities for girls and women to engage in activities that allow them to be 'in touch' both with their own bodies and with each other. This is, of course, not the case in competitive physical-contact sports such as boxing and I will elaborate on this distinction and its gendered implication below.

Issues of opportunities and access can be identified as one of the central themes across a range of contemporary female sports films. *Love and Basketball* highlights gender inequalities within sport, both with regard to the social recognition and status gained by sporting success, as well as with regard to the opportunities for the pursuit of sport as a profession. The film traces Monica's (Sanaa Lathan) struggles to gain recognition for her athletic talent and her attempts to pursue a career as a professional athlete, which is contrasted with her basketball-playing boyfriend, Qunicy's (Omar Epps), meteoric rise to fame and financial success. In *Million Dollar Baby*, Frankie's (Clint Eastwood) initial refusal to 'train a girl' when Maggie (Hillary Swank) asks him to be his coach points to the institutional and cultural barriers to women's access to the boxing context in particular. Similarly, Diana's presence in the local boxing gym in *Girlfight* is met with fierce resistance, both from the other boxers and their coaches as well as Diana's family and friends. *She's the Man* and *Gracie* address specifically the unequal sporting opportunities provided for boys and girls in the context of soccer. Since there are no girls' soccer teams at their respective schools, the only way for Viola (Amanda Bynes) and Gracie (Craly Schroeder) to 'fulfil their dreams' is to find a way to play on the boys' soccer teams. In the case of *She's the Man*, a gender disguise comedy, Viola gains access to the boys' soccer team by pretending to be her twin brother, Sebastian. Inevitably, the main focus of the film is on Viola's comical struggle to 'be a boy'. The situation becomes even more complicated when Viola, disguised as Sebastian, falls in love with one of her male teammates, who has, of course, no idea that Sebastian is really a girl. While *She's the Man* engages with questions

around how women might 'do' masculinity, and while the film seemingly points to the constructedness of masculinity as an embodied performance, both the comedic context and the underlying/disguised heterosexual romance strand firmly re-establish traditional gender and sexual binaries. Larger socio-cultural issues around unequal access and opportunities for girls in sport are, at best, sidelined. Gracie, on the other hand, fights institutional barriers (the school board) and her family's and friends' prejudices in order to gain access to the boys' varsity soccer team *as a girl*, and eventually succeeds. The resistance of male athletes to accept a woman into their sporting community is also highlighted in the surfing film *Blue Crush*, where Anne Marie (Kate Bosworth) experiences not so much the institutional but the cultural resistance to women's presence in this traditionally male-dominated sport.

What the films mentioned here have in common, then, is an acknowledgement of the gender inequalities within sport and much of the narrative focus is on the characters' attempts to overcome these barriers. The emphasis is therefore not necessarily on what they achieve *as athletes*, but as girls/women who follow their gender inappropriate dream in a man's world. In the context of mainstream cinematic conventions, the focus on the individual and on individual achievement is not surprising. However, the marginalization of larger social structures in favour of a foregrounding of individual agency (which is often supported/made possible by sympathetic male characters) adds a sense of ambiguity, and a distinctly postfeminist (and neo-liberal) undertone to the films' articulation of female empowerment: notions of freedom, empowerment, agency and choice are offered as a kind of substitute for feminist politics and transformation, which, as McRobbie argues, ultimately disempowers women.[15]

What is additionally remarkable in this postfeminist context is that the female sporting protagonists tend to be rather isolated figures, with the exception of the varyingly strong bonds to 'supporting' male characters, often their trainer or coach. In particular, they tend to be cut off from other female characters and there is often no hint of a sense of community, female bonding or the opportunities for shared achievement and fun that sports provide. Notable exceptions include *Blue Crush*, with its focus on the close-knit community of the three central female surfing characters Anne Marie, Eden (Michelle Rodriguez) and Lena (Sanoe Lake), as well as *Stick It*, a film about gymnastics in which the developing friendship between the athletic female protagonist, Haley (Missy Peregrim), and her fellow female gymnasts is of central narrative significance. However, the great majority of female

sports films focus on their sporting protagonists in isolation, not only in films featuring individual sports such as boxing, where this might occur 'naturally', as a by-product of the sport itself, but also in films featuring team sports such as soccer or basketball. This is most notable, perhaps, in *Love and Basketball*, where Monica's character is largely devoid of meaningful relations and interactions with other female characters and her female teammates. With regard to *She's the Man* and *Gracie*, the fact that there are no girls' soccer teams and the female protagonists therefore have to play on the boys' team, means that the depiction of female friendship within the sports context is narratively impossible. One of the reasons for this tendency to depict female athletic characters in isolation is, perhaps, the common-sense association of female athleticism and masculinity with lesbianism. In fact, films such as *Blue Crush* and *Bend it Like Beckham* that depict female bonding between athletic characters and within the sports context have been particularly popular with lesbian audiences, and the depiction of close relationships between (physically) strong and assertive characters is arguably where the possibilities for such alternative viewing pleasures potentially lie.[16] However, the general isolation of athletic girls and women *from each other* also feeds into postfeminist notions of a depoliticized individualism (tied up, as it is, with the heterosexual subject), as opposed to female community and its transformative implications.

What is additionally notable in this context is that these narratives of (supposed) empowerment through sport are played out almost exclusively in relation to teenage characters, and there are some important links to the more general socio-cultural acceptability of girls' and young women's, as opposed to older/mature women's, engagement in 'masculine' sporting activities. Most female sports films draw more or less explicitly on the tomboy narrative, which sees girls' 'masculine' behaviours and appearances as part of a pre-adult phase that is eventually overcome on the way to adult womanhood.[17] Even 31-year-old boxer Maggie in *Million Dollar Baby* embodies the tomboy stereotype, particularly in relation to her childish and immature disposition that is most explicitly articulated through her relationship with her substituted father/coach, Frankie. This pattern fits with suggestions that female athleticism with its potential associations with tomboyism and lesbianism is acceptable as a temporary phase that has to be overcome as girls develop into appropriately feminine women. In relation to women's presence in the action genre, Tasker suggests that the tomboyish heroine can be read as a 'girl' who has not yet accepted the responsibilities of adult womanhood, independently of her age.[18]

This confinement of female physicality and bodily action to a pre-adult phase can be read as an attempt to assuage the anxieties around women's (bodily) empowerment and the threat this poses to heteronormative binaries of gender and sexuality. It also feeds into postfeminist notions of femininity as a bodily property that needs to be continually 'worked on', monitored and controlled – a (media) discourse that is targeted at young women in particular.[19]

Women, sport, cinema: Gender/genre trouble?

I have already referred to the 'troubling implications' of female athleticism and it is therefore useful to explore this notion in more detail, not only in relation to women's presence in this traditionally male-dominated domain but also to women's *embodiment* of characteristics (e.g. muscles, power, strength, aggression, quickness, speed) that are often assumed to be 'natural' attributes of the male body. Female athleticism counters the traditional associations of femininity with passivity, weakness and vulnerability and disrupts assumptions about male physical superiority.[20] The muscular female body signals the ability to protect oneself from (physical and sexual) abuse and even implies the possibility for women to be perpetrators of (physical and sexual) violence. Generally, the more muscular, and thus masculine, the female body the more imminent the perceived threat to social gender relations that are based on binary and hierarchical notions of gender.[21] This points to the very narrowly defined boundaries of the 'makeover paradigm' that Gill identifies as central to postfeminist (media) culture: only very particular kinds of 'working on' the body are encouraged and tolerated, and women's (supposedly freely chosen) preoccupation with their bodies is problematic if it does not reinforce a heteronormatively feminine ideal.

One of the ways in which the transgressive potential of female athleticism is contained is the gendering of different sporting activities. Girls and women tend to be encouraged to pursue female-appropriate sports, such as figure skating or gymnastics – sports in which traditional gender ideals are largely kept in place, both through a competitive emphasis on appropriately feminine attire and appearance as well as on appropriately feminine movements and activities. This containment mechanism, functioning to police gender binaries and boundaries, is typically referred to as the 'feminine apologetic'. Feder argues that figure skating is one of the more accepted sports (as measured in media coverage and endorsement deals for athletes) because 'figure skating's "apology" is actually incorporated into the competition, where costume,

makeup, and gestures feminize and soften athletic prowess required for executing triple jumps and flying sit-spins'.[22] She also argues that television coverage and more general public/media discourses contribute to a specifically gendered narrative surrounding figure skating competitions that is centred on the female competitors' femininity. It is therefore not surprising, perhaps, that there are a range of female sports films that feature female-appropriate sports such as figure skating (*The Cutting Edge* [Glaser, 1992], *Ice Princess* [Fywell, 2005]), gymnastics (*Stick It*), cheerleading (*Bring it On* [Reed, 2000]) and various forms of competitive dance (*Step Up* [Fletcher, 2006], *Honey* [Woodruff, 2003]). The athletic activities pursued by the protagonists do not necessarily challenge assumptions about appropriately feminine behaviour and their athletic performances are easily and unproblematically integrated into traditional Hollywood narrative trajectories, obsessed, as they are, with heterosexual romance. In fact, films about figure skating or dance provide ample opportunities for the heterosexual romance narrative to be articulated *within* the context of athletic performance. In these films, monitoring, self-disciplining and 'working on' the body are thus conveniently linked to individual (sporting) achievement and heterosexual femininity and romance.

What is more, figure skating, gymnastics and cheerleading are sports in which success is determined by a panel of judges. Athletes perform in a stage-like setting for the gaze of both the judges and the spectators. The judges' gaze in particular is not incidental, but an absolutely central part of the performance. Performances in these sports take place, first and foremost, in order *to-be-looked-at*. This means that they are easily integrated into a mainstream representational framework where the female body has historically functioned as (sexualized) spectacle, an object of the (heterosexual male) gaze. These films, therefore, do not necessarily indicate a significant shift in representations of female bodies, but can be situated in relation to a long history of representations of femininity as staged spectacle.[23] Women's engagement in masculine sports such as American football, soccer, basketball or boxing, with their emphasis on violent bodily contact, aggression and the establishing of physical superiority, on the other hand provides a much more acute challenge to traditional gender binaries. Depictions of female boxers are therefore not so easily integrated into mainstream representational conventions.

In order to highlight the 'troubling' significance of the female *boxing* protagonist in particular, it is useful to contextualize this discussion not only in relation to debates about gender and sport, but also in relation to the representational context of the sports film genre.[24] This allows for

a more insightful consideration of the gendered implications of sports and athletic activity itself, the historical significance of sport and athleticism to cinematic articulations of masculinity, as well as the gendered implications of *looking at* the spectacle of (male and female) athletic performance.

With its roots in Muybridges' proto-cinematic stop-motion photography of bodily movement as well as early newsreel depicting sporting events, the sports film has been an integral part of cinema since its inception. The boxing film in particular has been an established tradition in Hollywood cinema and can be considered its most longstanding genre. Hollywood's history is characterized by the pervasiveness of athletic themes, sports-centred narratives and athletic bodies, including the frequent depiction of fictional and non-fictional boxing fights in early newsreel; Olympic swimmer Johnny Weissmueller's rise to fame as 'the-actor-who-played-Tarzan' in the 1930s and 1940s; iconic basketballer Michael Jordan's starring role as himself in the animation picture *Space Jam* (Pytka, US, 1996); the range of biopics about sports stars (e.g. *Ali* [Mann, 2001]), as well as Robert De Niro's Oscar-winning performance as the boxer Jake LaMotta in *Raging Bull* (Scorsese, 1980).

It goes without saying that the representation of sport and athletic bodies in Hollywood has taken place, more or less exclusively, in relation to men and masculinity. The boxing film in particular, as Grindon[25] points out, has centrally been about the articulation, and 'working out', of notions of a 'troubled masculinity' as inscribed on the body of the male boxer – with *Raging Bull* as perhaps the most poignant example. What is particularly intriguing about the historical significance of the boxing film is that the (semi-naked) male body is routinely 'on display' within this genre, exposed to the gaze of diegetic and non-diegetic spectators, arguably a position reserved for the female body in mainstream cinema.[26] However, the very nature of boxing, involving, by definition, muscular power, bodily violence, aggression and injury, is said to disavow the erotic implications of the gaze directed at the boxing body[27] – although the ambiguities surrounding the display of the male boxing body are never ultimately resolved, its display remaining troublingly precarious:

> Hollywood films about sport generally centre on the male body [...] as object of desire. If, as feminist film theory has argued, classic Hollywood is dedicated to the playing out of male Oedipal anxieties across the woman's body, object of the 'male' gaze, what does it mean to place the male body at the centre?[28]

Tensions arise because the emphasis on the male body 'ties the [athlete] to the woman's position in mainstream cinema'.[29] On the other hand, the bodily power and agency connoted by the athletic body assuage the underlying (homoerotic) tensions. Rather than constituting simply an object *to-be-looked-at* and desired, then, the athletic male body on display carries ambiguous and contradictory connotations of passivity and agency, as outcomes of fights and games, for instance, are impact for narrative development.

While the academic interest in the sports film is not extensive, there are attempts to identify its generic characteristics – that is 'the shifting yet patterned relationship within or between subject-matter, presentation, narrative and affect'.[30] Acknowledging the functional role of Hollywood genre films as isolating and providing symbolic solutions for socio-cultural problems and conflicts, Grindon offers one of the most in-depth explorations of the generic conventions of the boxing film and proposes a 'structure of meaning' characteristic of the genre. Grindon argues that the boxing film evolves around the fundamental conflicts of 'body versus soul', 'opportunity versus difference', 'market values versus family values', 'anger versus justice', as well as the tension between the violence in the ring and the (heterosexual) romance surrounding the boxing action.[31]

The boxer's disadvantaged working-class and/or ethnic-minority background often fuel anger. This anger functions as justification for the violence that is distilled and spectacularly staged in the boxing ring. For the boxer who is a member of an 'oppressed underclass struggling to rise',[32] boxing with its lure of fame and money represents an opportunity for integration into mainstream consumer culture. The boxer's success, in turn, threatens to alienate the boxer from his (disadvantaged) family and community. These generic conflicts, it is suggested, are played out over the body of the boxer – who is, of course, assumed to be male. As Woodward puts it, 'the archetypal boxer in film has traditionally been portrayed as a singular heroic figure of troubled masculinity'.[33]

I have taken some time here to outline the historical roots and generic characteristics of the sports/boxing film in order to highlight the intrinsic male-centredness and masculine implications of the genre, both in terms of its (heteronormative) narrative trajectories and visual conventions. By definition, then, the recent entrance of female protagonists into the genre causes all kinds of (gender/genre) 'trouble' – similar, perhaps, to the emergence of female heroines in the action genre in the 1980s.[34] Hillary Swank's Oscar-winning performance as Maggie in

Million Dollar Baby is a particularly interesting case in point. The film follows the conventions of the genre, for Maggie comes from a disadvantaged, working-class background, seeing boxing as the only way out of a miserable life without any real purpose. It is important to note, however, that Maggie's life outside of the boxing context is only ever very briefly alluded to on a very small number of occasions. Most of the film is situated in the boxing context, showing Maggie either at training or during fights. The only contact 31-year-old Maggie has is with Frankie, who functions as a substitute father figure throughout the film – apart from this, she is utterly isolated. One of the ways in which the film attempts to contain the genre/gender trouble embodied by the female boxer is by detaching Maggie from the larger socio-cultural structures in which her boxing activities are situated and have meaning. Rather than engaging explicitly with the larger implications of Maggie's gender-transgressive activity, boxing becomes a deeply personal endeavour in the film, played out almost exclusively in relation to Maggie's platonic relationship to Frankie. Her struggle is depoliticized and disconnected from the potentially transformative implications of women's engagement in (masculine) sports.

While boxing tends to be explicitly linked to notions of heterosexual masculinity in the (male) boxing film genre, with heterosexual romance narrative strands playing a central role in articulating the larger socio-cultural significance of boxing and the kind of masculinity associated with it, Maggie's character is strangely desexualized. Arguably, this functions to disavow the transgressive implications of Maggie's 'masculinity',[35] its associations with lesbianism and the perceived incompatibility of female masculinity and heterosexuality. However, it could also be argued that intertextual associations with Hillary Swank's previous performance as the transgender Teena Brandon/Brandon Teena in *Boys Don't Cry* (Kimberly Pierce, 1999) draw attention to the ambiguous articulation of gender and sexuality in her performance as a female boxer in *Million Dollar Baby*.

Girlfight, starring Michelle Rodriguez as the Latina boxer Diana, on the other hand, engages with the larger implications of female boxing more explicitly, by situating Diana's character both within the context of her immediate family (who disapprove of her engagement in boxing) and in the context of the Hispanic community in New York. Her boxing activity becomes part of her socially-situated identity and takes on social significance. This is articulated most explicitly via Diana's romantic relationship to fellow boxer, Adrian (Santiago Douglas), which functions to highlight the intrinsic associations between boxing and masculinity,

the gender trouble associated with women's engagement in boxing, as well as the problems this poses in the context of heterosexual relations within a strictly binary framework of gender and sexual difference. Diana's 'musculinity', a bodily sign of empowerment, has troubling implications both for Diana and for Adrian as their relationship does not 'fit' the male/masculine/active/strong, female/feminine/passive weak model of heterosexual relations. Rather than resolving these tensions, either by feminizing Diana or by attributing a superior masculinity to Adrian, the film's ending retains a sense of contradiction, with Diana beating Arian in the climactic final bout. As such, *Girlfight* follows the established conventions of the (male) boxing film genre quite closely, particularly in terms of narrative structure. However, the central conflicts and tensions addressed by the film differ significantly from those identified by Grindon as typical for the genre. Diana's engagement in boxing is not motivated by the prospect of money and fame, or an improvement in social status – on the contrary, boxing reaffirms her outsider status. Instead of evolving around notions of class and/or racial inequalities, the film's structuring tensions centre on the ambiguities surrounding Diana's gender and sexual identity as they are brought about by her engagement in boxing. Importantly, these tensions are not resolved, and a normatively gendered equilibrium is not re-established at the end of the film. The transgressive implications of Diana's engagement in boxing are not 'boxed in' or contained through generic and narrative conventions, but 'matter' beyond the confines of the film.

The narrative trajectory of *Million Dollar Baby*, on the other hand, functions to violently contain Maggie's implicit gender transgression, with a generic shift from boxing film to melodrama in the final part of the film. She is left paralysed from the neck down after a vicious attack by her most 'evil' opponent and the final part of the film depicts her 'unjust' suffering and her climactic suicide – Maggie's acquisition of bodily agency and empowerment are utterly negated. It is almost as if the film reaches the end of the generic road (of the boxing film) with the protagonist's suffering and death constituting the only acceptable resolution. Nonetheless, despite attempts to contain the transgressive agency associated with its physically powerful female protagonist, *Million Dollar Baby's* critical and box-office success is significant considering its portrayal of a female boxing protagonist in this historically male-dominated genre that is based, as we have seen, on strictly binary understandings of gender and sexuality. Woodward suggests that the figure of the female boxer raises important questions

'about how and why women might "do" masculinity [...] and whether there are alternative reconfigurations of gender identities'[36] – issues that the female boxing film, by definition, engages with. It also raises more general questions about how female characters might 'do' heroism within the context of mainstream cinematic narratives – and within the larger socio-cultural context more generally.

Athletic performance, 'believable' bodies: Throwing like a girl?

Despite the various containment mechanisms in place, from the feminine apologetic, the gendering of different types of sports, as well as narrative and generic containment, a number of critics highlight the transgressive and subversive potential of women's engagement in sports. Butler, for instance, suggests that women's pursuit of sports constitutes a public staging and contestation of gender ideals, as normative assumptions about the 'natural' female body and its physiology are challenged and undermined. Therefore, women's sports are a crucial space for the rearticulation and transformation of gender ideals. Bodies, such as tennis player Martina Navratilova's, that were once considered monstrously masculine have, over time, been integrated into notions of intelligible, acceptable and even desirable female physiology. Women's sports can thus be seen as a space in which 'our ordinary sense of what constitutes a gendered body is itself dramatically contested and transformed'.[37] Sports films are part of this process. *Girlfight* in particular challenges our ordinary sense of the kinds of roles available for women in cinema, through its depiction of a visibly strong and muscular female boxing protagonist, played by the 'naturally' athletic Michelle Rodriguez whose powerful physique and movements lend a significant sense of authenticity and believability to the film's boxing sequences.

Similarly, *Million Dollar Baby*, despite the narrative containment of its protagonist's bodily agency, features a muscular and physically powerful female boxing protagonist, played by one of Hollywood's most recognizable female stars. The rigorous training undertaken by Swank in preparation for the role (much discussed around the time of the film's release) ensures, again, an important sense of believability when it comes to the boxing activity itself. Both films are also explicit in their depiction of the physical, bodily implications of boxing: we see the characters/actresses sweat, hear their heavy breathing, see the exhaustion on their faces, hear bones cracking upon the impact of opponents' punches and we 'see' their muscles 'work'. *Stick It*, with its rebelliously tomboyish

protagonist, Hayley, also features a muscular and powerful female body that is truly troubling. Although the film's focus is gymnastics, a sport with feminine connotations, the gymnasts' bodily exertion and the bodily effort and strength that are required in order to make the gymnastics performances *appear* effortlessness, are overtly emphasized in the film's training sequences.

There is, I contend, a significant difference between films like *Girlfight*, *Million Dollar Baby* and *Stick It*, and films such as *Gracie*, *She's the Man* or *Wimbledon*, in which the female characters do not embody their athleticism *believably*. They run up to the ball at awkward angles, their legs and arms do not follow through when they shoot or throw, and they run 'like a girl', meaning their movement is inhibited and self-conscious, rather than confident and assertive[38] The actresses do not have the kinds of athletic bodies that would make their sporting actions or movements possible in the first place – no amount of editing can successfully conceal this. As such, their embodiment of traditionally feminine forms of comportment, movement and gesture ensures that their presence is less troubling; it has no 'substance' and is clearly confined to the realm of image and spectacle.

Conclusion: *Just do it*?

Overall, then, the increased presence of women in the sports context, as well as the increased visibility of female athletes, both within cinema and beyond, can be considered a sign of progress. Institutional gender inequalities as well as conservative ideas about gender are being challenged, providing girls and women with a range of previously unavailable opportunities. However, the celebration of women's presence in the contemporary sports context is by no means unequivocal.

What tends to be underestimated with regard to feminist discourses that see the increased presence of women within sports (particularly at the professional level) as a sign of progress, are the implications of sport as a context fundamentally based on notions of individualism, competitiveness (at all costs), super-stardom, commodification as well as violence and injury:

> Gendered heroism is being constantly challenged by women who are appropriating the narratives of maleness and transforming themselves from victims into superstars. According to many feminists, to claim an identity that used to be exclusively male in a macho, sexist culture is symbolically heroic. However, what is often forgotten

is that the fierce concern for equality props up the violence, cor-
ruption and commercialisation and exploitation that plague men's
sports.[39]

Additionally, Carty reads the change in acceptable bodily ideals brought
about by women's engagement in sport and the increased visibility of
female athletes, celebrated by Butler and others, more suspiciously:

> The most recent shift features female athletes who embrace new
> notions of femininity that include muscles, strength, fitness, and
> competitiveness. This is a move away from traditional depictions of
> vulnerability, fragility, dependence, and subservience [...] However,
> at times the strong powerful bodies women have attained to enhance
> their performance are currently transformed into objects of sexual
> desire. At issue is if this is merely a new way to sexualise women's
> (now toned) bodies.[40]

Carty is one of many critics to suggest that the acceptance of new
bodily forms and their integration into notions of desirable femininity
function to reposition the athletic female body as the object of hetero-
sexual male desire and thus undermine its transgressive potential. The
contemporary presence of women as athletes in the sports context is
therefore imbued with a characteristically postfeminist sense of contra-
diction, in that feminist 'progress' (i.e. girls' and women's access to the
sports context) is strangely 'entangled' with a postfeminist sensibility
that is characterized by an emphasis on femininity, a cultural obsession
with the body as a marker of identity, an emphasis on individual choice
and agency (via particular 'lifestyles' and consumption), and the perva-
sive sexualization of culture, with women's (empowered) bodies at the
centre.[41]

Heywood and Dworkin similarly highlight that the increased visibil-
ity of female athletes and non-traditionally muscular and strong female
bodies from the mid-1990s onwards was accompanied by the increased
sexualization of female athletes, the fetishizing of women's (and men's)
muscles, and the inclusion of the empowering potential of female ath-
leticism into discourses not only of health but of beauty culture.[42] It is
important, at this point, to note the ways in which Hillary Swank's phys-
ical transformation for her role as a female boxer in *Million Dollar Baby*
was presented as a beauty project within public/media discourses and
the ways in which Swank was excessively glamorized and feminized at
the Academy Award Ceremony in 2004 where she received an Oscar for

her performance as the female boxer, Maggie.[43] Additional postfeminist tendencies identified by Heywood and Dworkin include the promotion of an athletic 'lifestyle' for women that is linked to the cultivation of women as a mass market by big corporations. The authors suggest that the increased visibility of female athletes was essentially market-driven, leading to a peculiar situation in which female athletes continued to be marginalized within traditional sports media (i.e. sports news, live coverage of sporting events), but gained considerable profile within advertising in particular, with companies such as Nike essentially selling women empowerment and liberation in the form of shoes. 'The marketing of women's empowerment through sport fosters regressive illusions that obscure real, structural inequalities inherent to a market system and the sports world that is intrinsically part of it, a world that serves to empower only a very few individual women and (at best) ignores all the rest.'[44]

I would like to conclude this chapter by suggesting that the increase in mainstream cinematic representations of female athletes can be situated, at least partially, in this context. The films discussed here, centred as they are on variously non-traditional female protagonists, without question provide (empowering) viewing pleasures to their young female audiences in particular. However, they are also clearly part of the process in which notions of female empowerment and progress are increasingly depoliticized, commodified and sold back to girls and women, both in the form of shoes and in the form of (cinematic) fantasies of individual empowerment, at the expense of a consideration of larger structural inequalities.

Notes

1. Katharina Lindner, 'Bodies "in action": Female athleticism on the cinema screen', *Feminist Media Studies*, 11:3 (2011), pp. 321–345; D. W. Pearson, 'The depiction and characterization of women in sport film', *Women in Sport and Physical Activity Journal*, 10:1 (2001), pp. 103–124.
2. L. Heywood and S. Dworkin, *Built to Win: The Female Athlete as Cultural Icon* (Minneapolis, MN: University of Minnesota Press, 2003).
3. R. Gill and C. Scharff, 'Introduction', in *New Femininities: Postfeminism, Neoliberalism and Subjectivity*, ed. by R. Gill and C. Scharff (Basingstoke: Palgrave Macmillan, 2011).
4. R. Gill, 'Postfeminist media culture: Elements of a sensibility', *European Journal of Cultural Studies*, 10:2 (2007), pp. 147–166.
5. S. Cahn, *Coming on Strong: Gender and Sexuality in 20th Century Women's Sport* (Boston, MA: Harvard University Press, 1994), p. 1.

6. J. Hargreaves, *Sporting Females: Critical Issues in the History and Sociology of Women's Sports* (London: Routledge, 1994); K. Woodward, *Boxing, Masculinity and Identity: The 'I' of the Tiger* (London: Routledge, 2007).

7. R. W. Connell, *Masculinities* (Berkeley, CA: University of California Press, 1995).

8. Cahn, *Coming on Strong*.

9. R. Boyle and R. Haynes, *Power Play: Sport, Media and Popular Culture* (Edinburgh: Edinburgh University Press, 2009); L. McKernan, 'Sport and the first films', in *Cinema: The Beginnings and the Future*, ed. by C. Williams (London: University of Westminster Press, 1996), pp. 107–116.

10. Woodward, *The 'I' of the Tiger*, p. 3.

11. A. Reed, *Cage Rage* (2008), http://www.sundayherald.com/life/people/display.var.2104383.0.0.php, (accessed 20 January 2012).

12. Keeping in mind the problematic implications of attempts to categorize different feminist 'strands', 'liberal feminism' here refers to the kind of feminism concerned with achieving (gender) equality within existing socio-cultural and institutional structures, rather than challenging oppressive structures themselves.

13. Heywood and Dworkin, *Built to Win*.

14. D. Whitson, 'The embodiment of gender: Discipline, domination, and empowerment', *Gender and Sport: A Reader* (New York: Routledge, 2002), pp. 227–240 (p. 232).

15. A. McRobbie, *The Aftermath of Feminism: Gender, Culture and Social Change* (London: Sage, 2009).

16. K. Lindner, ' "In touch" with the female body: Cinema, sport and lesbian representability', in *The Handbook of Gender, Sex and Media*, ed. by K. Ross (Oxford: Wiley-Blackwell, 2012); K. Lindner, ' "There is a reason why Sporty Spice is the only one of them without a fella ... ": The "lesbian" potential of *Bend it Like Beckham*', *New Review of Film and Television Studies*, 9:2 (2011), pp. 204–223.

17. B. Creed, 'Lesbian bodies: Tribades, tomboys and tarts', in *Sexy Bodies: The Strange Carnalities of Feminism*, ed. by E. Grosz and E. Probyn (London: Routledge, 1995), pp. 93–94.

18. Y. Tasker, *Spectacular Bodies: Gender, Genre and the Action Cinema* (London: Routledge, 1993).

19. Gill, 'Postfeminist media culture'.

20. L. Heywood, *Bodymakers: A Cultural Anatomy of Women's Bodybuilding* (New Brunswick: Rutgers University Press, 1998).

21. J. Brace-Govan, 'Looking at bodywork: Women and three physical activities', *Journal of Sport and Social Issues*, 26:4 (1999), pp. 403–420.

22. A. Feder, ' "A radiant smile from the lovely lady": Overdetermined femininity in "ladies" figure skating', *The Drama Review*, 38:1 (1994), p. 63.

23. L. Mulvey, 'Visual pleasure and narrative cinema', *Screen*, 16:3 (1975), 6–18.

24. The integration of female sporting protagonists into this historically male-centred/masculine genre contrasts heavily with the (reassuring) presence of athletic protagonists in more traditionally postfeminist genres such as the romantic comedy or rom-com (e.g. *Wimbledon* [Loncraine, 2004]) or the chick flick (e.g. *Bring it On*).

25. L. Grindon, 'Body and soul: The structure of meaning in the boxing film genre', *Cinema Journal*, 35:4 (1996), pp. 54–69; L. Grindon, 'The boxing film and genre theory', *Quarterly Review of Film and Video*, 24(5) (2007), pp. 403–410.
26. Mulvey, 'Visual pleasure'.
27. Dyer, 'Don't look now: the instabilities of the male pin-up', *Screen*, 23(3–4) (1982), pp. 61–73.; S. Neale, 'Masculinity as spectacle', *Screen*, 24(6) (1983), pp. 2–16.
28. P. Cook, 'Masculinity in crisis?', *Screen*, 23(3/4) (1982), p. 42.
29. Grindon, 'Body and soul', p. 60.
30. D. Rowe, 'If you film it, will they come?', *Journal of Sport and Social Issues*, 22(4) (1998), p. 351.
31. Grindon, 'Body and soul'; Grindon, 'The boxing film and genre theory'.
32. Grindon, 'Body and soul', p. 5.
33. Woodward, *The 'I' of the Tiger*, p. 122.
34. Tasker, *Spectacular Bodies*; C. Holmlund, *Impossible Bodies: Femininity and Masculinity at the Movies* (London: Routledge, 2001).
35. Tasker, *Spectacular Bodies*.
36. Woodward, *The 'I' of the Tiger*, p. 5.
37. J. Butler, 'Athletic genders: Hyperbolic instance and/or the overcoming of sexual binarism', *Stanford Humanities Review*, 6:3 (1998), http://www.stanford.edu/group/SHR/6-2/html/butler.html (accessed 15 March 2012).
38. M. I. Young, 'Throwing like a girl: A phenomenology of feminine body comportment, motility and spatiality', *Human Studies*, 3:2 (1980), pp. 137–156.
39. J. Hargreaves, *Heroines of Sport: The Politics of Difference and Identity* (London: Routledge, 2005), p. 3.
40. V. Carty, 'Textual portrayals of female athletes: Liberation or nuanced forms of patriarchy?' *Frontiers*, 26:2 (2005), p. 137.
41. Gill, 'Postfeminist media culture'; A. McRobbie, 'Postfeminism and popular culture', *Feminist Media Studies*, 4:3 (2004), pp. 255–264.
42. Heywood and Dworkin, *Built to Win*.
43. Woodward, *The 'I' of the Tiger*, p. 141.
44. Heywood and Dworkin, *Built to Win*, p. 3.

Index

Printed and bound by CPI Group (UK) Ltd, Croydon, CR0 4YY